BETTY KUHNER

BETTY KUHNER

THE AMERICAN FAMILY PORTRAIT

KATE KUHNER & STEVEN STOLMAN

GIBBS SMITH
TO ENRICH AND INSPIRE HUMANKIND

To our beautiful moms in heaven,

Elizabeth Kuhner and Gloria Sloat Stolman

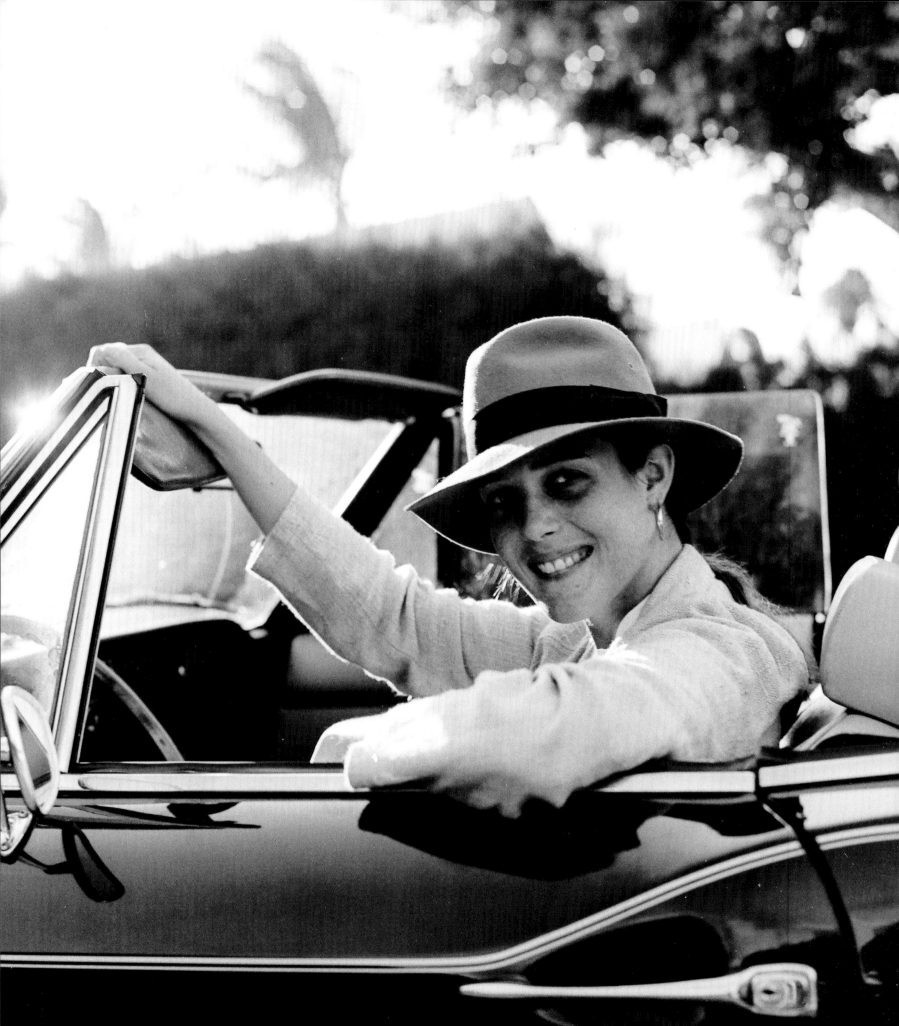

CONTENTS

FOREWORD

Liza Pulitzer Calhoun

Being photographed by Betty Kuhner was always a family event. She was a big part of our family, as Mom considered Betty and her husband, Russell, to be two of her best friends. Her style was unique, and every photo we ever had taken became a family treasure. You could walk into any house, anywhere in the world, see a photo of an individual or a family, and instantly recognize Betty's work. She was truly an artist with an amazing eye, and her belief in black-and-white imagery remained strong throughout her life. With her trusty Hasselblad strapped around her neck, and her enormous glasses perched on the end of her nose, off we would go, around our garden, looking for the perfect shot that she had in mind. And as she was looking down into the lens of that black box, she never stopped laughing and talking. She was part of our family, and if Mom had her way, she would have been in the photo with us.

Liza Pulitzer, Palm Beach, Florida, 1980.

PREFACE

Kate Kuhner

I have always looked up to my mother. She was not your traditional mom of the 1950s and '60s; she was the unique working mother. I must admit that I would have preferred her to be waiting at home for me after school with a tray of freshly baked brownies, just like TV's June Cleaver. But now, with the advantage of maturity, I can appreciate the invaluable lessons I learned from her, not necessarily from her role as a homemaker, but rather from her role in the working world.

From the beginning, my mother always had her own point of view. Standing on the sidelines while my photographer father was working, she would often say, "Russ, why don't you try it from this angle?" or "How about doing it this way?" Finally, in annoyance, my father said, "Betty, get your own camera!" And so she did.

Her first client was the Jessup family in Greenwich, Connecticut. Mom felt that if she fell flat on her face, Greenwich was far enough away from Westport, where we lived, that she would not tarnish my father's reputation as an accomplished professional photographer. Armed with her own Hasselblad and her warm personality, she ran out the door, looking over her shoulder and asking, "Now, which button do I push again?" The rest is history.

Mom's unique point of view took the families out of their formal living rooms and, instead, had them interacting with each other out on their lawns, hanging from trees, running on the beach or frolicking in the ocean. A new standard was born.

Kate and Betty on location at the Las Brisas hotel in Acapulco, Mexico, 1972.

Her own uniform consisted of white slacks, a blue cotton shirt and her hair held back by a crisp cotton scarf. The final accent was her famous oversized glasses. It was informal but distinctively stylish. In giving me tips when I took over her business, she said, "Have a uniform that you put on before every job. It helps to create a feeling of confidence and relaxed professionalism."

She also urged me to always be myself. That philosophy served her well, whether she was photographing a next-door neighbor, a duke and duchess or a political family dynasty. She was forever confident, cozy, warm and engaging, uninhibited by her subjects' fame or fortune.

When our family first arrived in Palm Beach, Lilly Pulitzer was her first client. The photos were taken and the proofs delivered; mom waited to hear Lilly's reaction. Weeks went by and still no word from Lilly. Mom knew she had to reach out, but instead of writing a formal letter, she simply wrote, "Lilly-poo, have you forsaken me?" From that moment on, she and Lilly were the best of friends.

My parents entertained all the time, and their clients often became friends, most of them equally creative, artistic and eclectic. Mom was a fantastic cook, and dinner was always a serve-yourself feast laid out in our kitchen—a uniquely casual approach for then-quite-traditional Palm Beach. Guests were always enchanted by her easy informality and universally let their hair down.

My mother's unique point of view combined with her warmth and natural ability to make everyone comfortable were the keys to her success as a photographer, home decorator, entertainer and, most importantly, mother. Because of her, I too am proud to be a confident woman, a professional photographer and someone unafraid to follow their own muse. I couldn't have asked for a better parent, friend and mentor. I will forever strive to live up to her legacy.

Thank you, Mom!

Regarding family names:

Just as my mother redefined the American family portrait, so too has the American family itself evolved. As people enjoy longer, healthier lives and a more open society, one everlasting marriage per person is no longer the rule but the exception.

To that end, so many of the wonderful people in this book may have had one name when the photograph was taken, but now have another. For consistency, we are using the names listed in Mom's original files.

PORTRAITS BY A LADY

Steven Stolman

As is the way of the world, what is at first groundbreaking over time can become de rigueur. Take, for example, one of today's smart set must-haves: a wistful, evocative black-and-white professional photograph of mother and child, or the kids, or the entire family or a newly engaged couple—casually dressed, perhaps barefoot, interacting naturally and captured just so, on the beach or in front of a tree, all appearing breezy and bronzed, carefree and relaxed, elegantly at ease.

It wasn't always this way. For decades, the typical family photo was posed and stiff, usually taken in front of the living room fireplace. That is, until photographer Betty Kuhner found fault with this accepted style. "As a teenager in Connecticut, I used to walk by this photographer's storefront," she recalled, "and on display were positively the most awful family portraits—everyone seated and looking in the same direction. Years later, I discovered that the photographer would toss his keys in the air to get everyone's attention. Can you imagine?"

Kuhner's initial dissatisfaction with the status quo not only created but also popularized the genre of "the environmental portrait" throughout a career that spanned five decades. Indeed, among the affluent habitués of Newport, Greenwich, Southampton, Grosse Pointe and Palm Beach, Betty Kuhner became the family

photographer of record. Through her lens passed the images of America's toniest tribes, with names like Armour, DuPont, Duke, Ford, Gubelmann, Kennedy, Lauder, Merck and Phipps among her frequent subjects.

Her career was truly the product of happenstance. Like so many women of the 1950s, Kuhner was a stay-at-home mom with three kids in picture-perfect Westport, the southern Connecticut suburb with a decidedly artistic bent. Her husband, Russell, was a well-known commercial photographer who specialized in ad campaigns and portraits of men—most of them corporate titans who required such photographs for their annual reports, news releases and ubiquitous boardroom walls. "Russell's assistant became pregnant, so out of necessity he asked me to fill in," Kuhner recalled. "Pretty soon he got tired of me putting my two cents in, so he gave me my own camera."

She started small, offering her services to friends and neighbors. "It was really remarkable. I'd knock on the front door of a family that I didn't necessarily know for a sitting. Two hours later I really felt as though I had a lot of insight into who they were," she said. She also began to acquire her own commercial accounts, specifically home furnishings and lingerie. She shot one particular lingerie campaign on location at Round Hill, Jamaica. Even by today's "seen it all" standards, the photos remain inspired, artistic—even rather provocative, given that most of the half-slip-clad models are topless, shot from behind. The presence of a toddler, though, imparts innocence to the otherwise risqué rigmarole.

Kuhner's jobs, and those of her husband, were always found without the benefit of an agent. "It really was all by word of mouth," she said. "And many of the top ad execs lived in Westport, so they knew us." When the Kuhners began to winter in Florida, Betty took her camera along. Her first clients were Lilly Pulitzer and her family—an extraordinary chronicle that captured decades of the late fashion icon and her brood.

With time and practice, Betty developed a unique sense of composition and an ability to put her subjects at ease to the point where they lost all sense of the camera yet remained ironically, photogenic. A Betty Kuhner photograph crystallized the moment while eschewing pretension. Best of all, everyone looked terrific. "I

always tried to capture a family's love for each other," she admitted. She recalled one particular sitting—an attractive couple with two sons, ages eight and ten. "Usually boys are so difficult. But these two were unusually cooperative. I posed them in a chair under a branch; they were like little actors. And the parents just hugged and cuddled for me; it was all so touching," she said. When they were finished, the mother took Kuhner aside and asked for two sets of proofs. "Such an unnecessary expense!" Betty exclaimed. "Wait to see the results and then pick your prints." The mother replied, "Both my husband and I need a complete set. We're separating tomorrow and I want the children to remember a happy family."

Regardless of changing family dynamics, one thing remains intact: an almost universal affection for Betty Kuhner's photographs, especially by those who have them in their possession. Perhaps it's about reclaiming lost youth, or revisiting happier times. So many of the pictures now depict marriages long dissolved, or family ties unraveled, or years and lives gone by; yet in each and every one, joy is evident. After Betty retired, her daughter, Kate, followed in her mother's footsteps. Armed with her mom's Hasselblad, she creates portraiture that pays homage to the family legacy. Indeed, those who have been photographed by both Kuhner women have remarked that they were amazed at the similarity of both the experiences and the outcome. "From my mom, I learned all about dealing with people—becoming part of a family and bringing out the relationships among them," said Kate. "And, of course, everything about lighting—finding that wonderful backlight that erases every line."

The Environmental Family Portrait

While Betty Kuhner is widely credited with popularizing the environmental family portrait, the genre had already begun to emerge as early as the mid-1940s, courtesy of news photographer Arnold Newman. As a freelancer for publications such as *Fortune, Life* and *Newsweek,* Newman was often called upon to photograph well-known persons. Like Betty, he too was uninspired by the status quo and felt that regardless of the fame of the subject, the photograph itself should be interesting and exciting. His images of Marlene Dietrich, John F. Kennedy, Pablo Picasso, Marilyn Monroe and Audrey Hepburn remain iconic in the collective conscience of millions.

Betty, in contrast, rarely photographed individuals, and most of her subjects, with a few extraordinary exceptions, were generally unknown outside of their communities. Of course, given that those communities were typically enclaves of America's wealthiest families, so many of the surnames are indeed familiar. After all, who wouldn't be aware of products as ubiquitously American as Ford automobiles and Hoover vacuum cleaners? But in the majority of Betty's archive, the typically obvious trappings of wealth—imposing mansions, exquisite clothing and jewelry and expensive cars—are decidedly absent. Her subjects are mostly dressed casually and are photographed in locations as anonymous as a field of grass, a sandy beach or in a tree, hanging like so many monkeys. The collateral that is absolutely evident in each and every Betty Kuhner photograph, however, is love.

The subtle documentation of interpersonal interaction is also a hallmark of Betty's extraordinary style. Her subjects appear relaxed and at ease, undoubtedly comforted by being in the presence of their kin. No one seems the least bit aware of the camera. In Betty's pictures, mothers gaze lovingly into their children's eyes or are hugging them tightly; fathers are proud; and kids are, well, kids—poised for mischief, laughing, obviously curious and, in a few isolated shots, clearly bored to tears. Such is the honesty that the environmental portrait is able to communicate so brilliantly. And this is why it has become the preferred standard for both individual and group photography to this day. How fortunate we all are that groundbreakers like Arnold Newman and Betty Kuhner had the audacity to think outside the box.

The High Society Tossed Salad

Among Betty's subjects are some of the most revered family names in American history. And while the Ford and Kennedy dynasties are relatively easy to organize into concise family trees, several clans that are part and parcel to so many chapters of the American story are intertwined in ways that would be hard for even an experienced genealogist to comprehend.

Nowhere else is this more apparent than in Palm Beach, where the descendants of Charles Munn (Armour, Boardman and Pulitzer) intersect with Bostwicks, Phippses, Rosenthals and many, many more, creating the most interesting flowchart. Even with

divorces and multiple remarriages, everyone seems to get along, frequently allowing two ladies of approximately the same age to actually be each other's stepmother or stepdaughter-in-law, or two unrelated best friends to easily share the same last name, albeit, perhaps not at exactly the same time. Weddings are particularly amusing, as families have become so blended over the generations that it's often impossible to easily respond to the question: bride or groom's side? Inevitably, the answer is both! Call it the "Blue Book Brady Bunch" or "Yours, Mine, Ours and Pretty Much Everyone Else's." Regardless, these uniquely blended families offer a marvelous illustration of camaraderie, civility and, in most cases, familial love.

An early Betty Kuhner portrait of Pauline Baker (now
Pauline Pitt), Palm Beach, Florida, 1960.

THE PORTRAITS

Just don't pay attention to me!

Betty Kuhner

Previous overleaf: Liza Pulitzer, Palm Beach, Florida, 1983.

ARMOUR FAMILY

Even after more than a century and a half of expansions, diversifications, acquisitions and sell-offs, the Armour name will always be associated with two words: meatpacking and Chicago.

In 1867, twenty-four-year-old Philip Danforth Armour used a windfall of $8,000 from the California gold rush to open wholesale grocery businesses, first in Cincinnati and then Milwaukee, ultimately moving to Chicago in 1875. The rest is history, becoming a part of the great American Gilded Age success story, while putting meat—primarily pork—on millions of dinner tables, along with numerous related animal products. "Everything but the squeal" was somehow, someway sold by the Armour Company. Descendants went on to thrive in banking in Chicago and ranching in Texas, accompanied by significant success in the oil business.

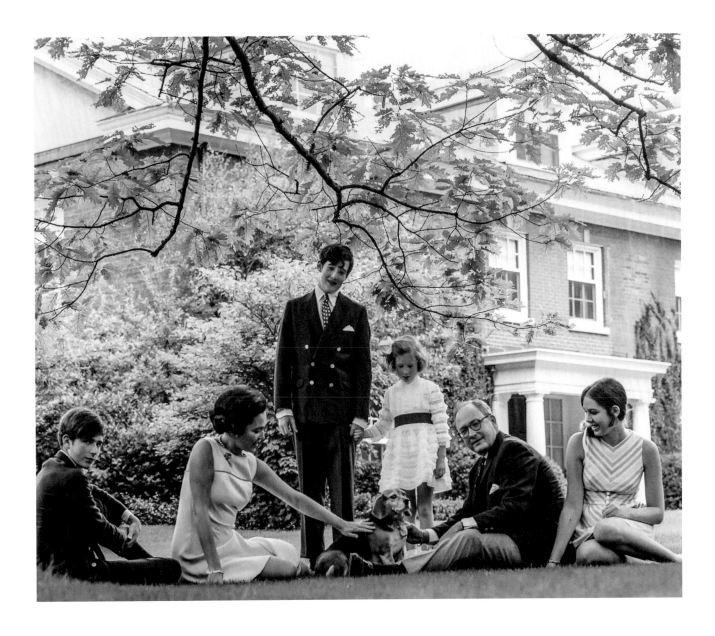

Mr. and Mrs. Laurance H. Armour Jr. and family,
Lake Forest, Illinois, 1969.

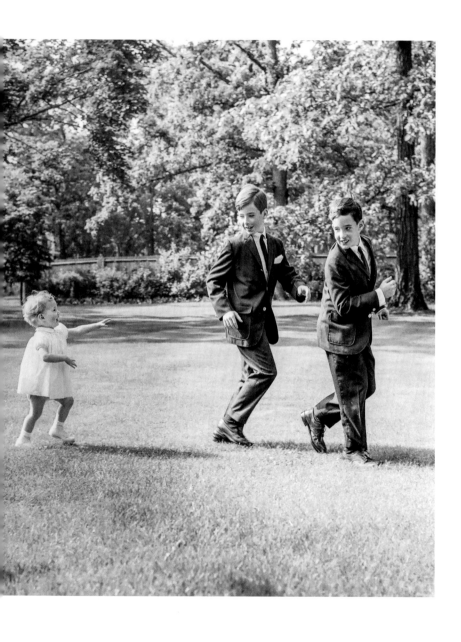

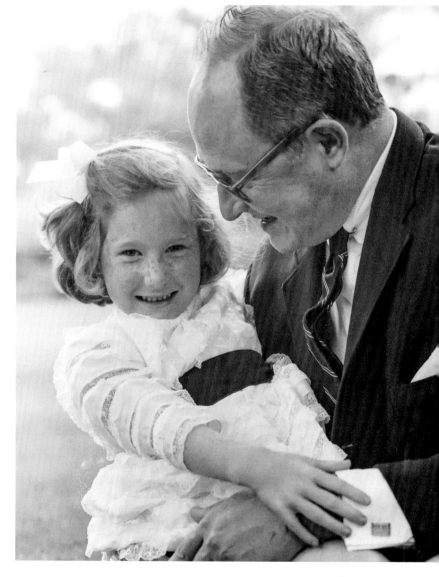

Brooks, Laurance III and Steven Armour, Lake
Forest, Illinois, 1965.

Laurance Jr. with daughter Brooks, Lake Forest,
Illinois, 1969.

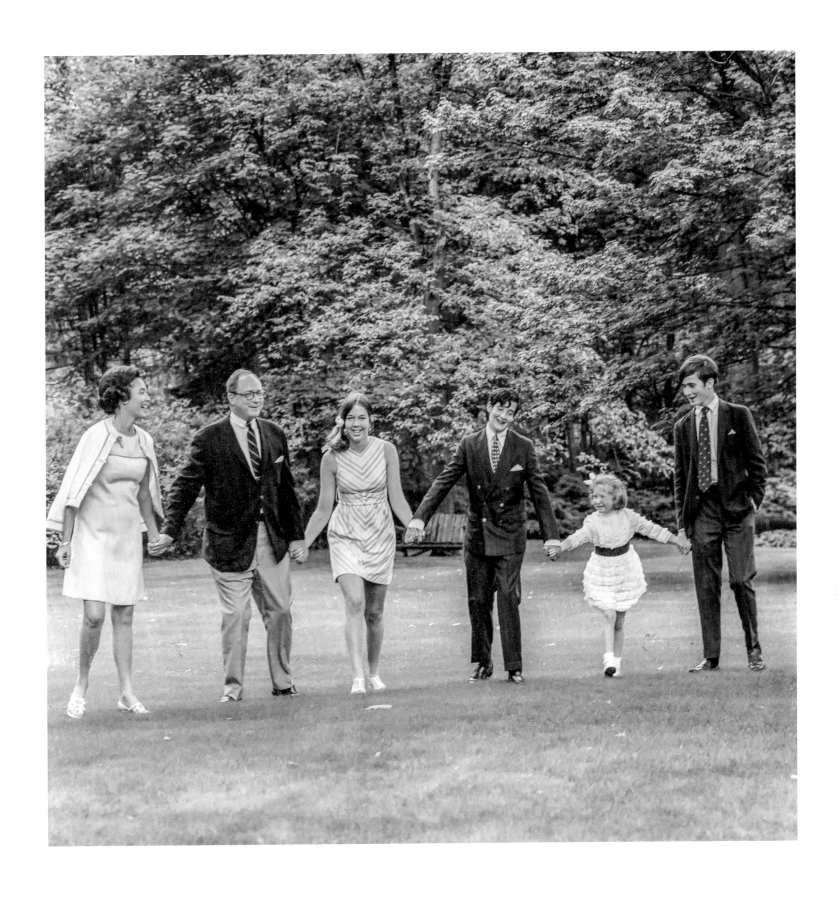

The Armour Family, Lake Forest, Illinois, 1969.

BANCROFT FAMILY

Originally from Boston, but equally associated with New York City, Southampton, Palm Beach and the storied Gold Coast of Long Island, the Bancroft family once owned Dow Jones & Company, publisher of the *Wall Street Journal*. Uniquely private, they remain an integral part of the American firmament as defined by the Social Register.

Margaret "Peg" Bedford's father, Frederick, was a director of the Standard Oil Company. She and her first husband, Thomas Bancroft, had one daughter, Muffie. A second marriage to Prince Charles d'Arenberg produced one son, Pierre. In 1968, Peg married yet again to the Duke d'Uzes.

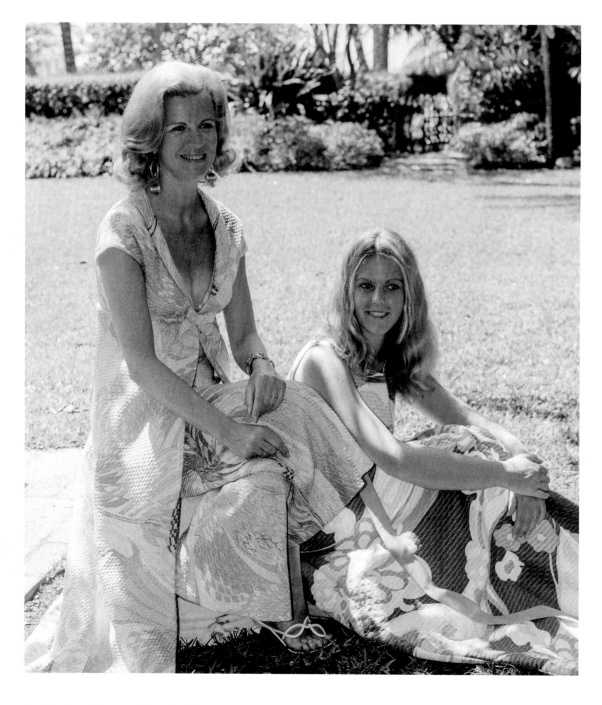

Peg, Duchess d'Uzes, and her daughter, Muffie, from her first marriage to Thomas Bancroft, Palm Beach, Florida, 1970.

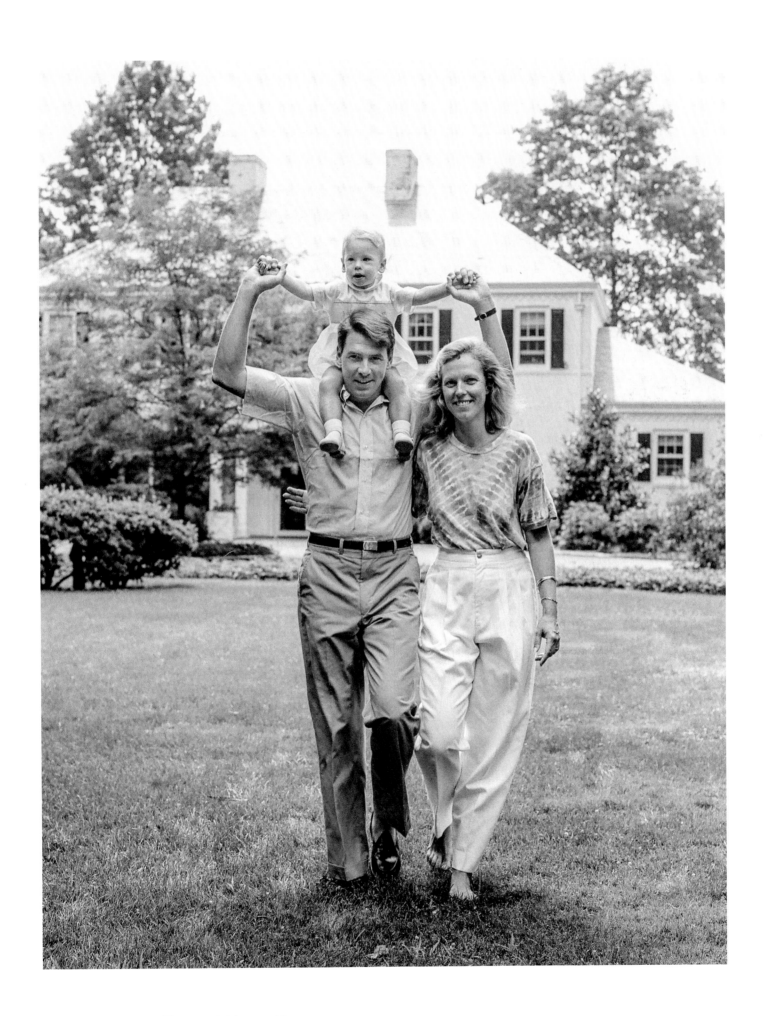

Stephen and Muffie Bancroft Murray with son
Frick, Green's Farms, Connecticut, 1991.

I loved Betty… I just adored her! She was a very special part of growing up and spending time in Palm Beach.

Muffie Bancroft Murray

Prince Pierre d'Arenberg, Menetou-Salon, France, 1965.

Prince Pierre d'Arenberg, Menetou-Salon, France, 1965.

BARDES FAMILY

The Cincinnati-based Bardes family rose to wealth and prominence on the kitchen stovetop, quite literally. Founded in 1894, the Incandescent Light & Stove Company built gas stoves and lighting fixtures for homes, adding electrical products as technology progressed. Ultimately becoming a leading manufacturer of electrical connectors, ILSCO is now in its third generation of Bardes ownership. Family members still call Cincinnati home, along with Newport, Palm Beach and Philadelphia.

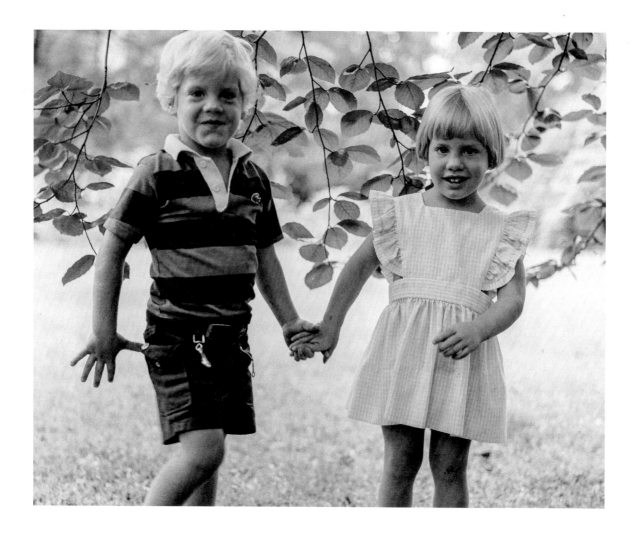

Betty gave me a lifetime of wonderful memories. She captured the moment and kept them for me forever.

Britty Bardes Damgard

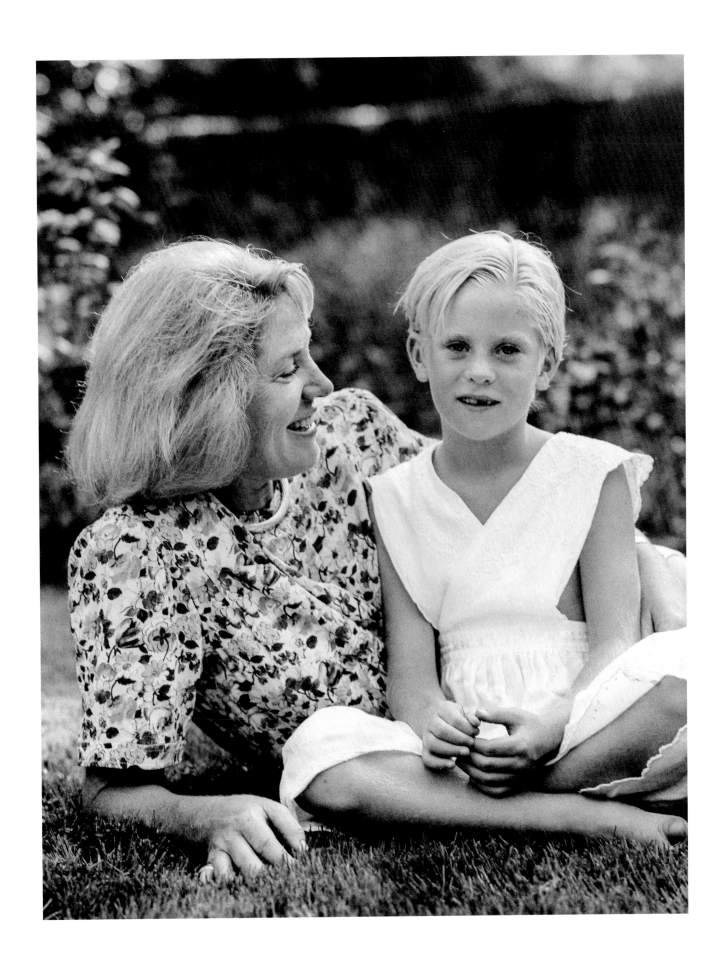

Facing: Blakely and Merrill Page, Newport, Rhode Island, 1977.

Britty Bardes Cudlip with daughter Mary Brittain, Newport, Rhode Island, 1990.

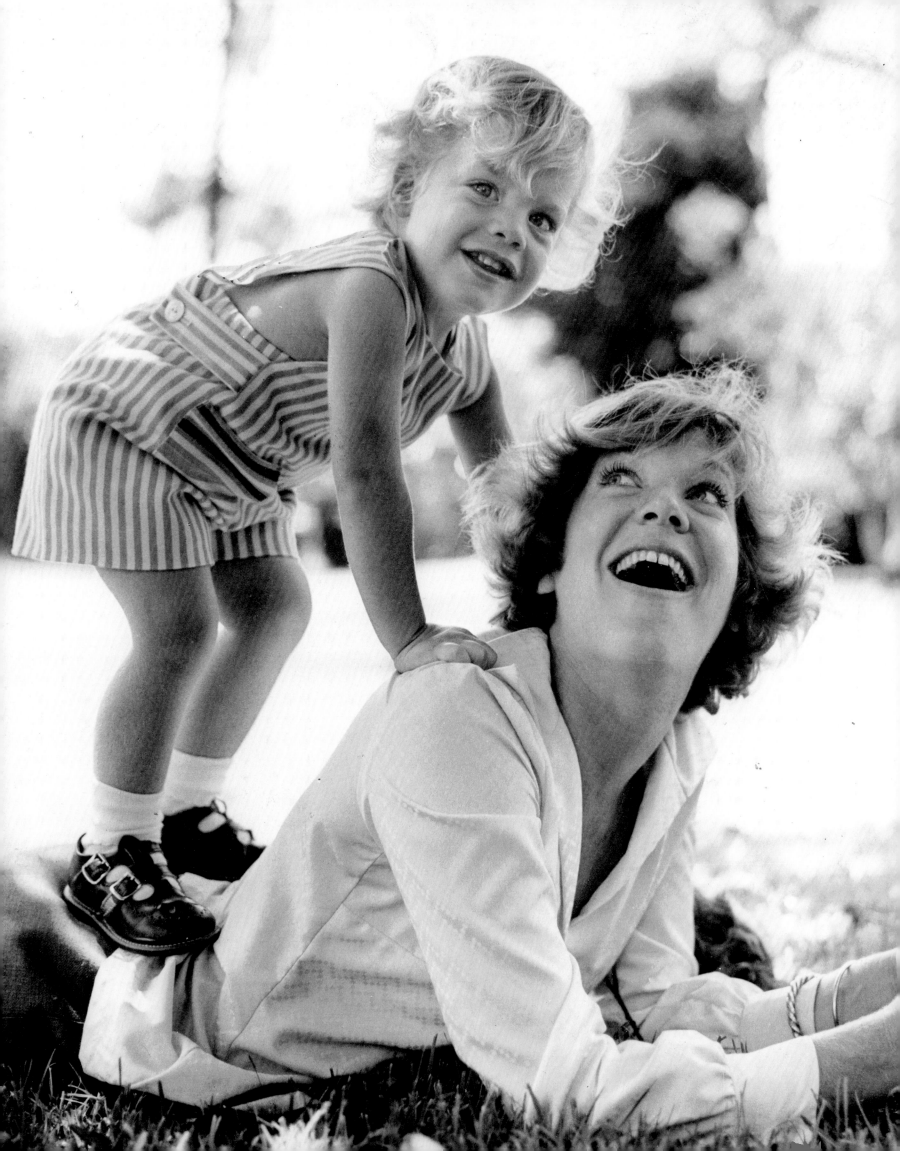

My mom must have thirty to forty of Betty's pictures of our family, at various ages and stages, covering the walls of her office. I just love going in there to look, think, remember, and see the family traits that have passed from generation to generation. It's as though, for a moment, time has stopped, and I'm a kid again.

Blakely Page

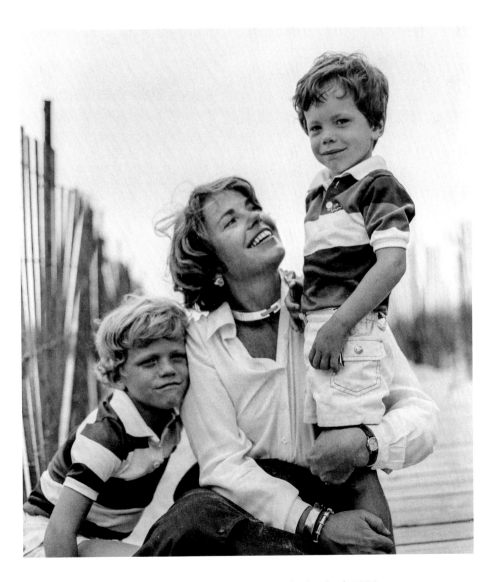

Facing: Britty Bardes Page with son Blakely, Newport, Rhode Island, 1976.

Above: Merrilyn Bardes Quinn with sons Thomas and Piper, Newport, Rhode Island, 1977.

BENJAMIN FAMILY

Another name with ties to Standard Oil, William "Bill" Benjamin moved his family from Connecticut to Florida in the 1950s. In 1957, he purchased Casa Alva, the spectacular Manalapan estate designed by architect Maurice Fatio in 1934 for Consuelo Vanderbilt Balsan, the former Duchess of Marlborough. The Benjamins were truly Manalapan's first family: Bill was responsible for much of the area's residential real estate development and even served as mayor.

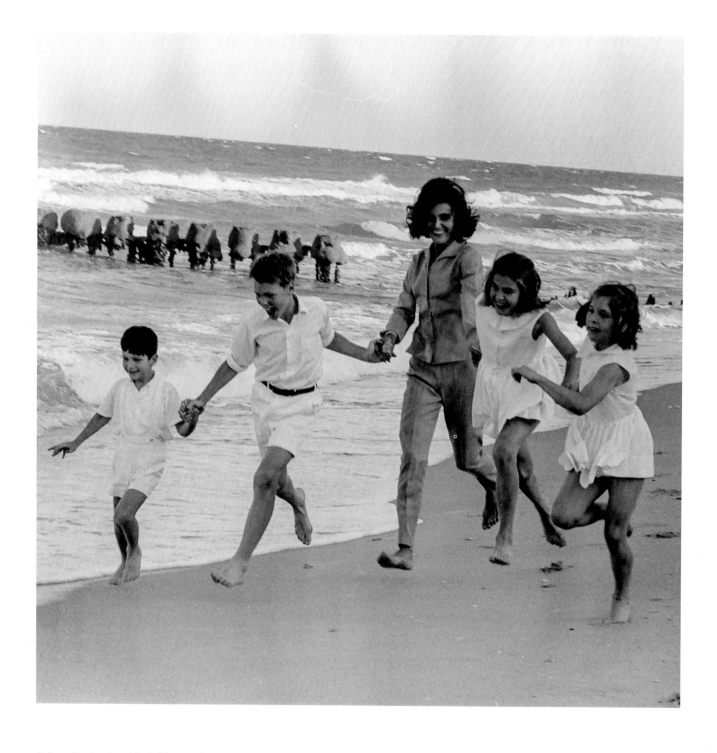

Odette Benjamin with children, Palm Beach, Florida, 1961.

William and Maura Benjamin with Jamie and Holly
Riordan and daughter Katie, Manalapan, Florida, 1991.

BISHOP FAMILY

Cleveland based, but a part of the Palm Beach community since the mid-1940s, members of the Bishop family enjoyed success in the worlds of finance, feed and grain, and fashion.

Mr. and Mrs. Warner Bishop with children Wilder and Brooks, Long Island, New York, 1980.

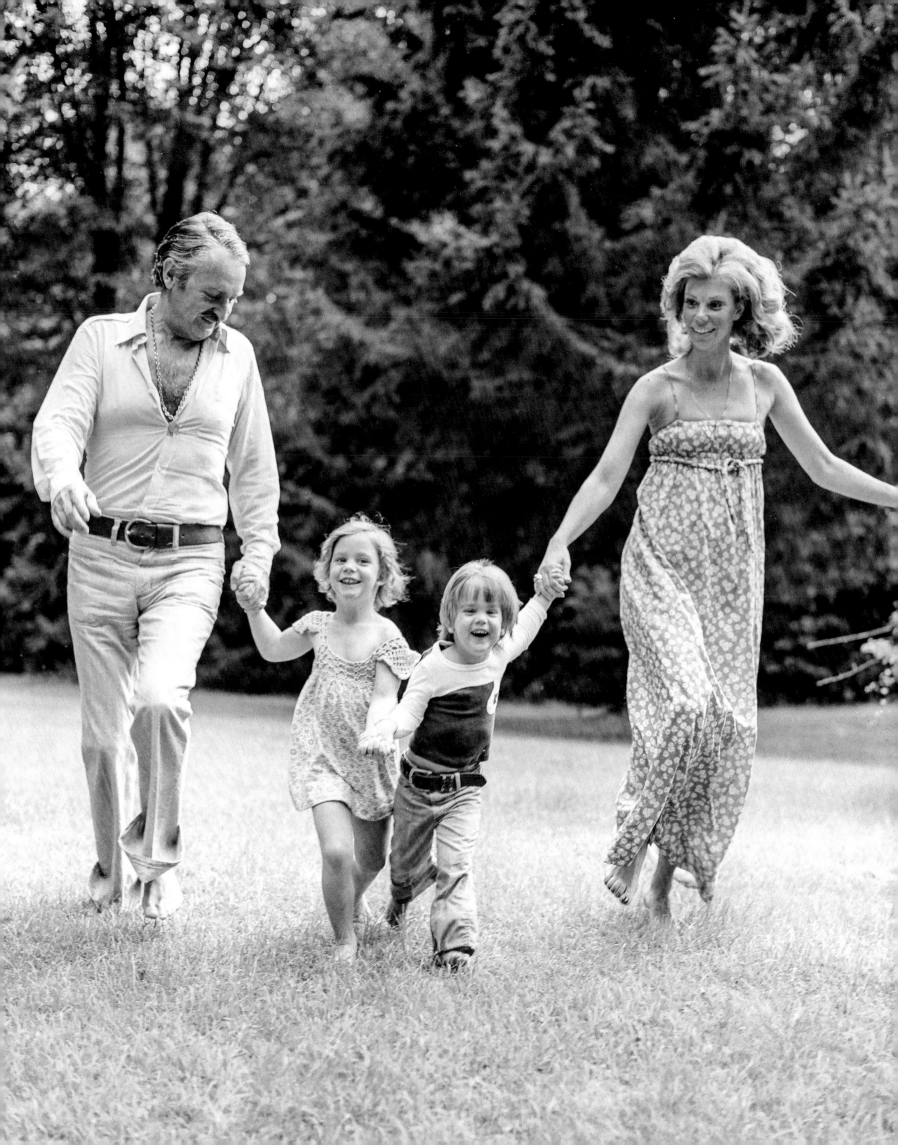

BISSELL FAMILY

The definition of a "clubbable" type, William Bradford Bissell's pedigree checked all the necessary boxes: Choate, Yale, the Society of Colonial Wars and a decided presence on the New York/Hamptons/Palm Beach circuit, along with a long and distinguished career in medicine.

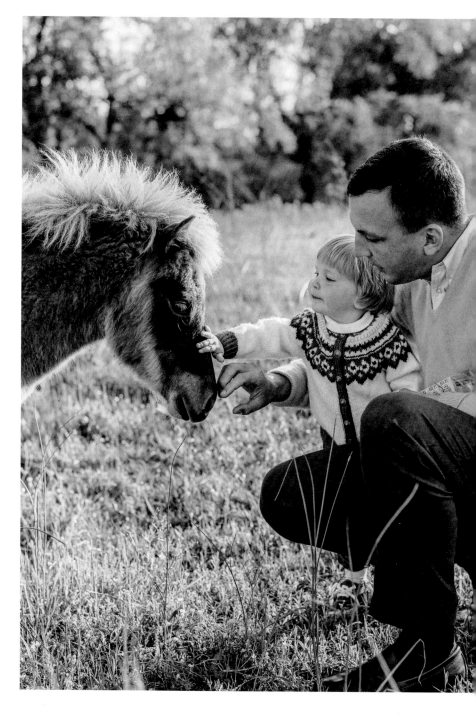

Barbara Bissell, Charlotte, North Carolina, 1967.

Howard C. Bissell with daughter Barbara, Charlotte, North Carolina, 1967.

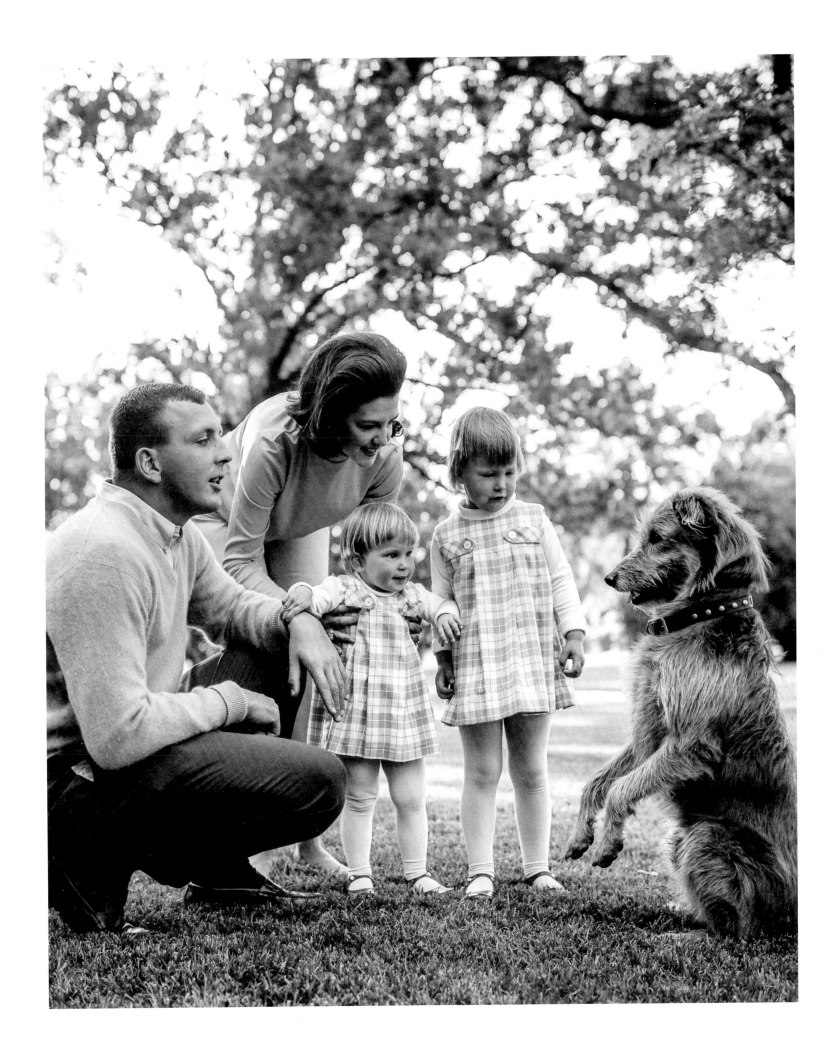

Mr. and Mrs. Howard C. Bissell with daughters
Barbara and Cary, Charlotte, North Carolina, 1967.

BOARDMAN FAMILY

 The Boardman clan is a mainstay of the high society habitats of Palm Beach, New York City, the Hamptons and Long Island's Gold Coast, with direct connections to other luminary names such as Drexel, Munn and Straus.

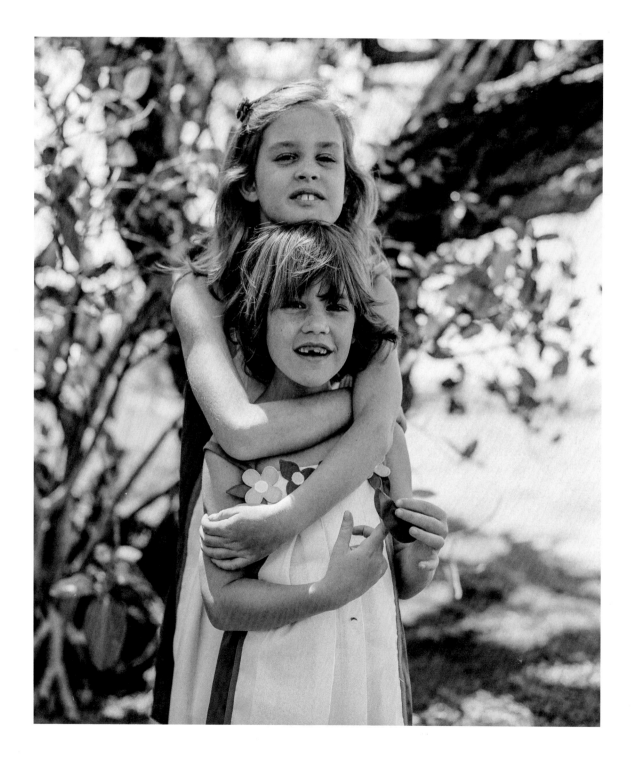

Serena and Samantha Boardman, Palm Beach, Florida, 1978.

Facing: Dixon and Pauline Boardman with daughters Samantha and Serena, Palm Beach, Florida, 1978.

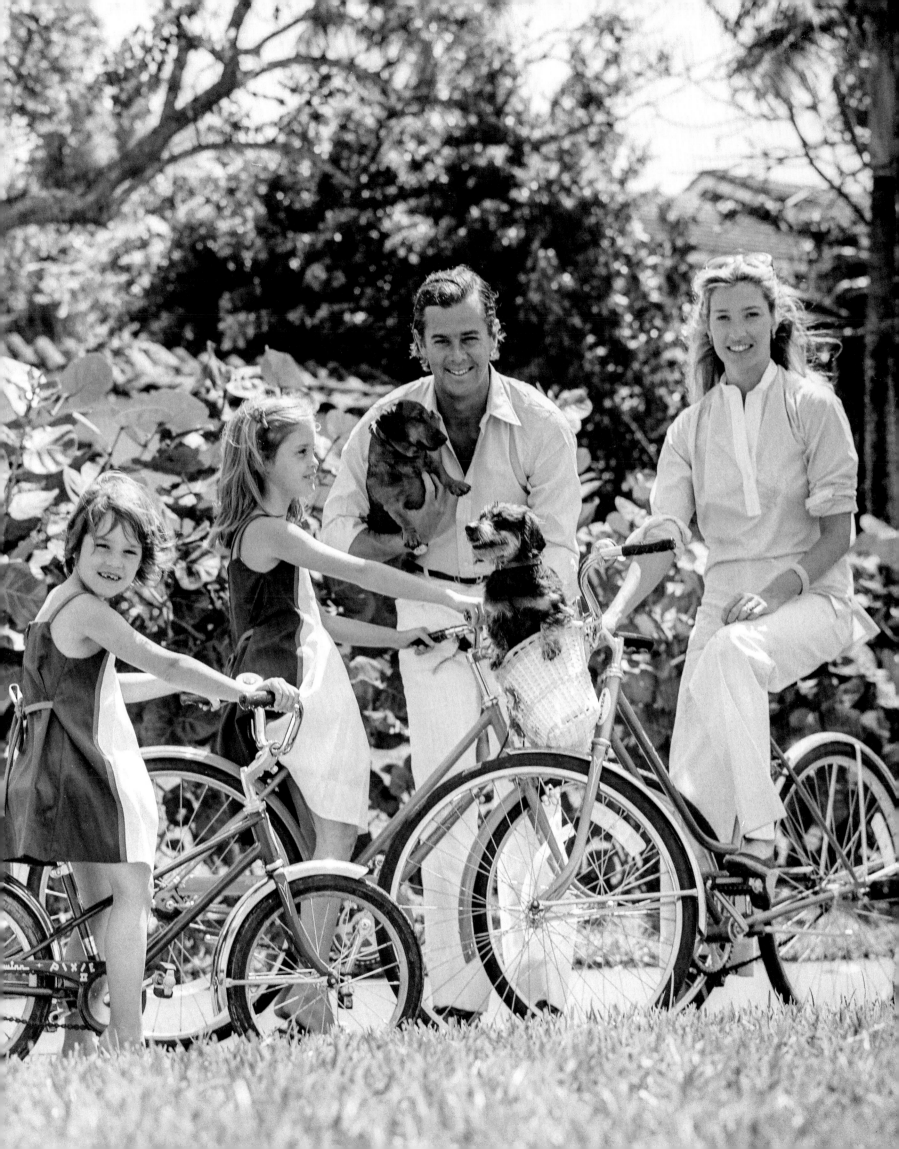

BUTLER FAMILY

The Butler family, specifically patriarch Paul Butler, will forever be known for creating the western Chicago suburb of Oak Brook. Along with real estate development, additional sources of family wealth came from the paper industry and general aviation.

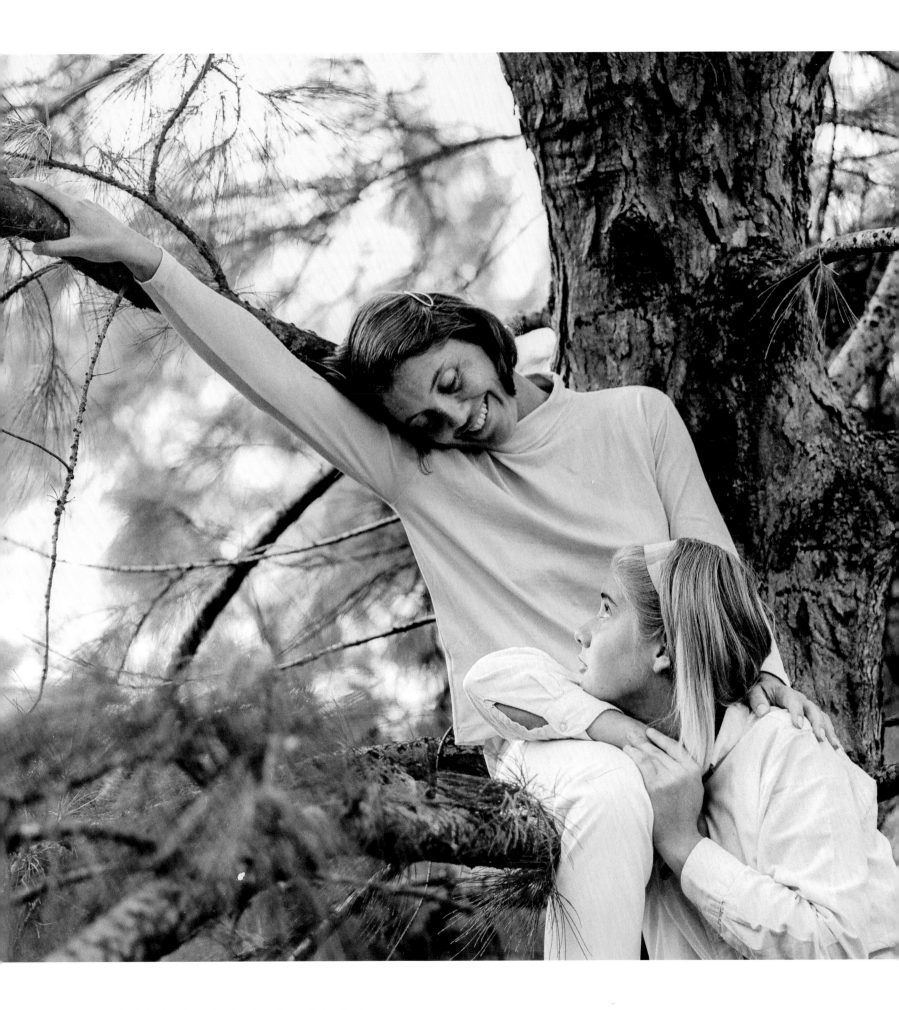

Jorie Butler Kent with daughter Reute, Palm Beach,
Florida, 1964.

COLEMAN FAMILY

Much loved and respected, the Coleman family is known for citizenship and public service. After a successful career in finance, Denis Coleman served as US consul general to Bermuda in addition to several terms on the Palm Beach town council.

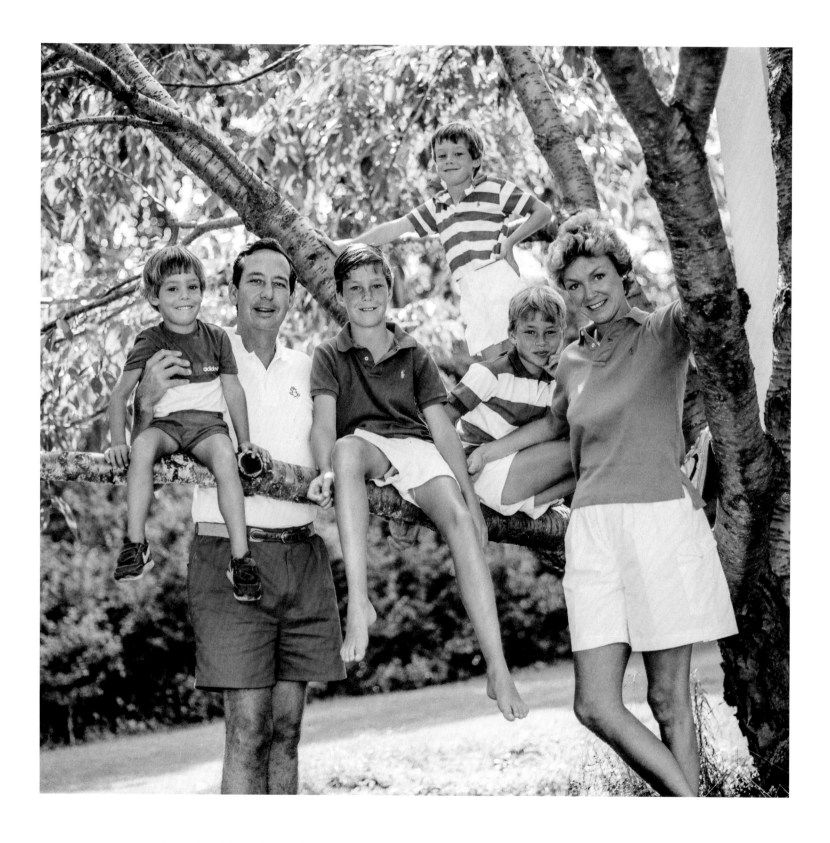

Denis and Annabelle Coleman with family, Greenwich, Connecticut, 1985.

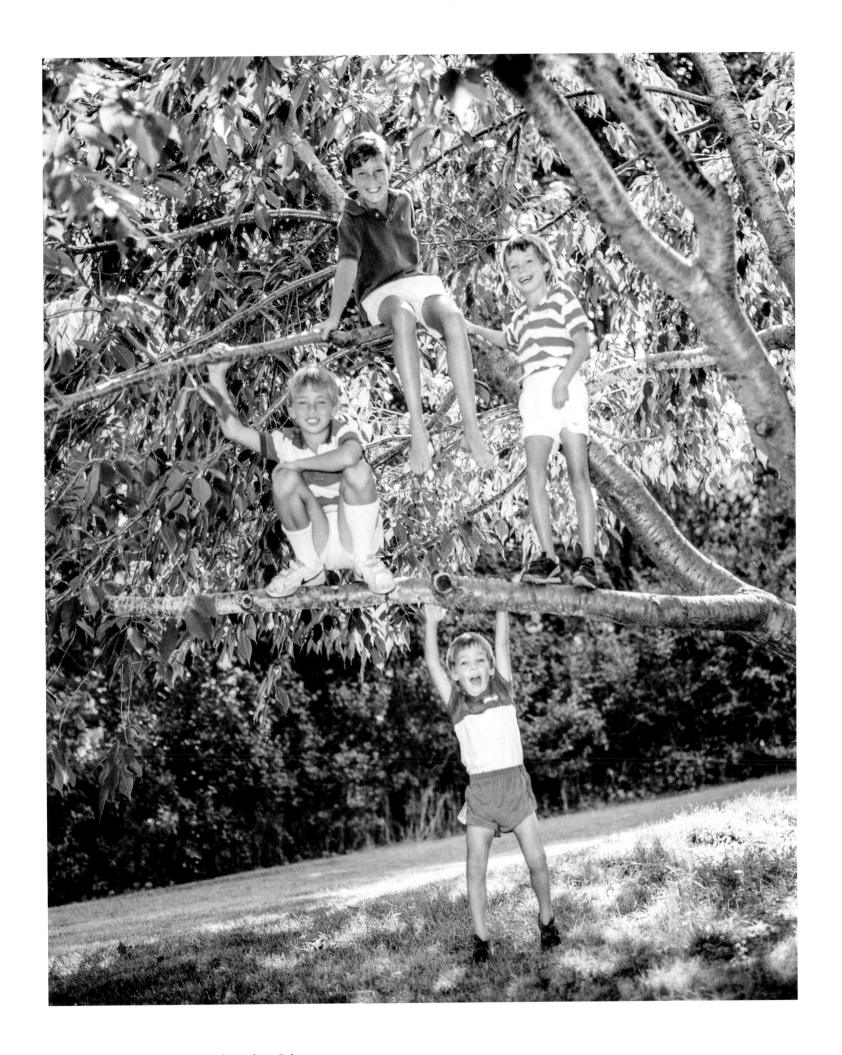

Denis III, Nicky, Timmy and Matthew Coleman,
Greenwich, Connecticut, 1985.

COULTER FAMILY

Jim and Ginger Coulter were longtime friends of the Kuhners. Through Ginger's representation, Betty Kuhner's photographic talents were made known to the best families of Lake Forest, Illinois.

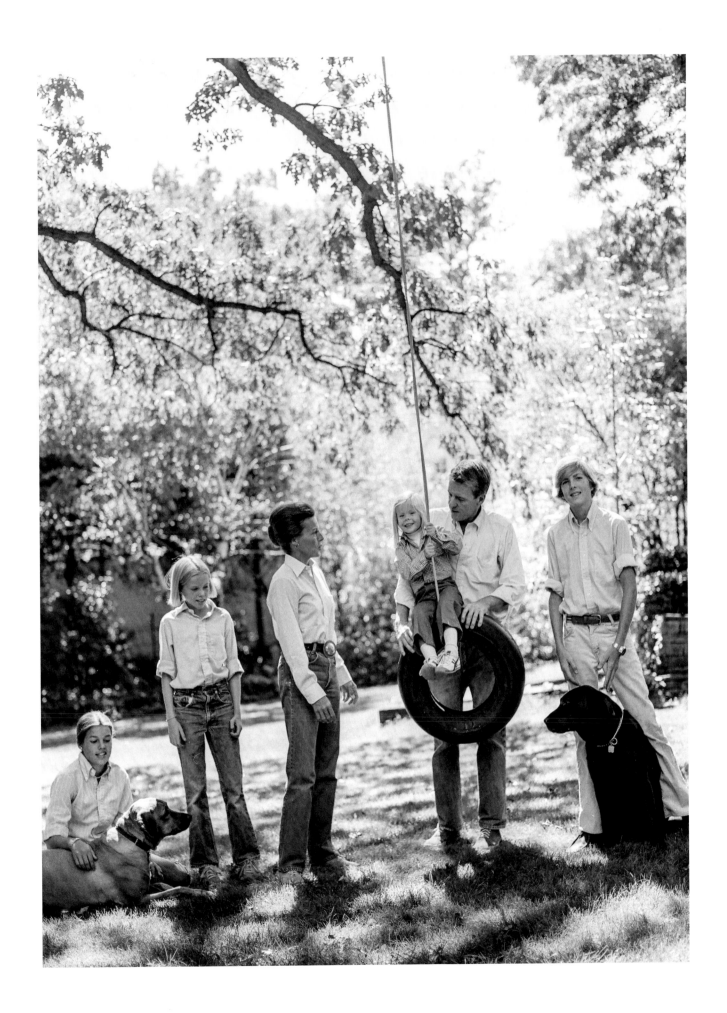

Mr. and Mrs. James Coulter and family, Lake Forest,
Illinois, 1976.

CRICHTON FAMILY

While proudly Louisianan, the Crichton family has strong enough Scottish heritage to warrant their own tartan, composed of cerulean blue, green, red and white. Marriages, divorces and offspring added names such as Clark, Fuller, Glassell, Gubelmann and Monell to the mix, along with businesses like General Motors, Packard, the Transcontinental Gas Pipeline Company, and a little gadget called the cash register.

The Crichton blended family, Palm Beach, Florida, 1968.

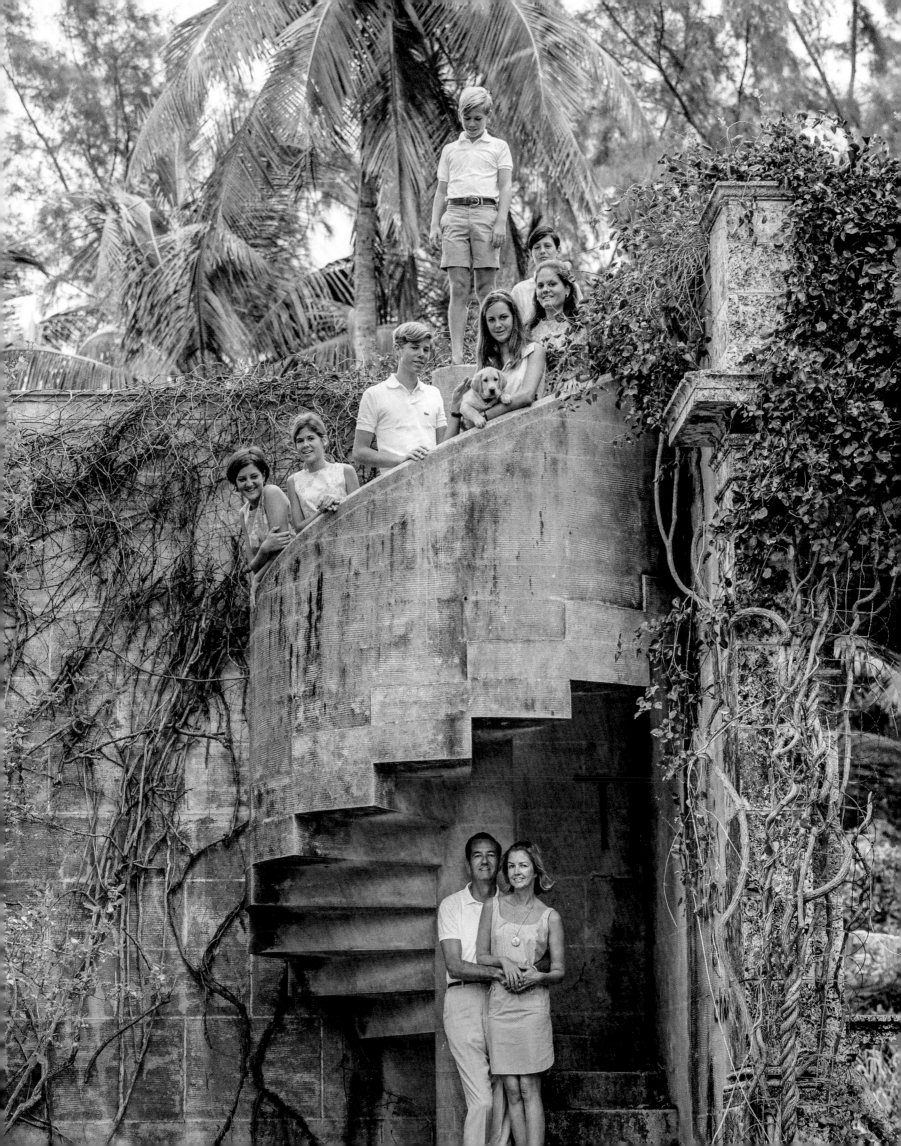

48 Kate Crichton, Palm Beach, Florida, 1965.

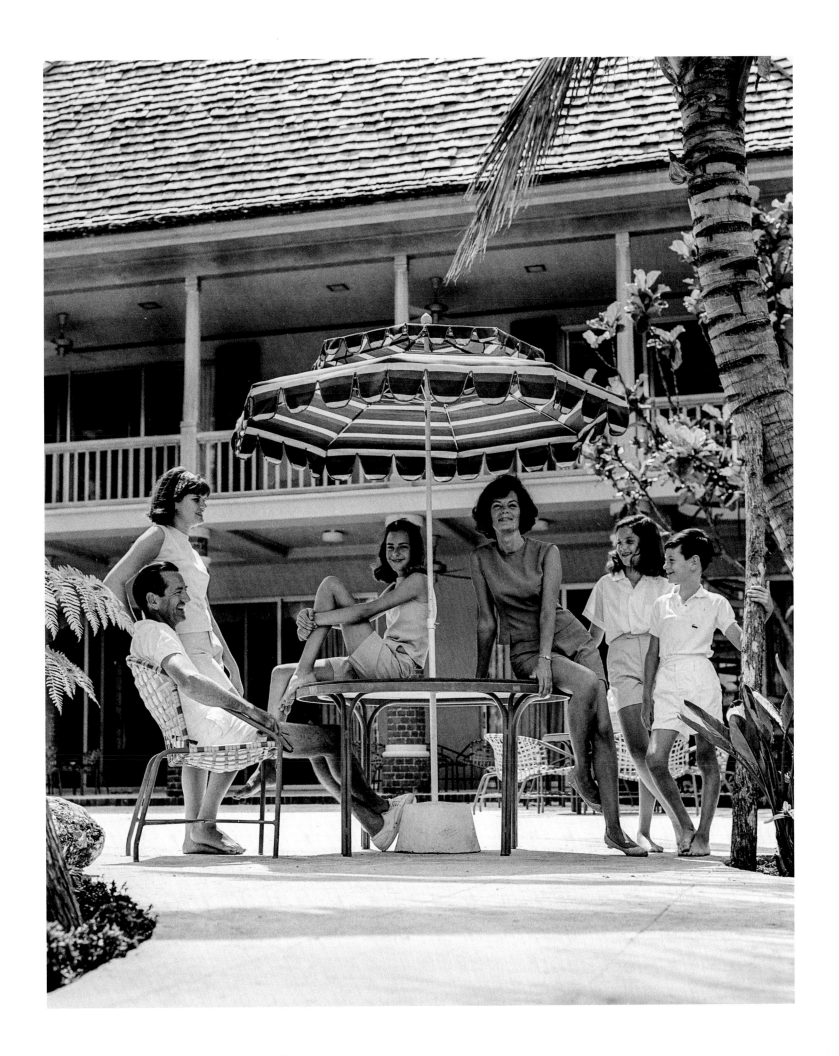

Mr. and Mrs. John H. Crichton with children Kate,
Bunnie, Lili and John Jr., Palm Beach, Florida, 1965.

CUSHING FAMILY

The Cushing family name first appeared in Newport during the Gilded Age. In the mid-1860s, Bostonian Robert Cushing purchased a parcel of oceanfront land and built a sprawling summerhouse for his family, named "The Ledges." It remains one of the most impressive estates on the East Coast and to this day belongs to the Cushing family.

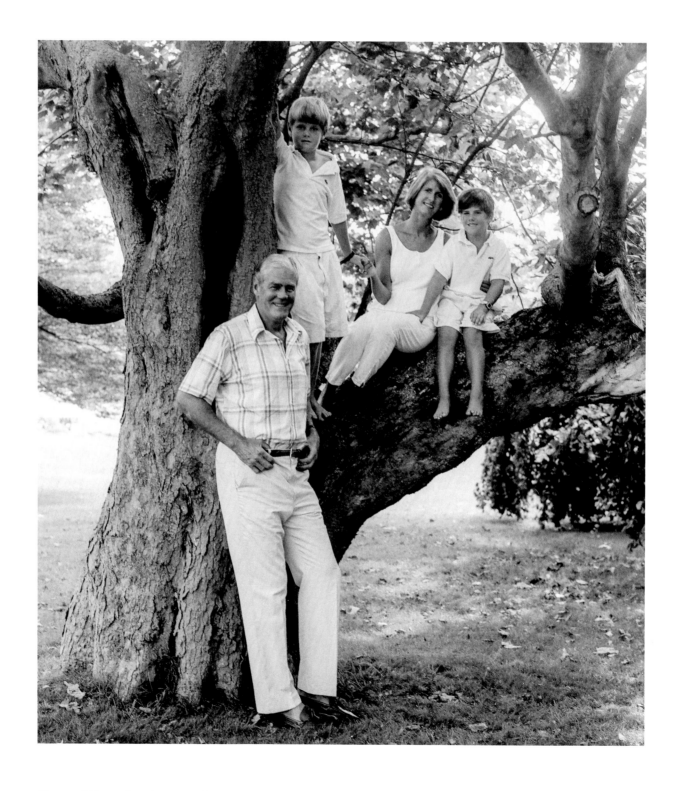

Nora and Howard Cushing Jr. and sons Howard and Jamie, Newport, Rhode Island, 1990.

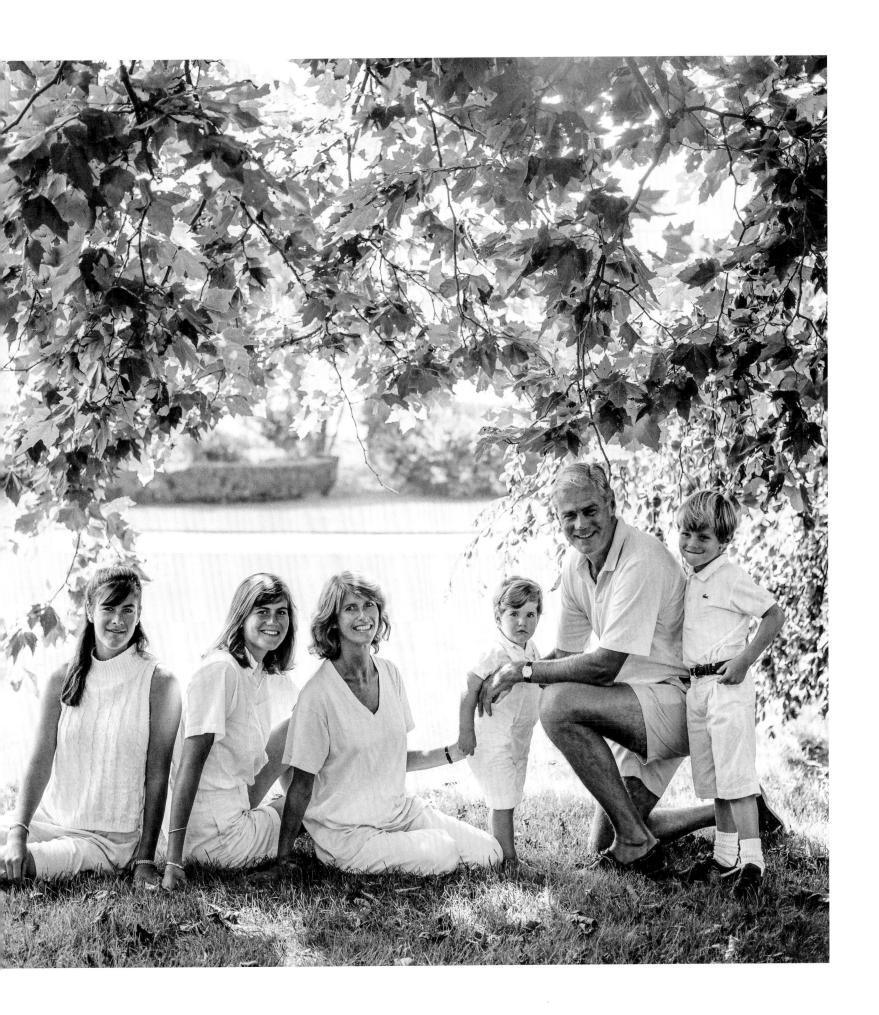

Mr. and Mrs. Howard Cushing Jr. with their
blended family, Newport, Rhode Island, 1986.

DONNELL FAMILY

John Donnell was the grandson of the founder of the Ohio Oil Company, which was renamed the Marathon Oil Corporation in 1962. With his second wife, the former Maureen Caraboolad, he lived in grand style in spectacular homes in Palm Beach and Newport, while also maintaining a strong connection to his hometown of Findlay, Ohio, about forty miles south of Toledo.

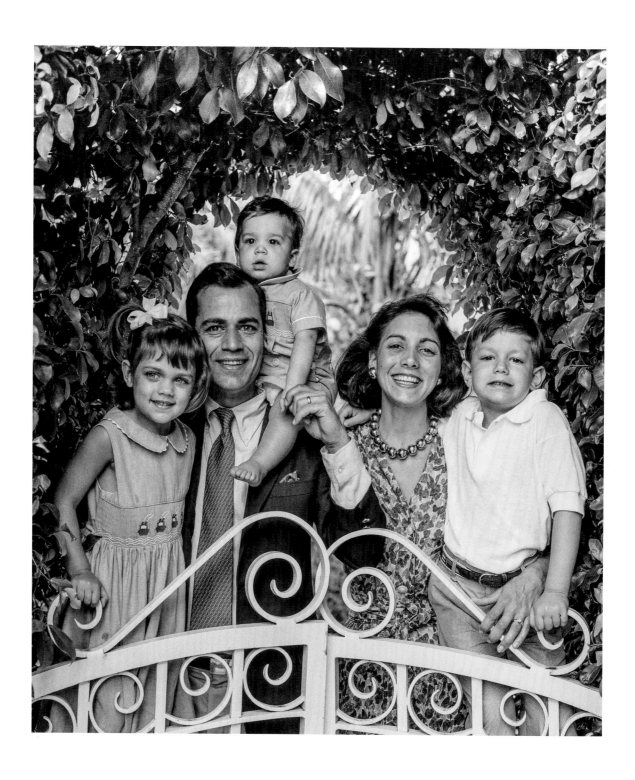

Michael and Laurel Caraboolad with children Ryan, Nicole and Eric, Palm Beach, Florida, 1991.

Mr. and Mrs. John Donnell, Palm Beach, Florida, 1992.

DONNELLEY FAMILY

In Chicago, the Donnelley name means printing. Founded in 1864 by Richard Robert Donnelley, R. R. Donnelley & Sons (widely known simply as RR Donnelley) grew, through decades of mergers and acquisitions, into a global leader in commercial printing and now digital communications. Regardless of the advances of modern technology, however, the company will always be known as the printer of the Yellow Pages.

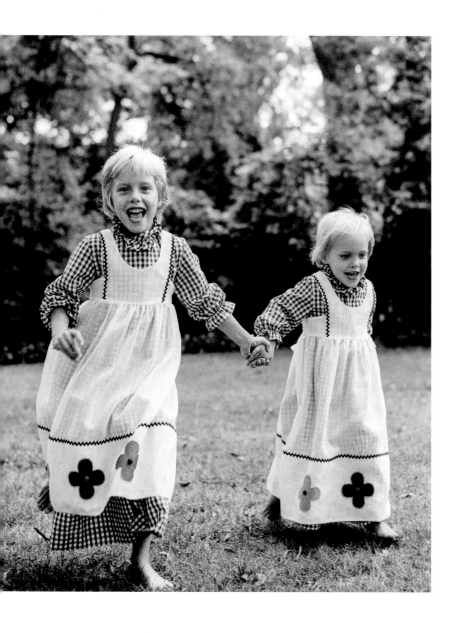

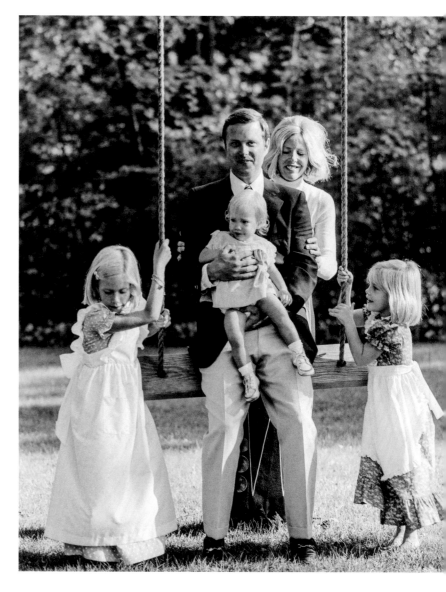

Courtney and Brooke Donnelley, Lake Forest, Illinois, 1973.

Mr. and Mrs. Richard R. Donnelley with children Courtney, Mary Gwynne and Brooke, Lake Forest, Illinois, 1975.

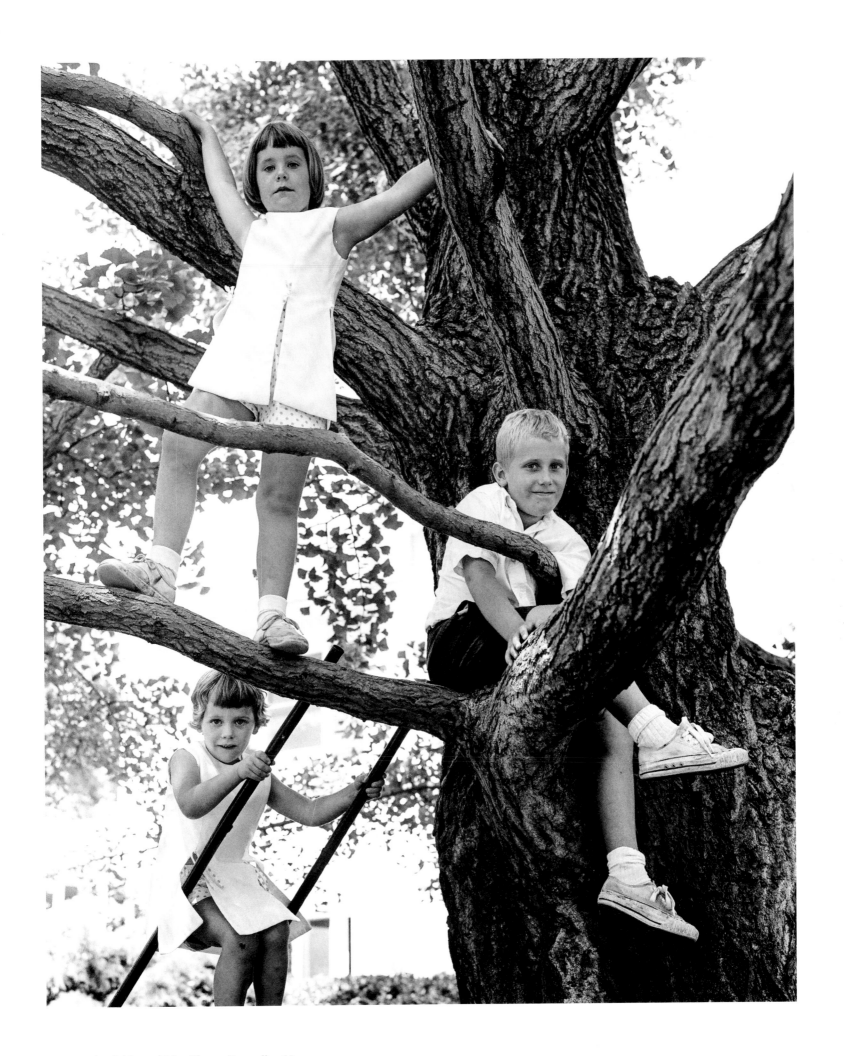

The children of Mrs. Thorne Donnelley, Naoma,
Laren and Reuben, Lake Forest, Illinois, 1965.

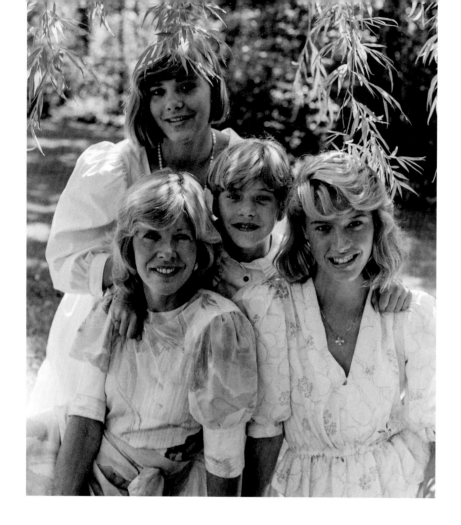

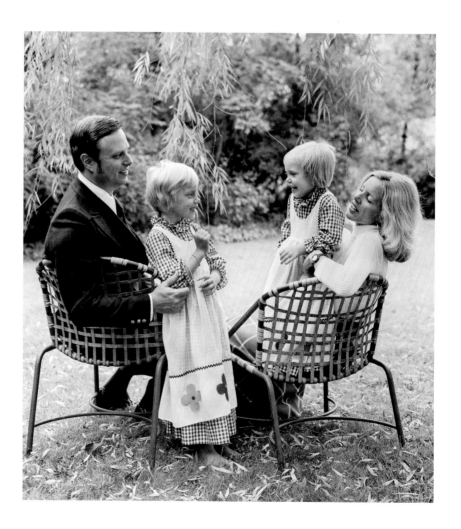

Mary Donnelley with daughters Courtney, Brooke and Mary Gwynne, Lake Forest, Illinois, 1985.

Richard and Mary Donnelley with daughters Courtney and Brooke, Lake Forest, Illinois, 1973.

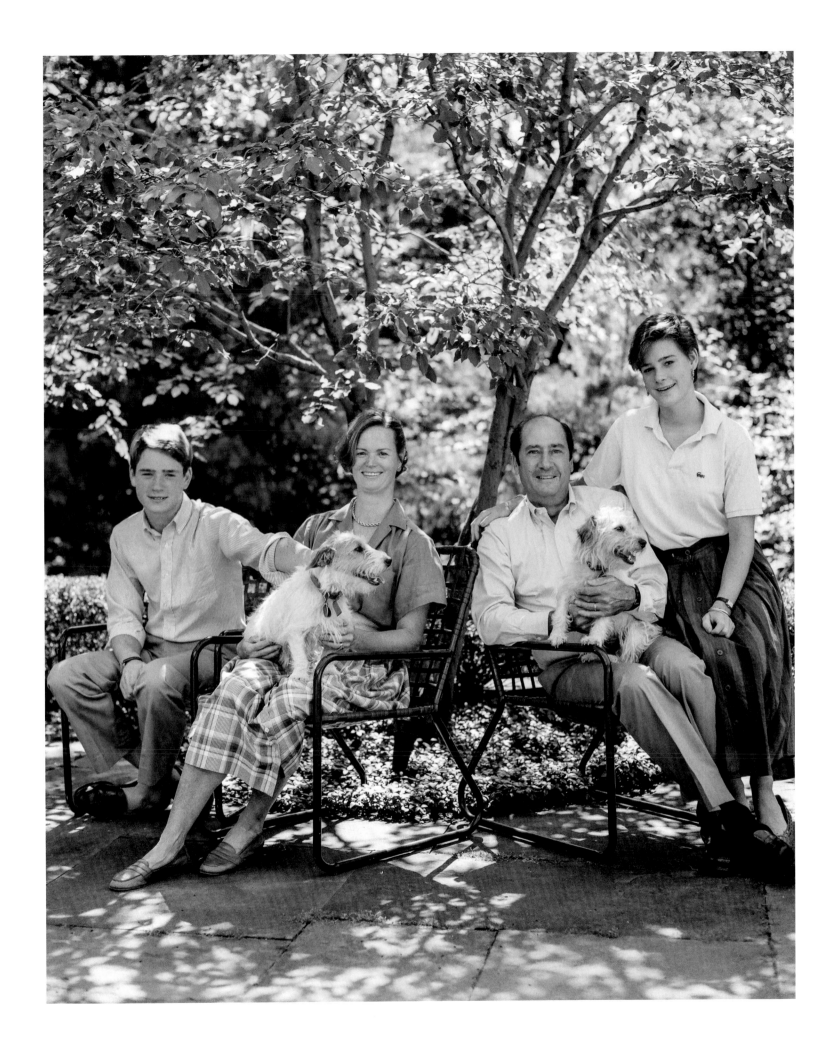

Thomas E. Donnelley II and Barbara Donnelley
with their family, Lake Forest, Illinois, 1984.

DOUBLEDAY FAMILY

The scion of the Doubleday Publishing house, Nelson Doubleday's roots were the same as so many others of Long Island's Gold Coast. He was born in Oyster Bay and attended the exclusive Green Vale School then Eaglebrook and Deerfield Academy before entering Princeton. After a stint in the air force, he had a succession of jobs at Doubleday Publishing, ultimately becoming its president. He was the chairman of the board of the New York Mets baseball team. His first wife was Florence McKim, the sister of Lilly Pulitzer and daughter of Lillian Phipps. They had four daughters together before moving on to other spouses, each with children of their own, creating a large blended family.

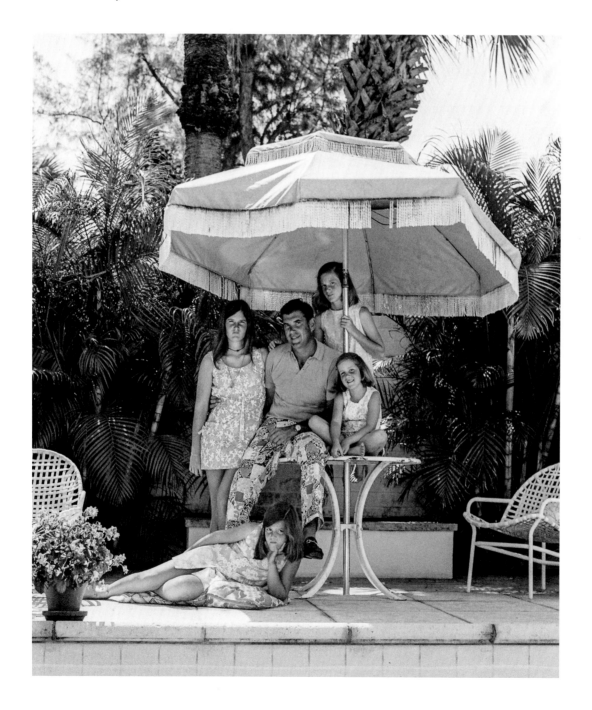

Nelson Doubleday with daughters Wendy, Nanki,
Lilly and Phoebe, Hobe Sound, Florida, 1970.

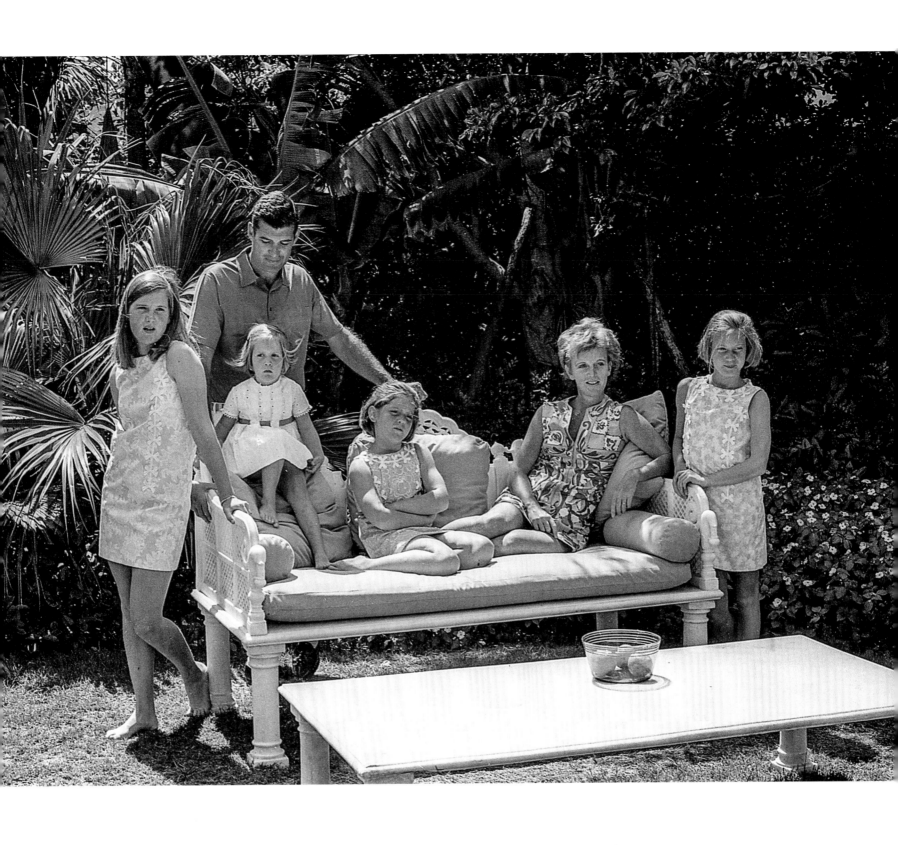

Mr. and Mrs. Nelson Doubleday with daughters Wendy,
Phoebe, Nanki and Lilly, Palm Beach, Florida, 1967.

DRYER FAMILY

The Dryer family hails from Rochester, New York, having started as coachbuilders in the 1800s. Over time, this evolved into an operation that manufactured vehicles as diverse as custom motor cars, tanks and even aircraft. But it was Joseph Dryer's move to Havana, Cuba, in 1952 that truly impacted this distinguished clan. There, he stayed with friends Mary and Ernest Hemingway and met and married Nancy Herrera, a Cuban native whose family owned a large pharmaceuticals company. After the Cuban revolution, the Dryers resettled in Palm Beach. A further example of high society's unique intersections and alliances: Joseph Dryer partnered with longtime friend Peter Pulitzer in establishing the Pulitzer Hotel in Amsterdam, which they owned for twenty-two years before selling to a company owned by the Aga Khan.

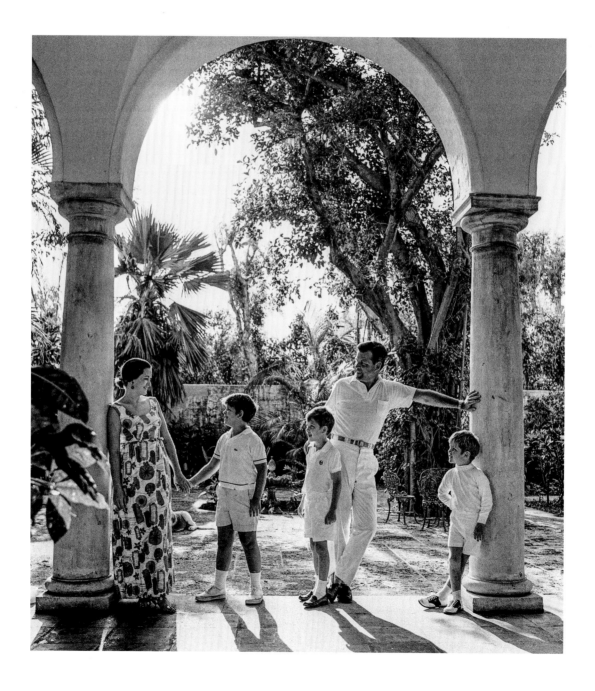

Mr. and Mrs. Joseph F. Dryer Jr. with sons Joseph III, James and Gregory, Palm Beach, Florida, 1965.

DUCHIN FAMILY

The Duchin name has brought music to the ears of millions. Beginning with Boston-born pianist and bandleader, Eddy Duchin, whose sweet sounds soothed millions before and during WWII, and, of course, furthered by his equally famous son, Peter, who remains America's most beloved high-society bandleader. Close associations with equally luminous names such as Harriman and Hayward have only added to the mythic nature of the Duchin story.

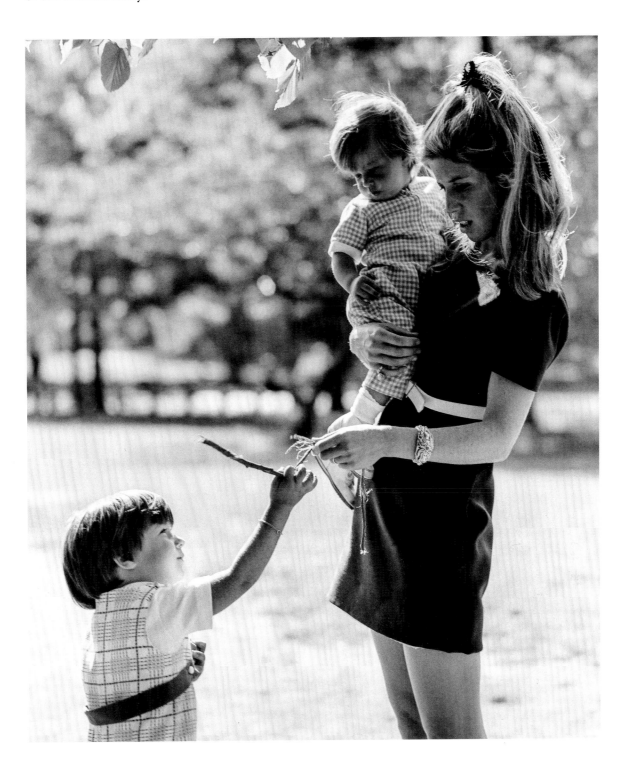

Mrs. Peter Duchin (Cherey) with children Jason and
Courtnay, New York, New York, 1969.

DUDLEY FAMILY

The Dudley family of Tennessee enjoyed the distinction of not only financial success, courtesy of the insurance industry, but also social prominence, certainly turbocharged by Guilford Dudley's appointment by Richard Nixon as Ambassador to Denmark. They lived in high style in both Nashville and Palm Beach, active in a myriad of social and philanthropic pursuits, most notably the Cheekwood Museum and Botanical Gardens, the Red Cross, and the American Cancer Society, among many others.

Jane Dudley with daughter Trevania, Palm Beach, Florida, 1961.

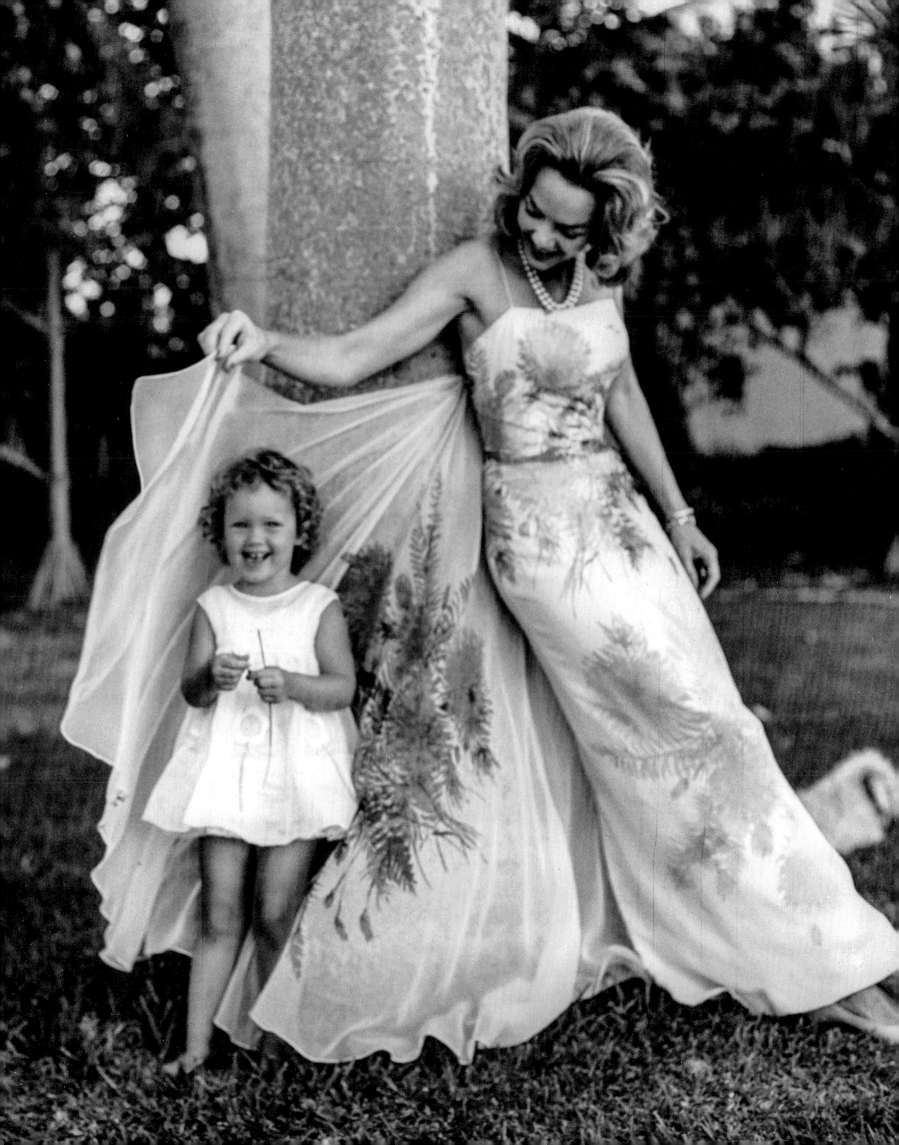

DUKE FAMILY

Descendants of the founders of the American Tobacco Company in North Carolina, founded in 1890, the Duke family enjoyed the type of dynastic wealth that served as the fuel source for what was once referred to as the American aristocracy. Further cominglings with similar families, such as the Drexels and Biddles of Philadelphia, only compounded an already unfathomable fortune that, while undoubtedly providing extraordinary comfort for its heirs also significantly served the needy in ways that set the standard for inspiring philanthropy. It still does.

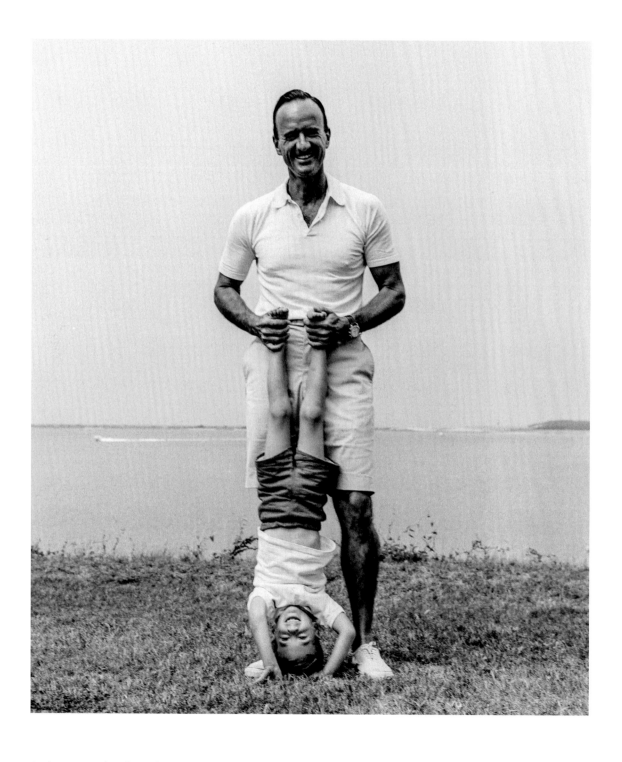

Anthony Drexel Duke and son, East Hampton, New York, 1964.

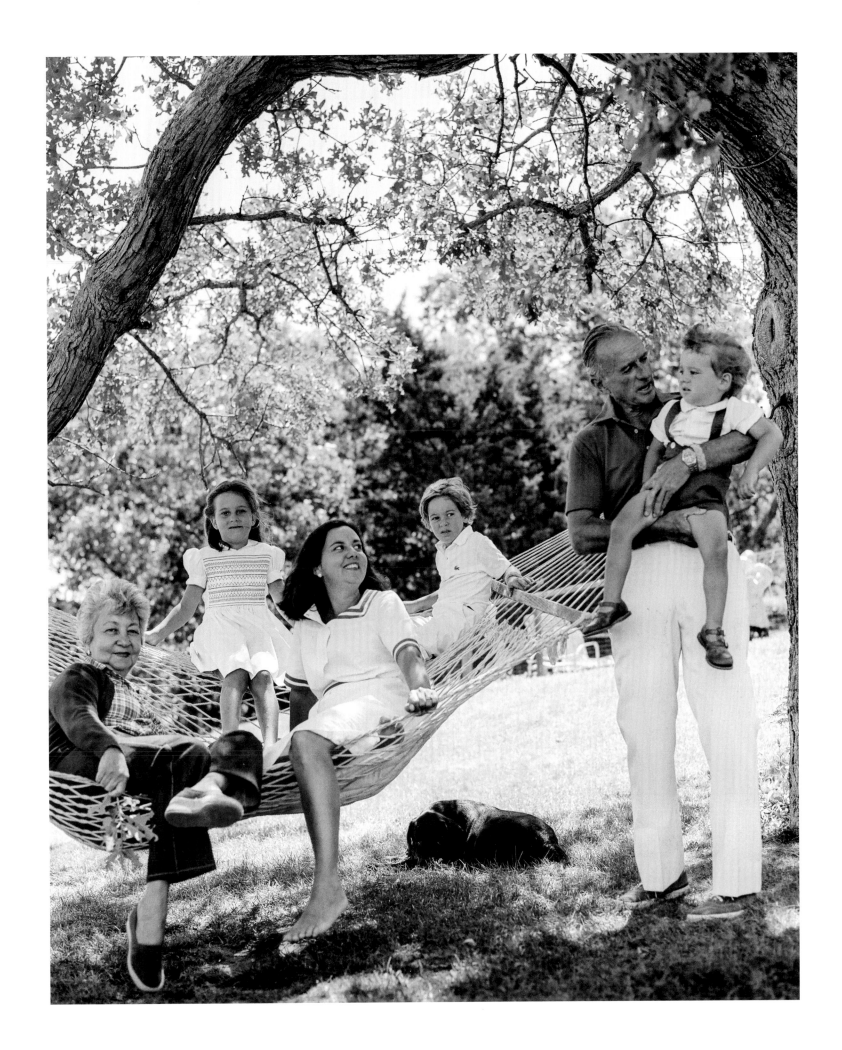

Mr. and Mrs. Anthony Drexel Duke and family,
East Hampton, New York, 1981.

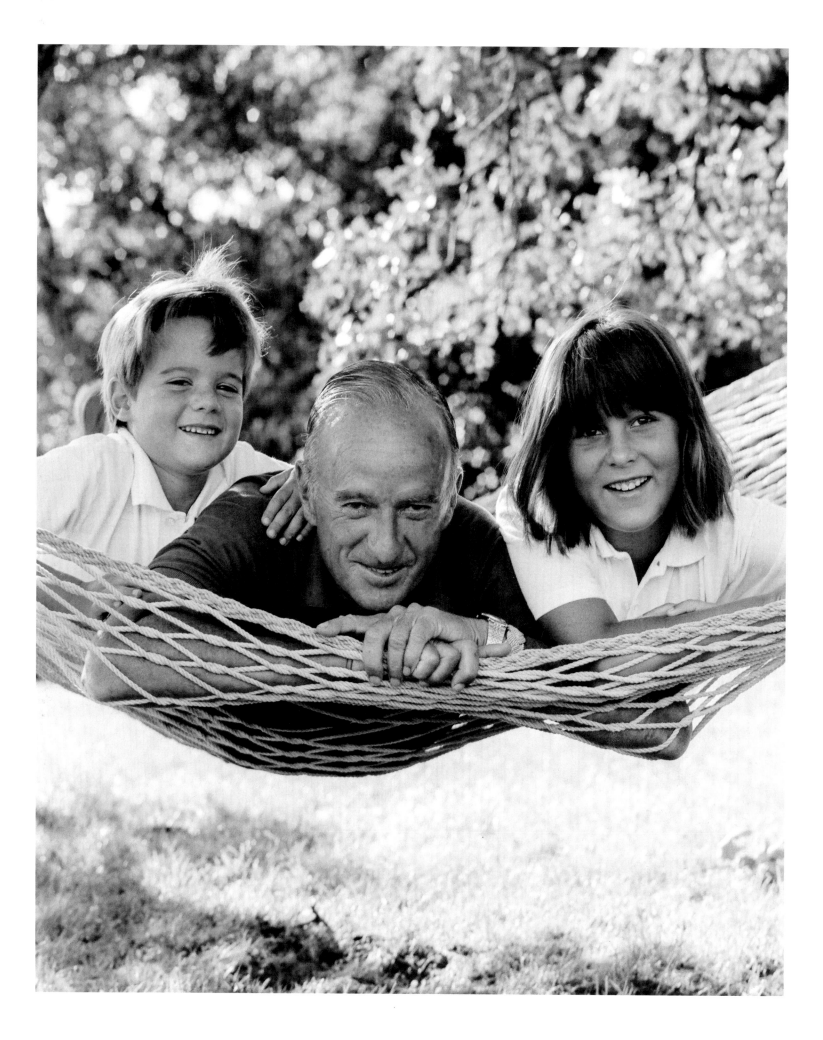

Anthony Drexel Duke with children, East Hampton,
New York, 1985.

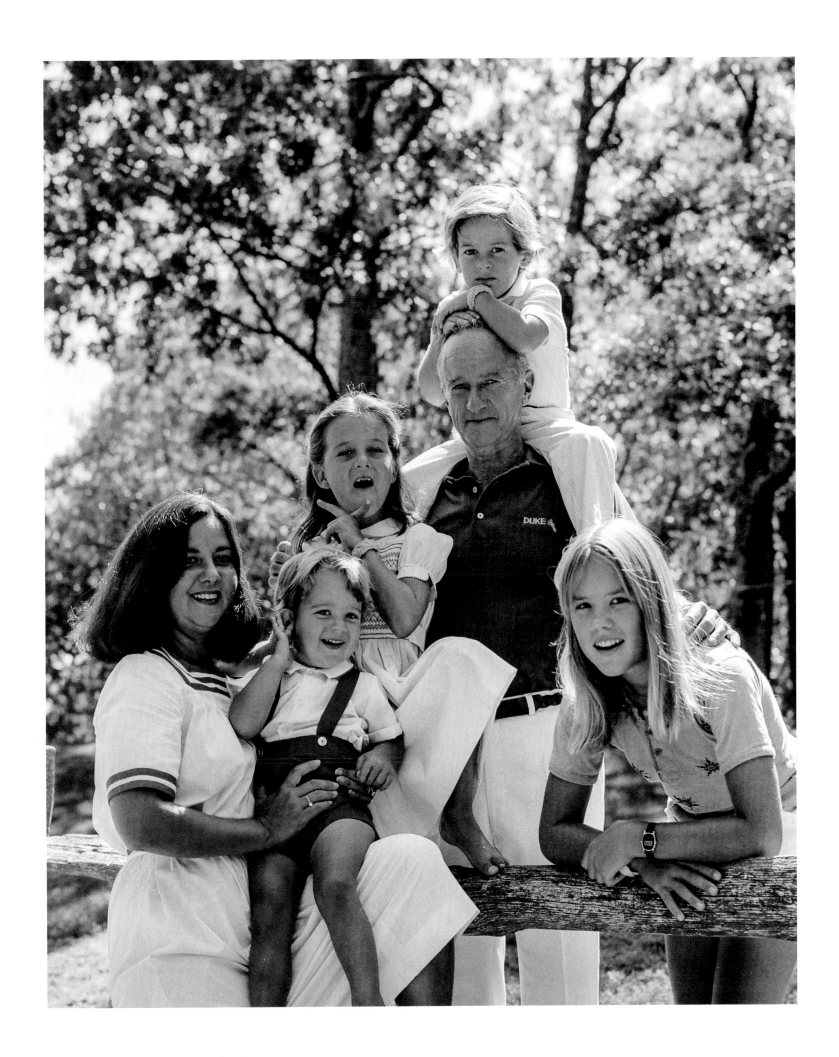

The Anthony Drexel Duke family, East Hampton,
New York, 1981.

DUPONT FAMILY

One of America's wealthiest families, this Delaware-rooted clan began their journey as the owners and operators of a gunpowder mill on the banks of the Brandywine River near Wilmington. Today, DuPont is one of the world's leading science and engineering companies, with operations in more than ninety countries. Known for their extraordinary connoisseurship, the DuPont family has opened many of its estates to the public as museums, gardens and parks.

Mrs. Edward Bradford DuPont and son Bradford, Wilmington, Delaware, 1966.

Alfred and Bradford DuPont, Wilmington, Delaware, 1966.

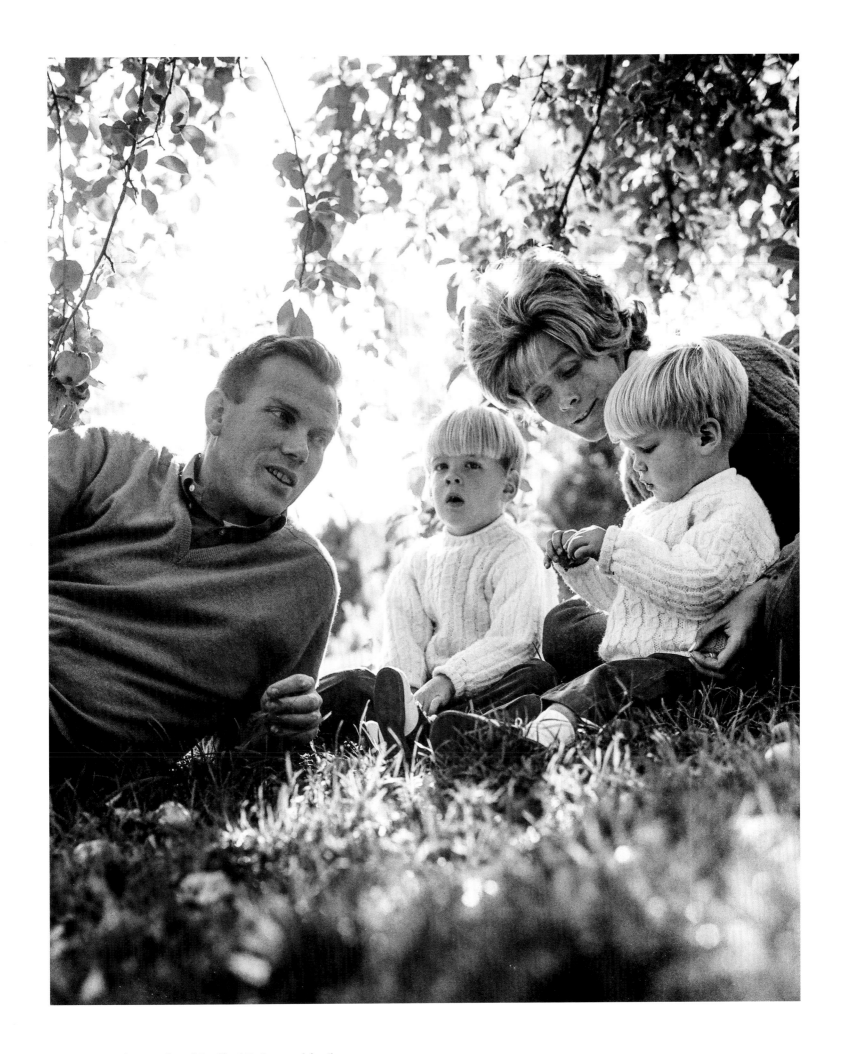

Mr. and Mrs. Edward Bradford DuPont and family,
Wilmington, Delaware, 1966.

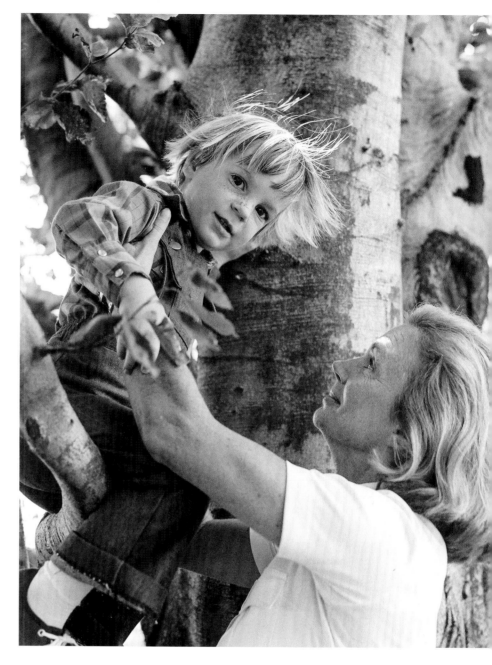

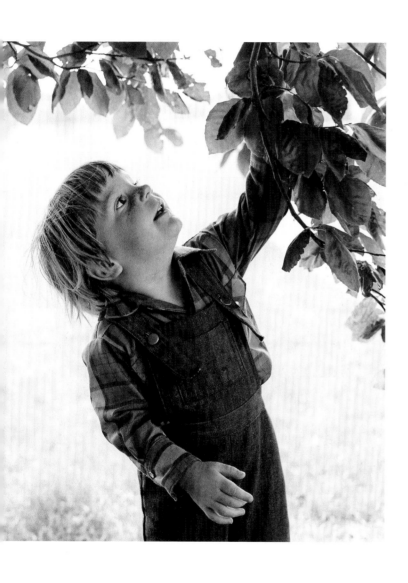

Eugene DuPont IV, Easton, Maryland, 1974.

Mrs. Eugene DuPont III with son Eugene IV, Easton, Maryland, 1974.

Mrs. Eugene DuPont III with daughters Suzie and
Sandy, Easton, Maryland, 1974.

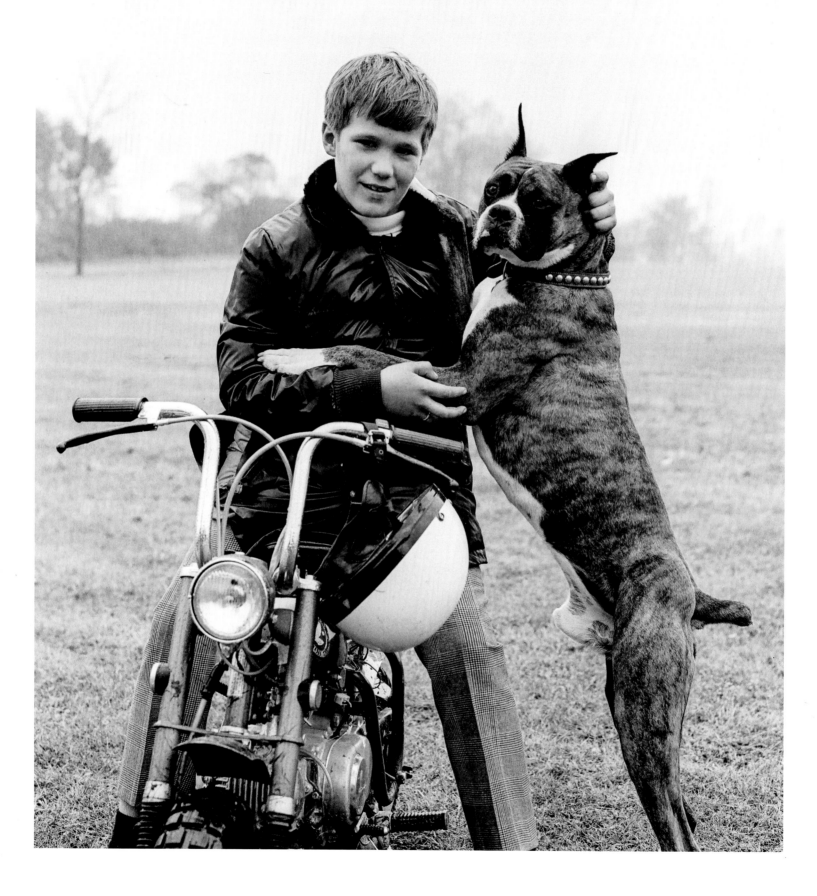

Jeffrey Morgan DuPont Nielson, Newark,
Delaware, 1969.

Facing: Mr. and Mrs. Richard Nielson and son
Jeffrey, Newark, Delaware, 1969.

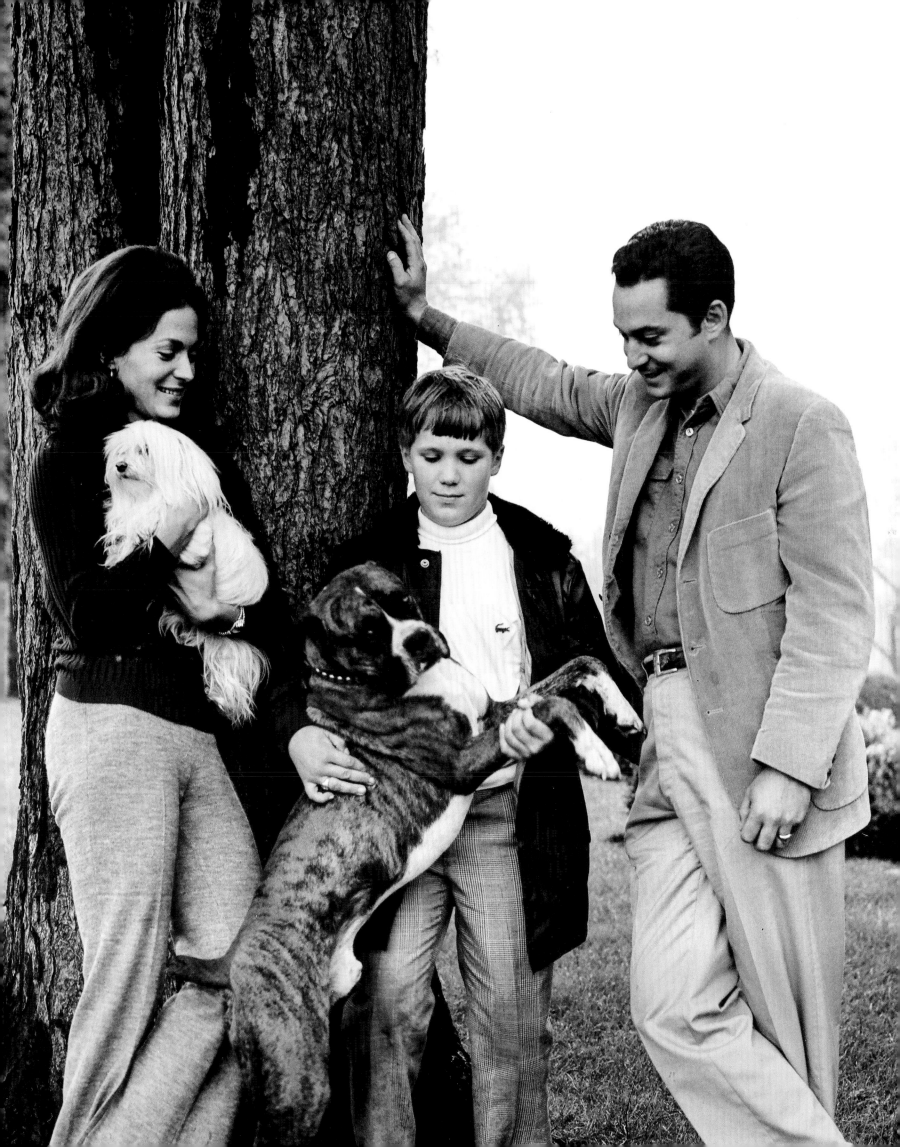

EARL FAMILY

Jerome "Jerry" Earl, the son of Sue and Harley Earl (General Motors' head of design and father of the Corvette), was, of course, born in Detroit, which certainly contributed to his lifelong passion for all things automotive. In 1961, he and his wife Suzanne moved from Grosse Pointe, Michigan, to Palm Beach and opened a well-known automobile dealership in Delray Beach.

The annual family photo shoot used to be a dreaded event—the itchy crinoline petticoats and patent leather shoes. Betty Kuhner changed all that!

Elizabeth Earl

Mr. and Mrs. Jerome Earl and family, Palm Beach, Florida, 1966.

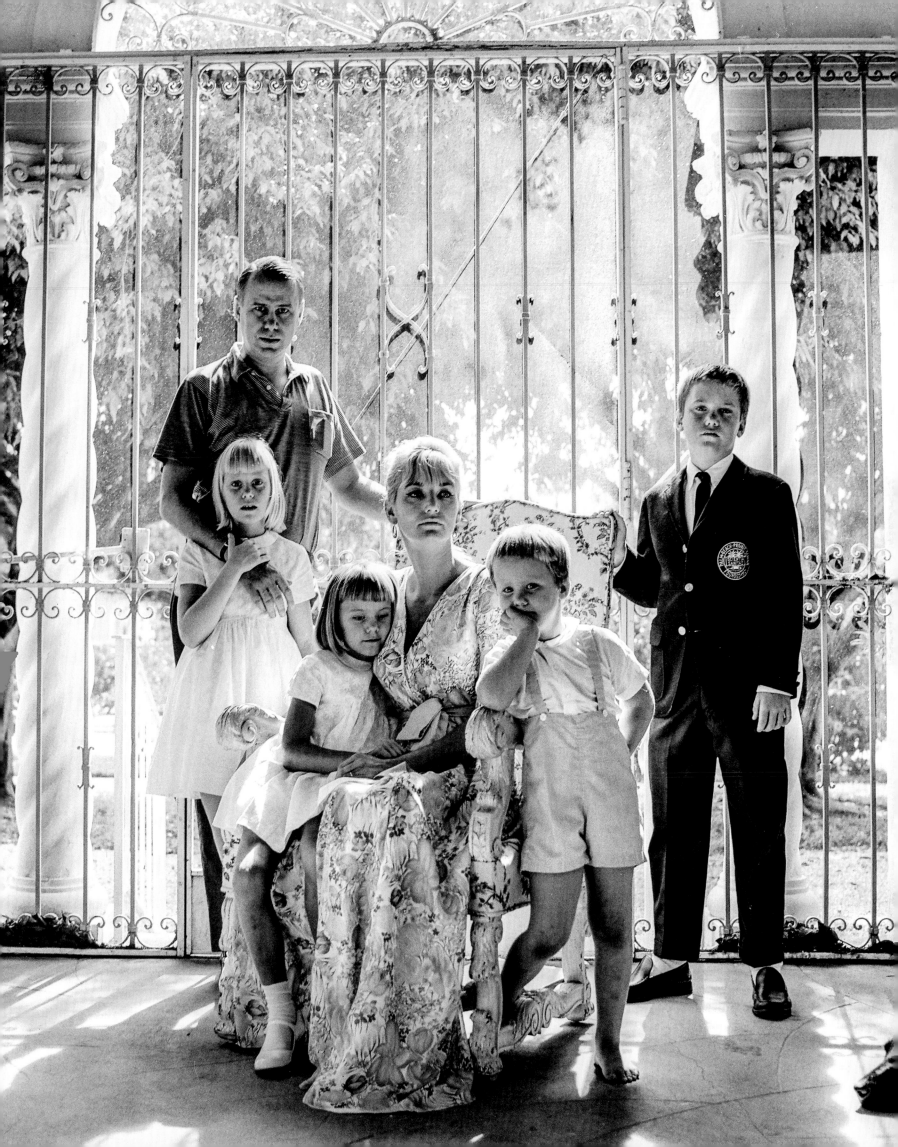

We were hopping in the ocean waves,
actually having a sand fight, and Betty
just captured us playing!

Suzanne Earl

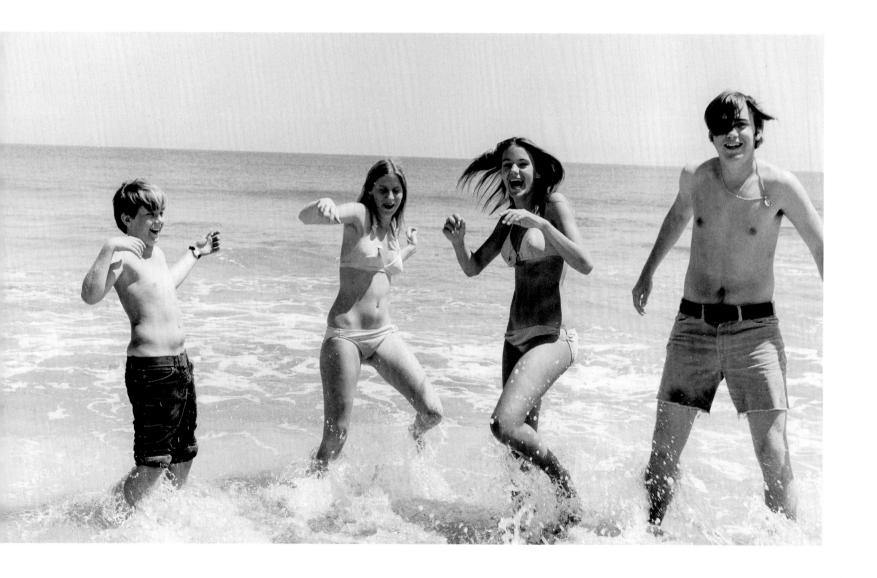

Richard, Suzanne, Elizabeth and Courtney Earl,
Palm Beach, Florida, 1972.

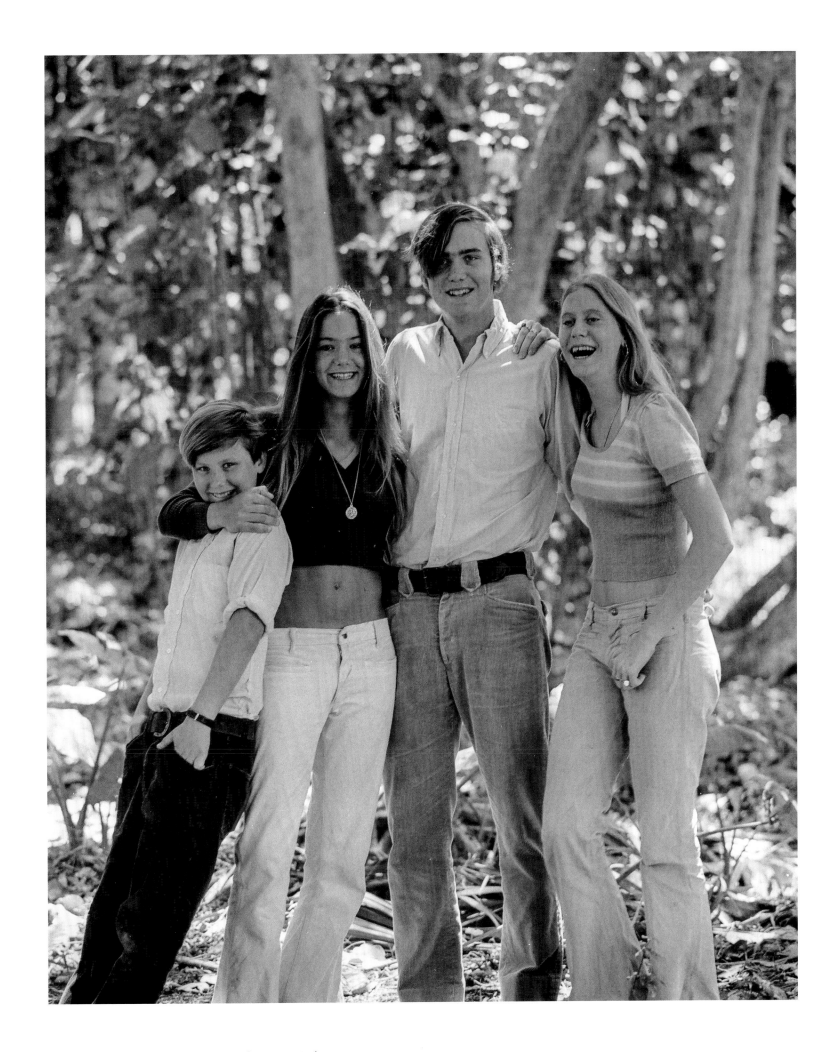

Richard, Elizabeth, Courtney and Suzanne Earl,
Palm Beach, Florida, 1972.

FARINAS FAMILY

Alberto and Alina Aguilera Farinas were married in Havana, Cuba, in 1950 and were a part of the large-scale Cuban migration to the United States following the overthrow of the Batista regime by Castro-led revolutionaries. They settled in Palm Beach in 1960 and, with their family, enjoyed long, happy lives—forever nostalgic for the Cuba of their youth, but grateful for the freedoms and comforts of their new home.

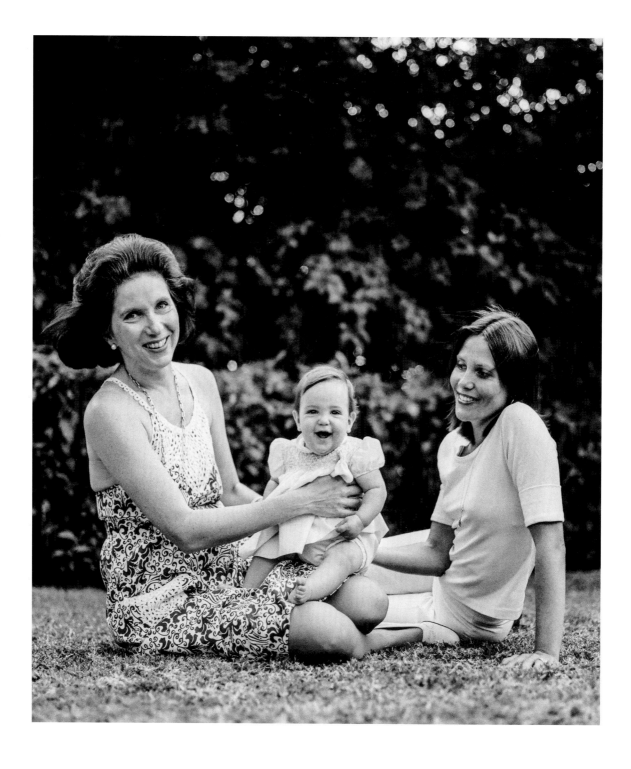

Alina Farinas with daughter-in-law Ginny and granddaughter Alina, Palm Beach, Florida, 1978.

FARISH FAMILY

Texans through and through, the Farish family descends from William Stamps Farish II, the president of Standard Oil from 1937 to 1942. Their passion for the breeding of thoroughbred racehorses is evidenced by a solid presence in Kentucky and Florida, along with close personal ties to another equestrian-centric clan, the British royal family. William Stamps Farish III served as US Ambassador to the United Kingdom from 2001 to 2004.

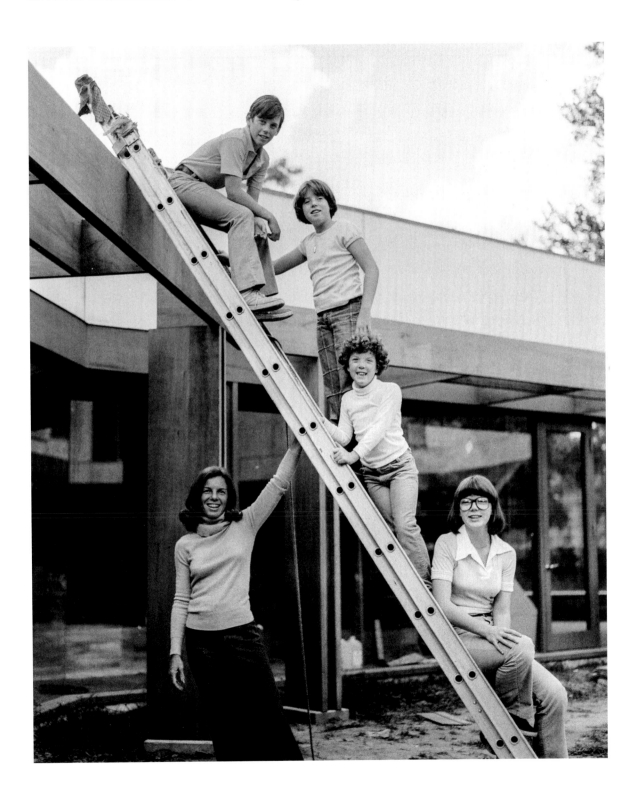

Mrs. William S. Farish (Sarah) with children Bill,
Laura, Hillary and Mary, Houston, Texas, 1976.

FIELD FAMILY

The Marshall Field name is indelibly etched into the history of Chicago. Though no longer in operation, Marshall Field and Company will forever be remembered as a legendary retail emporium that honored the slogan "the customer is always right." Marshall Field purchased Frederic & Nelson chocolatiers in 1929 and soon popularized Frango mints, making them one of America's favorite confections.

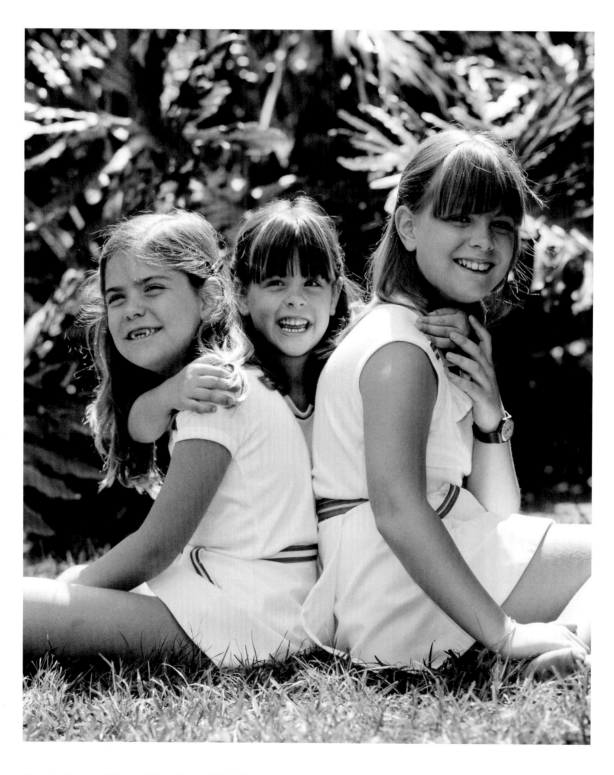

The daughters of Mr. and Mrs. Marshall Field V, Stephanie, Abigail and Jamee, Lake Forest, Illinois, 1985.

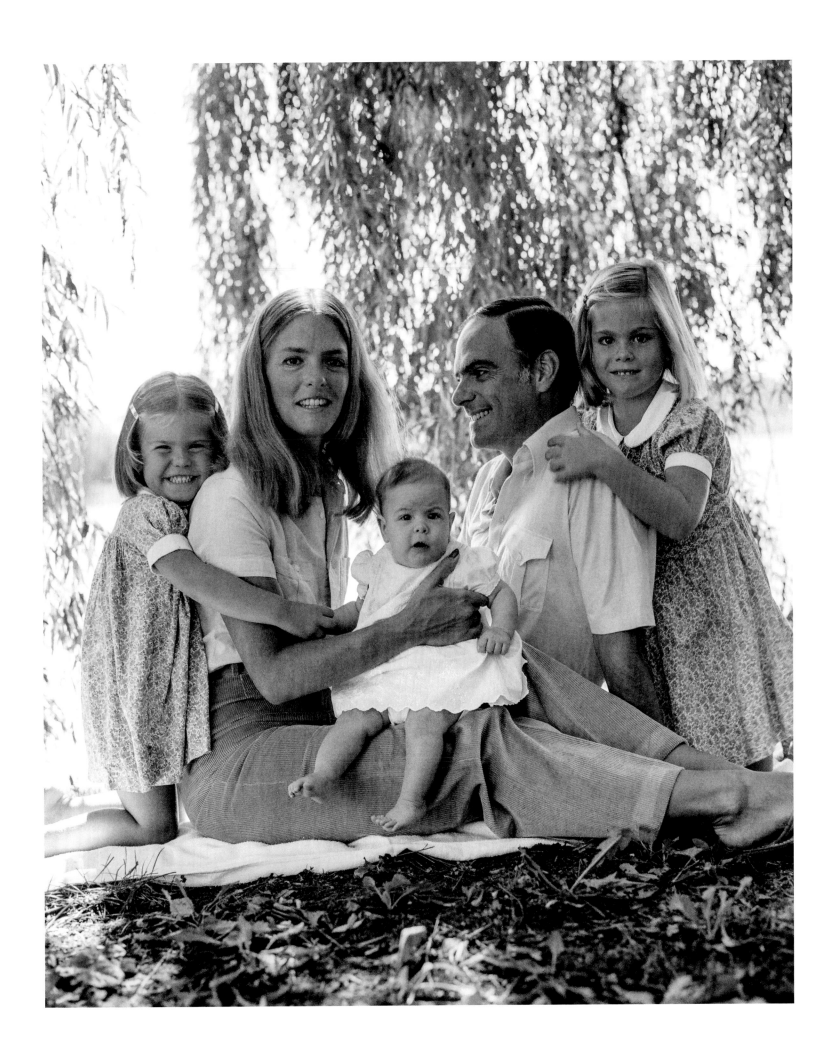

The Marshall Field V family, Lake Forest, Illinois, 1980.

FIRESTONE FAMILY

A fixture on Palm Beach's swinging '60s party scene, tire heir Russell A. Firestone Jr. and his third wife, schoolteacher Mary Alice Sullivan, were married from 1961 to 1967 and had one son, Mark. Mary Alice went on to marry Kentucky coal magnate John Asher in 1974.

Mary Alice Firestone with son Mark, Palm Beach, Florida, 1969.

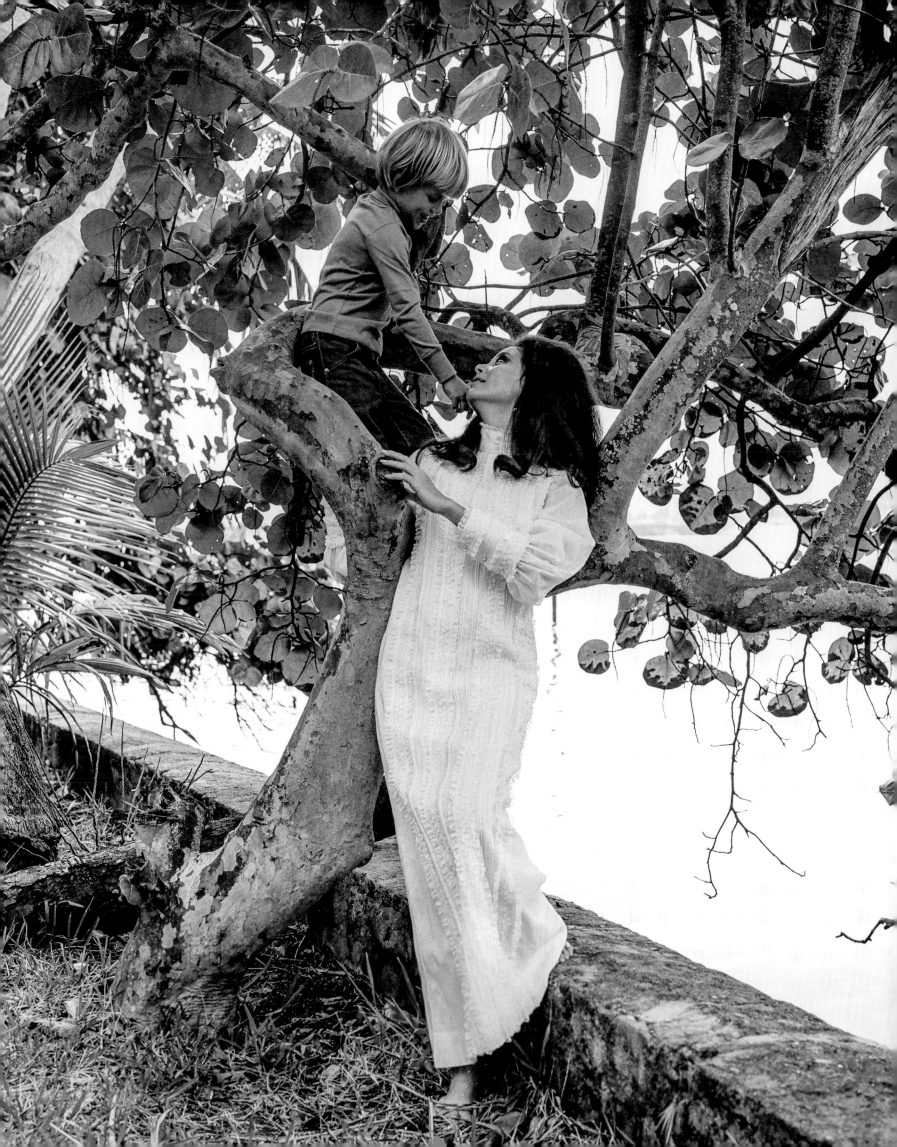

FORD FAMILY

When at age thity-nine Henry Ford founded the Ford Motor Company in 1903, in Dearborn, Michigan, never could he possibly have imagined that his last name would be inextricably aligned to the global auto industry for eternity. Whether photographed at home in Michigan or in Southampton, New York, where they summered for generations, the Fords will forever be America's "First Family on Wheels."

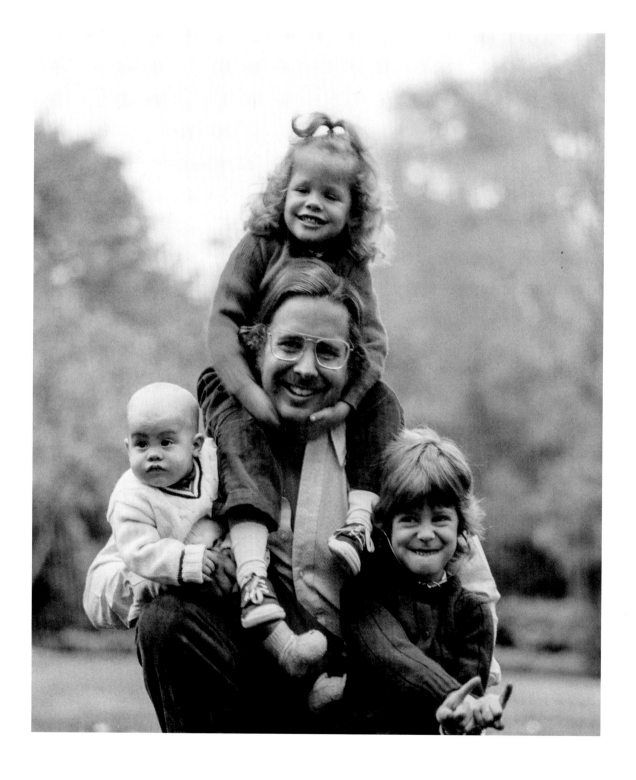

Walter B. Ford III with daughters Wendy, Bridget and Lindsey, Grosse Pointe, Michigan, 1970.

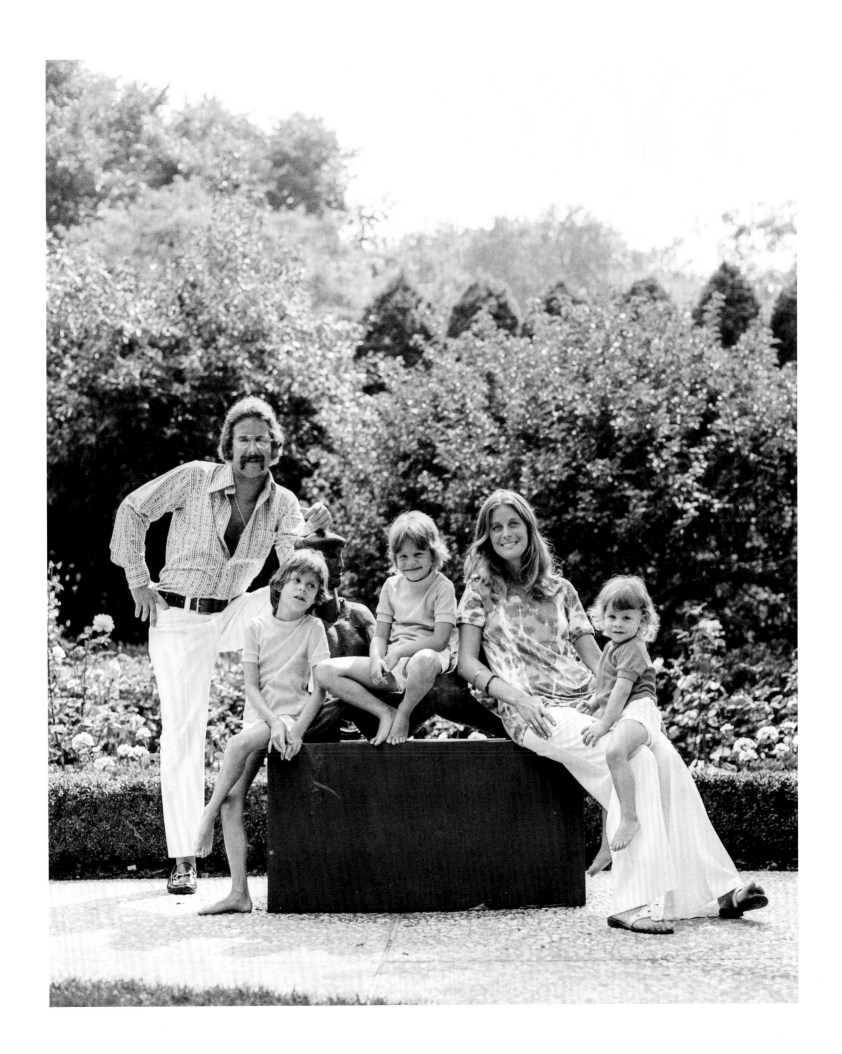

Mr. and Mrs. Walter B. Ford III and family,
Grosse Pointe, Michigan, 1973.

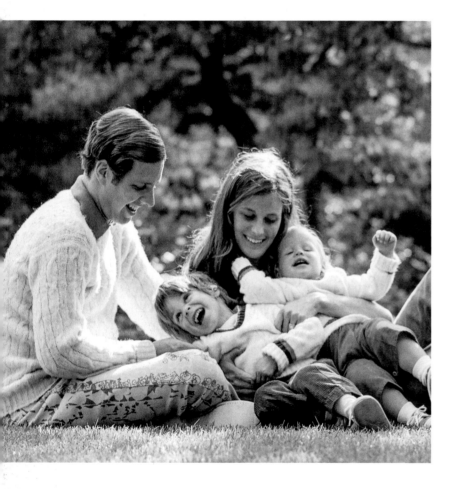

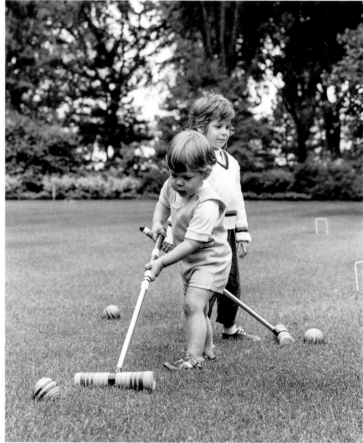

Bridget Ford and cousin Avery Bourke Jr., Grosse Pointe Farms, Michigan, 1969.

Facing: Allegra Charlotte Ford, daughter of Ann Ford Uzielli and her then-husband Gianni Uzielli, Southampton, New York, 1970.

Mr. and Mrs. Walter B. Ford III with daughters Bridget and Lindsay, Grosse Pointe Farms, Michigan, 1969.

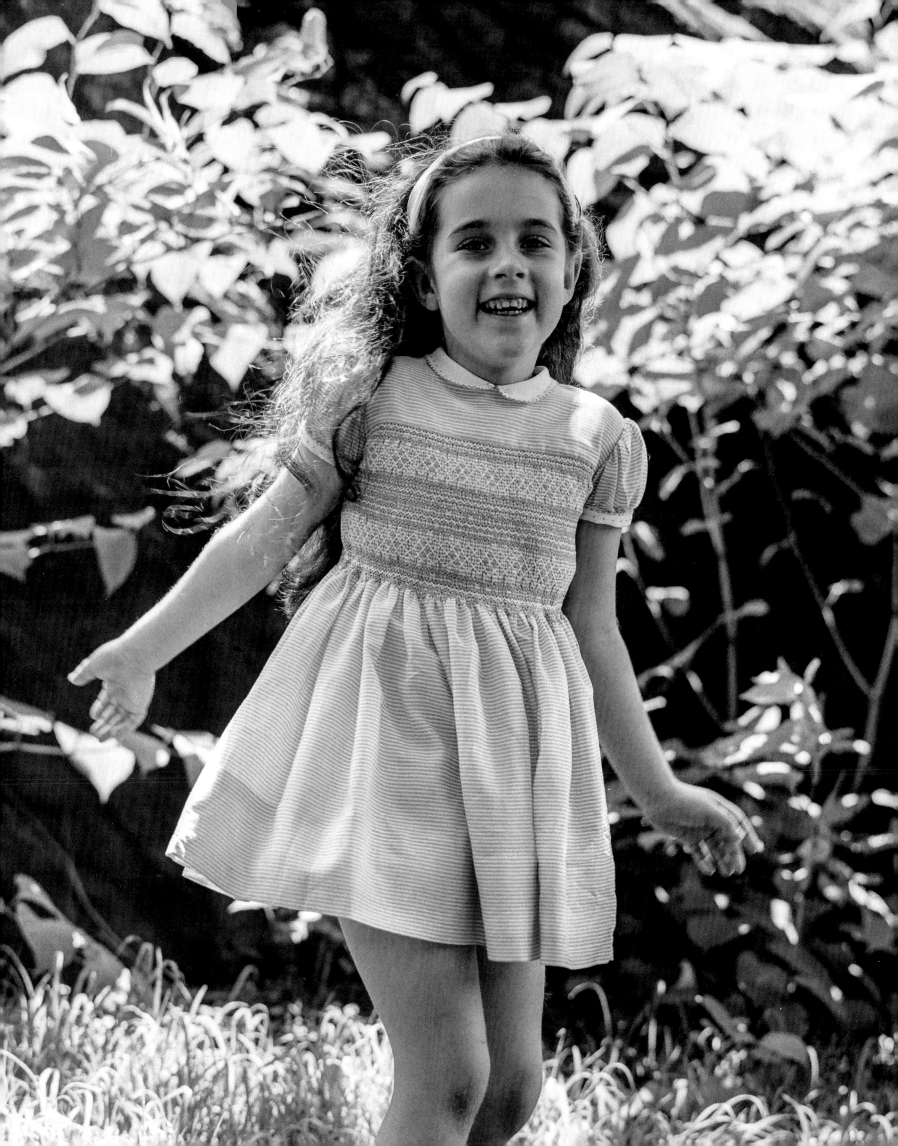

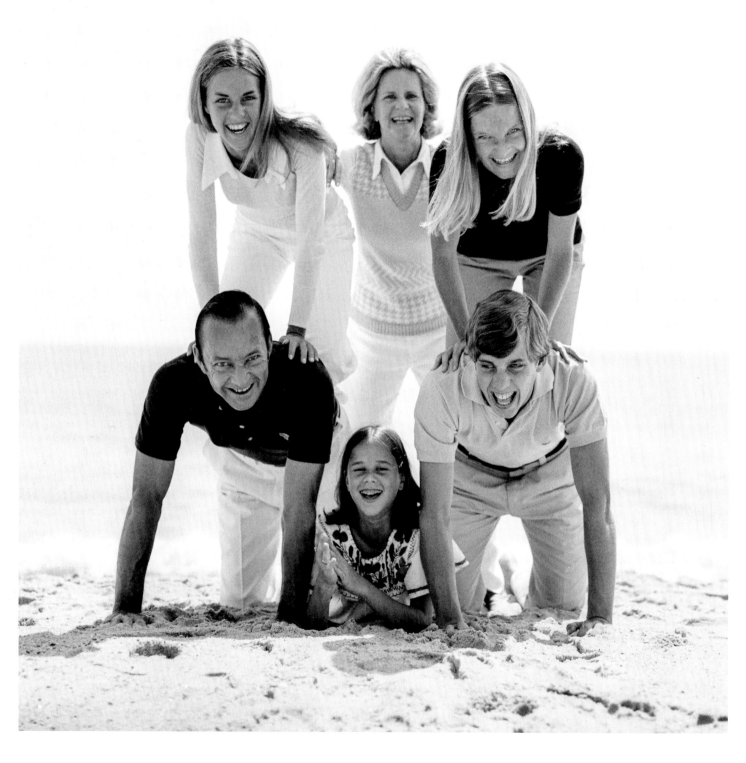

Mr. and Mrs. William Clay Ford Sr. and children
Muff, Elizabeth, Sheila and William Clay Jr.,
Grosse Pointe, Michigan, 1973.

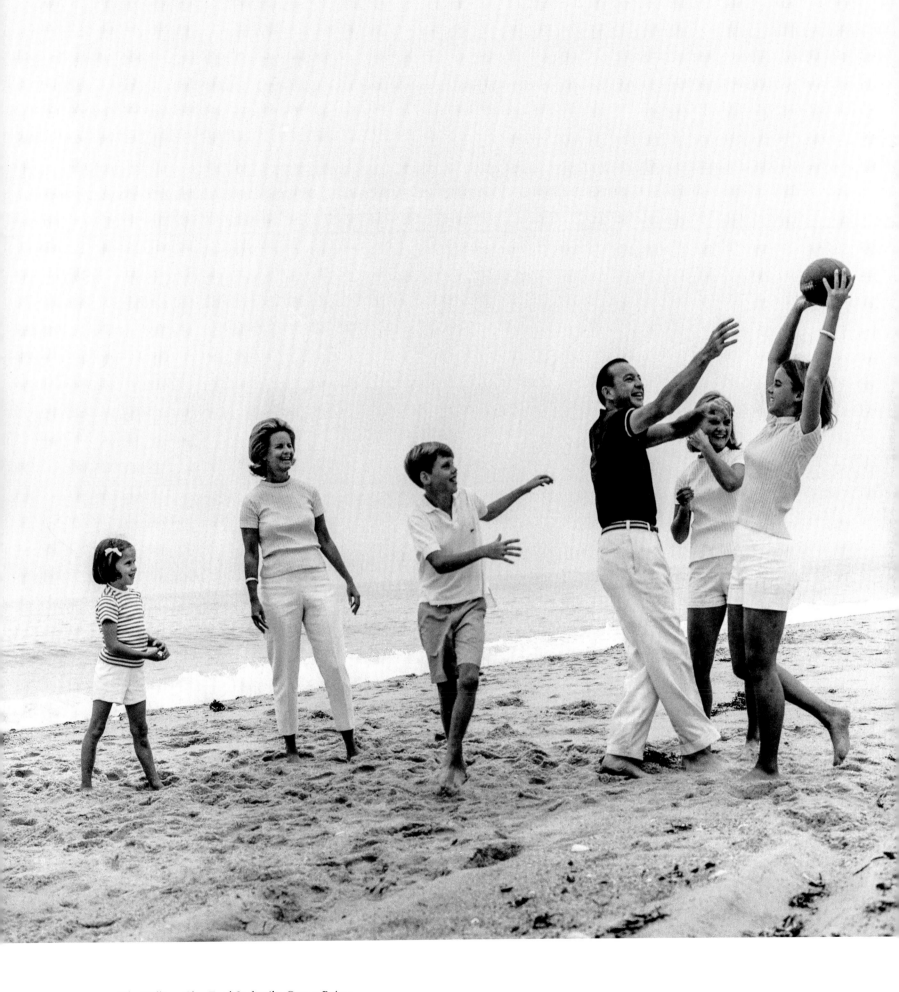

The William Clay Ford Sr. family, Grosse Pointe,
Michigan, 1967.

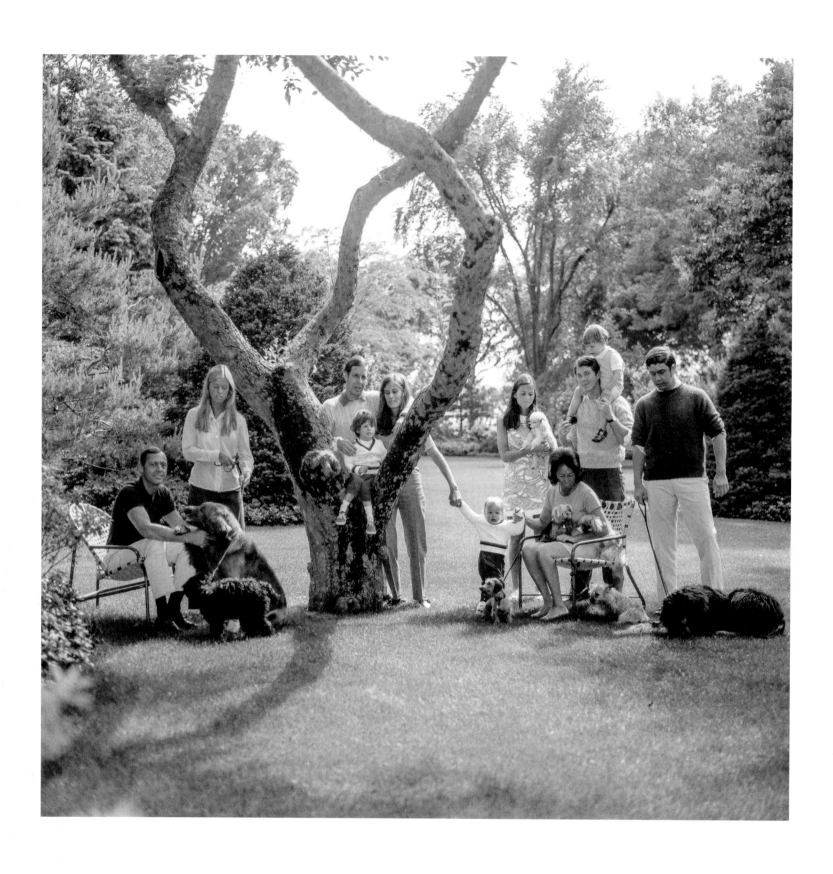

Josephine and Walter Buhl Ford II and family,
Grosse Pointe Farms, Michigan, 1969.

Facing: The William Clay Ford Sr. family, Grosse
Pointe, Michigan, 1974.

GEARY FAMILY

Hilary Roche and John Geary's wedding announcement in the *New York Times* took up a quarter page. He was the great-grandson of the late John White Geary, first mayor of San Francisco, a Union general in the Civil War, governor of the Territory of Kansas, and governor of Pennsylvania. She was the great-granddaughter of the late Thomas Edward Murray, the renowned electrical engineer and inventor. They had two sons, Jack and Teddy. Hilary ultimately remarried and is now the wife of Wilbur Ross, current US Secretary of Commerce. They live in New York, Southampton, Palm Beach and Washington, DC.

John and Hilary Geary with sons Jack and Teddy,
Southampton, New York, 1990.

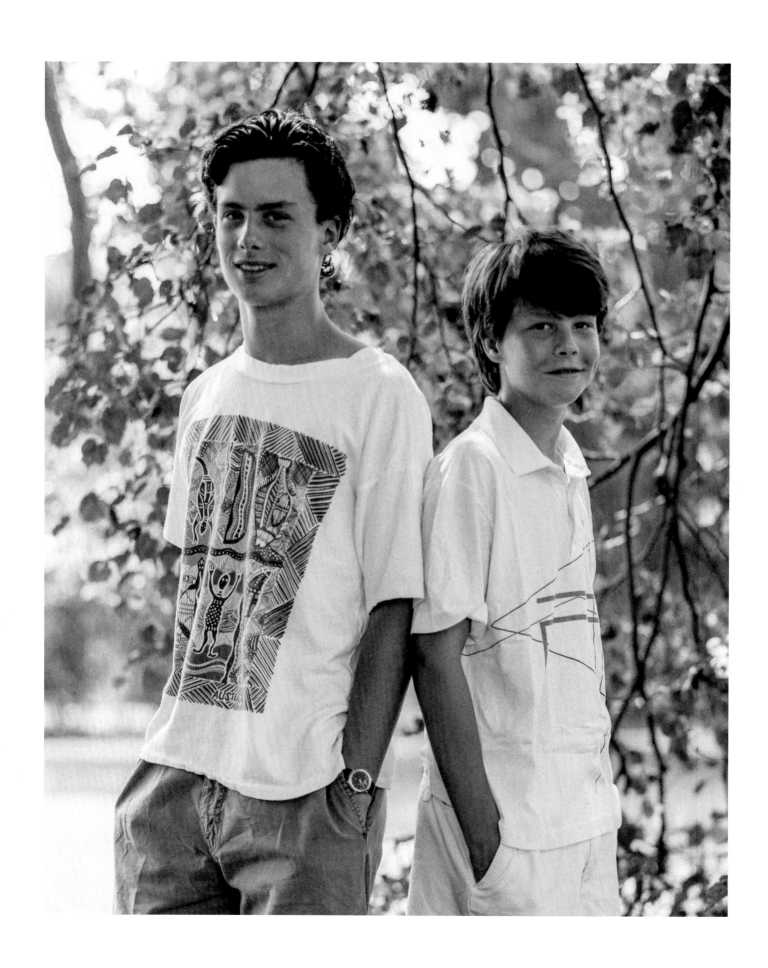

94 Teddy and Jack Geary, Southampton, New York, 1986.

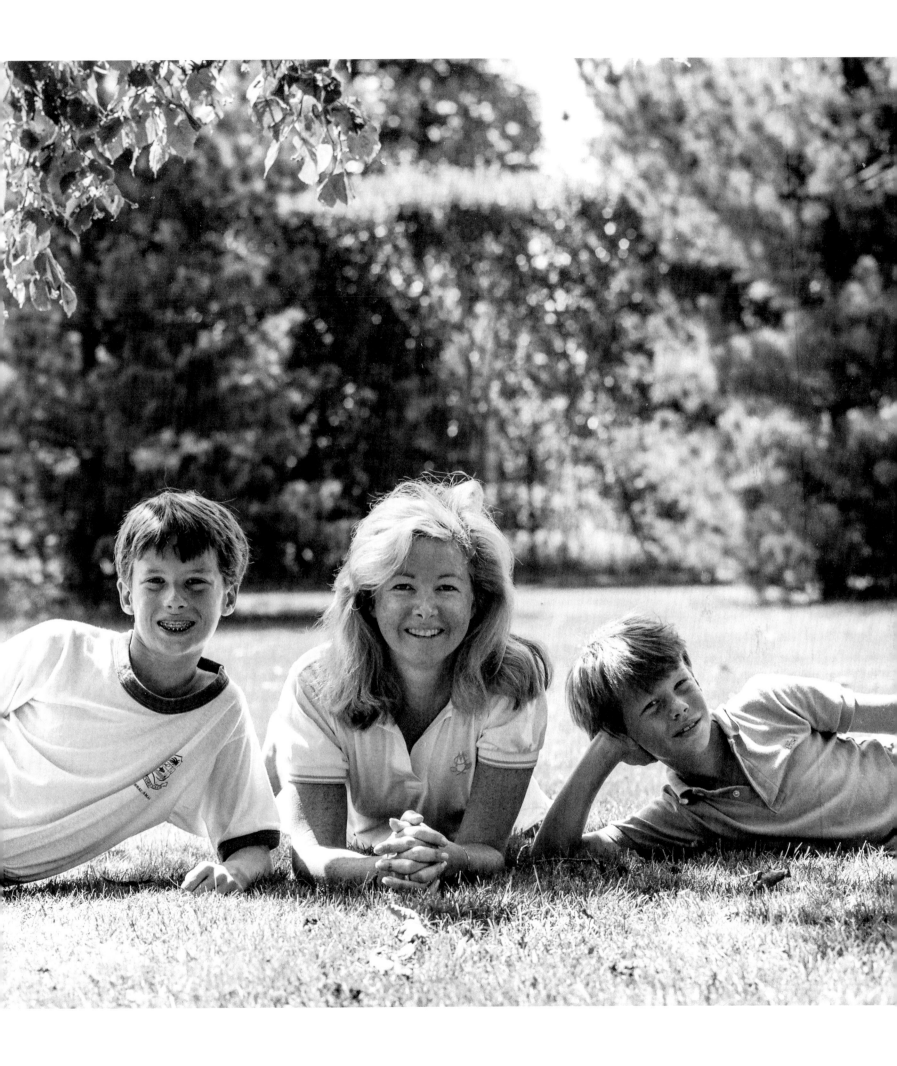

Teddy, Hilary and Jack Geary, Southampton, New York, 1981.

GOULD FAMILY

Jay Gould gained a high profile during America's Gilded Age, amassing spectacular power and wealth through the railroad industry, ultimately owning the Union Pacific Railroad among others. His descendants surely benefited from his fortune, and ensuing generations unilaterally morphed into one of America's most celebrated families, with spectacular achievements in business, the military, public service and philanthropy.

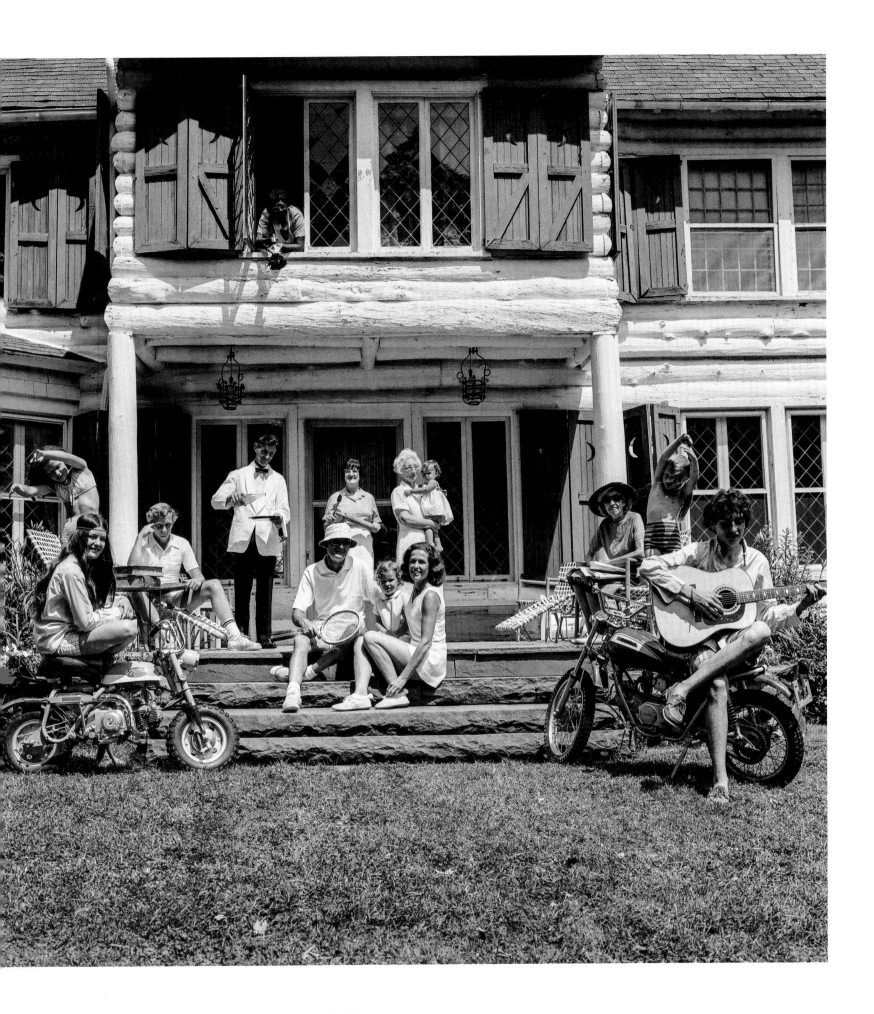

The Gould family with assorted friends and staff
members at "Furlow Ranch," Arkville, New York, 1971.

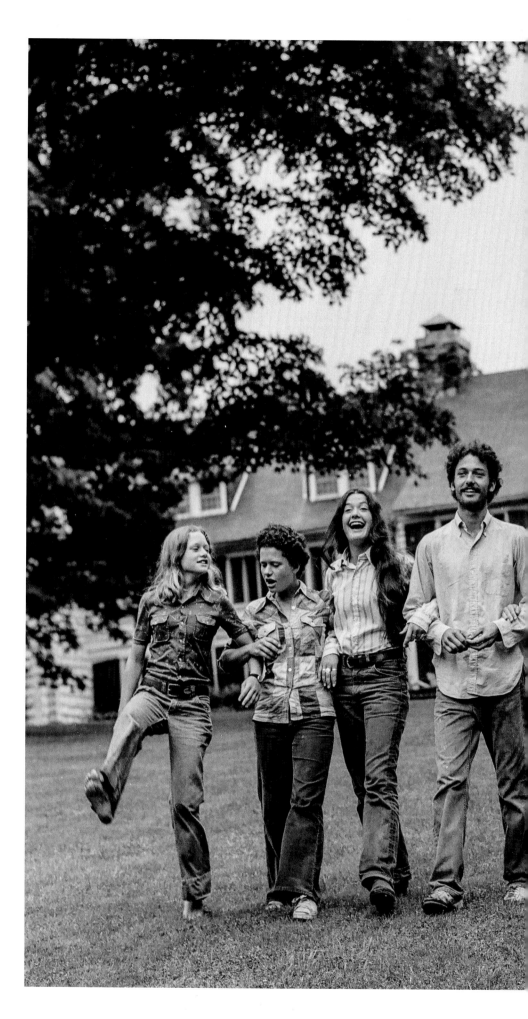

The entire Kingdon Gould Jr. family. Left to right: Thalia, Nunzy, Melissa, Caleb, Candida, King, Thorne, Frank and Lydia with parents Mary and Kingdon, Arkville, New York, 1975.

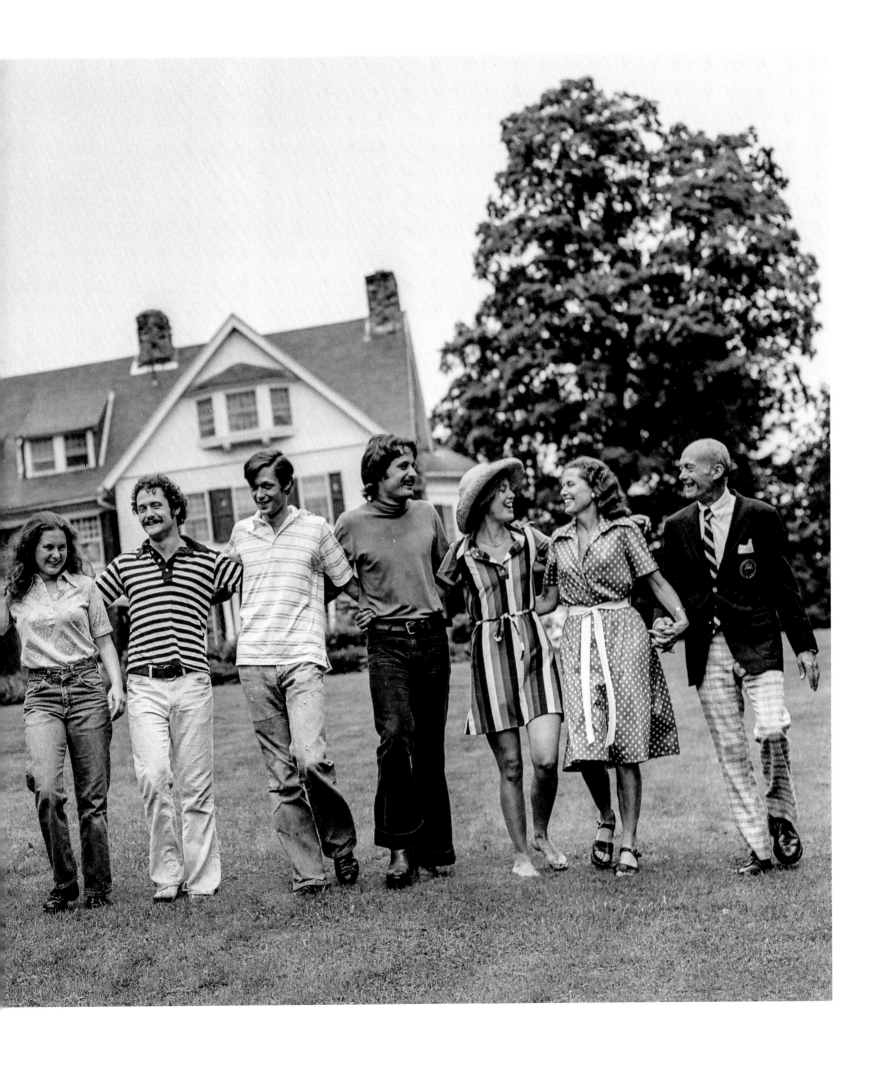

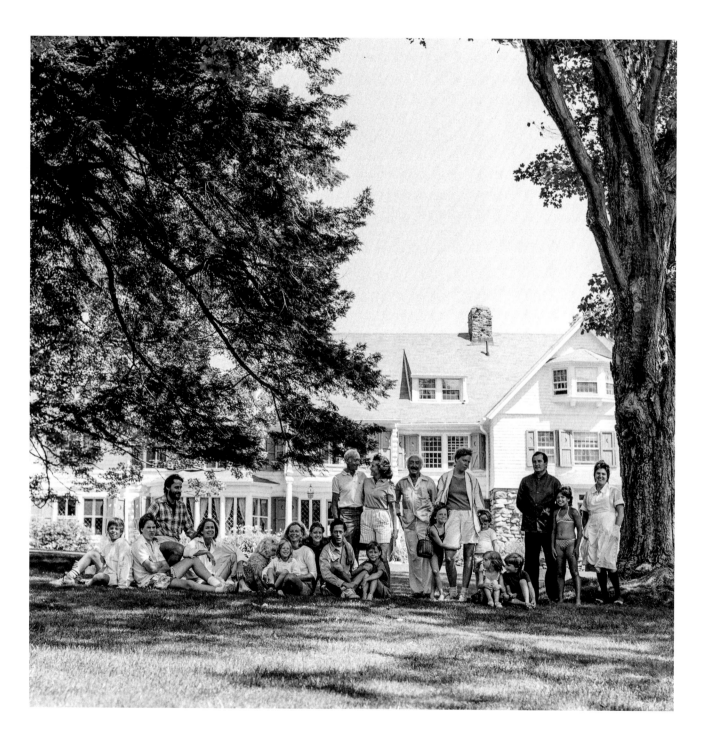

Three generations of Goulds along with longtime
staff members, Arkville, New York, 1985.

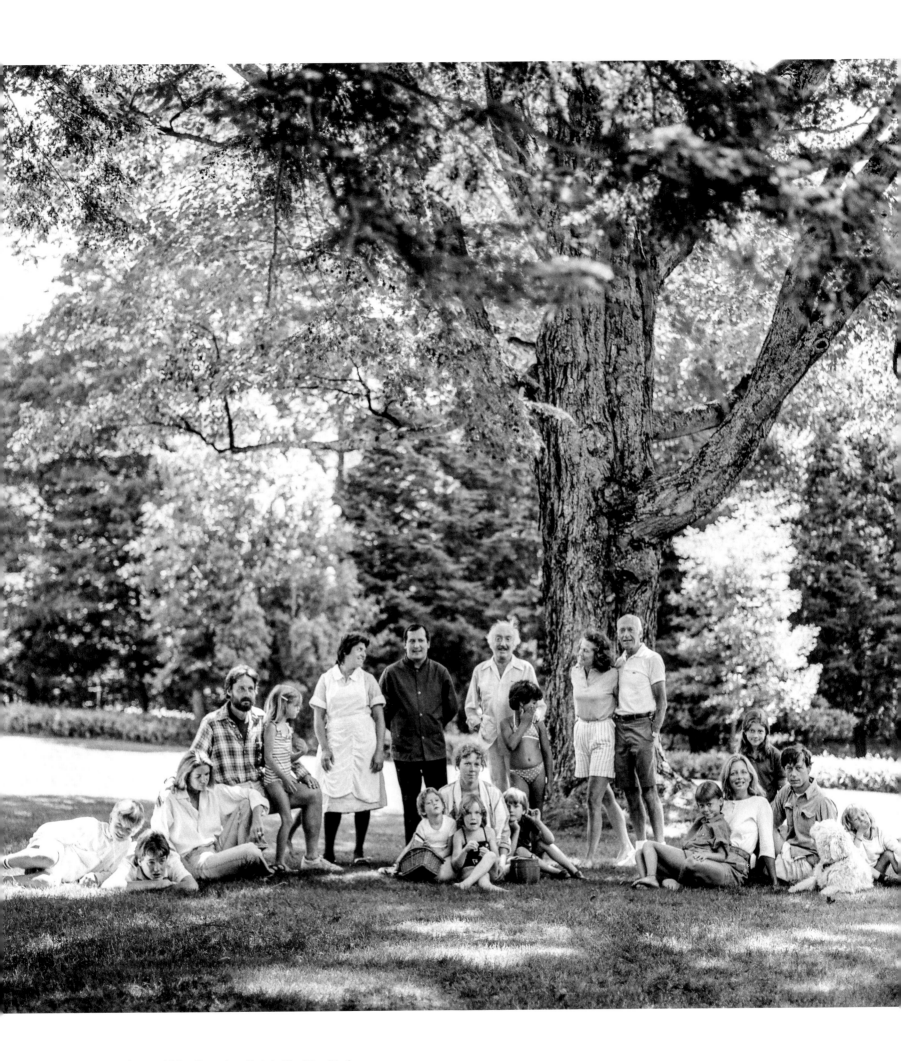

The Gould family and staff, Arkville, New York,
1985.

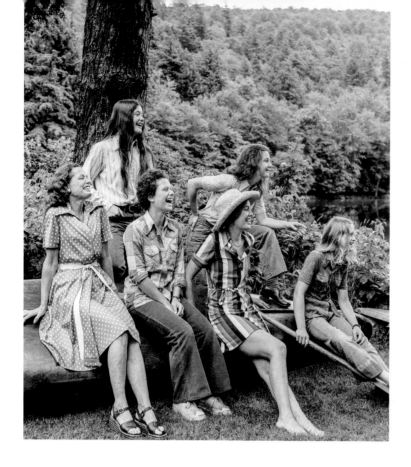

Mary Gould with her daughters Melissa, Nunzy, Lydia, Candida and Thalia, Arkville, New York, 1975.

Kingdon Gould and sons Caleb, King and Frank, Arkville, New York, 1975.

Mr. and Mrs. Kingdon Gould Jr., Arkville, New
York, 1985.

GUBELMANN FAMILY

The Gubelmann name will forever be associated with patriarch William Samuel Gubelmann, the St. Louis–born inventor and "father of all calculating machines in use today." He licensed his proprietary technology to companies like IBM, National Cash Register and Remington, amassing a fortune. Children and grandchildren settled in New York and its environs, and had getaways in Newport and Palm Beach, where they became accomplished sportspersons, philanthropists and pillars of society.

Susan, William, Wyeth, Barton, Walter, Marjorie, James and Kate Gubelmann, Palm Beach, Florida, 1976.

Tantivy, Bingo and Phoebe Gubelmann, Palm Beach,
Florida, 1982.

Two generations of Kuhners chronicled
five generations of the extended
Gubelmann family. These lovely
moments of our family life still thrive on
our bookshelves and in our mind's eye.

Kate Gubelmann

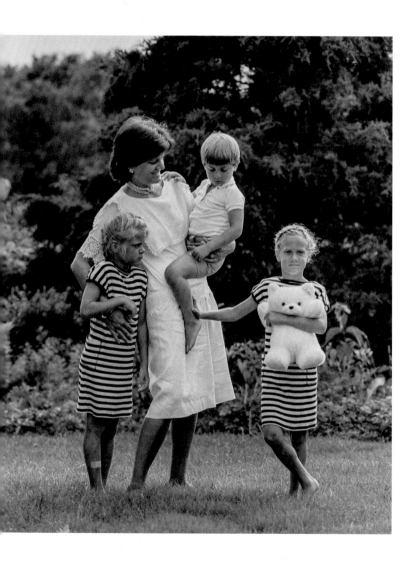

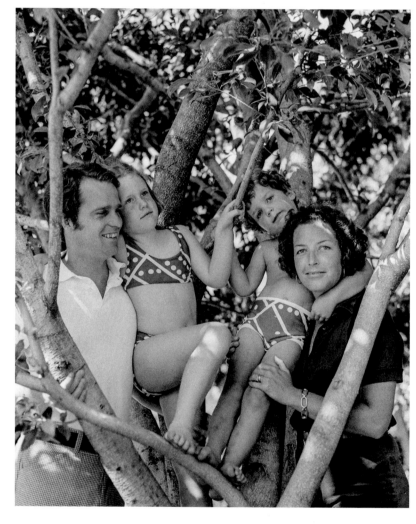

Kate Gubelmann with children, Bernardsville,
New Jersey, 1984.

William and Susan Gubelmann with children
Marjorie and Wyeth, Palm Beach, Florida, 1976.

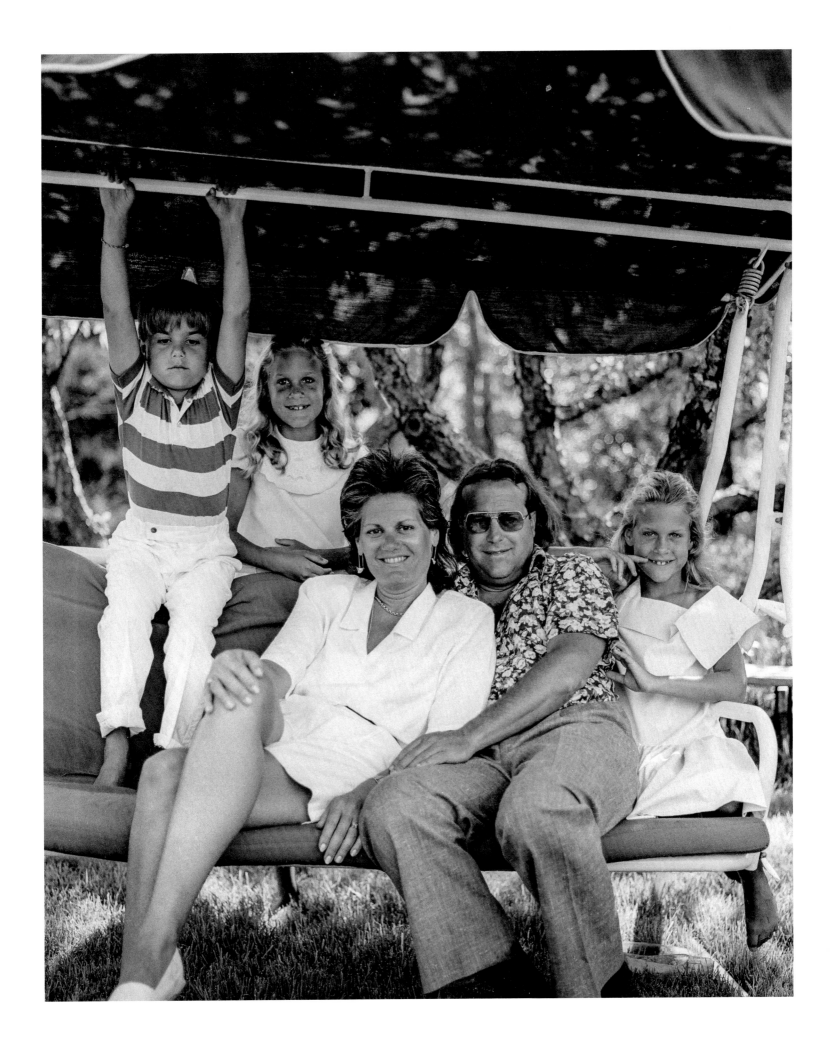

Kate and James Gubelmann and family, Palm Beach,
Florida, 1986.

HANNAH FAMILY

Darryl Hannah's journey to Hollywood began while growing up in the leafy Chicago suburb of Long Grove, Illinois. Insomnia enabled her to watch movies on television late into the nights, piquing her interest in the film industry. Also helpful was that her stepfather, Jerrold Wexler, was the brother of renowned cinematographer Haskell Wexler (*Who's Afraid of Virginia Woolfe?* and *One Flew Over the Cuckoo's Nest*). After studying ballet and acting at the University of Southern California, the parts began to come her way. Memorable on-screen performances include Brian de Palma's *The Fury* (premier), Ron Howard's *Splash* and a star turn in *Steel Magnolias*.

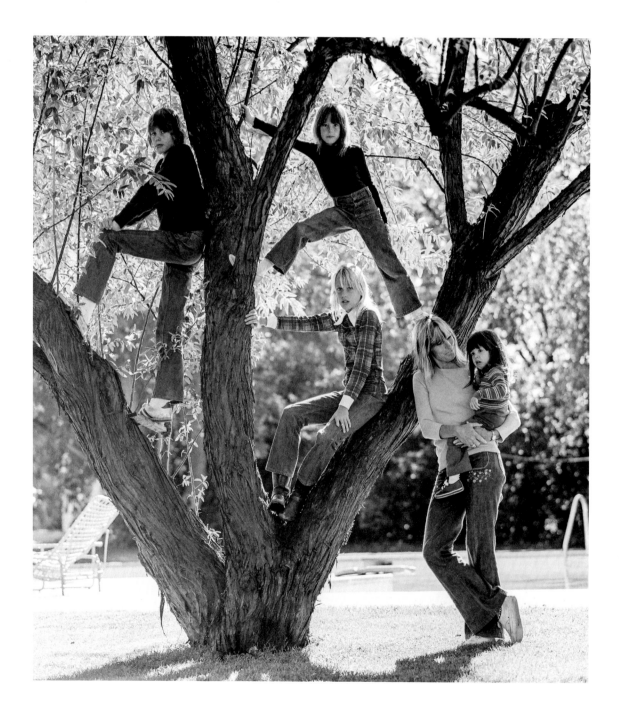

Susan Wexler with the blended Hannah/Wexler family, Long Grove, Illinois, 1972.

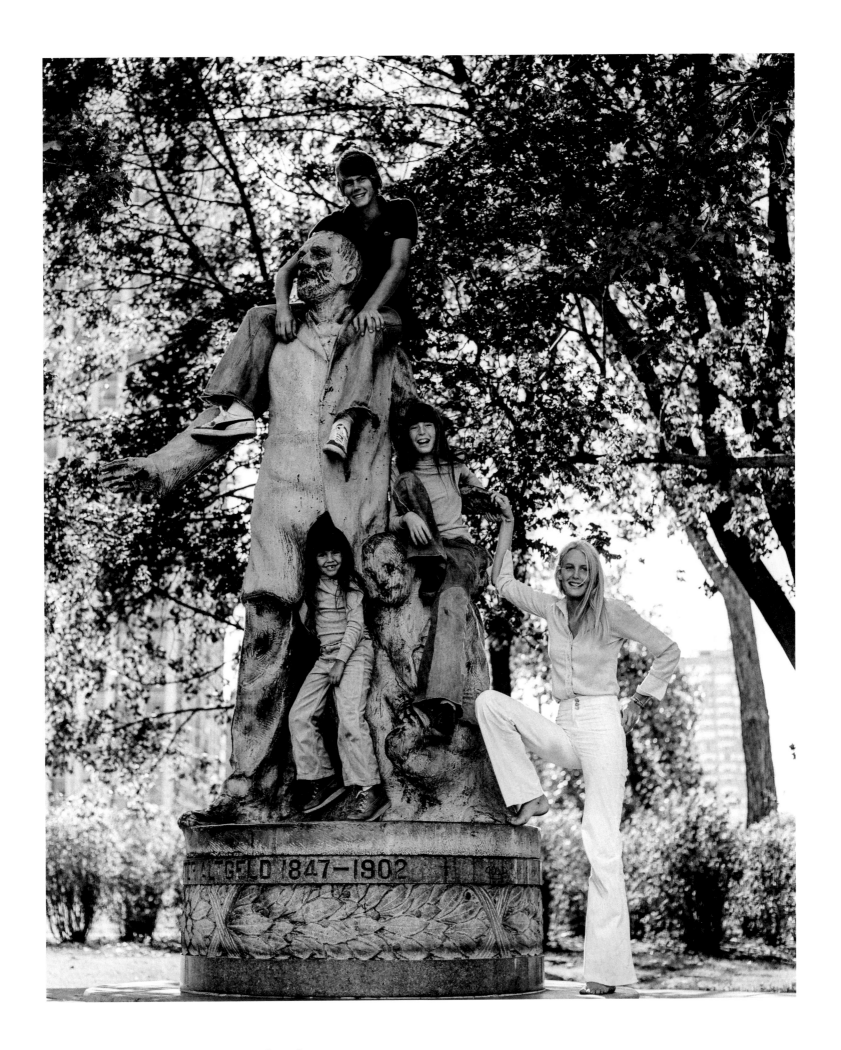

Don Hannah, Tanya Wexler, Page and Daryl
Hannah, Chicago, Illinois, 1976.

HARRIS FAMILY

Developer, civic leader and philanthropist Johnnie Harris and his wife Deborah are part of one of the first families of Charlotte, North Carolina. Johnnie's father, James, made his initial fortune in insurance but parlayed that into large real estate projects, ones that helped build the city of Charlotte into the sophisticated financial, cultural and athletic metropolis that it is today. The family's crowning achievement is the Quail Hollow Club, which has long been a mainstay on the PGA Tour.

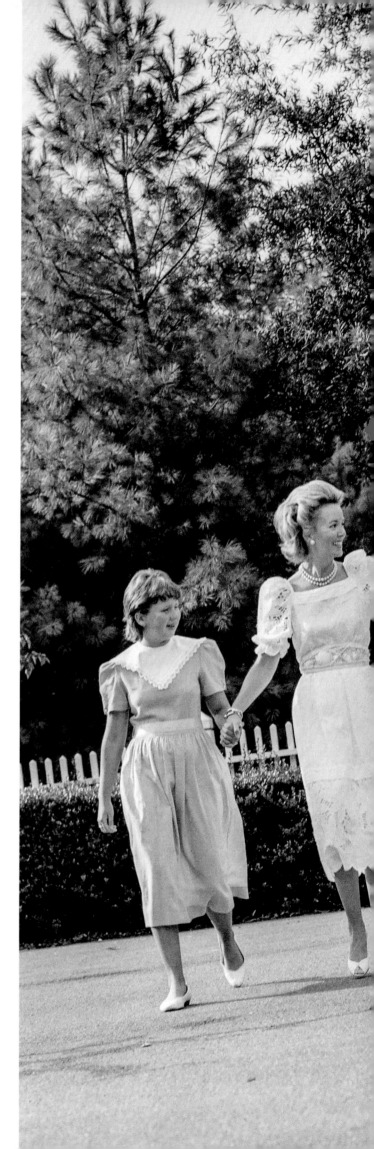

Deborah and Johnnie Harris with children Wendy, John and Sunny, Charlotte, North Carolina, 1982.

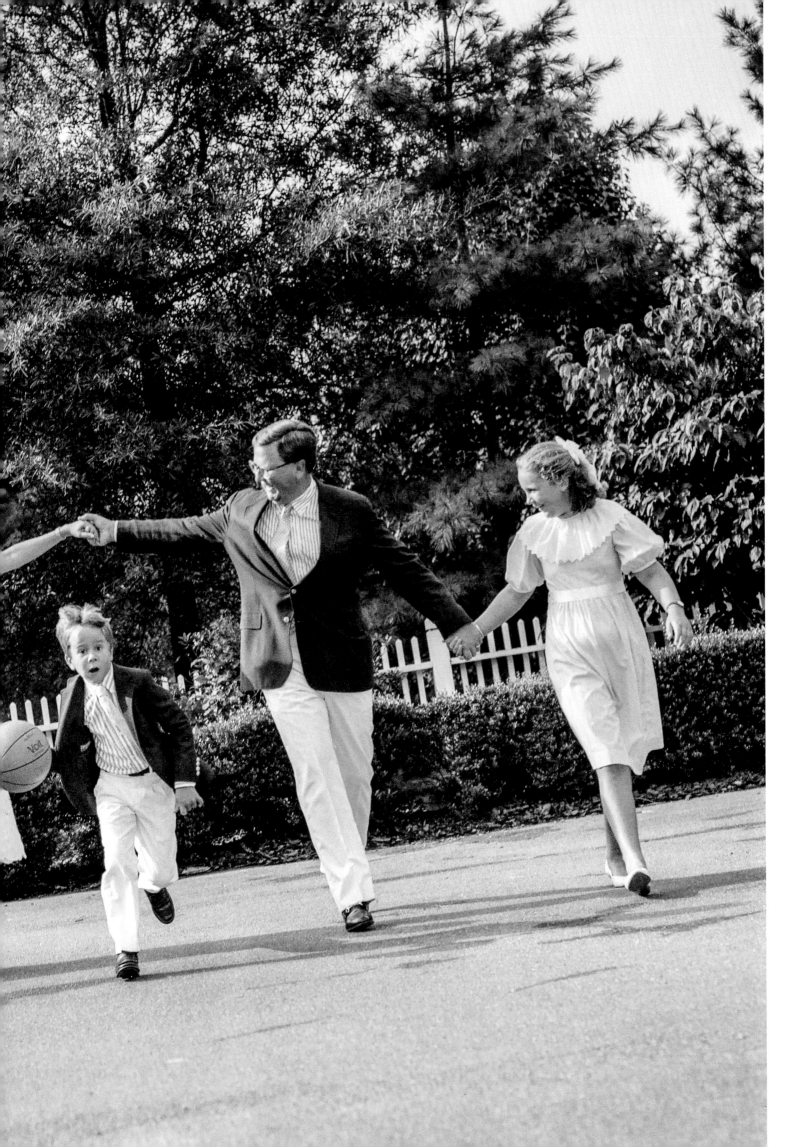

HOOVER FAMILY

Originally in the leather goods manufacturing business in Canton, Ohio, William Henry "Boss" Hoover bought a patent for an "Electric Suction Sweeper" from janitor/inventor James Spangler in 1908 and began producing the precursor of what would eventually become known worldwide as the upright vacuum cleaner. While the Hoover family is long gone from actual business operations, the brand endures, albeit as a division of a global conglomerate. Regardless, the Hoover vacuum cleaner is such an integral part of our collective consciousness that in Great Britain, the word is officially a verb. It is completely commonplace to say that one "Hoovers" the living room rug.

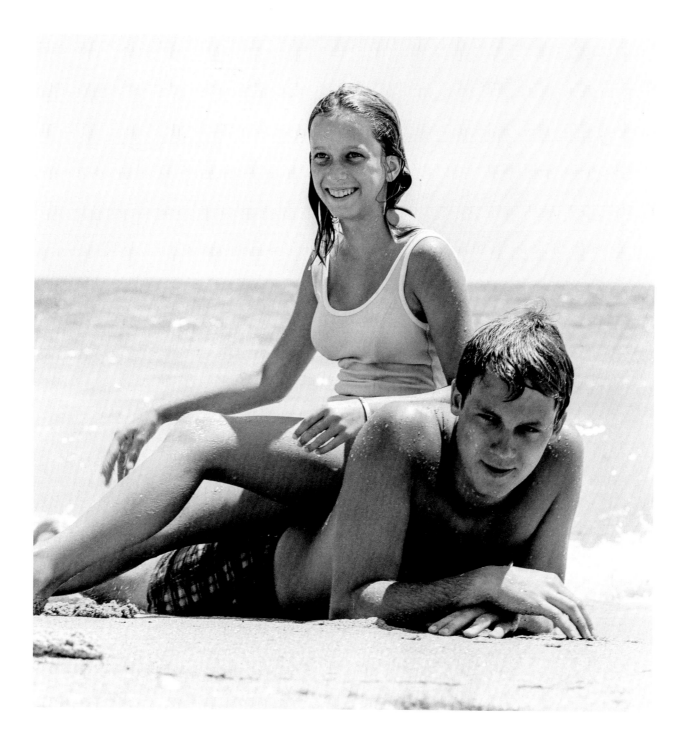

Elizabeth and Bunker Hoover, Bal Harbour, Florida, 1965.

HUFTY FAMILY

The Hufty name has been a fixture on the Palm Beach social landscape since the 1930s, beginning with Mann Randolph Page Hufty, a Washington, DC–born insurance executive and financier. His wife, Frances, was the granddaughter of John Archbold, one of the founders of Standard Oil. Both Page and Frances lived well into their nineties, with the emphasis on "well," and their descendants proudly sport monikers that contain various arrangements of Page, Archbold and Hufty.

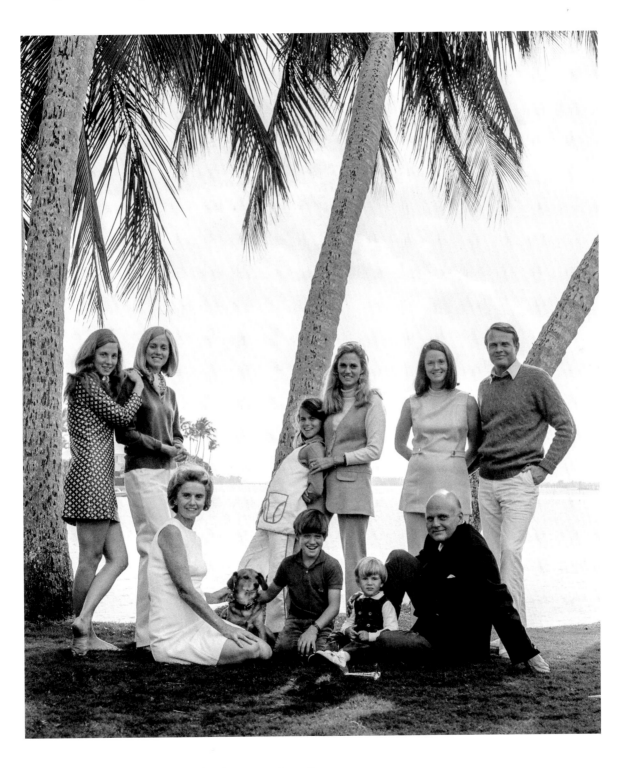

Mr. and Mrs. Archbold Hufty with daughters Mary Page, Page Lee, Alex Hufty de Atucha with her children, Frances and her husband, Carter Leidy Jr., Palm Beach, Florida, 1970.

HULITAR FAMILY

In patrician Palm Beach, Philip and Mary Hulitar were beacons of taste, style, and exuberant expression. A well-known couturier, Philip dressed the cream of high society along with becoming an accomplished sculptor. Apart from serving as his muse and best model, Mary, too, was a respected connoisseur of the arts. The parents of two daughters, Stefani and Renee, the Hulitars cut an imposing figure on the landscape of Palm Beach, from their fabulously eclectic oceanfront estate to their lifelong dedication to the Society of the Four Arts, the renowned cultural institution. To this day, the Hulitar name stands for outstanding citizenship, philanthropy, and the passionate pursuit of beauty in everyday life.

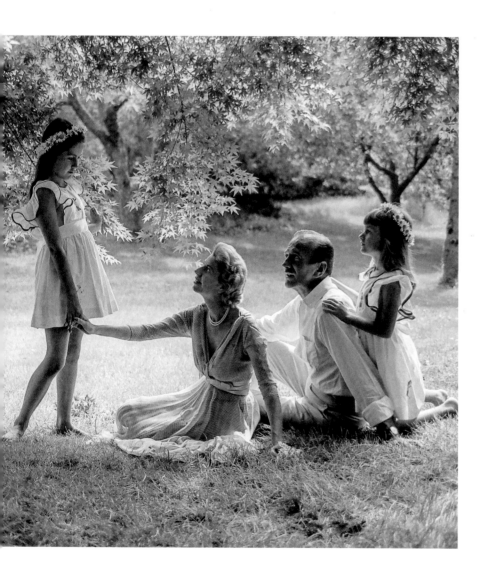

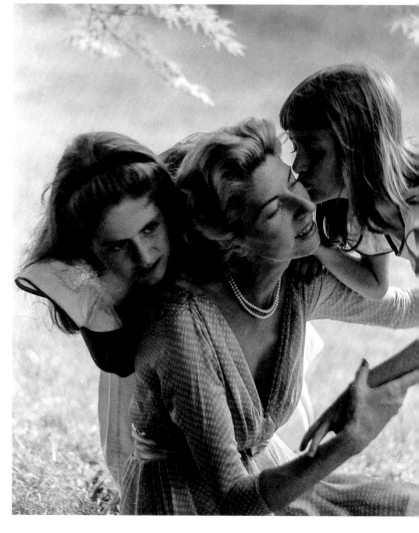

Mary and Philip Hulitar with daughters Stefani and Renee, Glen Cove, New York, 1960.

Mary Hulitar and daughters, Glen Cove, New York, 1960.

Betty was the warmest human being in the world.
I especially loved her eclectic dinner parties.

Stefani Hulitar

The Hulitar family, Palm Beach, Florida, 1980.

HUTTON FAMILY

Founded in 1904 by Edward Francis Hutton, the stock brokerage firm of EF Hutton famously became the one that America "listened to." Over the generations, this distinguished financial services family intertwined with others of the same ilk, namely Woolworth (retail), Post (cereal) and Chapin (automotive).

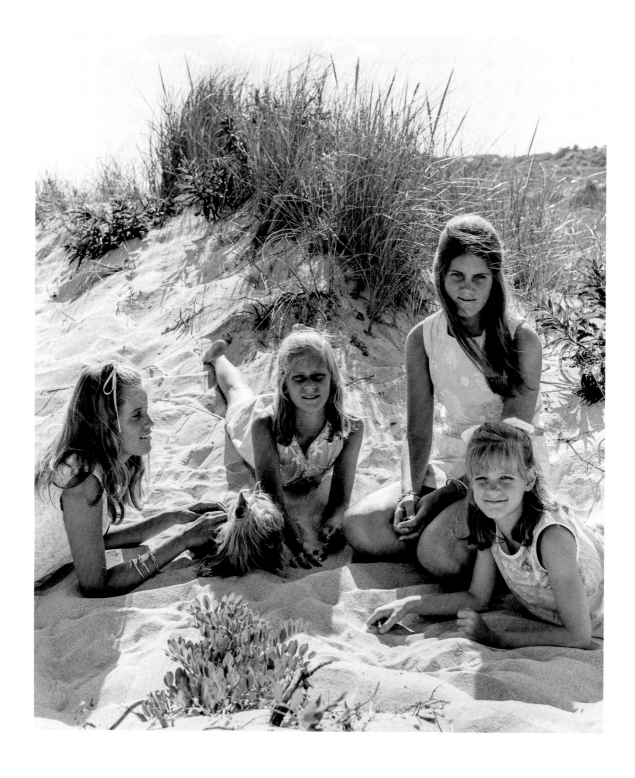

Hutton daughters Linda, Cynthia, Consuelo and
Mimi, East Hampton, New York, 1965.

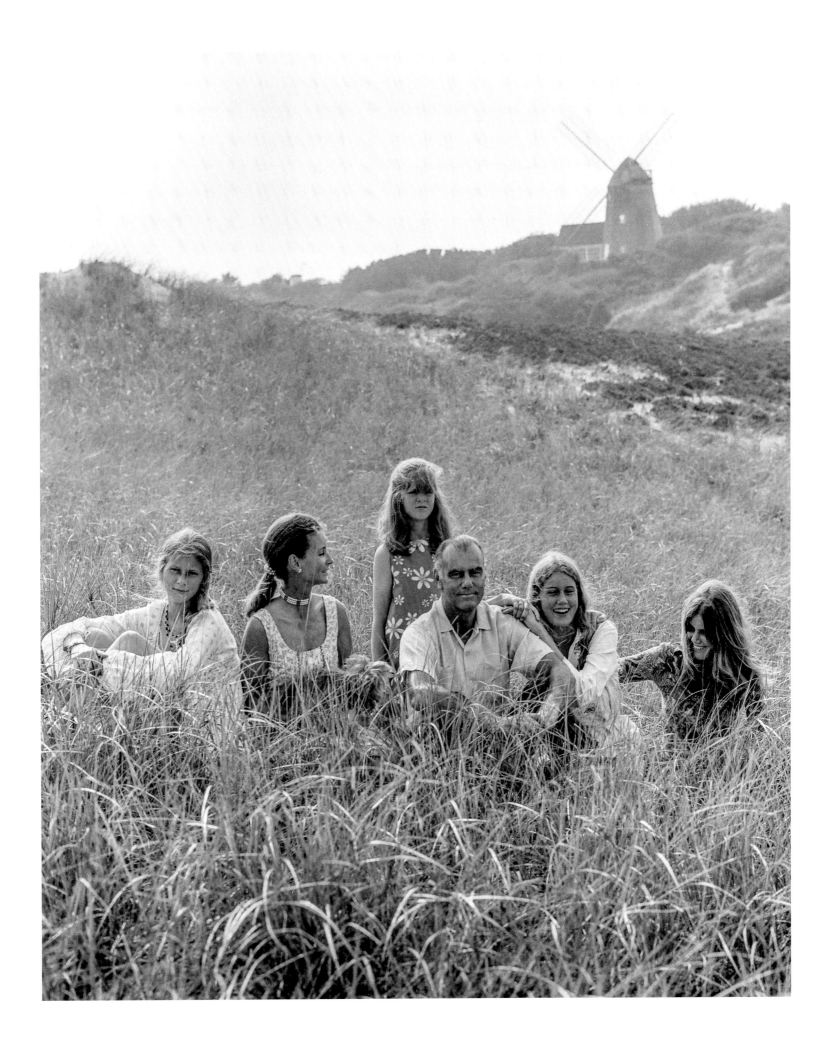

Ginny and William Hutton with their daughters,
East Hampton, New York, 1971.

JAVITS FAMILY

The Javits family remains a part of the New York story. Before becoming a New York senator, Jacob Javits and his brother, Benjamin, founded the law firm of Javits, Robinson, Leinwand & Reich. Benjamin's son, Eric, and his wife, Stephanie, were fixtures on the Southampton scene, known for their sophisticated taste and forward-thinking style. Stephanie was one of Lilly Pulitzer's first models, before becoming a successful interior and decorative accessories designer. Their son, Eric Javits Jr., is one of America's most celebrated milliners.

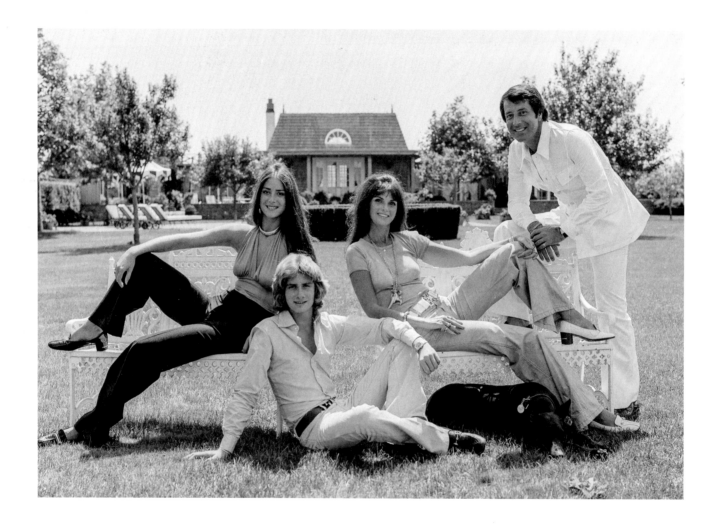

Betty was the first pregnant woman I had ever seen. I asked her about her enormous bulging belly and she explained to me how a baby was born from a mother after nine months in her belly.

Eric M. Javits

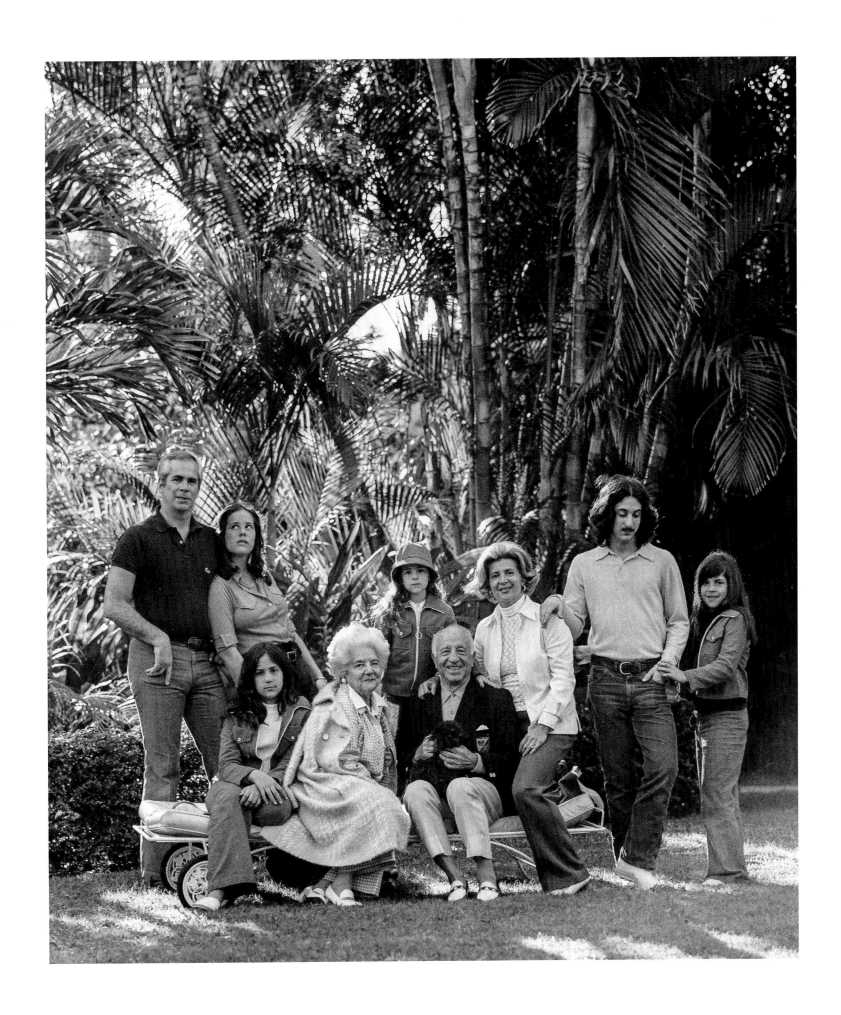

Facing: Eric and Stephanie Javits with their children, Jocelyn and Eric Jr., Southampton, New York, 1973.

Above: Lily and Benjamin Javits with their daughter, Joan Javits Zeeman, and her husband, Hans, and their children, Palm Beach Florida, 1966.

KENNEDY FAMILY

As the closest thing to royalty America will probably ever have, regardless of their gritty Boston saloon-keeping roots, the Kennedy family is part and parcel to the American story. Their spectacular triumphs and heartbreaking tragedies have impacted hundreds of millions of lives, while the doors that they opened, their selfless sacrifices and their innumerable contributions to society continue to reap rewards. Today, even in the face of gale-force winds, the Kennedy spirit continues to soar toward a more perfect union with megawatt smiles and a fortitude that simply, and thankfully, won't quit.

Edward M. Kennedy Family

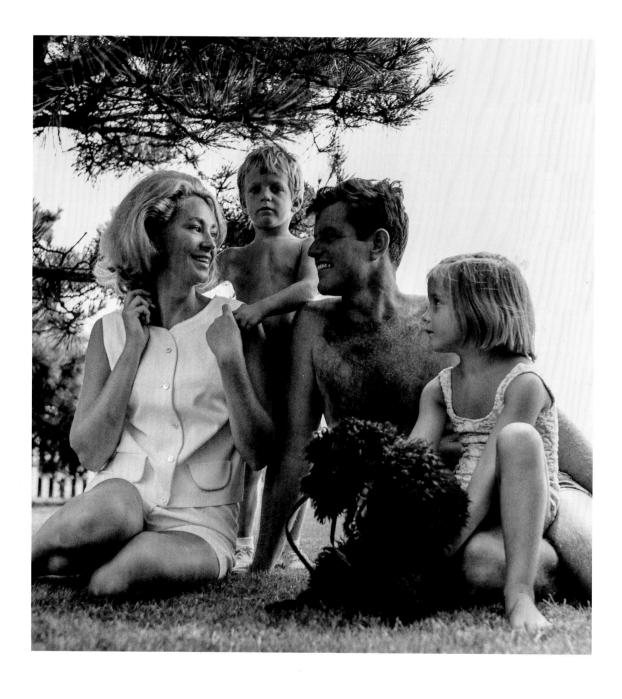

Joan and Ted Kennedy with their children Edward Jr. and Kara, Hyannisport, Massachusetts, 1965.

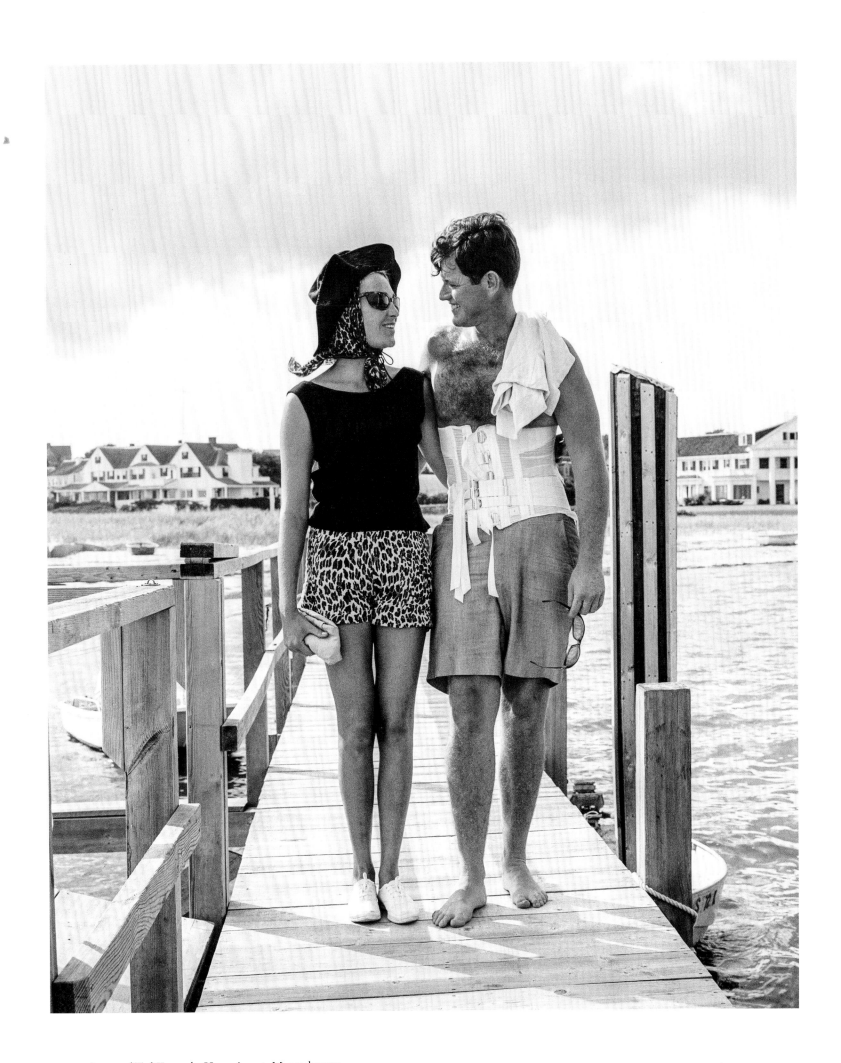

Joan and Ted Kennedy, Hyannisport, Massachusetts,
1965.

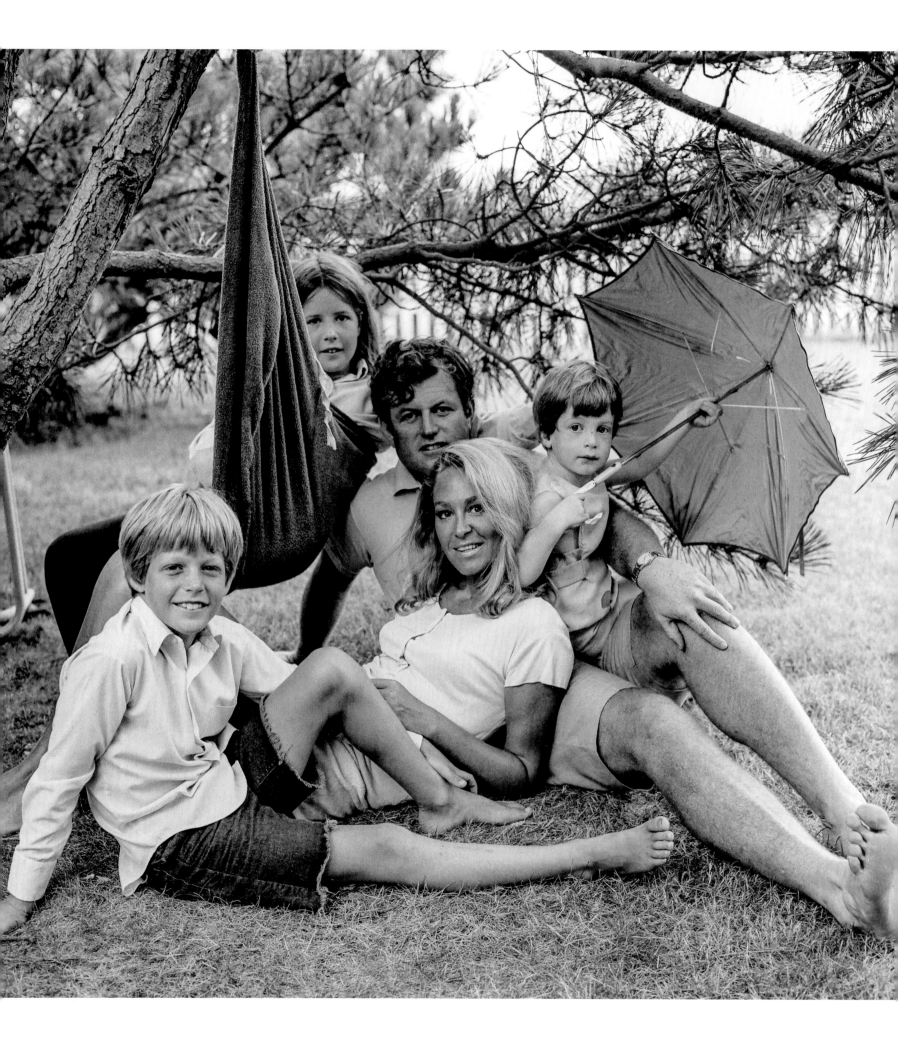

The Edward Moore Kennedy family, Hyannisport,
Massachusetts, 1970.

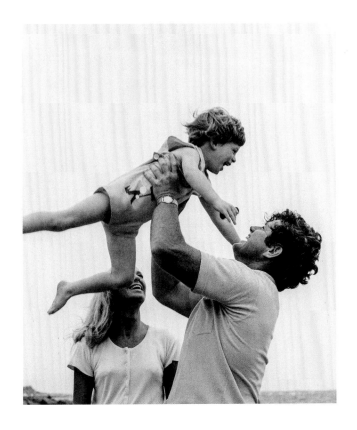

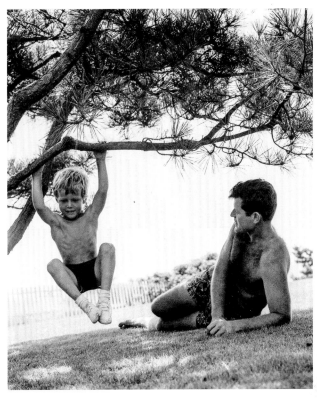

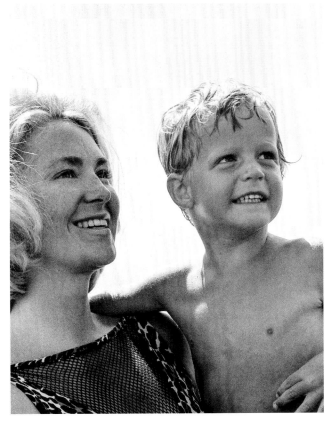

Top left: Joan and Ted Kennedy with son Patrick, Hyannisport, Massachusetts, 1970.

Bottom left: Joan Kennedy and son Edward Jr., Hyannisport, Massachusetts, 1965.

Top right: Edward Jr. and Ted Kennedy, Hyannisport, Massachusetts, 1965.

Bottom right: Edward Kennedy Jr., Hyannisport, Massachusetts, 1965.

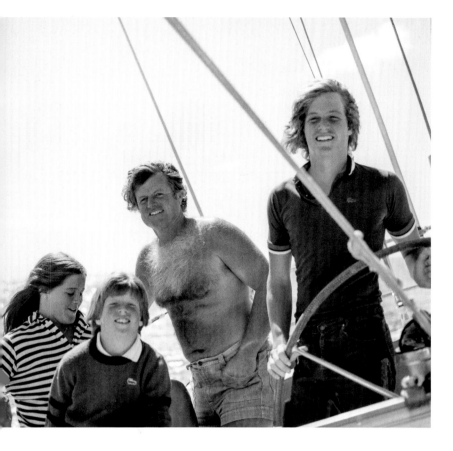

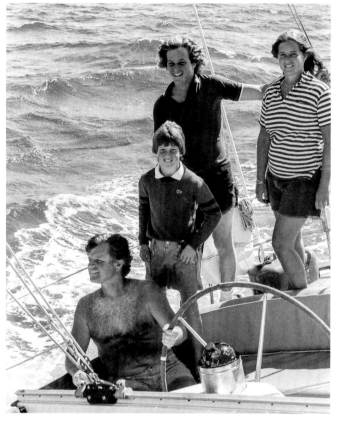

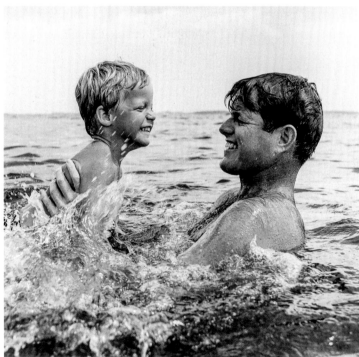

Top Left: Ted Kennedy with children Kara, Patrick and Edward Jr., Hyannisport, Massachusetts, 1977.

Bottom Left: Ted Kennedy with son Edward Jr., Hyannisport, Massachusetts, 1965.

Top Right: Ted Kennedy and children, Hyannisport, Massachusetts, 1977.

Facing: Joan and Ted Kennedy with children Edward Jr. and Kara, Hyannisport, Massachusetts, 1965.

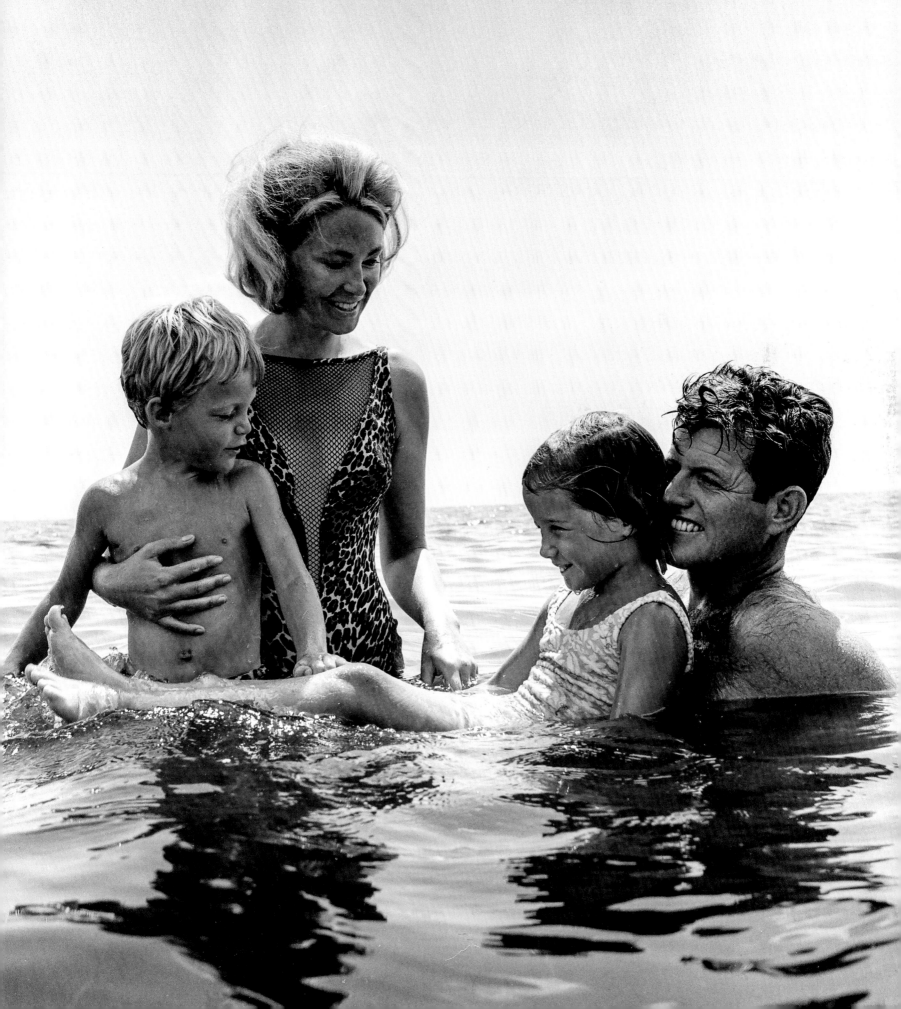

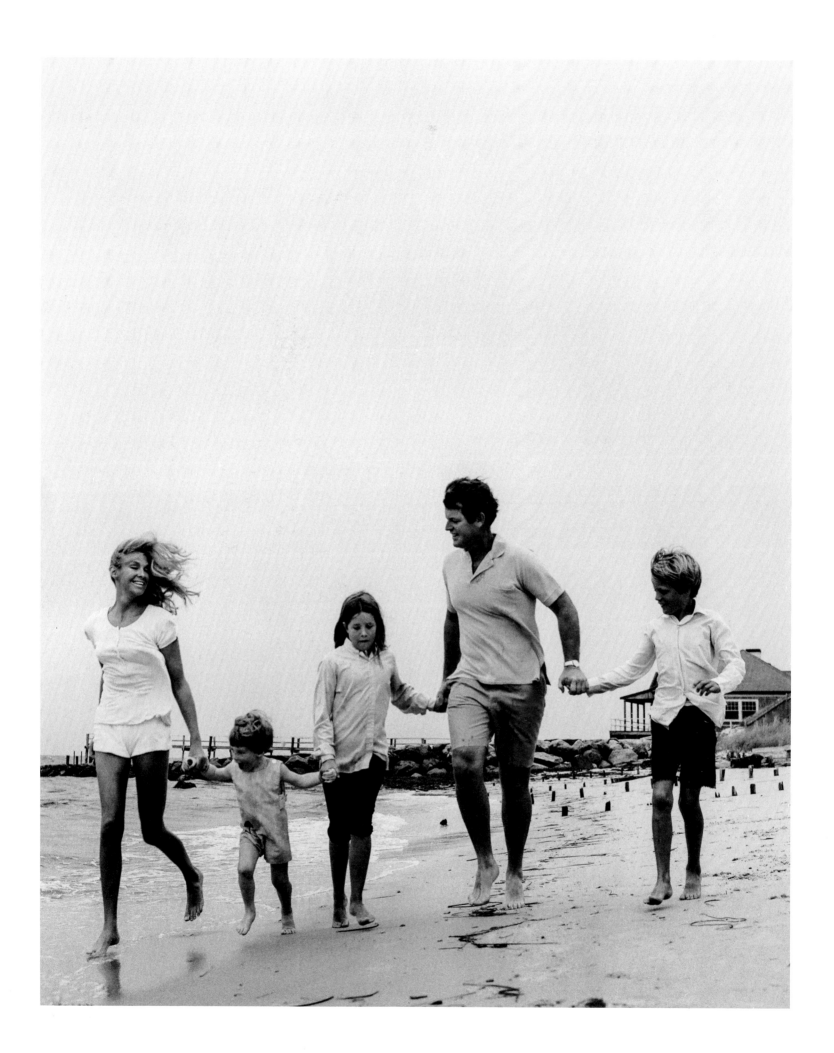

The Edward M. Kennedy family, Hyannisport,
Massachusetts, 1970.

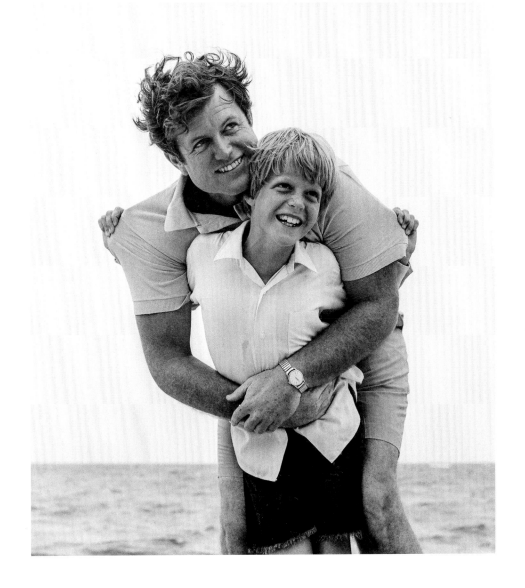

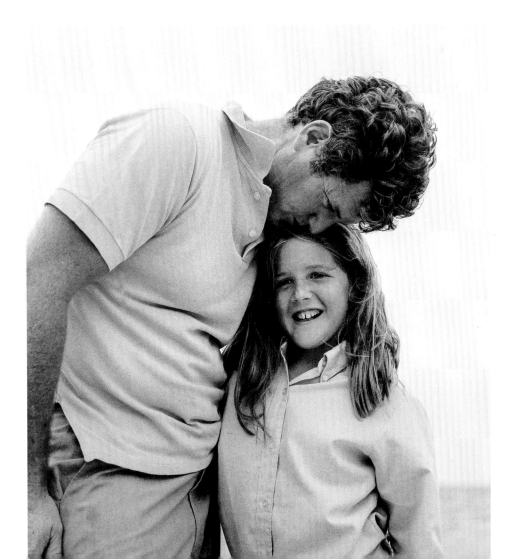

Above: Ted Kennedy with son Edward Jr., Hyannisport, Massachusetts, 1970.

Below: Ted Kennedy with daughter Kara, Hyannisport, Massachusetts, 1970.

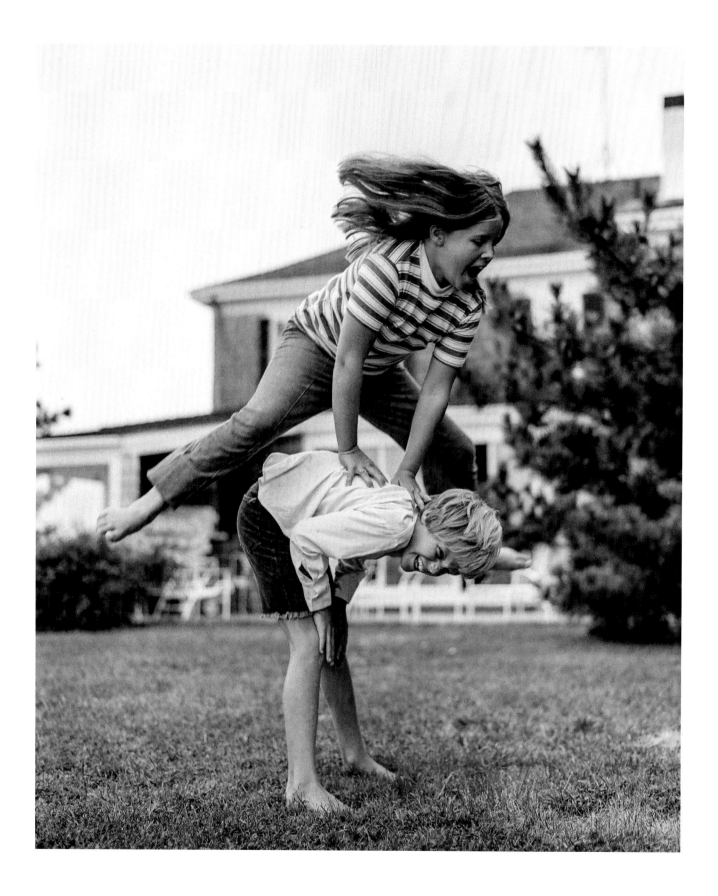

Kara and Edward Kennedy Jr., Hyannisport,
Massachusetts, 1970.

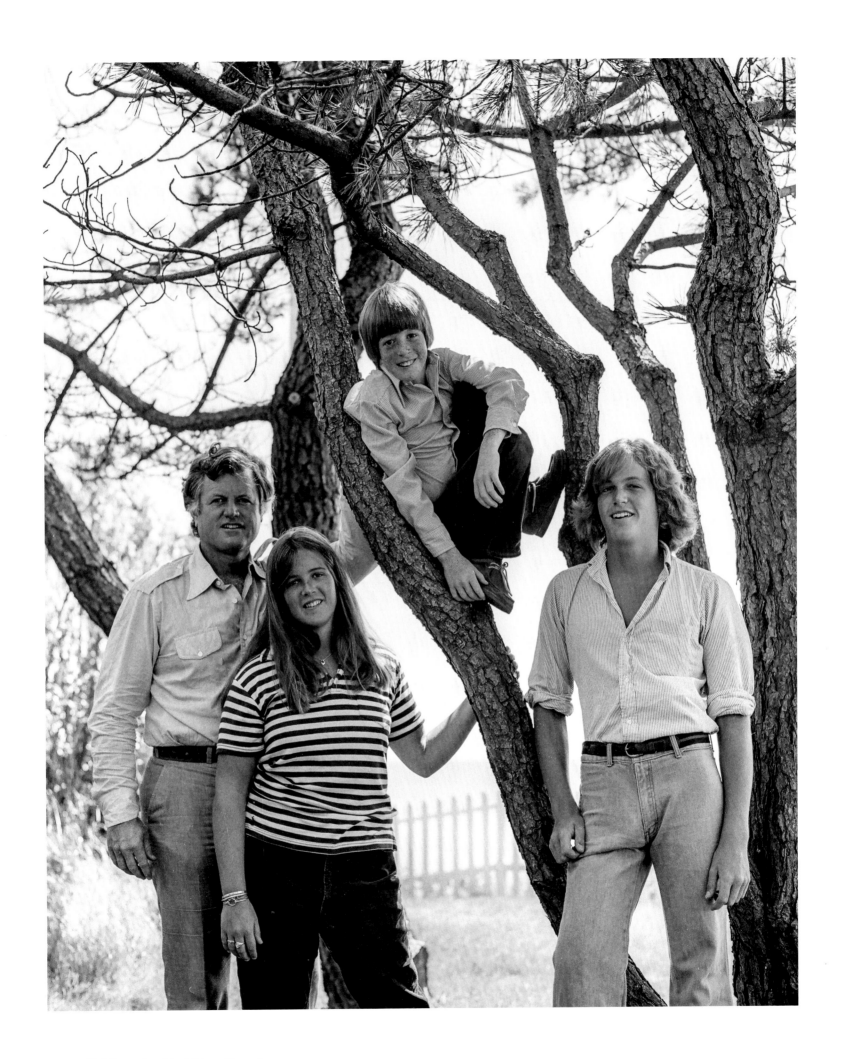

Ted Kennedy with children, Hyannisport,
Massachusetts, 1977.

John F. and Jacqueline Kennedy Children

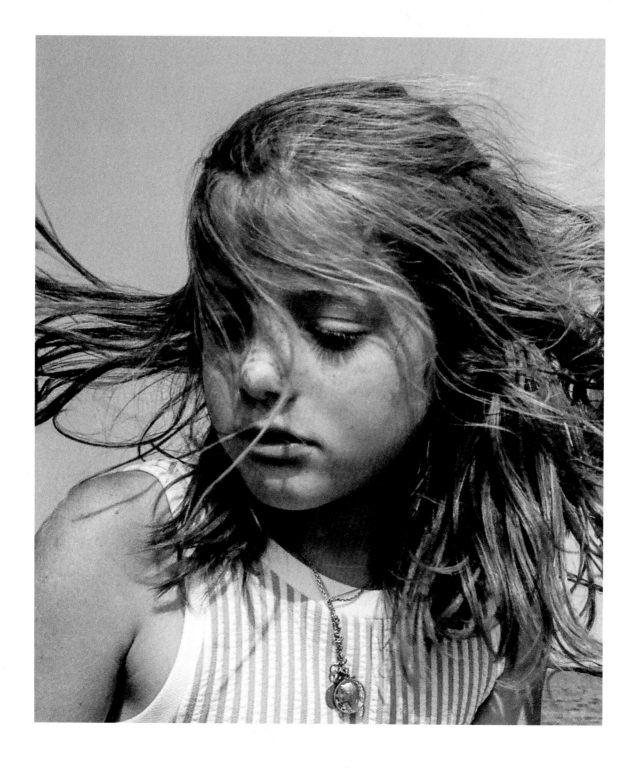

Caroline Kennedy, Hyannisport, Massachusetts, 1965.

Facing: Caroline Kennedy with her uncle Robert F. Kennedy, Hyannisport, Massachusetts, 1964.

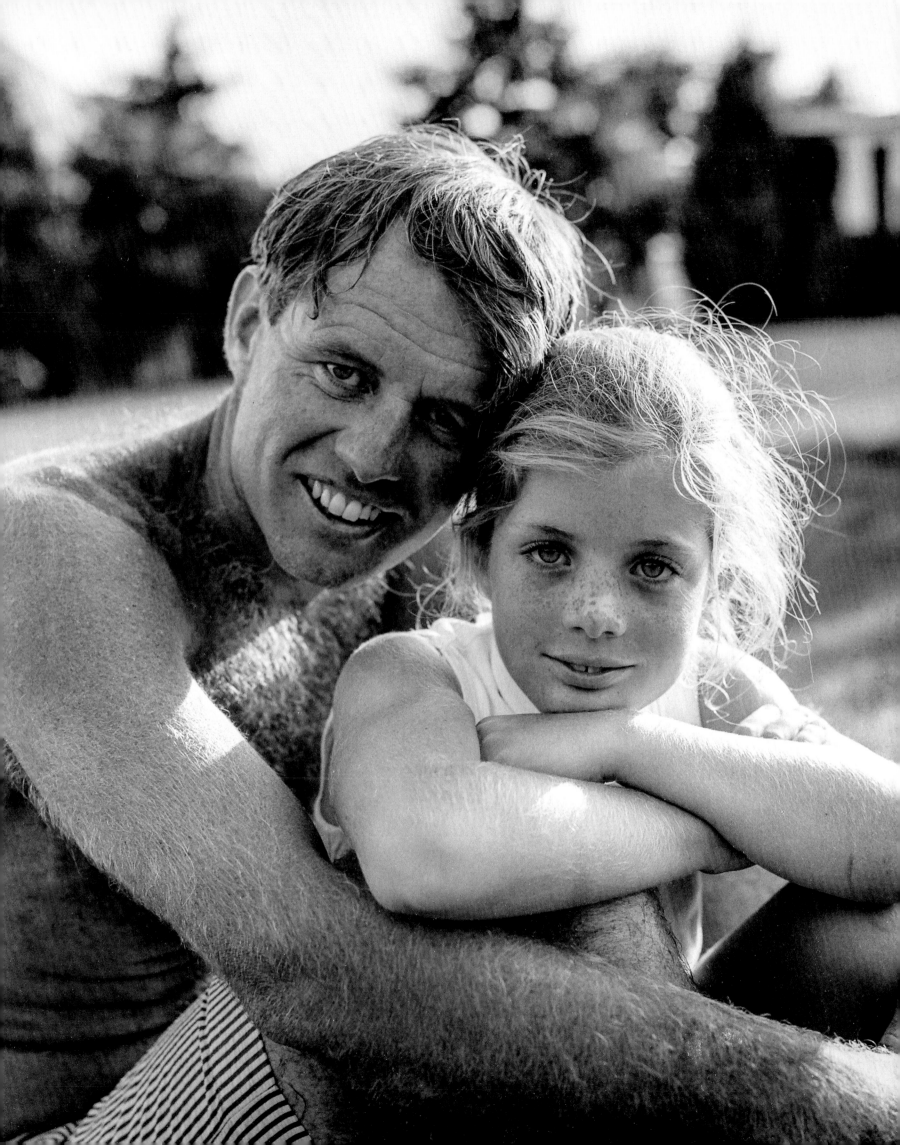

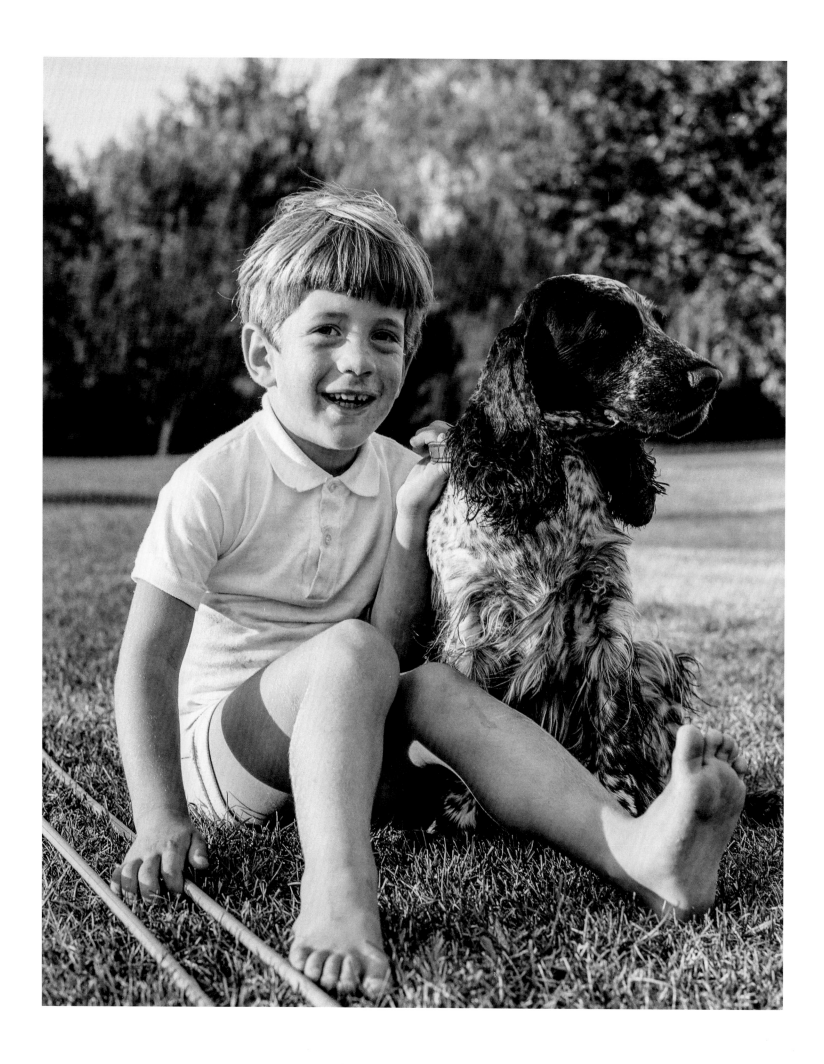

John F. Kennedy Jr., Hyannisport, Massachusetts, 1964.

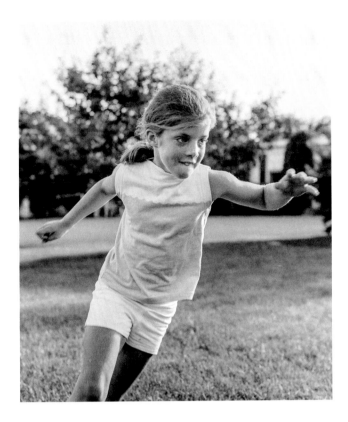

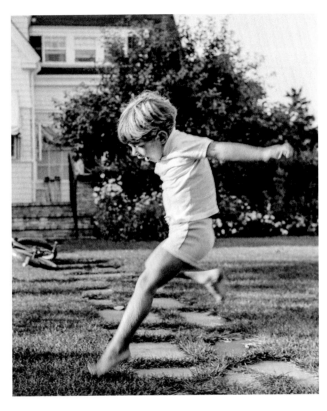

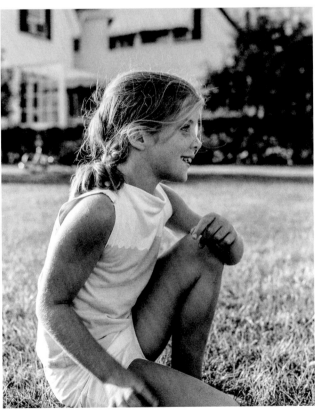

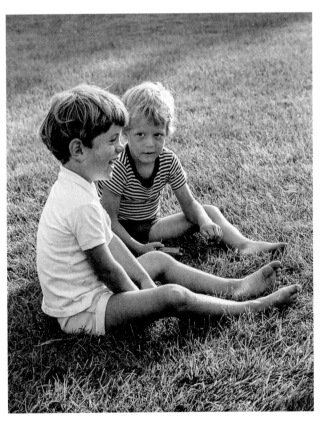

Top left: Caroline Kennedy, Hyannisport, Massachusetts, 1964.

Top right: John F. Kennedy Jr., Hyannisport, Massachusetts, 1964.

Bottom left: Caroline Kennedy, Hyannisport, Massachusetts, 1964.

Bottom right: John F. Kennedy Jr. and cousin Edward Kennedy Jr., Hyannisport, Massachusetts, 1964.

Robert F. Kennedy Family

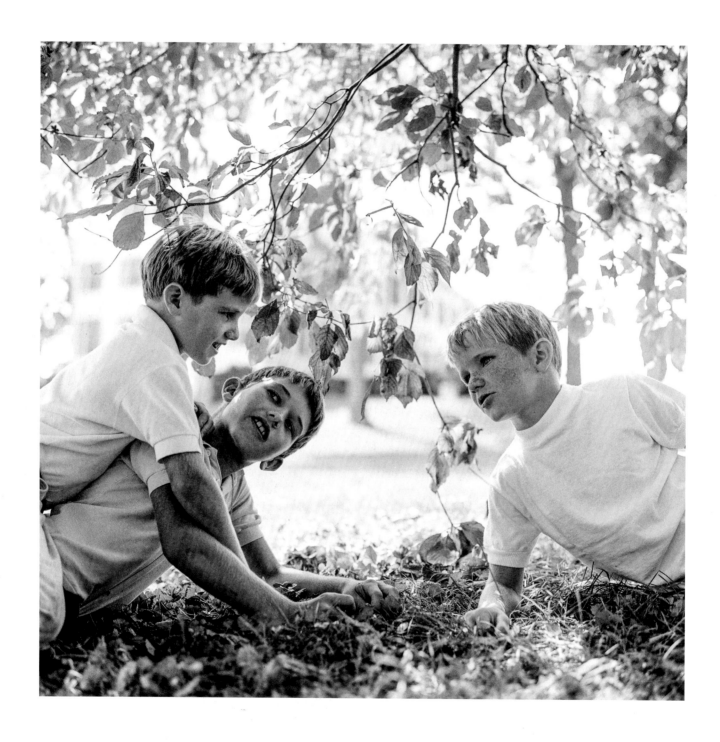

Michael, Robert Jr. and David Kennedy, McLean,
Virginia, 1964.

The Robert F. Kennedy family, McLean, Virginia, 1964.

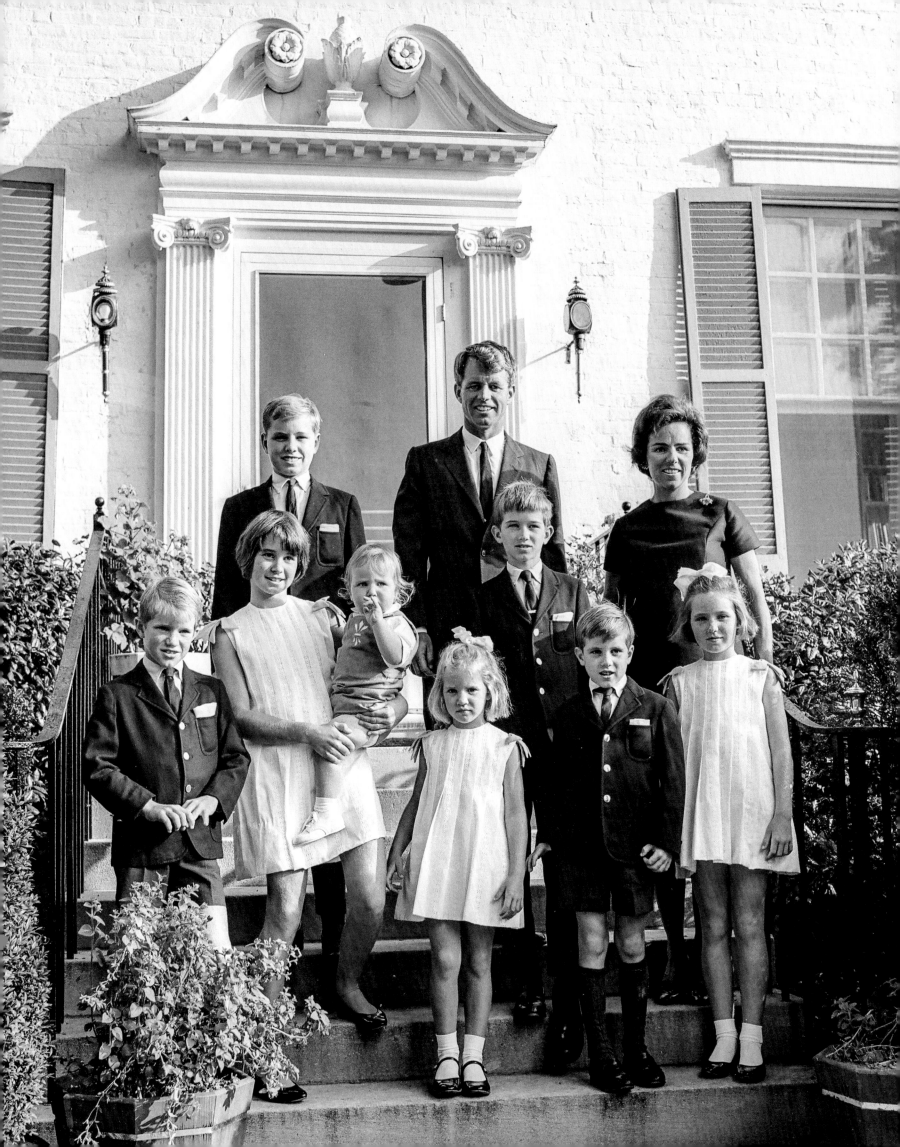

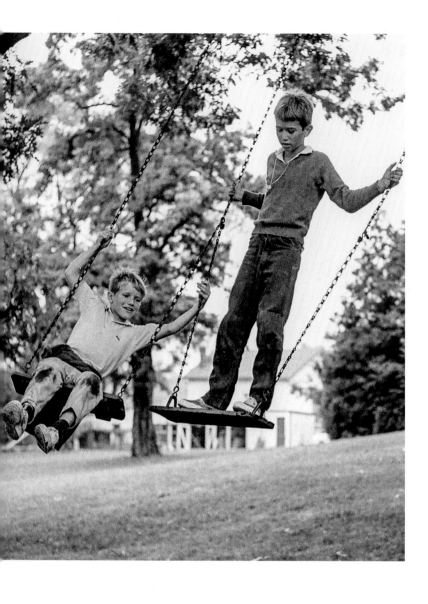

Michael and Robert Kennedy Jr., McLean, Virginia, 1965.

Michael Kennedy, McLean, Virginia, 1965.

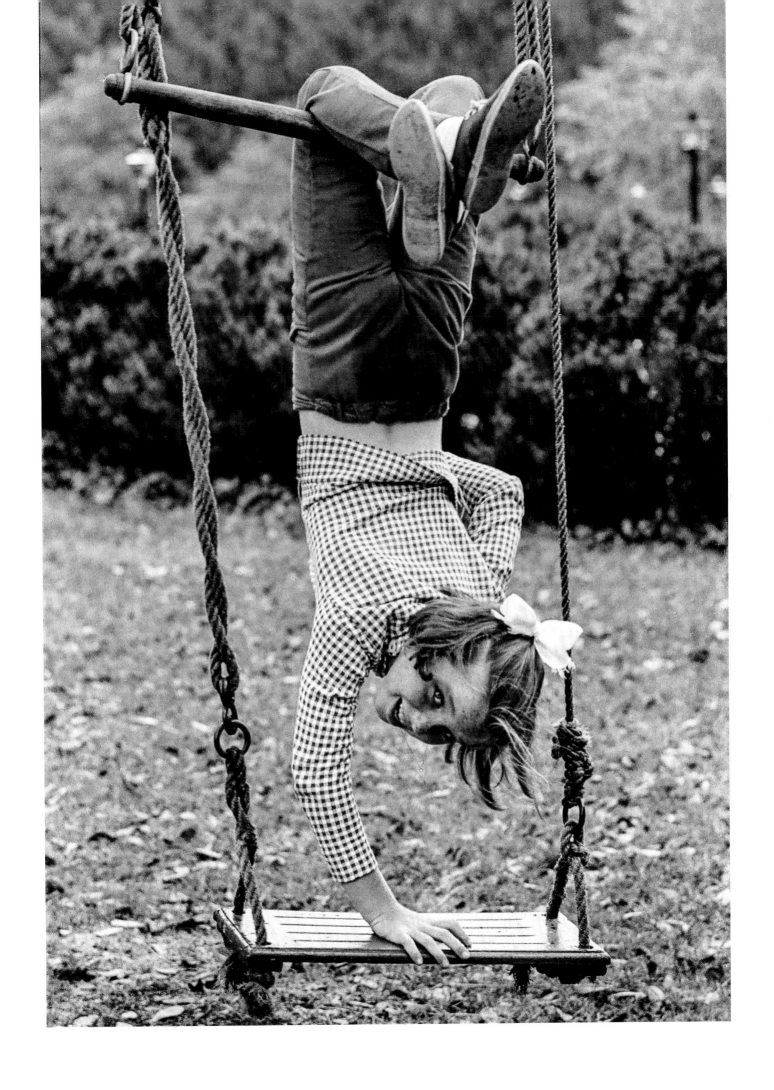

Courtney Kennedy, McLean, Virginia, 1965.

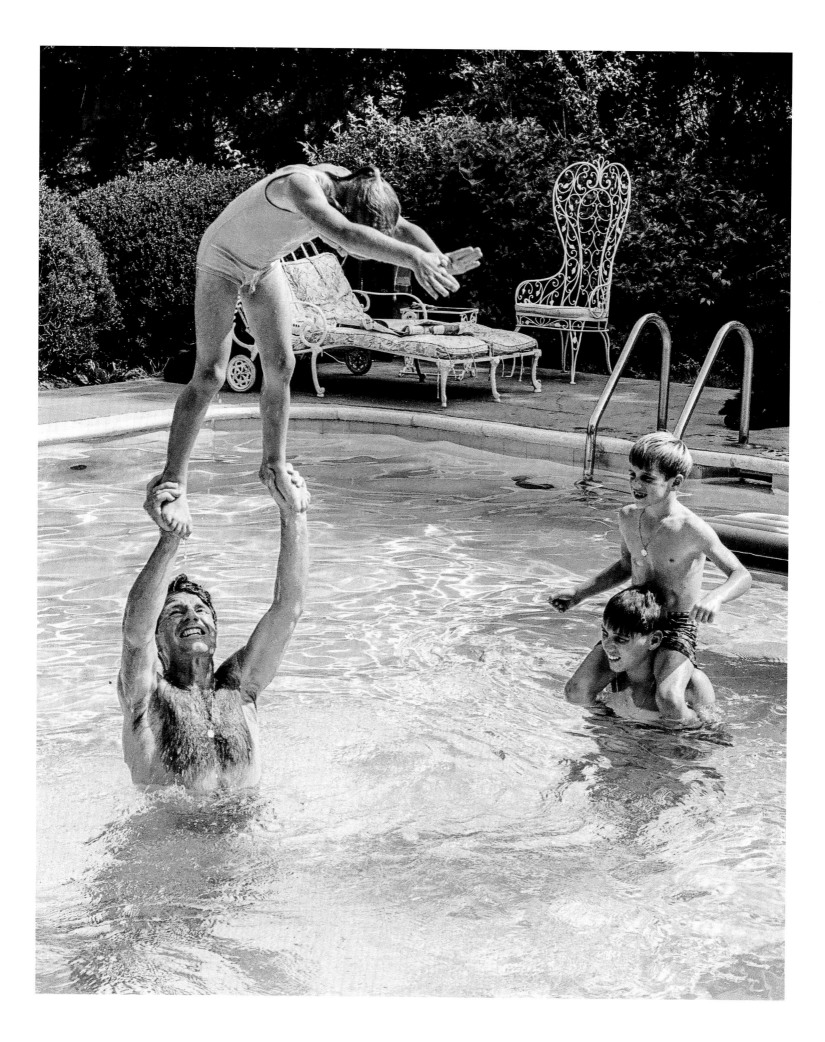

Robert F. Kennedy frolicking with children,
McLean, Virginia, 1964.

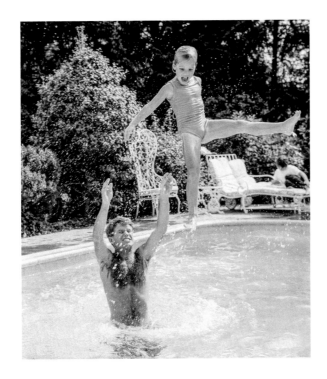

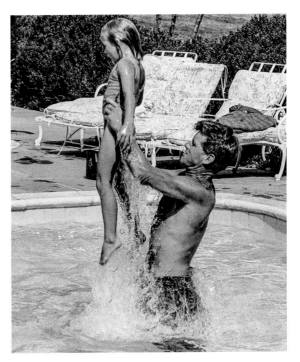

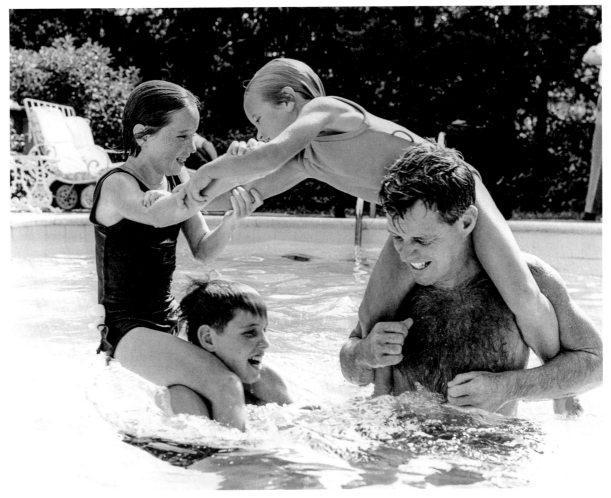

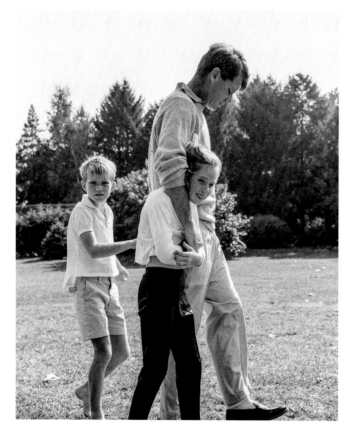

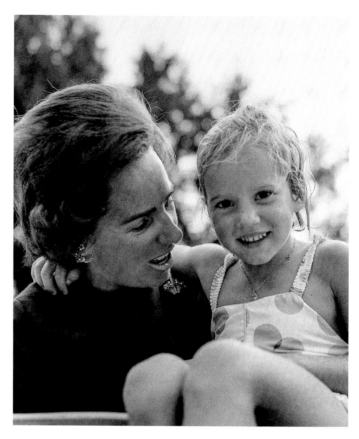

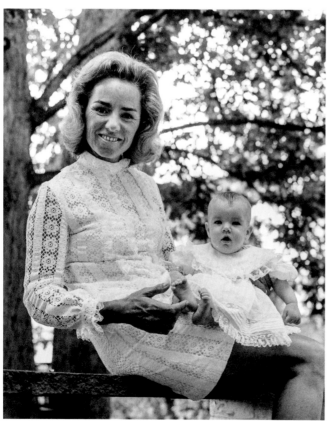

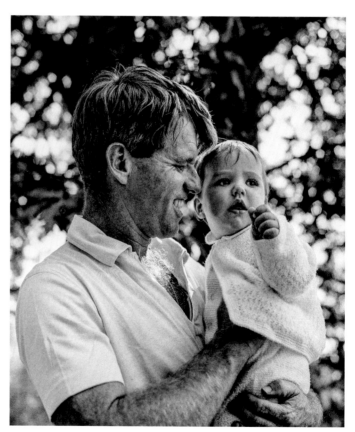

Above right: Ethel Kennedy and daughter Kerry, McLean, Virginia, 1964.

Below right: Robert F. Kennedy and son Christopher, McLean, Virginia, 1965.

Above left: Robert F. Kennedy with children David and Courtney, McLean, Virginia, 1965.

Facing: Robert Jr. and Kathleen Kennedy, McLean, Virginia, 1965.

Below left: Ethel Kennedy with son Matthew, McLean, Virginia, 1965.

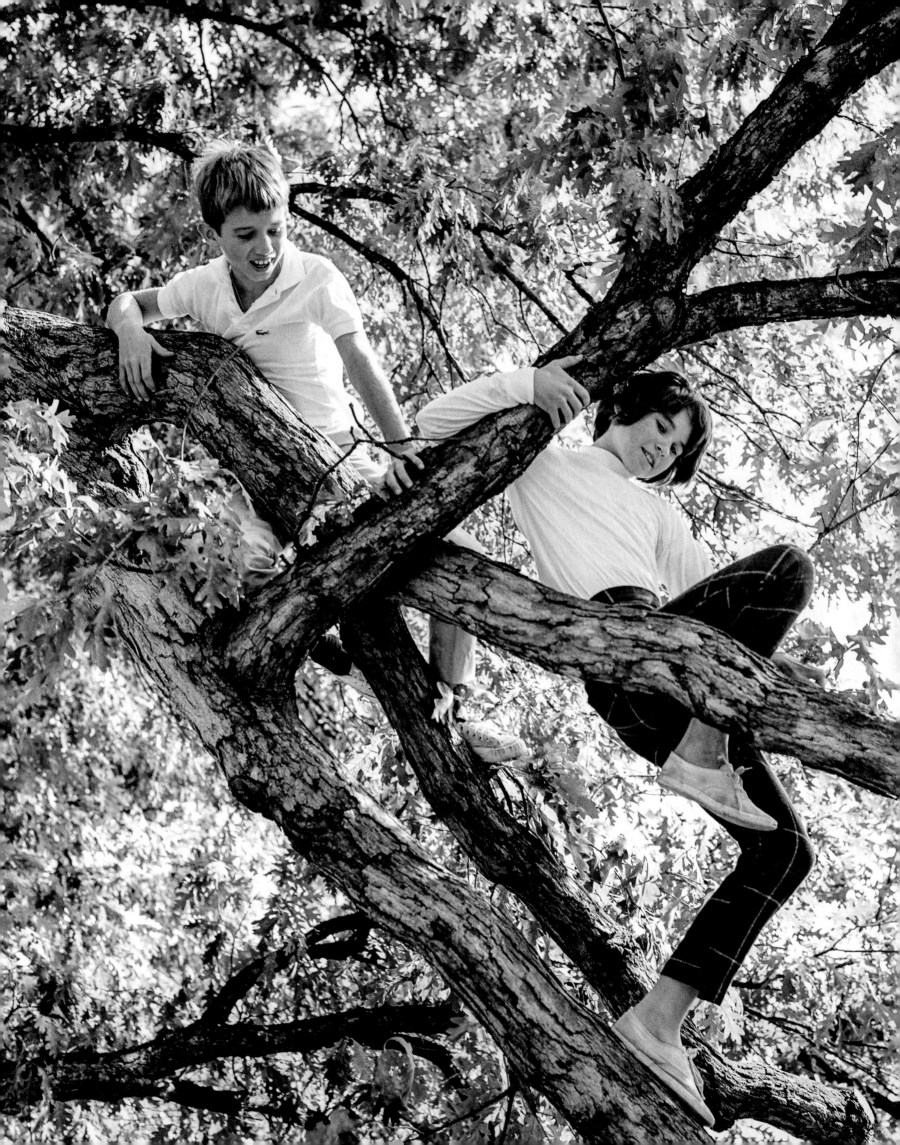

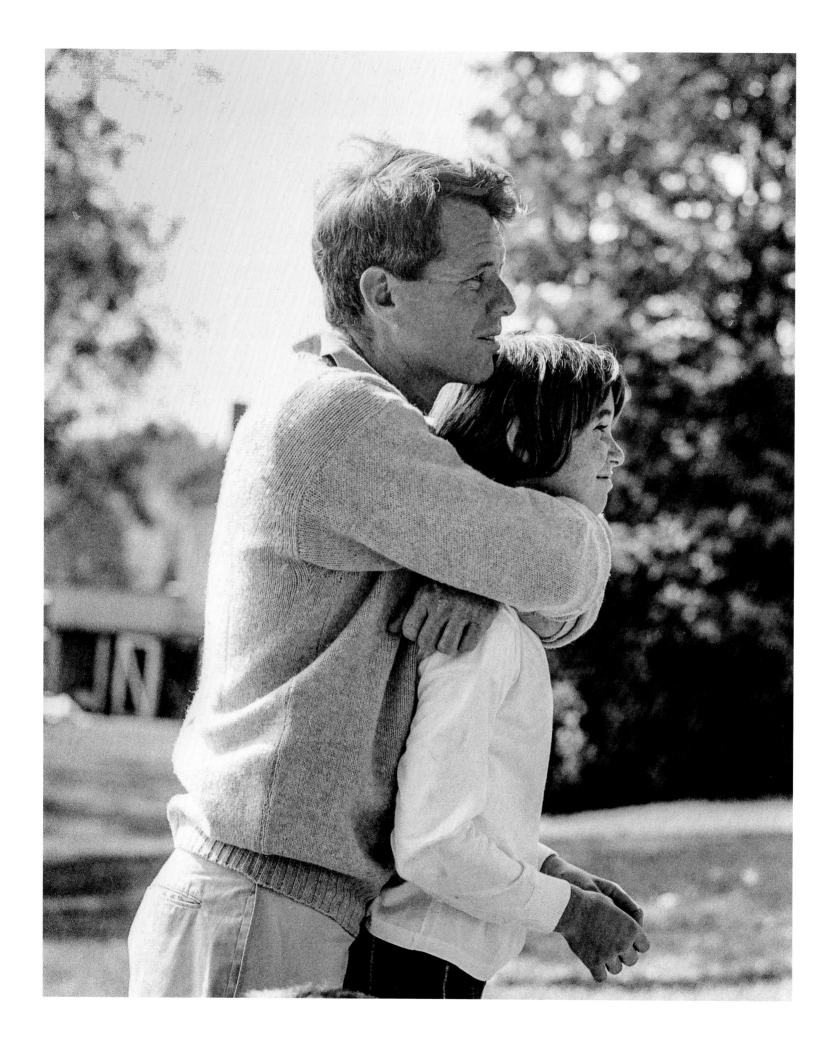

Robert F. Kennedy and daughter Kathleen, McLean,
Virginia, 1965.

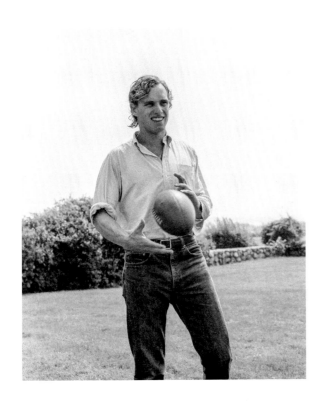

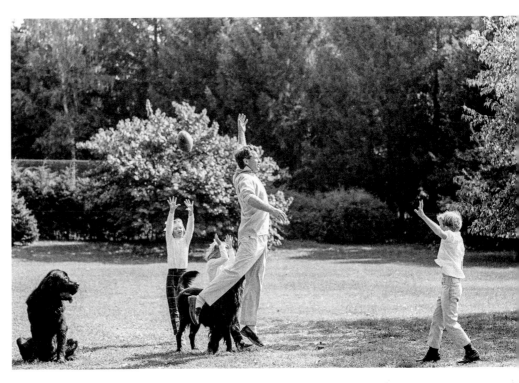

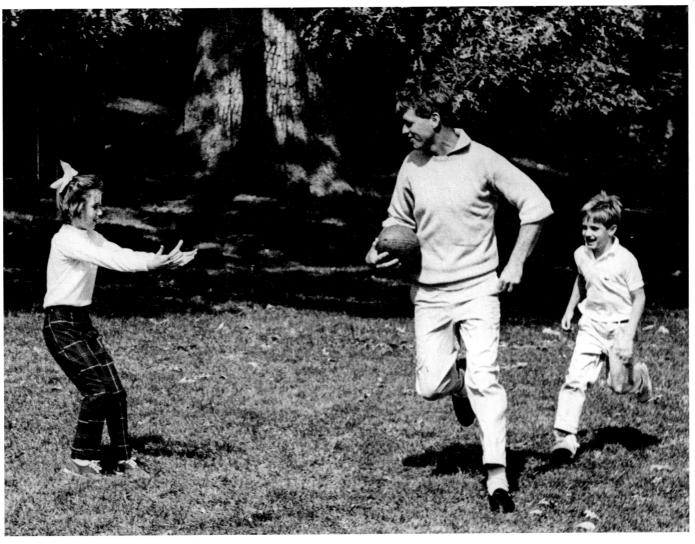

Top left: Joseph P. Kennedy II, McLean, Virginia, 1973.

Top right and bottom: Robert F. Kennedy family touch football game, McLean, Virginia, 1965.

144 Robert F. Kennedy children, McLean, Virginia, 1968.

Joseph P. Kennedy II and guests at a Fresh Air Fund
event at Hickory Hill, McLean, Virginia, 1973.

Robert F. Kennedy and daughter Kathleen, McLean,
Virginia, 1967.

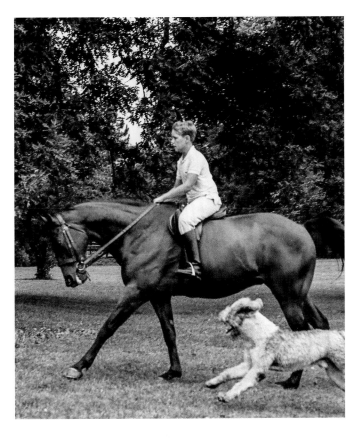

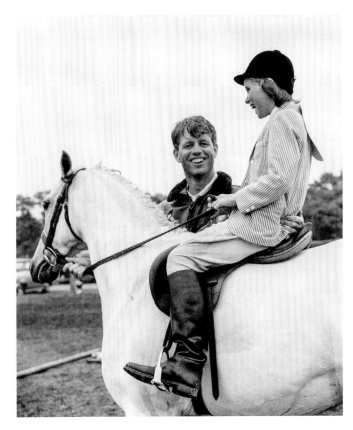

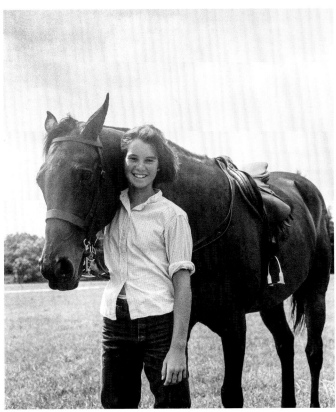

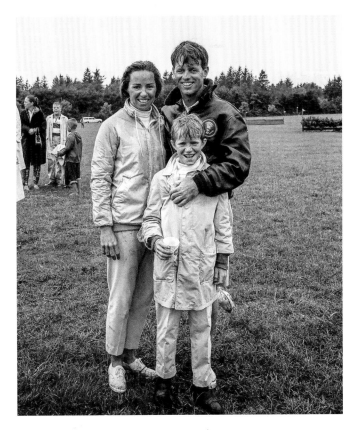

Robert F. Kennedy children at various equestrian
events, McLean, Virginia, 1967.

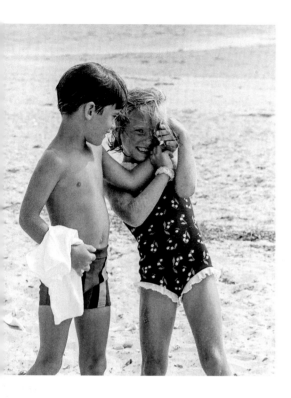 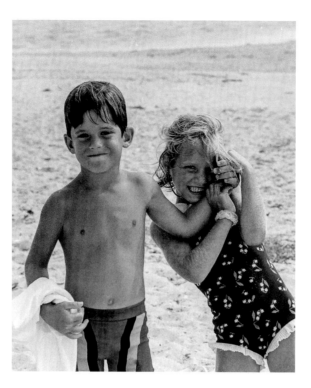

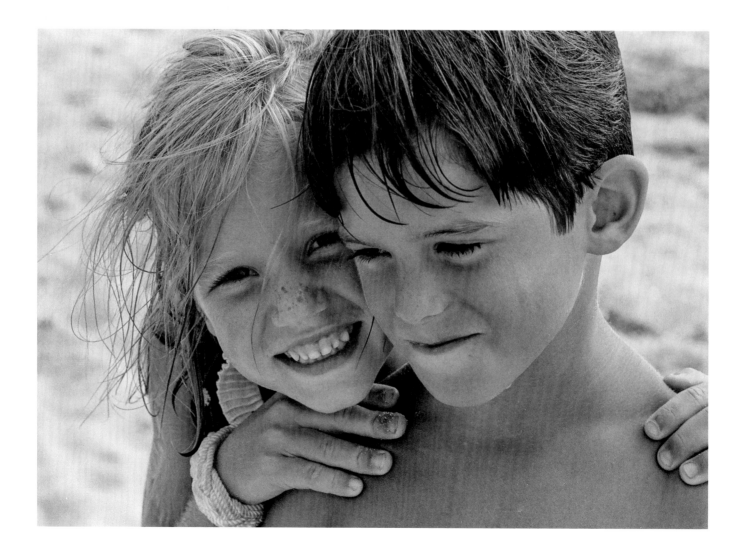

Robert F. Kennedy children, Hyannisport, Massachusetts, 1964.

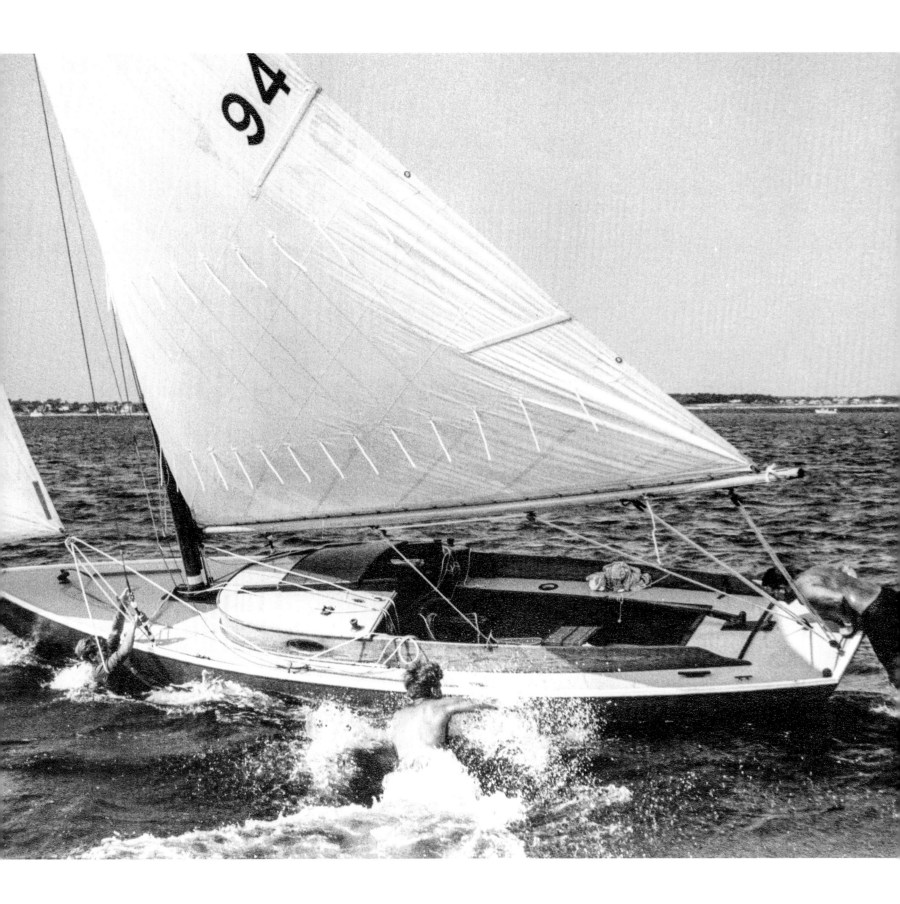

Hyannisport, Massachusetts, 1964.

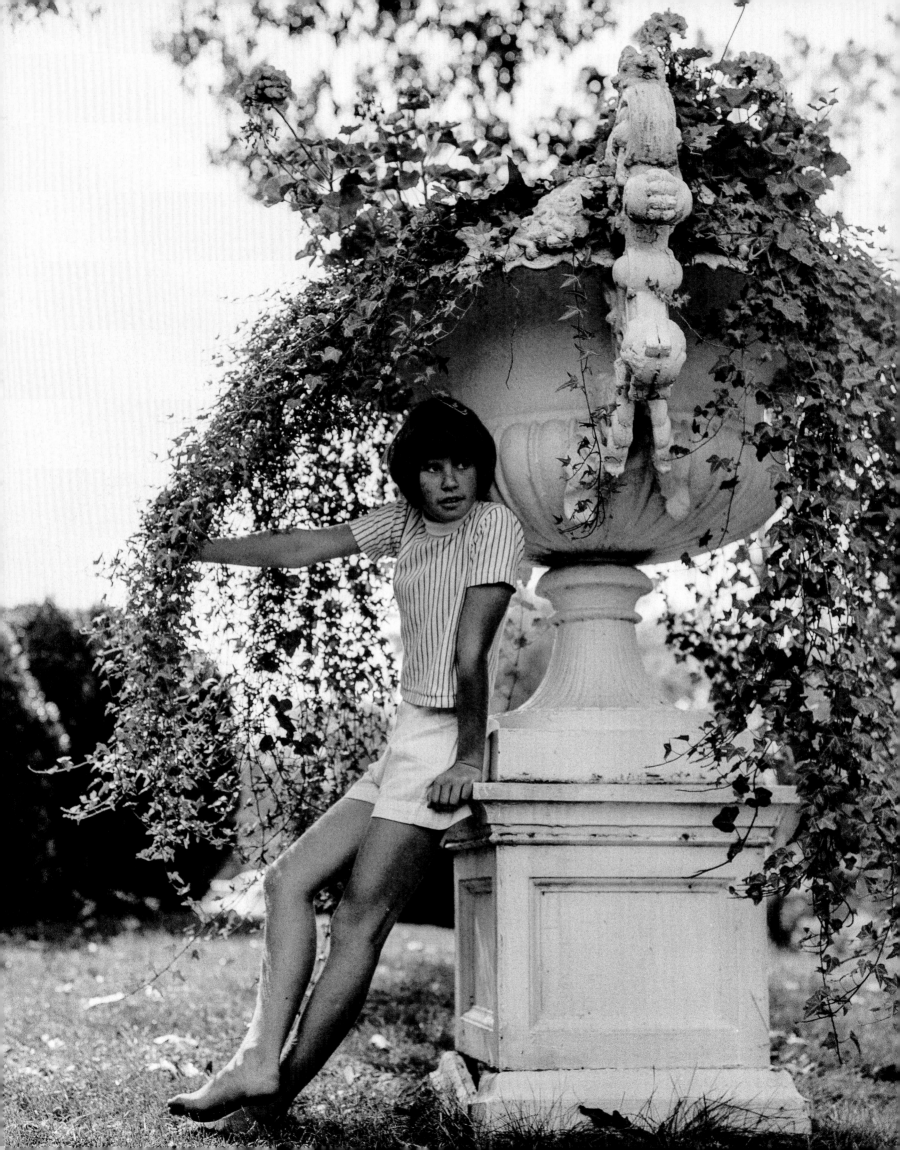

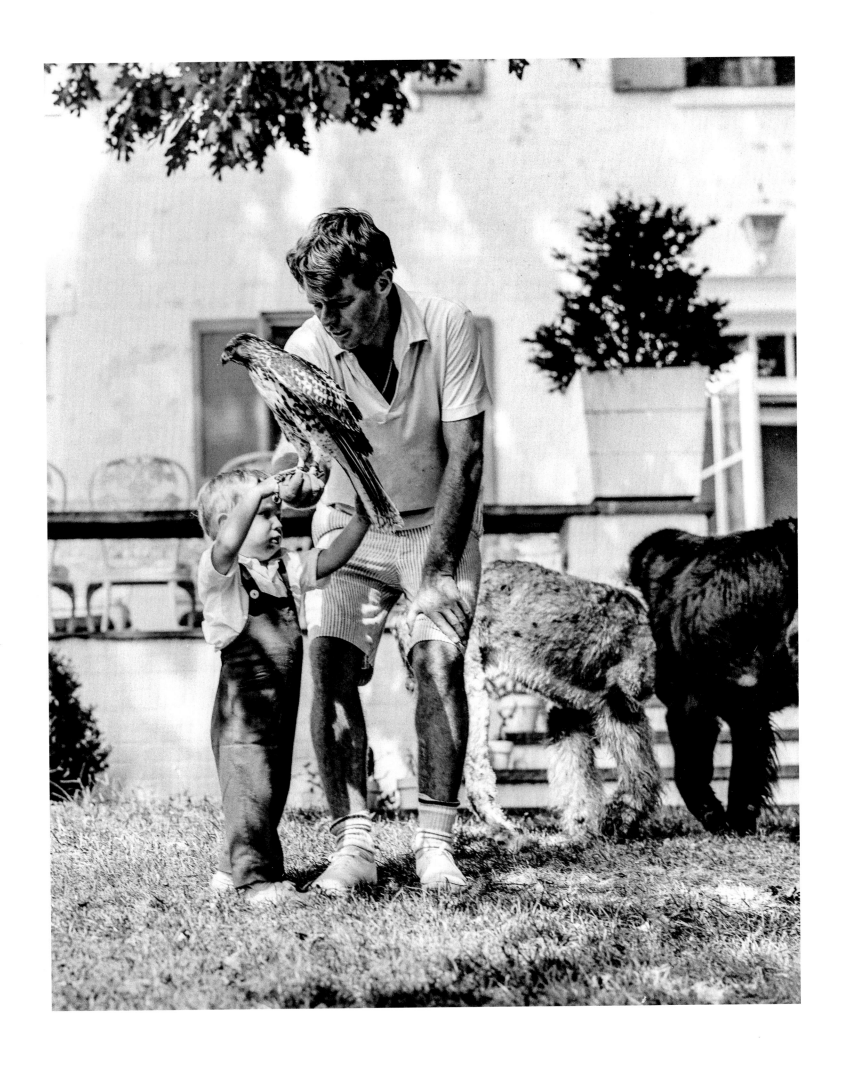

Facing: Kathleen Kennedy, McLean, Virginia, 1966.

Robert F. Kennedy and son Christopher, McLean, Virginia, 1966.

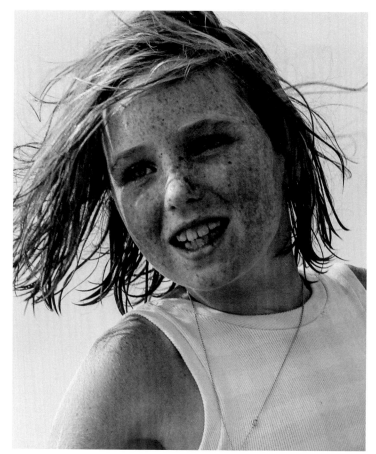

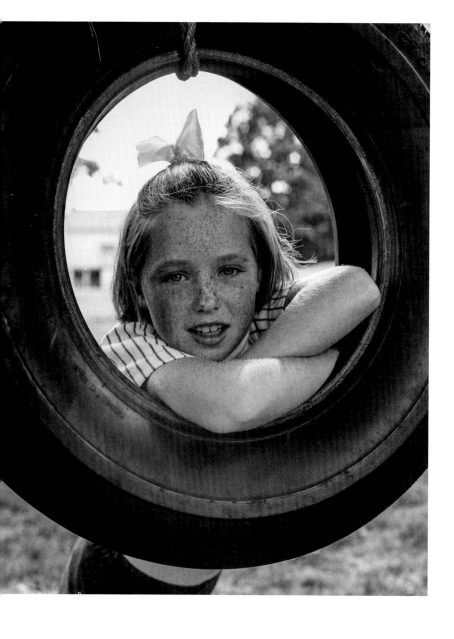

152 Courtney Kennedy, McLean, Virginia, 1966. Courtney Kennedy, Hyannisport, Massachusetts, 1968.

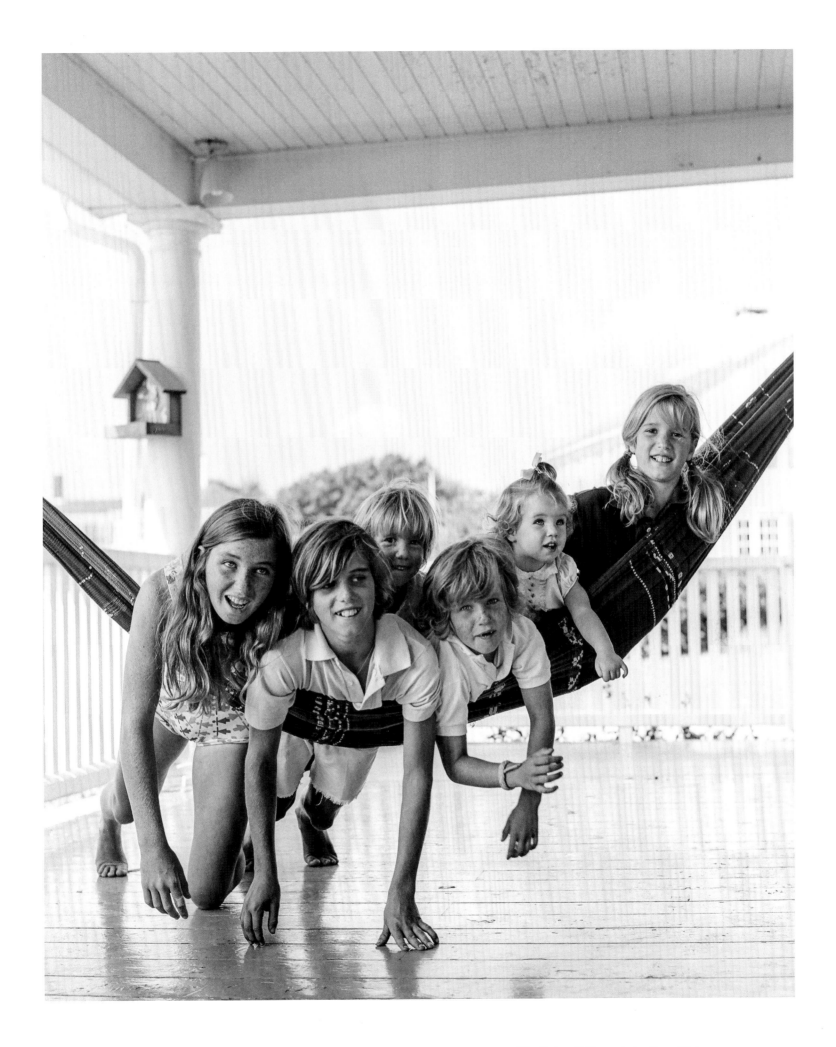

Robert F. Kennedy children, Hyannisport, Massachusetts, 1969.

Overleaf: The Robert F. Kennedy family at Hickory Hill, McLean, Virginia, 1964.

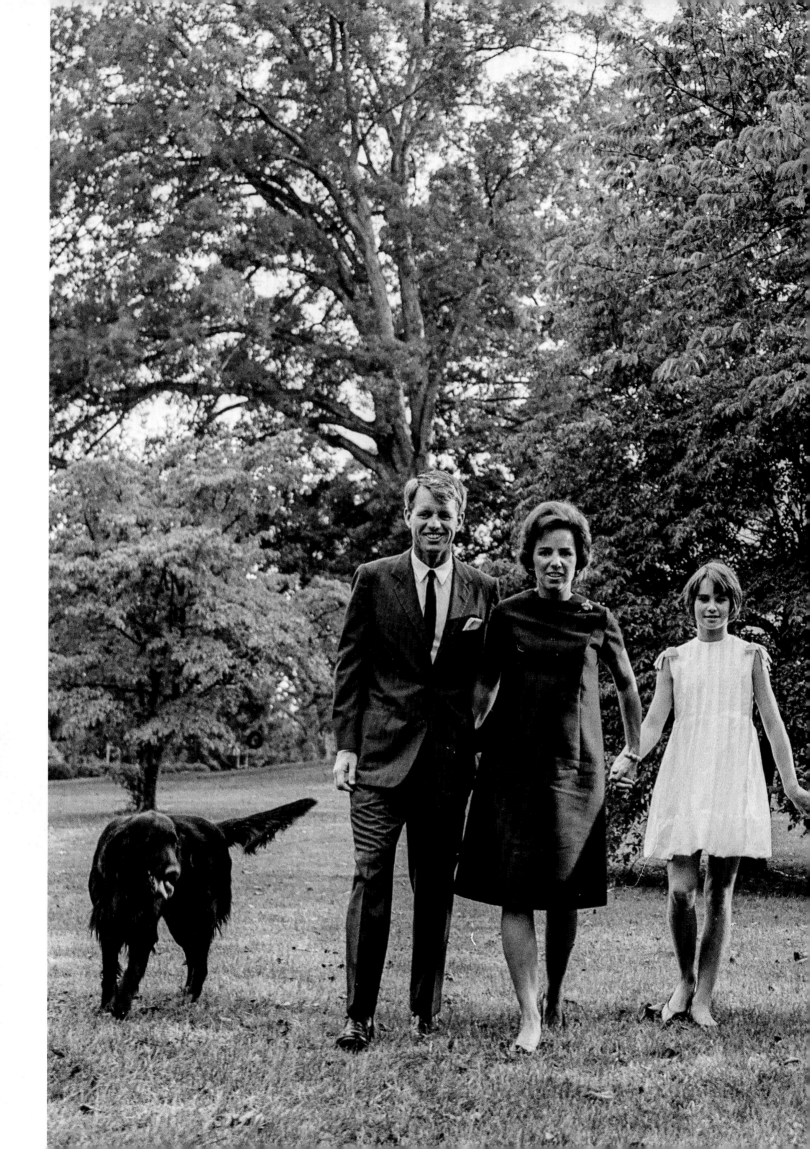

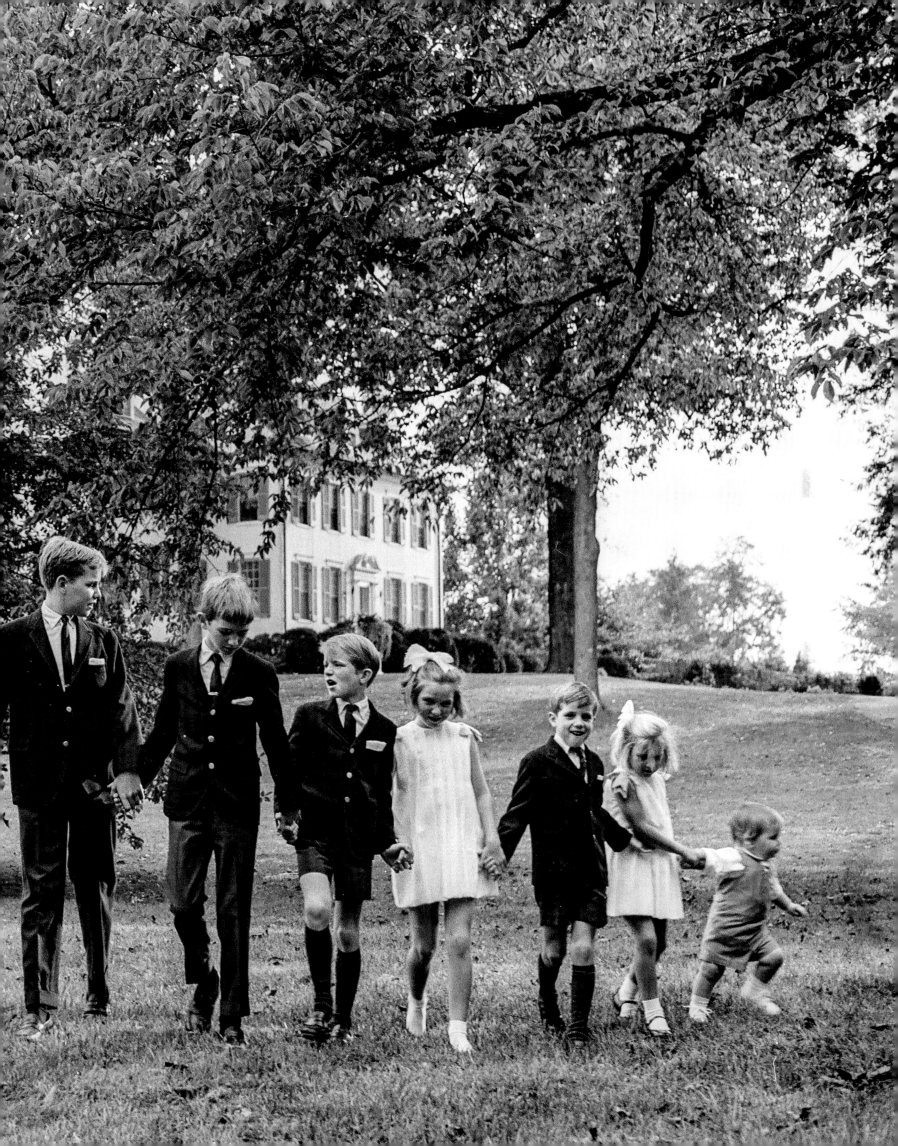

KINNEY FAMILY

Wealthy enclaves like Lake Forest, Illinois, are rife with family histories like the Kinneys'. Douglas Kinney, a Lake Forest native, met and married Martha "Marty" Snowden of Pittsburgh in 1954. After graduating from Harvard Business School, the Kinneys returned to Lake Forest and had seven children together. The marriage ended and Marty remarried William Rentschler, with whom she had another child. After that marriage ended, she moved to California to be closer to some of her children, who had relocated to the Bay Area. There, she reconnected with her first husband's Harvard classmate and friend Mike North, and married him in 2004. They enjoyed a happy life in Belvedere, California, until her death in 2018.

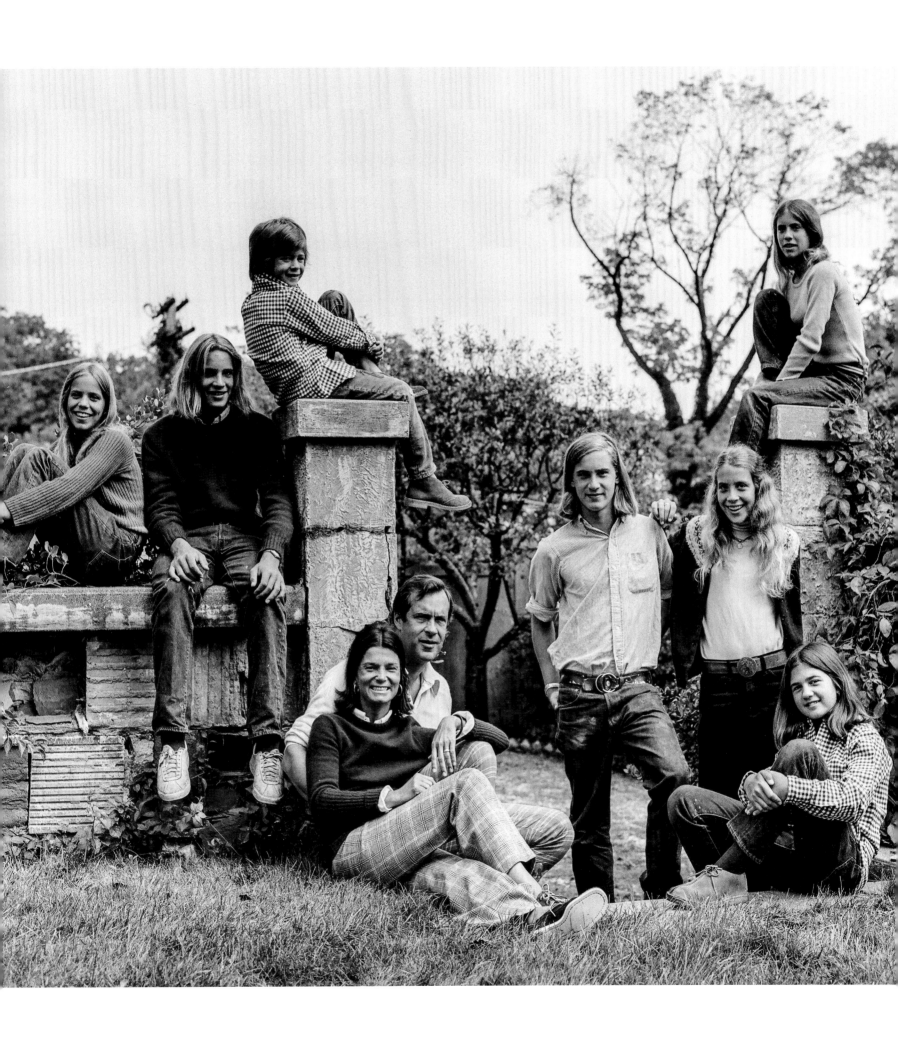

Martha and Douglas Kinney and children Elizabeth,
Ted, John, Doug, Martha, Hilary and Lisa, Lake
Forest, Illinois, 1973.

LANDA FAMILY

Successful Washington, DC, lawyer and corporate raider, Alfonso Howard Beaumont Landa collected many beautiful things. When he decided to downsize, the contents of his Palm Beach house were featured with great fanfare at a Sotheby's auction that attracted attendees with names like Kennedy and Annenberg. He even appeared on the cover of *Time Magazine* in 1958 as "The Proxy King," in an exposé of the expanding world of corporate takeovers.

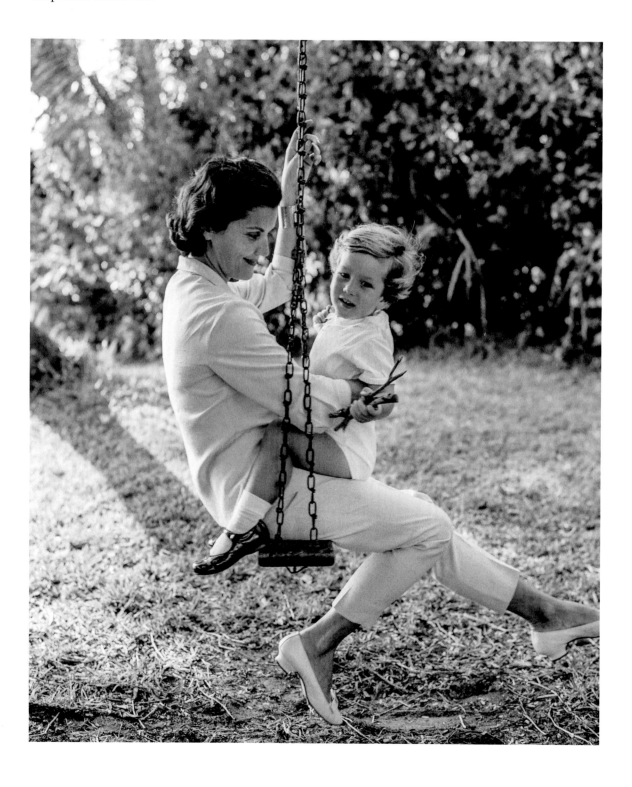

Mrs. Alfonso (Alexandra) Landa and son, Alfonso Jr., Palm Beach, Florida, 1963.

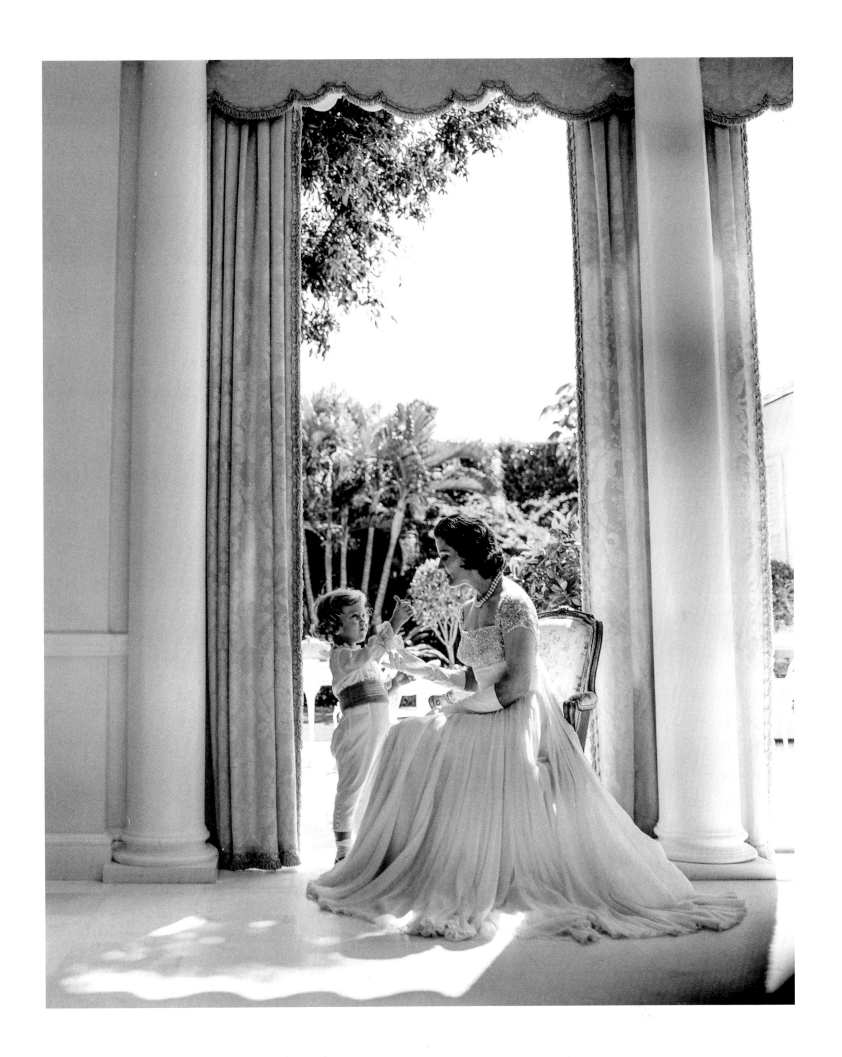

Alexandra Landa and son, Alfonso Jr., Palm Beach,
Florida, 1962.

LAUDER FAMILY

Even as a young woman growing up in Elmhurst, Queens, Estée Lauder (née Mentzer) took a keen interest in skin care, assisting her chemist uncle with his business of developing and marketing beauty products. Recognizing a captive audience at her own beauty parlor, she would do demonstrations and ultimately convinced the salon owner to sell her face creams. The rest is history. With husband Joseph, their sons, wives and grandchildren, the Lauders became and still are the world's most respected name in beauty, both inner and outer. Evelyn Lauder, the late wife of oldest son Leonard, founded the Breast Cancer Research Foundation, which has impacted and saved millions of lives, while granddaughter Aerin continues to expand the brand's reach. Indeed, beauty is as beauty does, as the extraordinary contributions of the Lauder family to the arts and medical research are unmatched in their impact, breadth and compassion.

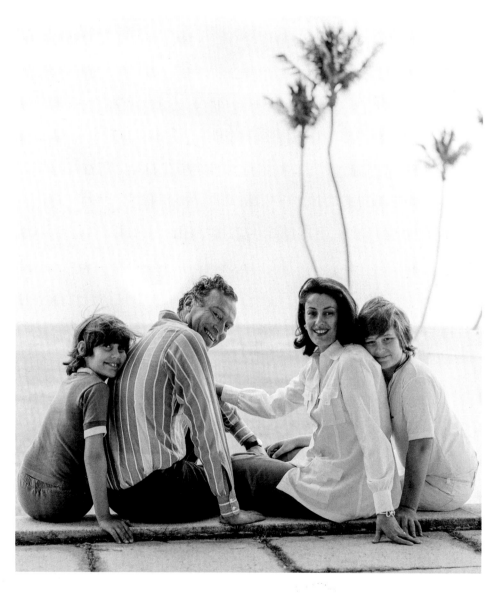

Above: Leonard and Evelyn Lauder with children Gary and William, Palm Beach, Florida, 1973.

Facing: Leonard and Estée Lauder with their two sons, Ronald and Leonard, their wives, Jo Carole and Evelyn, and their grandchildren, William, Aerin and Gary.

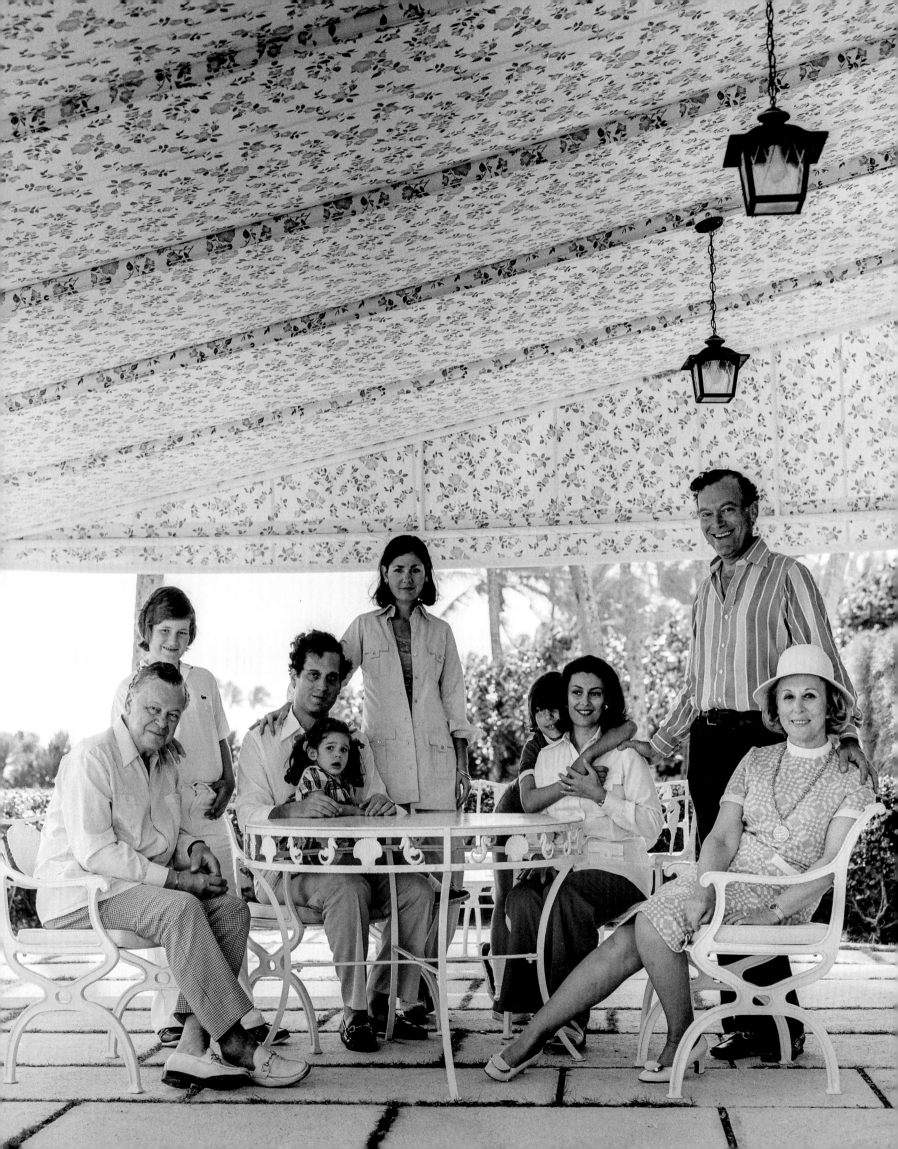

Betty perfectly captured the spirit of my family and our family traditions in Palm Beach. This is one of my favorite family portraits and I will forever hold it close to my heart.

Aerin Lauder

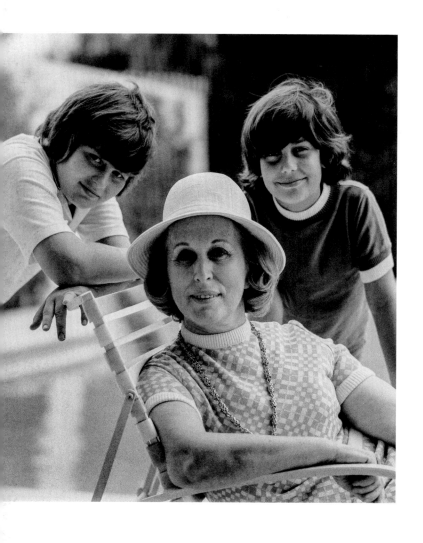

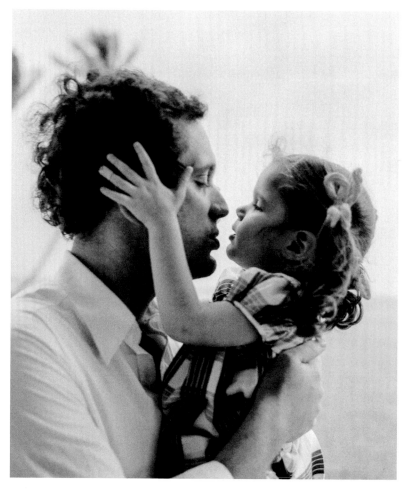

Estée Lauder with her grandsons, Palm Beach, Florida, 1973.

Ronald Lauder with daughter Aerin, Palm Beach, Florida, 1973.

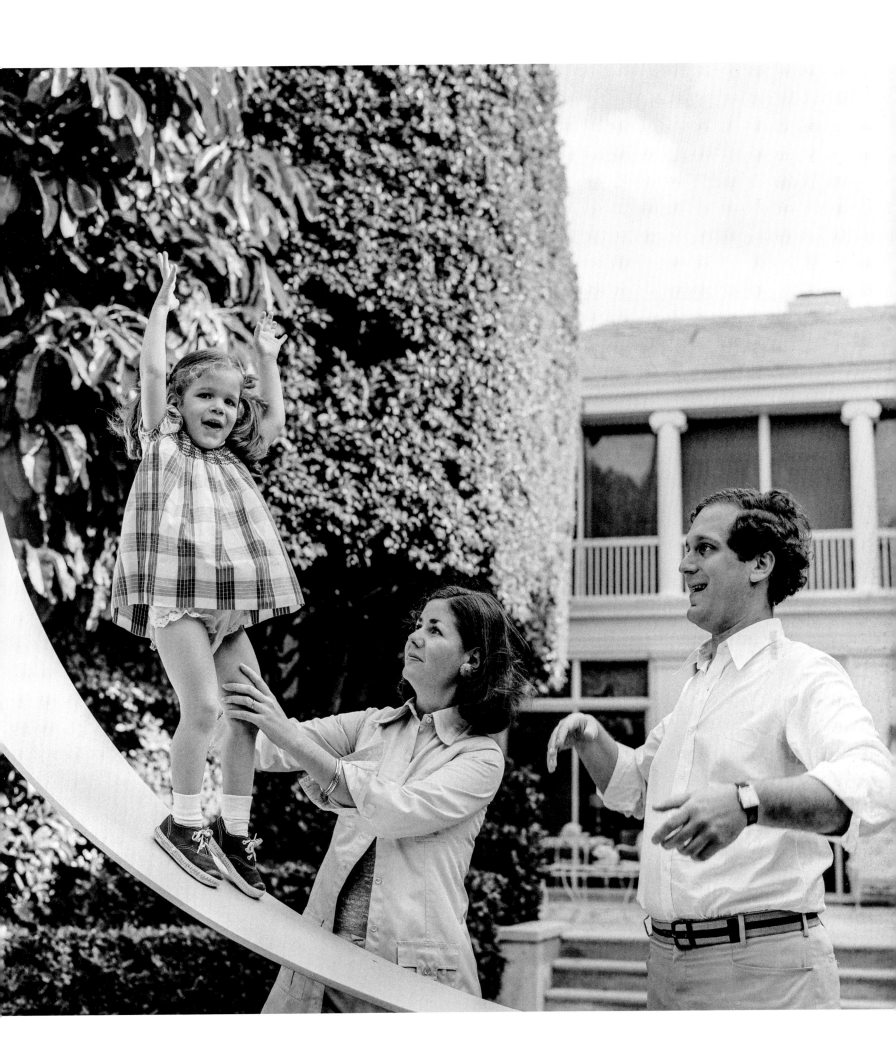

Jo Carole and Ronald Lauder with their daughter,
Aerin, Palm Beach, Florida, 1973.

LAWFORD FAMILY

The marriage of Patricia Kennedy, sister of the late president, to English actor Peter Lawford in 1954 only magnified her fame. All four of the couple's children were born in Santa Monica, California, and their life was integrated with the celebrities of the day. After the couple's divorce in 1966, Pat Lawford moved her family to New York, where they lived in Southampton's estate section.

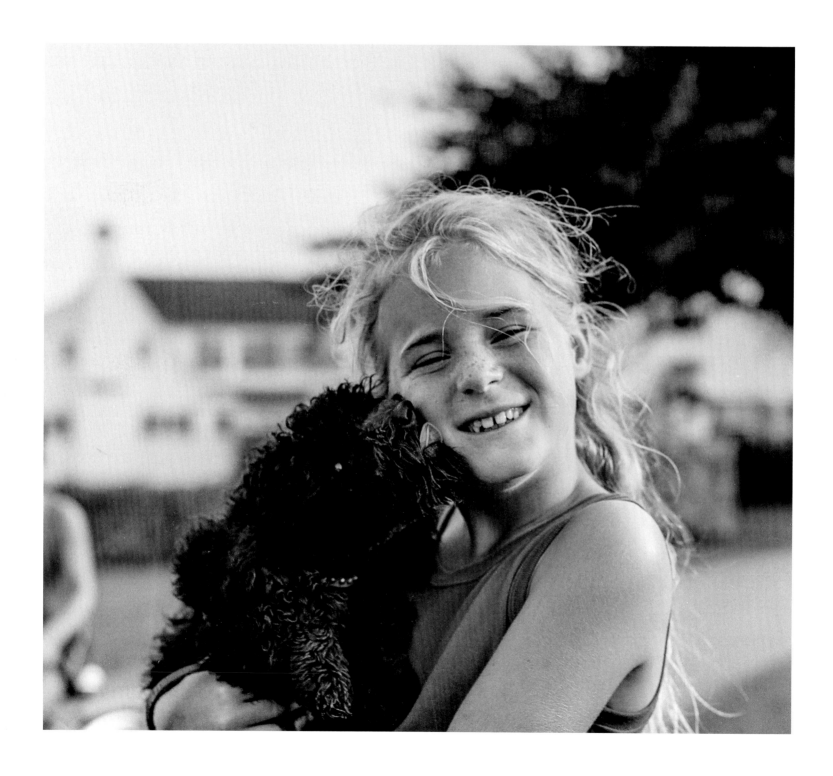

Sydney Kennedy Lawford, Hyannisport, Massachusetts, 1964.

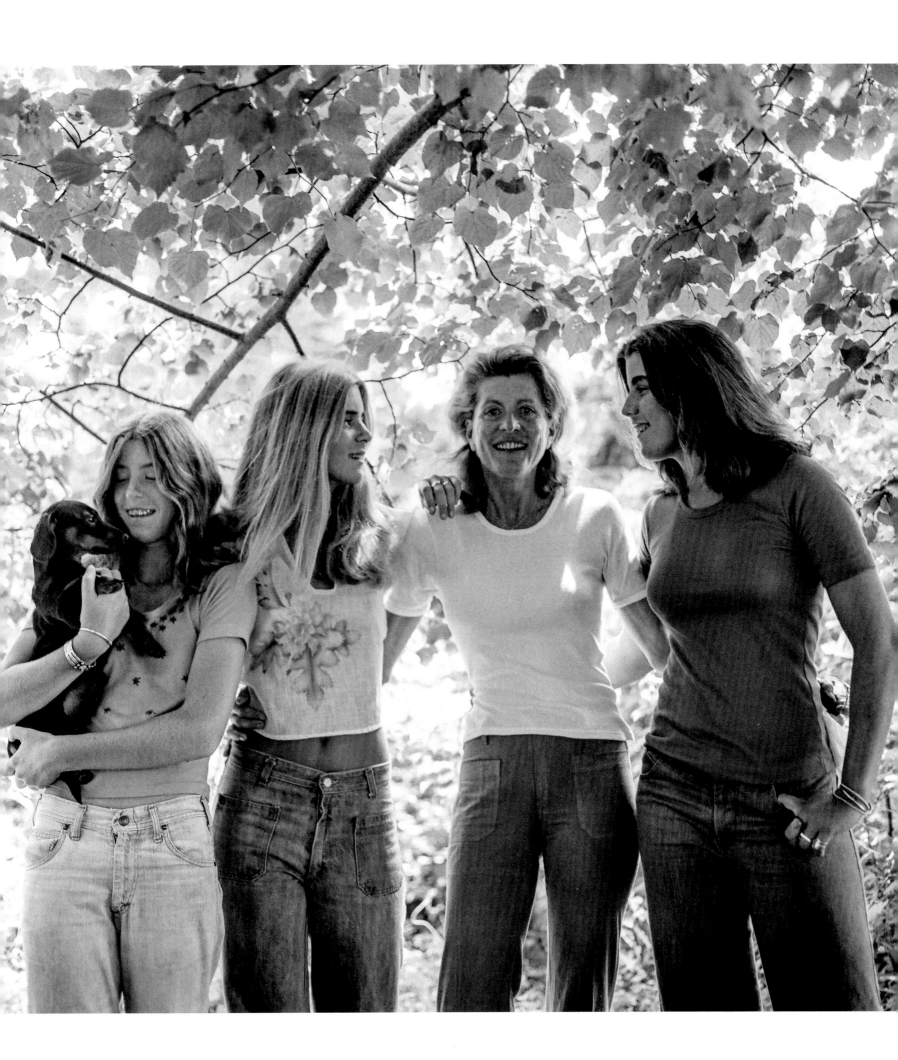

Patricia Kennedy Lawford with daughters Robin, Sydney
and Victoria, Southampton, New York, 1975.

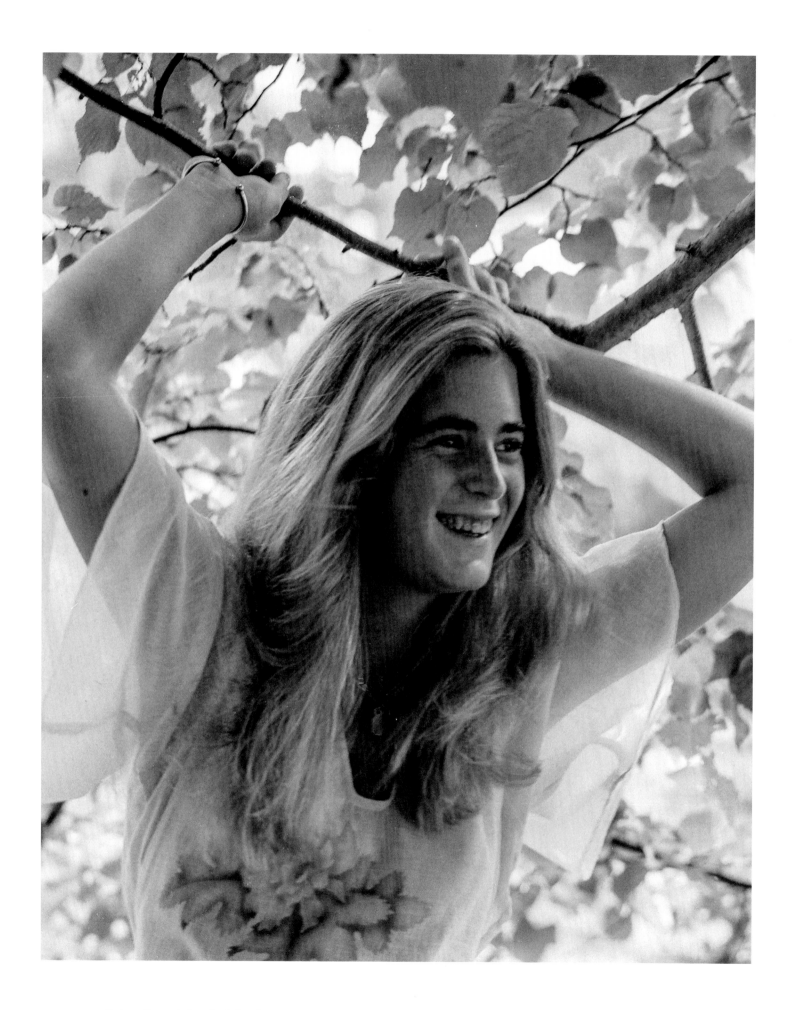

Sydney Kennedy Lawford, Southampton,
New York, 1975.

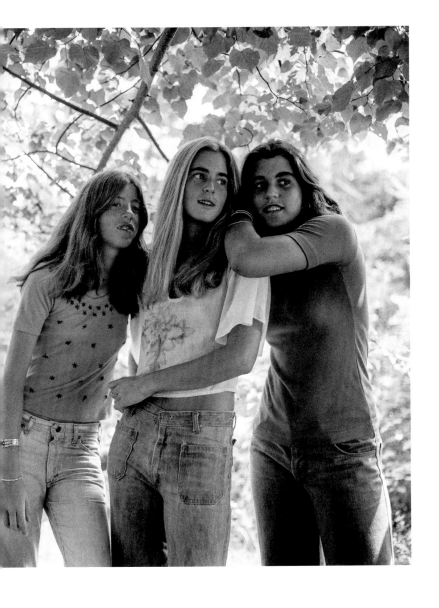

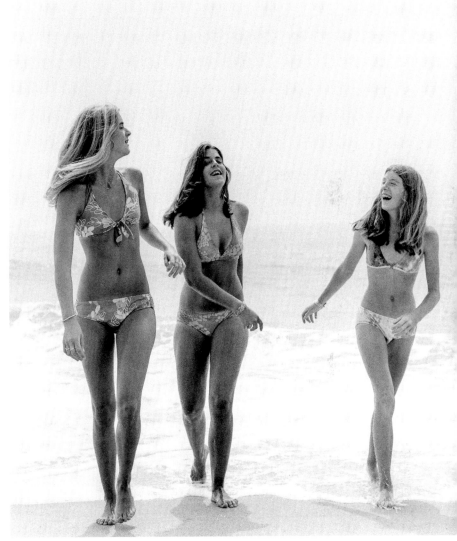

The Lawford girls, Southampton, New York, 1975.

Sydney, Victoria and Robin Lawford, Southampton,
New York, 1975.

LUFKIN FAMILY

Legendary financier, equestrian and environmentalist Dan Lufkin and his first wife, Elise, had four daughters, whom they raised between homes in Manhattan, Southampton and a sprawling farm in Fairfield County, Connecticut.

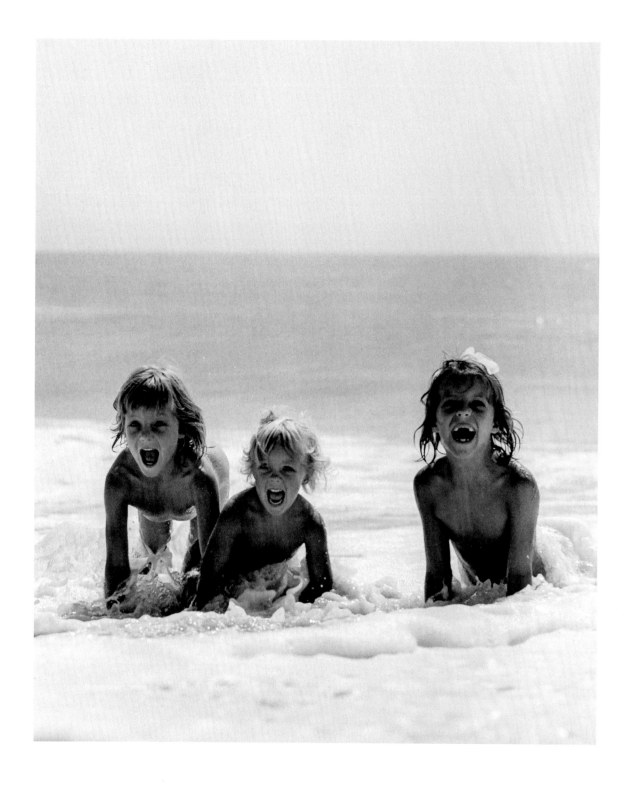

Elise, Margaret and Alison Lufkin, Southampton,
New York, 1970.

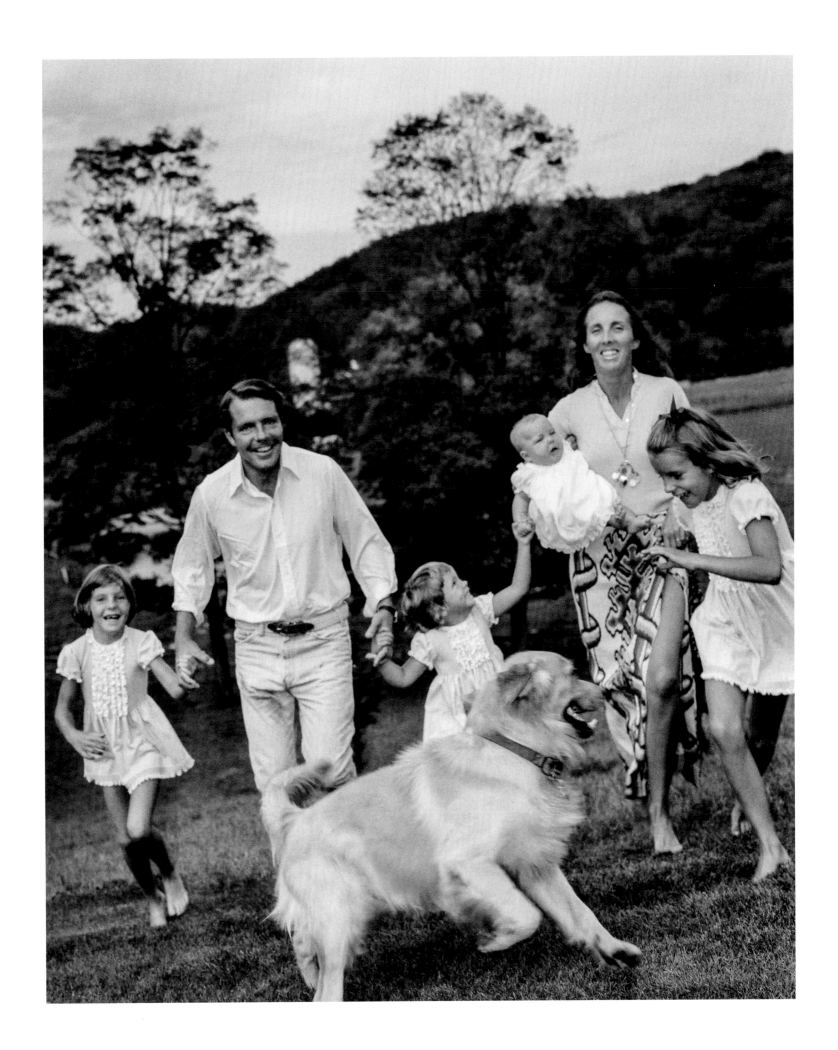

Dan and Elise Lufkin with daughters Margaret, Alison,
Abigail and Elise, Newtown, Connecticut, 1971.

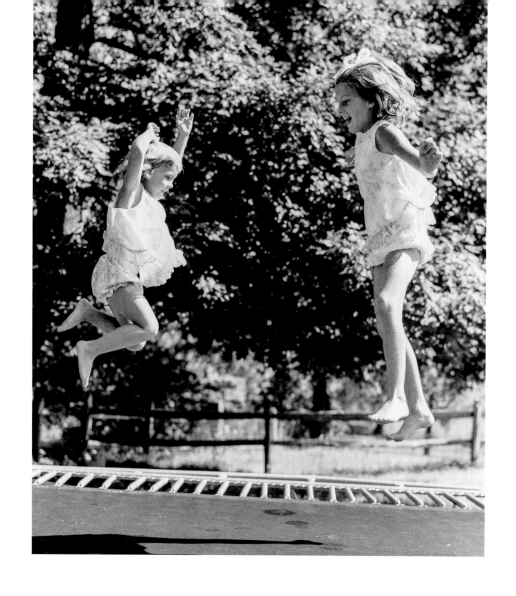

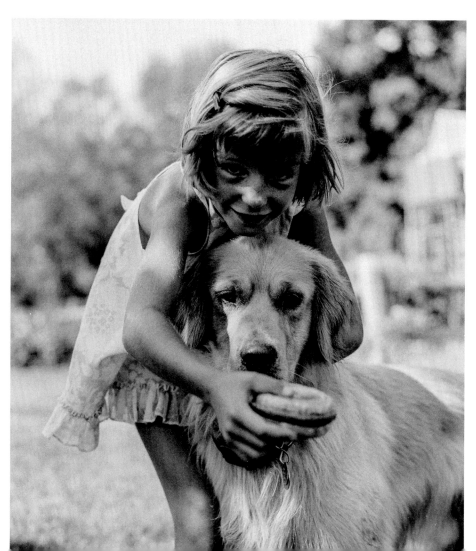

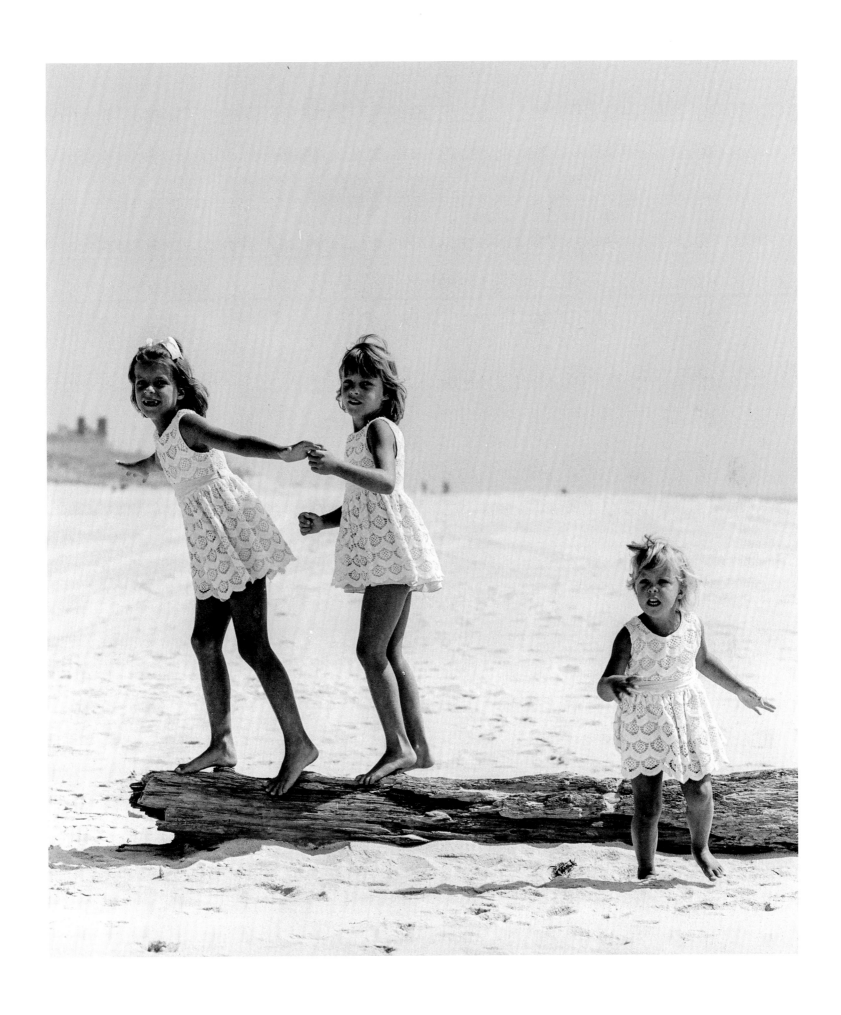

Facing above: Alison and Elise Lufkin, Newtown, Connecticut, 1971.

Facing below: Margaret Lufkin, Newtown, Connecticut, 1971.

Elise, Margaret and Alison Lufkin, Southampton, New York, 1970.

MATTHEWS FAMILY

The Matthews family descends directly from Palm Beach's founder, Henry Morrison Flagler. An early partner in Standard Oil, Flagler truly established Palm Beach as the premier American resort town by not only building a railroad to transport the rich and famous to his sub-tropical getaway, but by building spectacular hotels (only the iconic Breakers remains). He also built a breathtaking beaux arts mansion, which he named "Whitehall." It was converted to a museum by granddaughter Jean Flagler Matthews. Two of her sons, George and William, and their families, remain an important part of the fabric of Palm Beach.

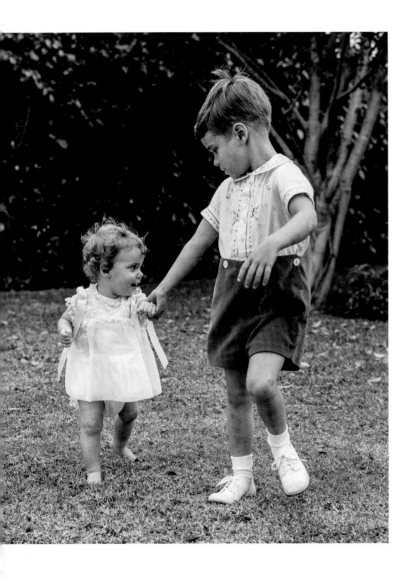

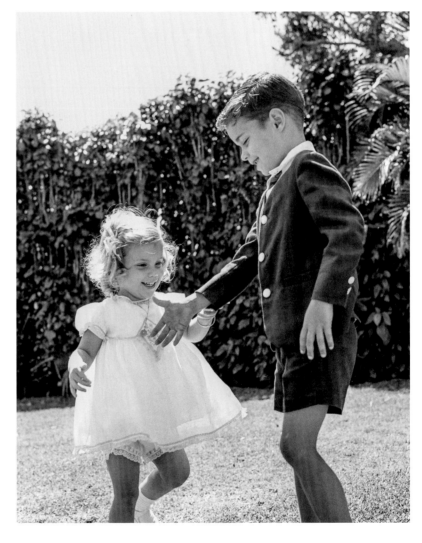

Left: Elizabeth and George Matthews Jr., Palm Beach, Florida, 1966.

Right: Elizabeth and George Matthews Jr., Palm Beach, Florida, 1967.

Facing: Betsy Matthews and son, George Jr., Palm Beach, Florida, 1964.

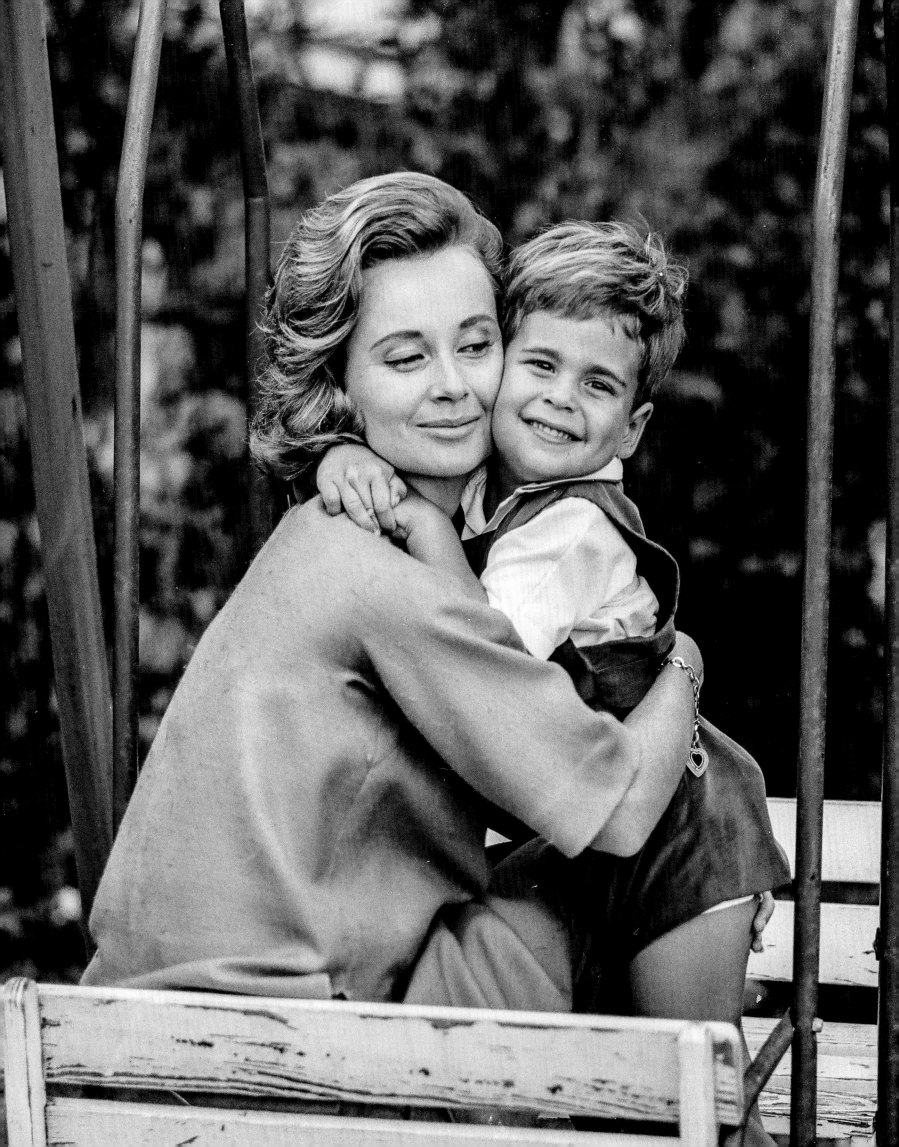

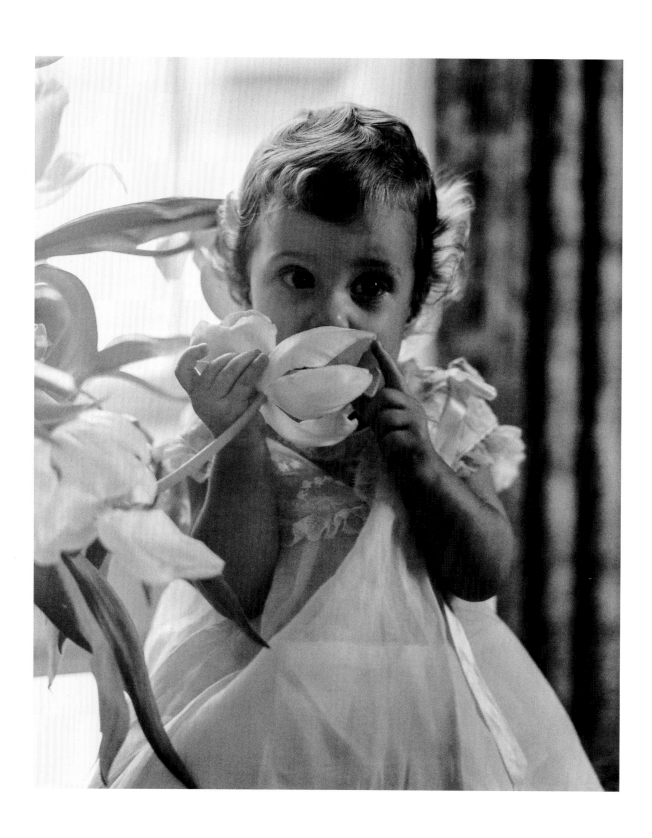

174 Elizabeth Matthews, Palm Beach, Florida, 1966.

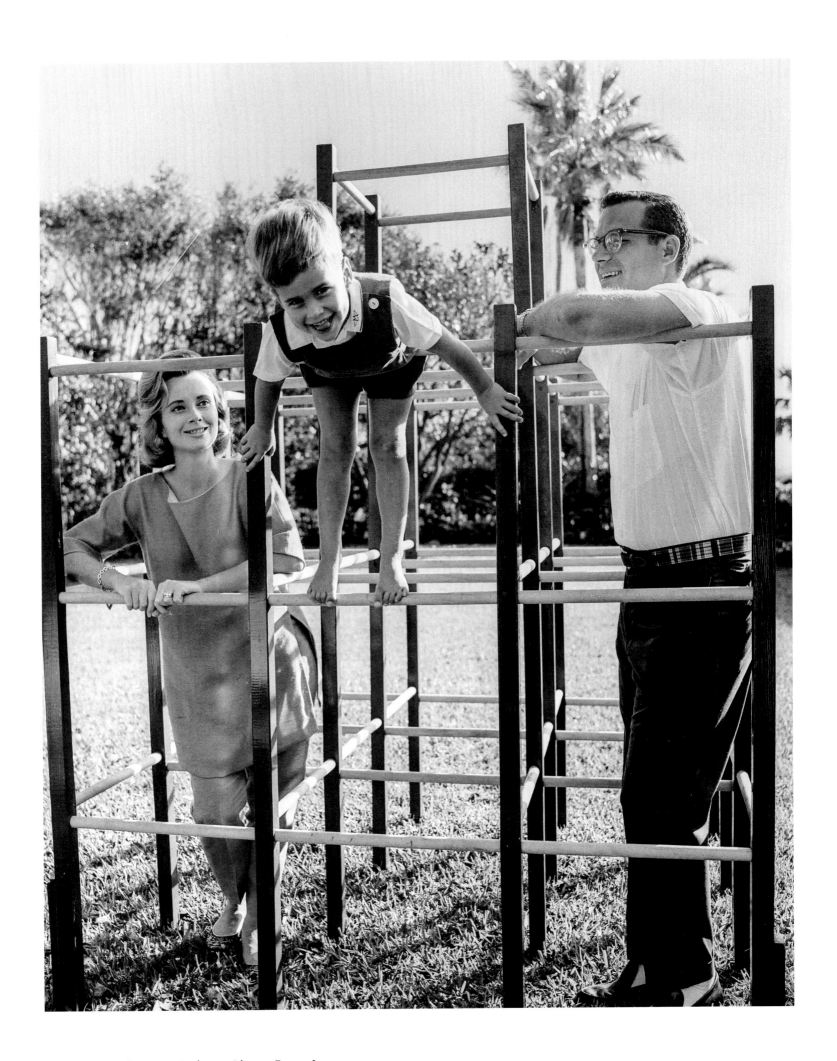

Betsy and George Matthews with son, George Jr.,
Palm Beach, Florida, 1964.

MAXEY FAMILY

Richmond, Virginia-born Talbott Bryan Maxey is the daughter of the late John Stewart Bryan III and one of Palm Beach's most beloved "great ladies," Kit Pannill, whose late husband, Bill Pannill, was president of the exclusive Everglades Club. Affectionately regarded as Palm Beach royalty, Talbott is a respected philanthropist, mother and passionate bridge player.

"I must have been eighteen or nineteen years old, and had just become a freshman in college. I wore my grandmother's earrings, and remember just doing the photo because that's what we were supposed to do. But it was really fun!"

Talbott Bryan Maxey

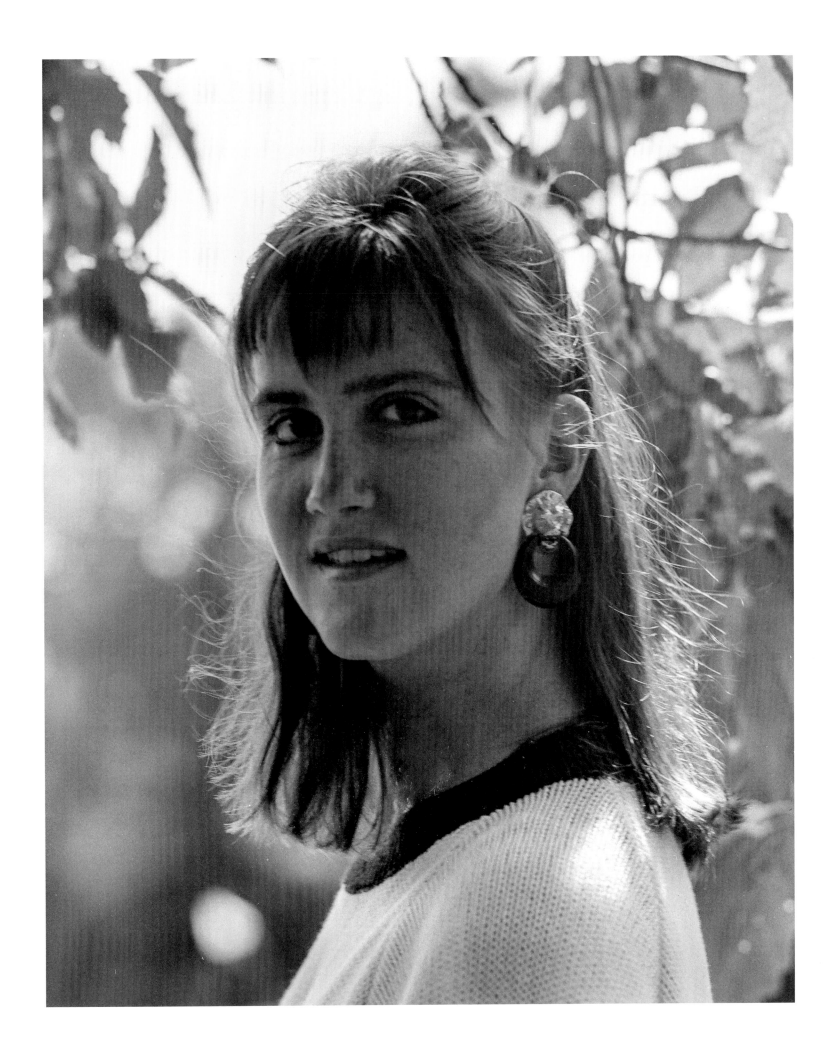

Talbott Bryan Maxey, Martinsville, Virginia, 1986.

McCONNELL FAMILY

Widow of Avon heir Neil McConnell, Sandra McConnell is a fixture on the New York and Southampton social scene, devoting much of her time, energy and substantial fortune to animal rights causes, specifically the Southampton Animal Shelter Foundation.

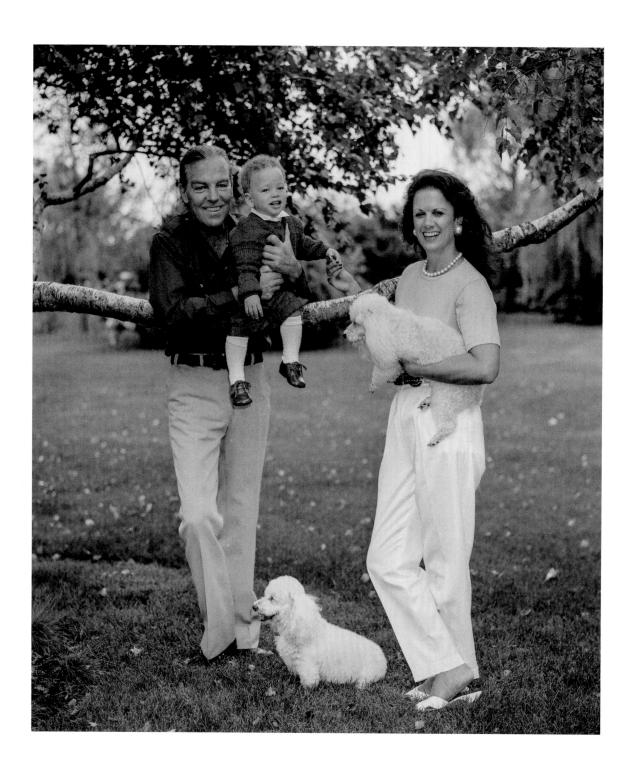

Neil and Sandra McConnell with their son, Charles,
Southampton, New York, 1990.

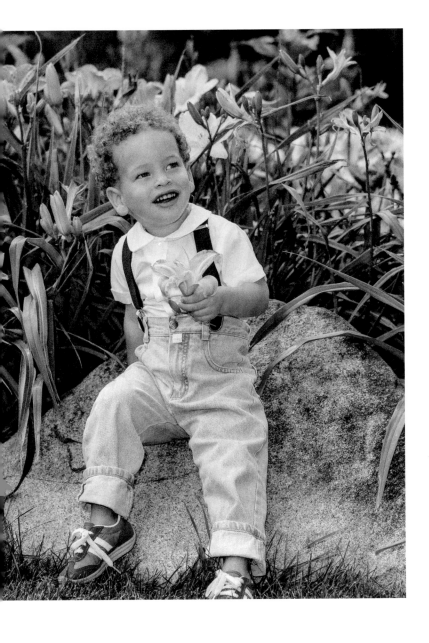

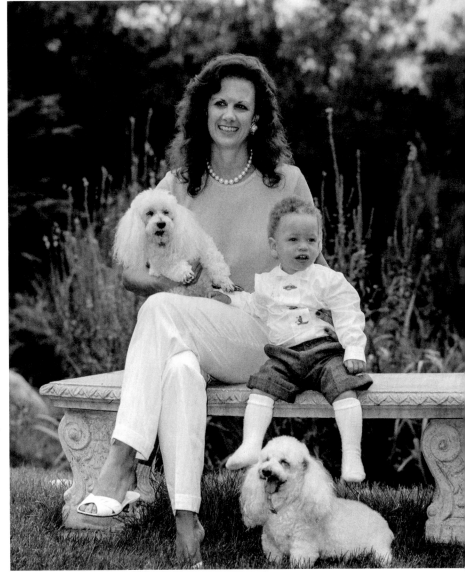

Charles McConnell, Southampton, New York, 1991.

Sandra McConnell and son Charles, Southampton, New York, 1990.

MERCK FAMILY

Established in the United States in 1891 as a subsidiary of a German company founded in 1668, the Merck & Co. as we know it was the brainchild of George W. Merck, who grew the business into the New Jersey–based global pharmaceuticals powerhouse that it is today. Descendant George "Laddie" Merck and his wife, Dede, a lay minister, are as much a part of the fabric of Palm Beach as the palms.

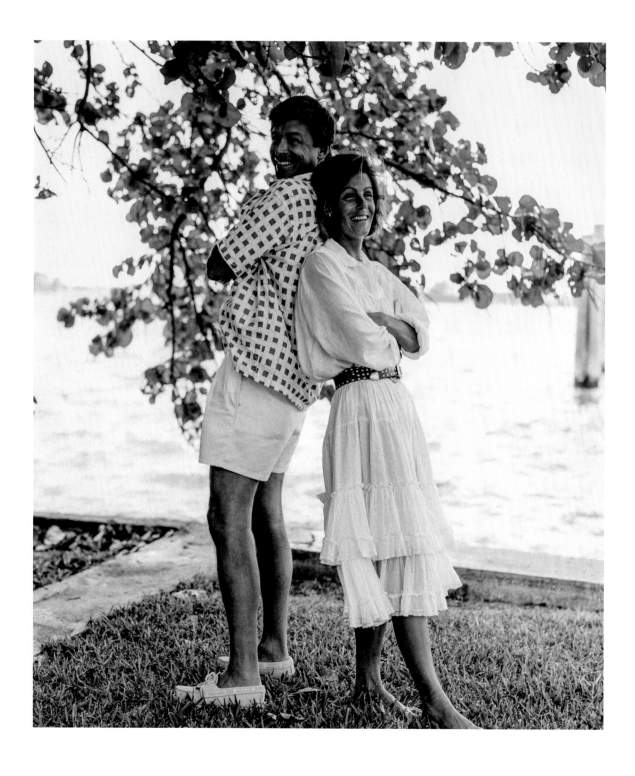

Laddie and Dede Merck, Palm Beach, Florida, 1988.

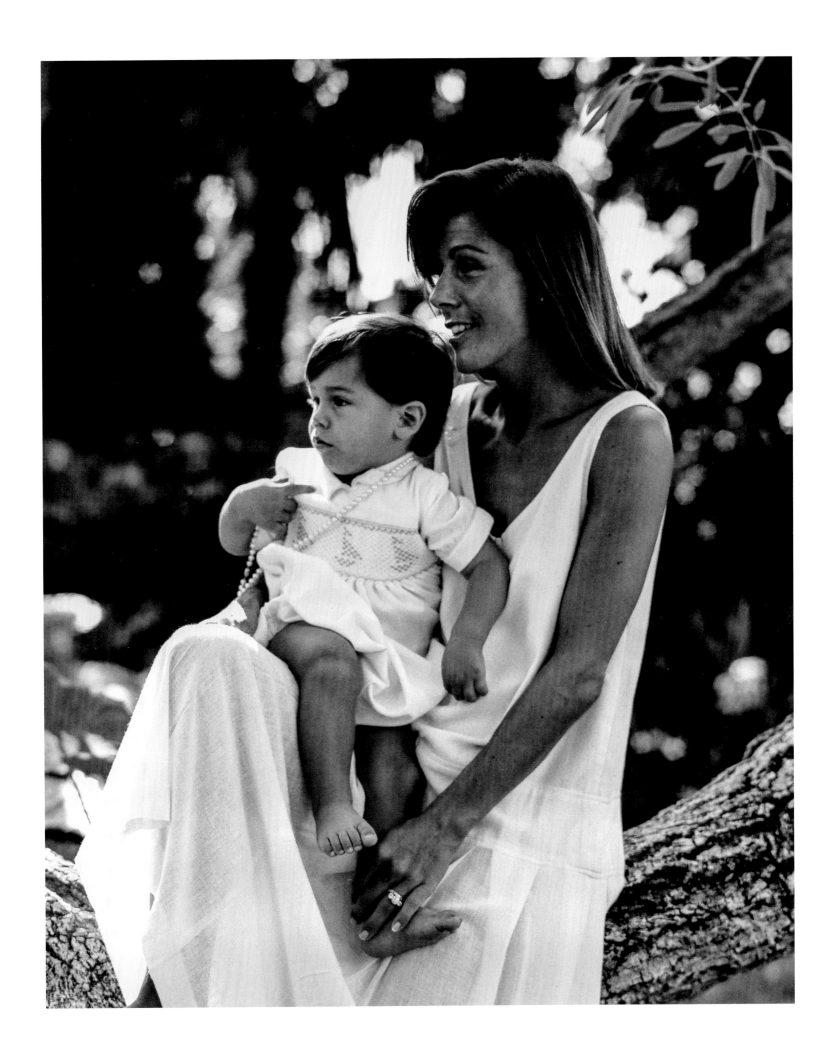

Dede Merck with son George, Palm Beach, Florida, 1990.

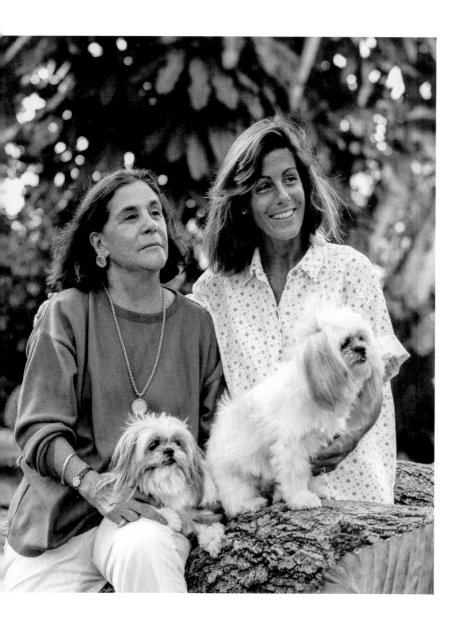

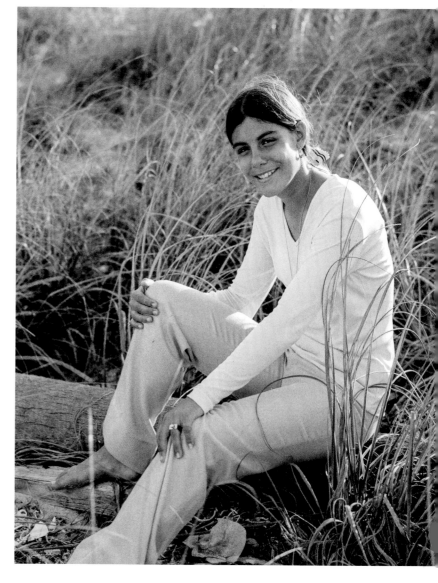

182 Dede Merck with her mother, Gwen, Palm Beach,
 Florida, 1991.

Dede Shook (later Merck), Palm Beach, Florida, 1978.

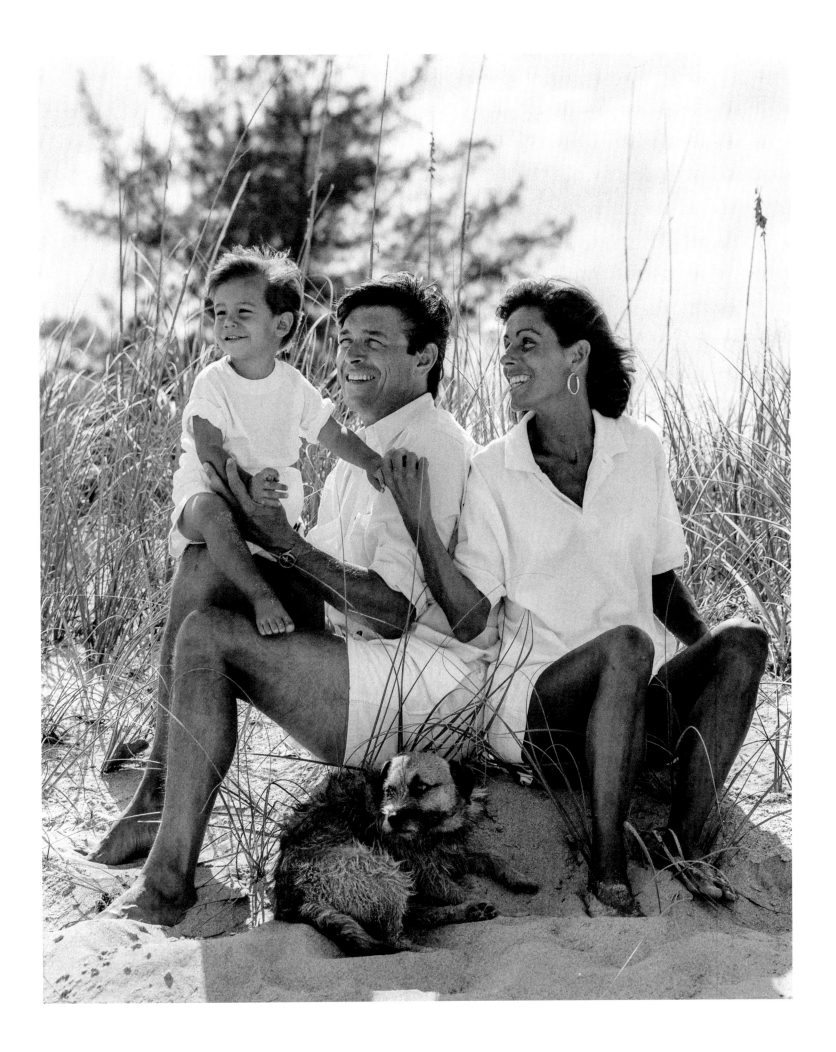

Laddie and Dede Merck with son George, Palm
Beach, Florida, 1991.

MONELL FAMILY

So many distinguished gentlemen have carried the name Ambrose Monell, one needs a flow chart. Judge Ambrose Monell Sr. was the definitive mid-nineteenth-century New Yorker and graduated from Columbia University. His son, also named Ambrose, was born in 1873 and graduated from the Columbia School of Mines in 1896; he enjoyed great success in finance along with the nickel, copper and steel industries but died at the young age of forty-eight. His son, Edmund "Ned," and his wife were prominent on the social circuits of Southampton and Palm Beach. They had two sons named Edmund and yet another Ambrose, first married to Renée Harron followed by Lili Crichton, sister of Kate Gubelmann. And on and on.

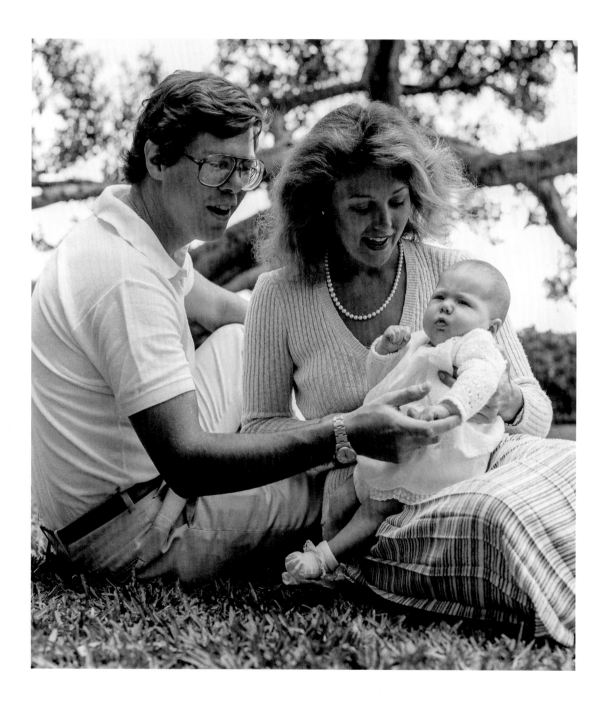

Ambrose and Renée Monell with daughter Nina,
Southampton, New York, 1981.

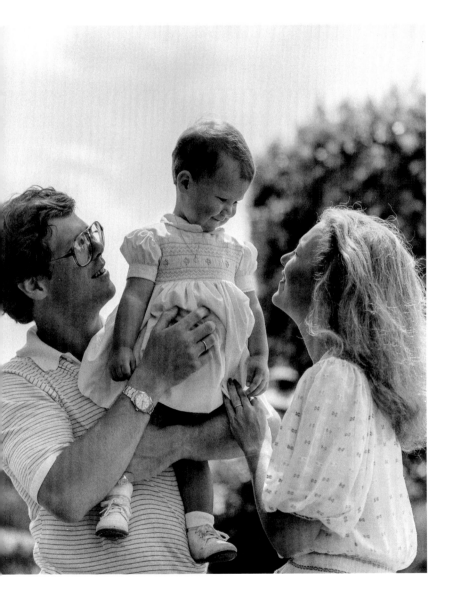

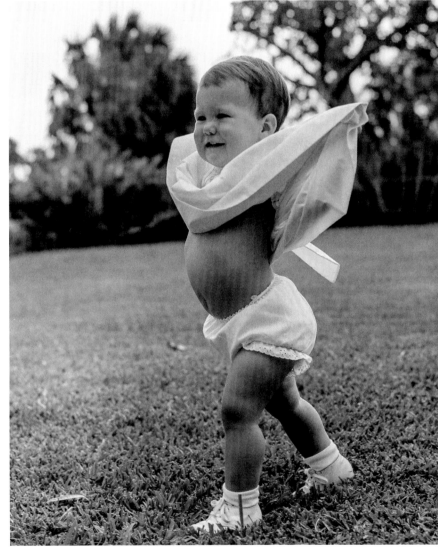

Ambrose and Renée Monell with daughter Nina,
Southampton, New York, 1982.

Nina Monell, Southampton, New York, 1982.

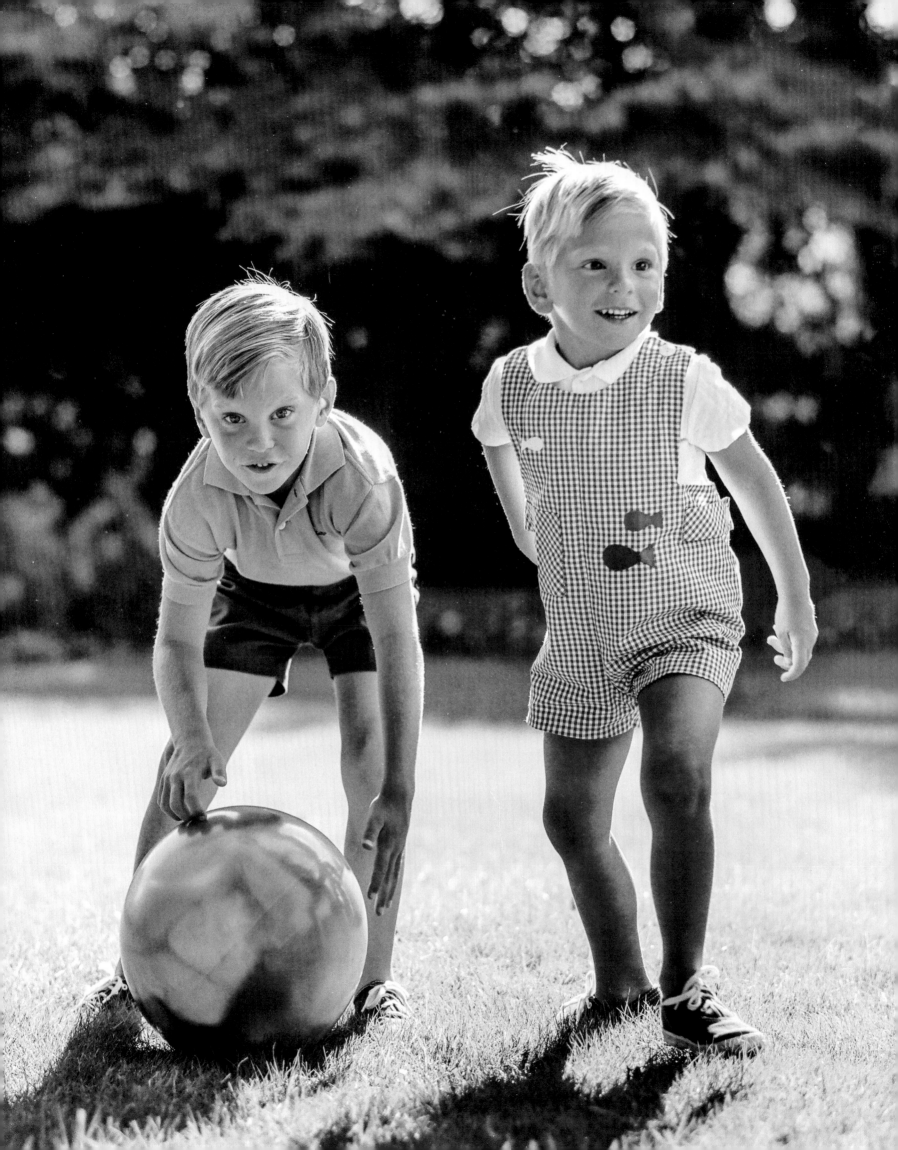

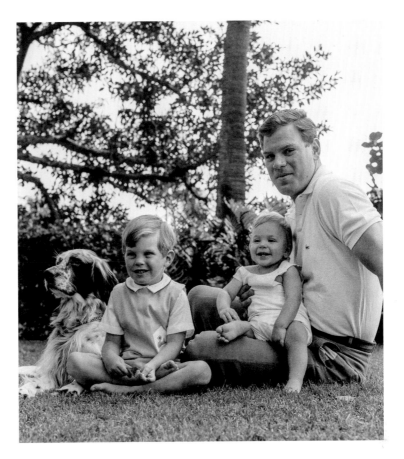

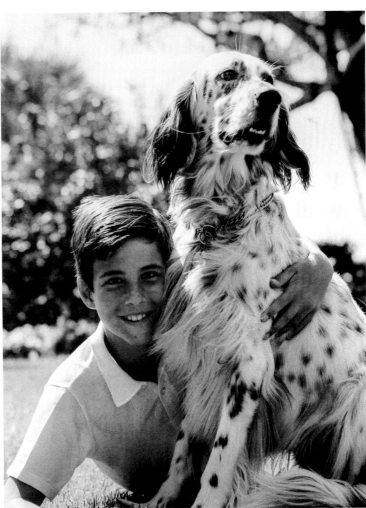

Above: Anthony K. Moulton, son of Mrs. E. C. Monell from another marriage, with his sons, Ned and Bruce, Palm Beach, Florida, 1968.

Below: Ned Monell, Palm Beach, Florida, 1968.

Facing: Ned and Bruce Moulton, sons of Anthony K. Moulton, 1970.

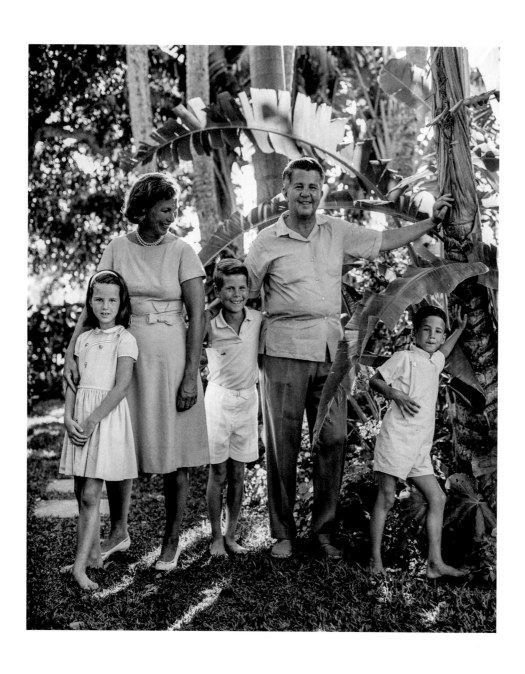

Mr. and Mrs. Edmund C. Monell and family, Palm Beach,
Florida, 1963.

Facing: The Monell/Moulton family, Palm Beach, Florida, 1968.

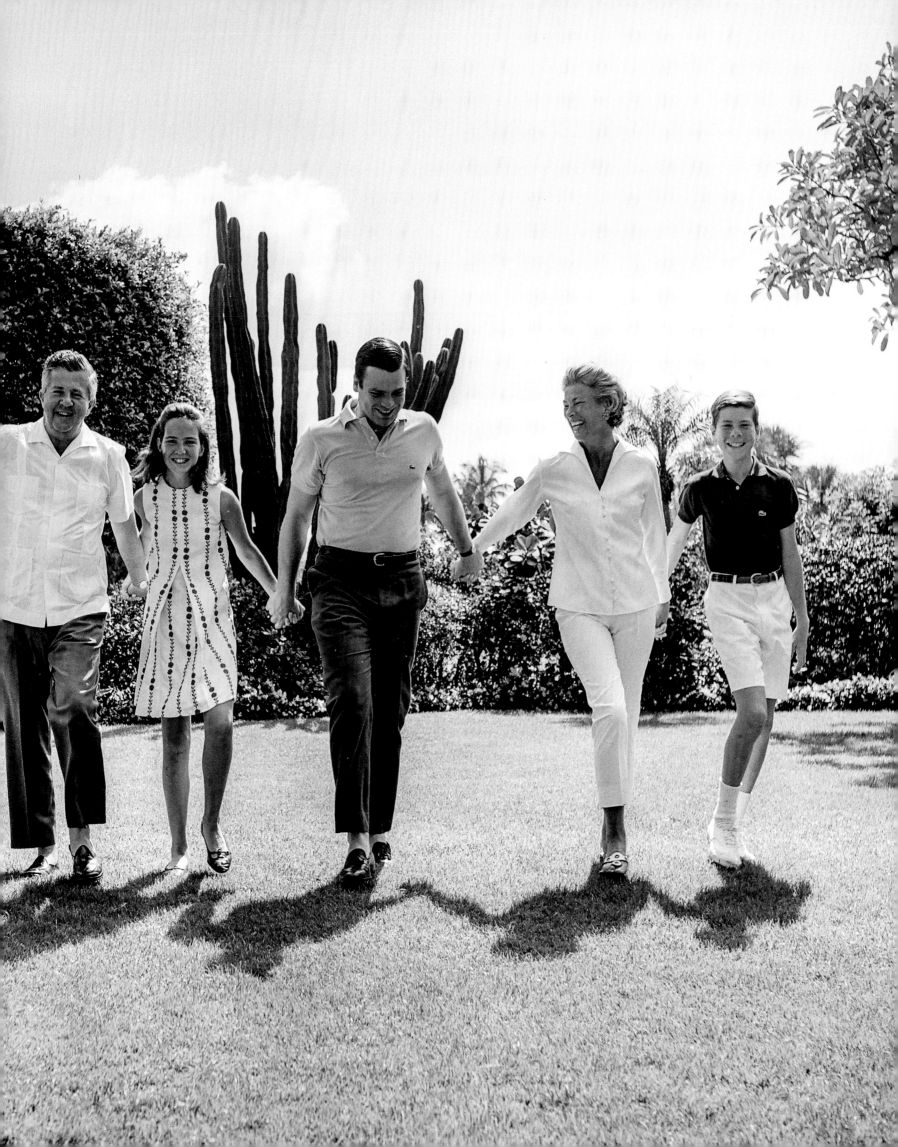

MORRISEY FAMILY

John and Frannie Morrisey were early members of the Palm Beach and Southampton social set. Her maternal grandmother, Mrs. Edward H. Johnson, owned "Agawam," one of Southampton's early grand summer cottages. Frannie, like her mother Florence Gensler, was an accomplished tennis player and was one of the first female governors elected at the exclusive Meadow Club, famous for its pristine grass courts just steps from the Atlantic Ocean. She was also a great friend of Lilly Pulitzer and for a time managed both the designer's Palm Beach and Southampton shops. The Morriseys had three children, John, Lucinda and Florence.

Frannie Morrissey with her mother and children, Johnnie, Lucinda and Florrie, Palm Beach, Florida, 1969.

OXENBERG FAMILY

As if the marriage of successful dress manufacturer and sportsman Howard Oxenberg to Princess Elizabeth of Yugoslavia wasn't enough to qualify the family name for notoriety, daughter Catherine certified it. Her featured role as Amanda Carrington in the 1980s prime-time soap opera *Dynasty* made Oxenberg a household name well beyond the confines of New York and Southampton.

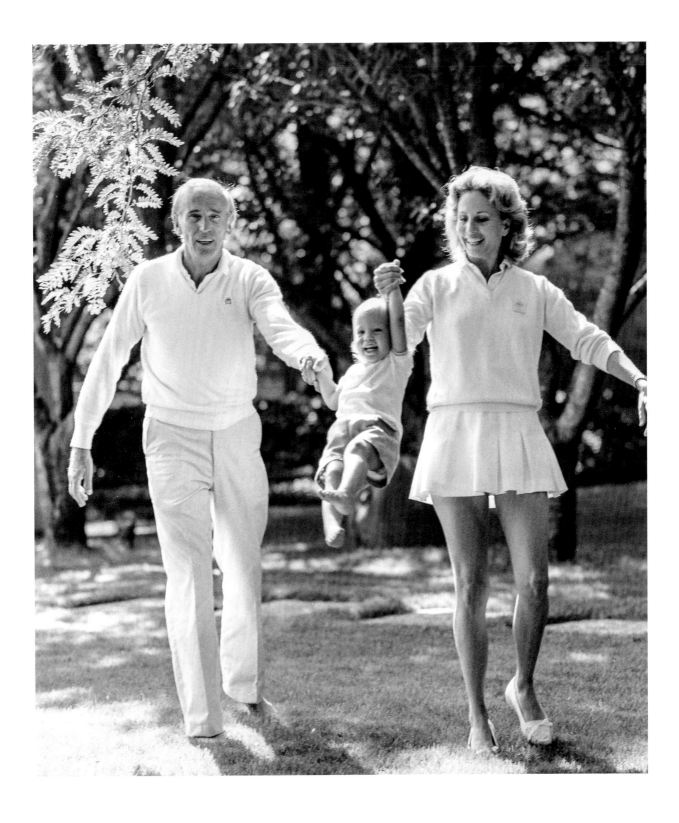

Mr. and Mrs. Howard Oxenberg with daughter
Ashley, Palm Beach, Florida, 1985.

PALMER FAMILY

The city of Chicago owes a great debt to the Palmer family. Without patriarch Potter Palmer (1826–1902) there would be no State Street, as it is known today, no Gold Coast, the city's most prestigious residential area, and most probably no Marshall Field & Co., the Midwest's iconic retail emporium. Ill health required Palmer, the sole owner/operator of a successful dry goods store on Lake Street, to bring in partners Levi Leiter and Marshall Field, and the rest is history: Marshall Field and Company became one of America's most renowned department stores until its merger and conversion to Macy's. Following the Great Chicago Fire, Palmer played an integral role in the city's recovery, realigning the commercial district from east-west to north-south along with developing swampland into one of the jewels of urban boulevards, Lake Shore Drive.

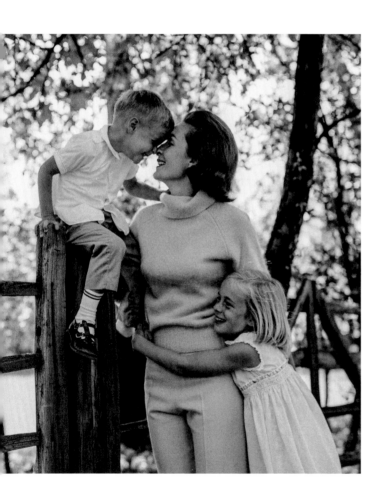

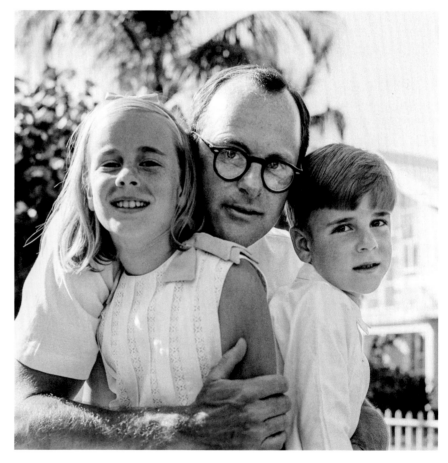

Mrs. Potter Palmer with children Yates and Pam, Palm Beach, Florida, 1965.

Potter Palmer with children Pam and Yates, Palm Beach, Florida, 1967.

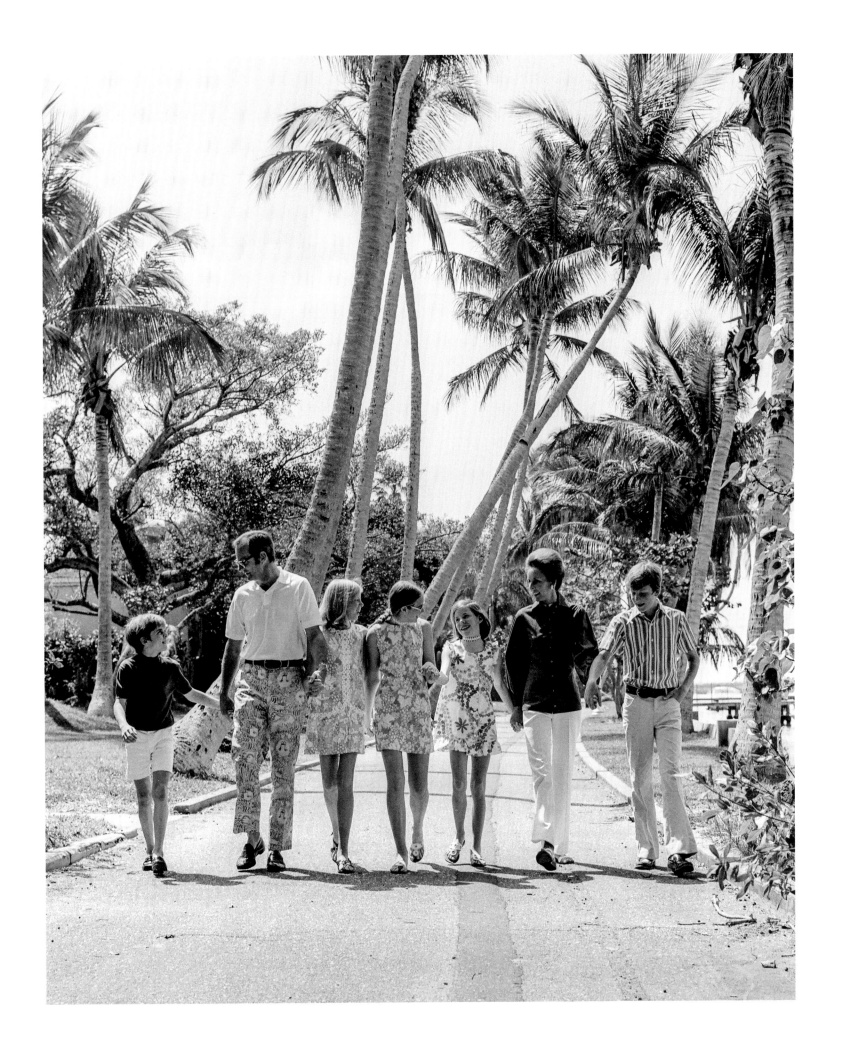

The Potter Palmer family, Palm Beach, Florida, 1971.

PHIPPS FAMILY

Henry Phipps was the son of an English shoemaker who immigrated to Philadelphia in the early 1800s, ultimately settling in Pittsburgh. There he partnered with Andrew Carnegie in the steel industry and invested in real estate. Although he did indeed achieve great wealth, he also believed in giving back for the public good and set the gold standard for philanthropy during the Industrial Age. Indeed, so great was that wealth that he was able to establish a private family financial institution—Bessemer Trust (still existing today)—to manage his own assets and those of his descendants.

With an imposing presence in South Florida and on Long Island's Gold Coast, along with extraordinary achievements in the world of thoroughbred racing, the Phipps family continues to thrive. Close relations have equally renowned surnames—Guest and Churchill, for example, with a few European titles thrown in for good measure.

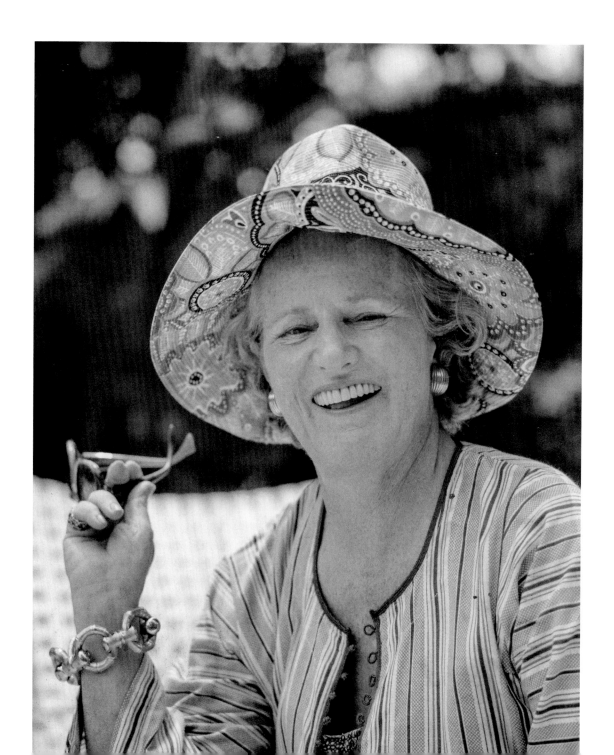

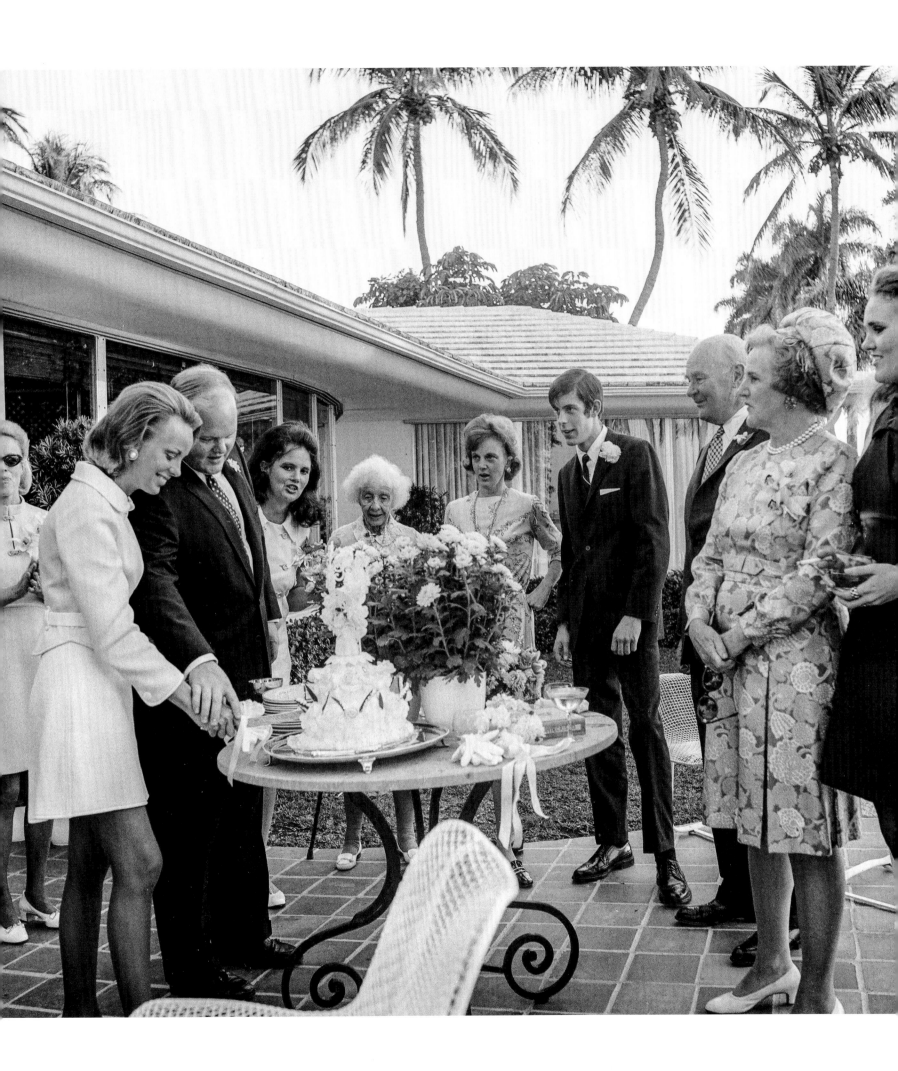

Facing: Lillian Bostwick Phipps, Palm Beach, Florida, late 1960s. Andie and Dinny Phipps' wedding, Miami, Florida, 1970. 201

Lillian Bostwick Phipps with grandson Peter
Pulitzer, Palm Beach, Florida, early 1960s.

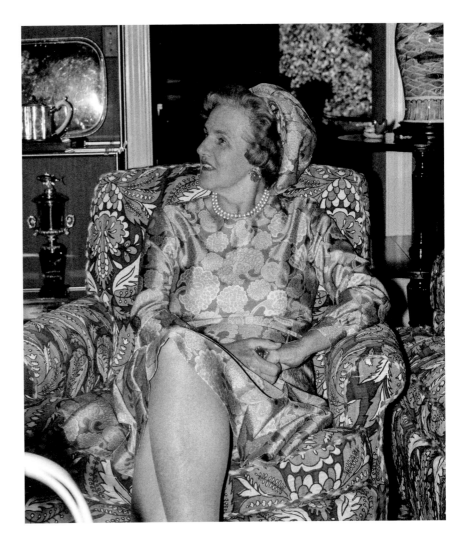

Above: Lillian Bostwick Phipps, Miami, Florida, early 1960s.

Below: Lillian Bostwick Phipps, Miami, Florida, 1970.

PITT FAMILY

Tall and movie-star handsome, William H. Pitt was a true legend in both residential and commercial real estate, dominating the landscape of Connecticut's exclusive Fairfield County. With both his first wife, Teddy, who died after forty-five years of marriage, and his second wife, Pauline Baker Boardman, Bill Pitt was the consummate definition of a patrician gentleman.

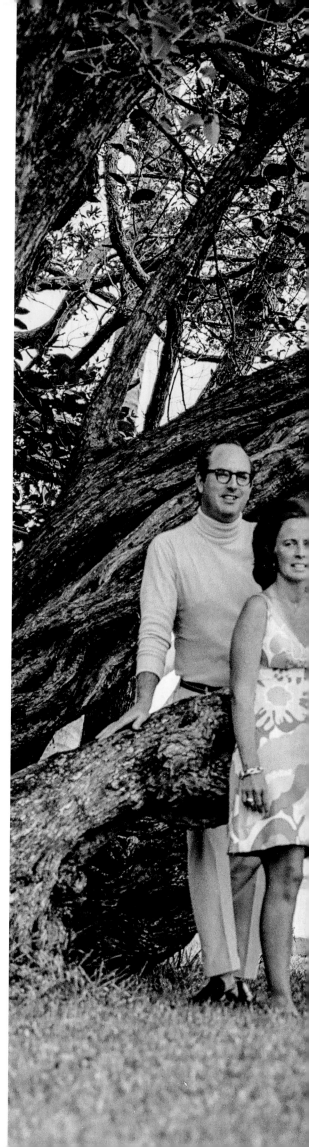

Teddy and Bill Pitt with their blended family, including son William Pitt Jr. and Teddy's daughters, Hope and Sandy, Palm Beach, Florida, 1973.

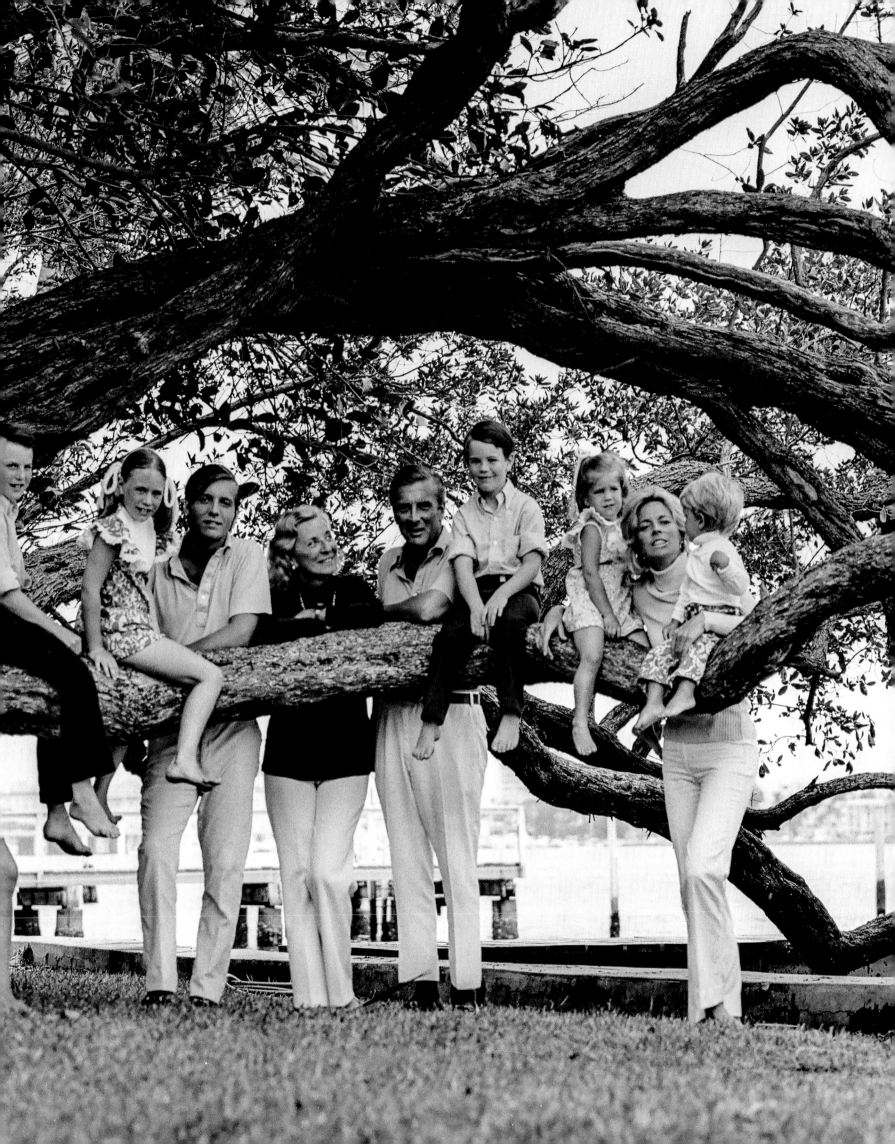

PRAY FAMILY

Malcolm S. Pray Jr., was born in New York and raised in the exclusive suburb of Greenwich, Connecticut, where, in addition to Palm Beach, he lived, married his wife, Natasha, raised a family and became one of the most successful men in the retail automotive business, owning and operating a string of dealerships. He was also well known for his extraordinary collection of vintage cars.

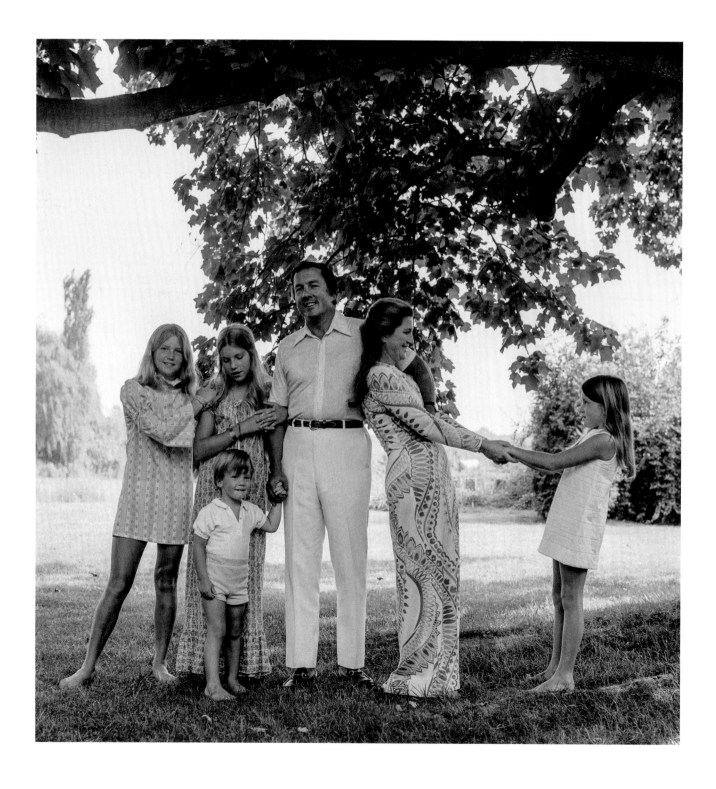

Malcolm and Natasha Pray and family, Greenwich, Connecticut, 1976.

I was always in awe of the way we were arranged, and yet the photographs turned out looking so natural!

Sabrina Pray Forsythe

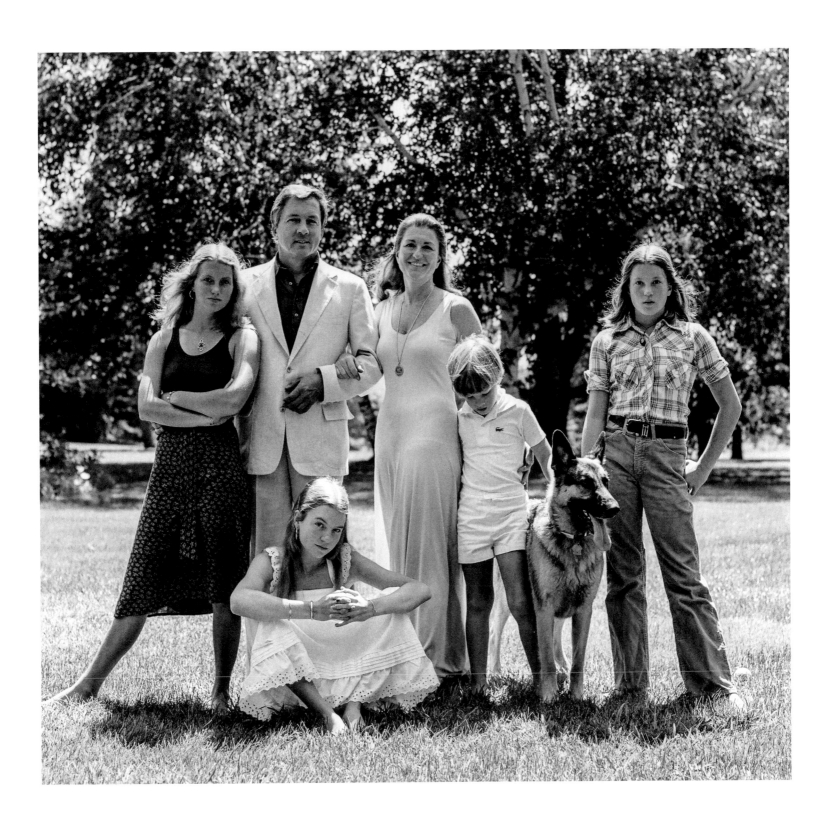

Malcolm and Natasha Pray and family, Greenwich,
Connecticut, 1981.

PRESTON FAMILY

The glamorous granddaughter of the founder of the Pulitzer Prize, Gladys "Patsy" Pulitzer grew up in Palm Beach. Her early first marriage to David Frost Bartlett ended in divorce. In 1959, she married Lewis Thomas Preston, the chairman of J. P. Morgan, president of the World Bank and a grandson of one of the partners of the Standard Oil Company. They lived in Washington, DC, and Palm Beach. In addition to being one of the Ford Agency's top models of the day, Patsy worked tirelessly for causes aligned with women's rights, most notably Planned Parenthood.

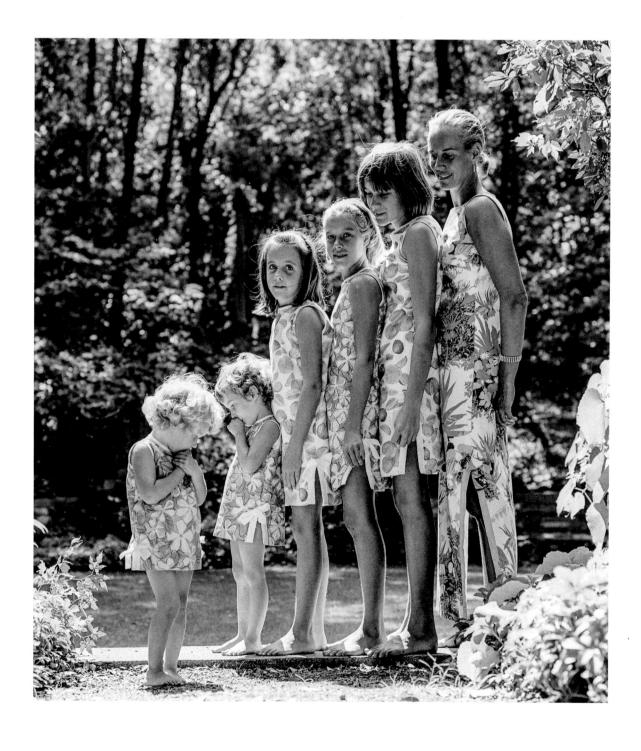

Patsy Pulitzer Preston and daughters, Mt. Kisco, New York, 1963.

"Oh, no . . . she's going to make someone climb
up that tree, and she's looking at me!"

Cooky Preston Bartlett

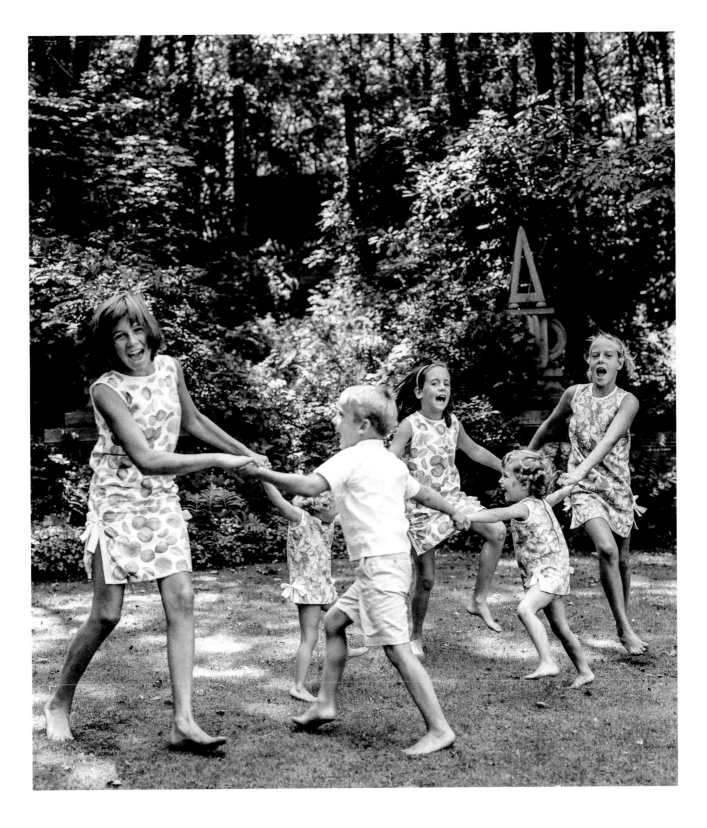

Ring-around-the-rosy, Mt. Kisco, New York, 1963.

PULITZER FAMILY

When Lillian "Lilly" McKim eloped with Herbert "Peter" Pulitzer, it might have been viewed as a high-society merger (Lilly's mom was a Bostwick, one of Standard Oil's founding families) and the Pulitzer family was neck in neck with the Hearsts for dominance of the American newspaper business. But more importantly, it was a marriage of two free spirits. Lilly and Peter were the first true bohemians to set up housekeeping in the patrician tropical enclave of Palm Beach, thereby making it okay to go barefoot, have diverse friends and interests and give value to the concept of joie de vivre. They impacted American life in so many more ways than they could have imagined, yet would have been the last ones to take credit for it. Anyone who has enjoyed dancing to the beat of their own drum owes this clan a debt of gratitude.

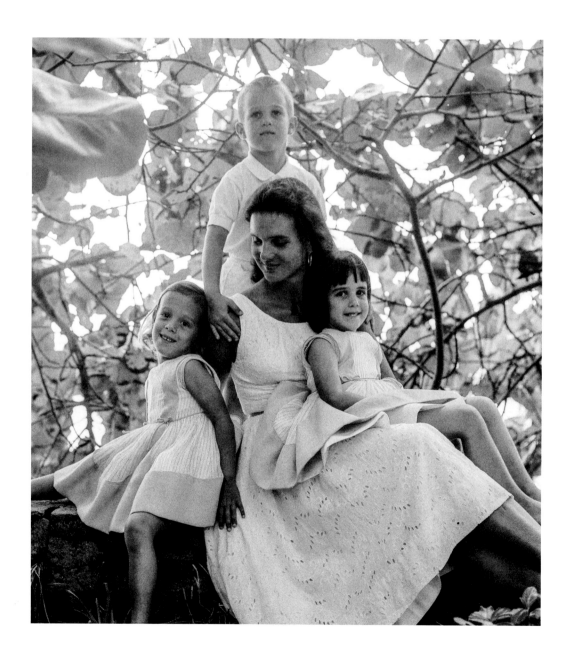

Lilly Pulitzer and children Minnie, Peter and Liza,
Palm Beach, Florida, 1960.

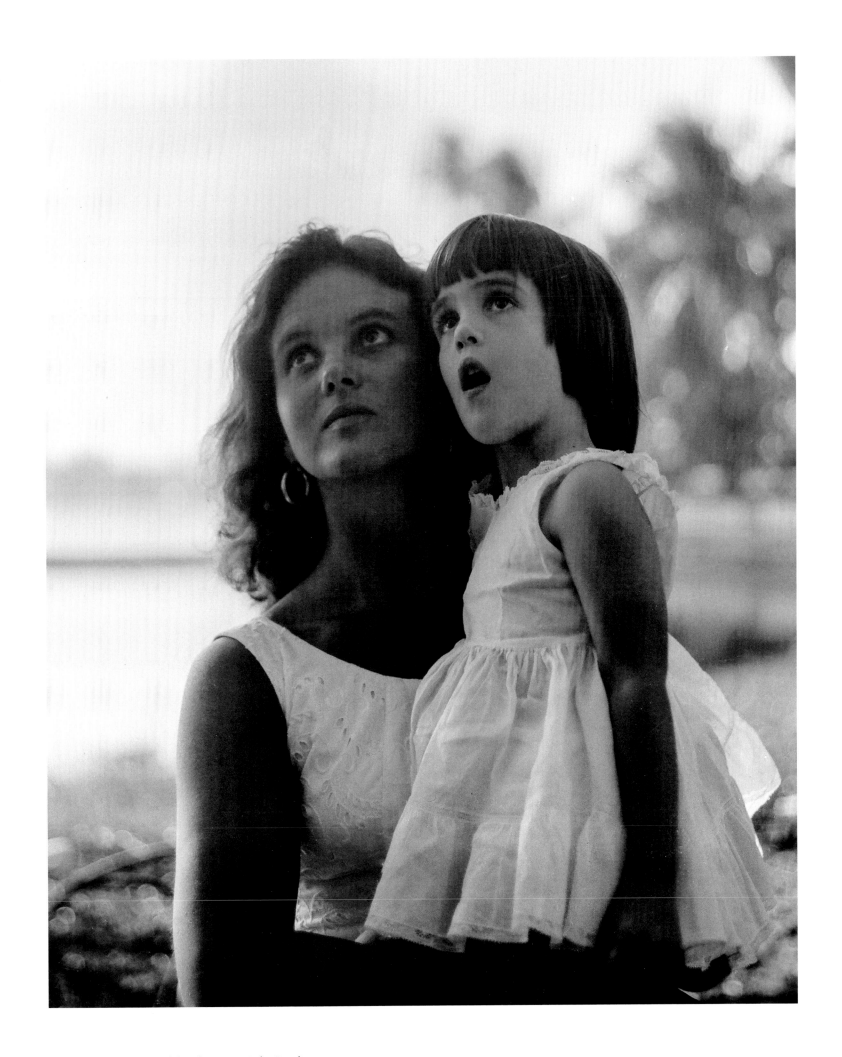

Lilly Pulitzer and daughter Liza, Palm Beach,
Florida, 1960.

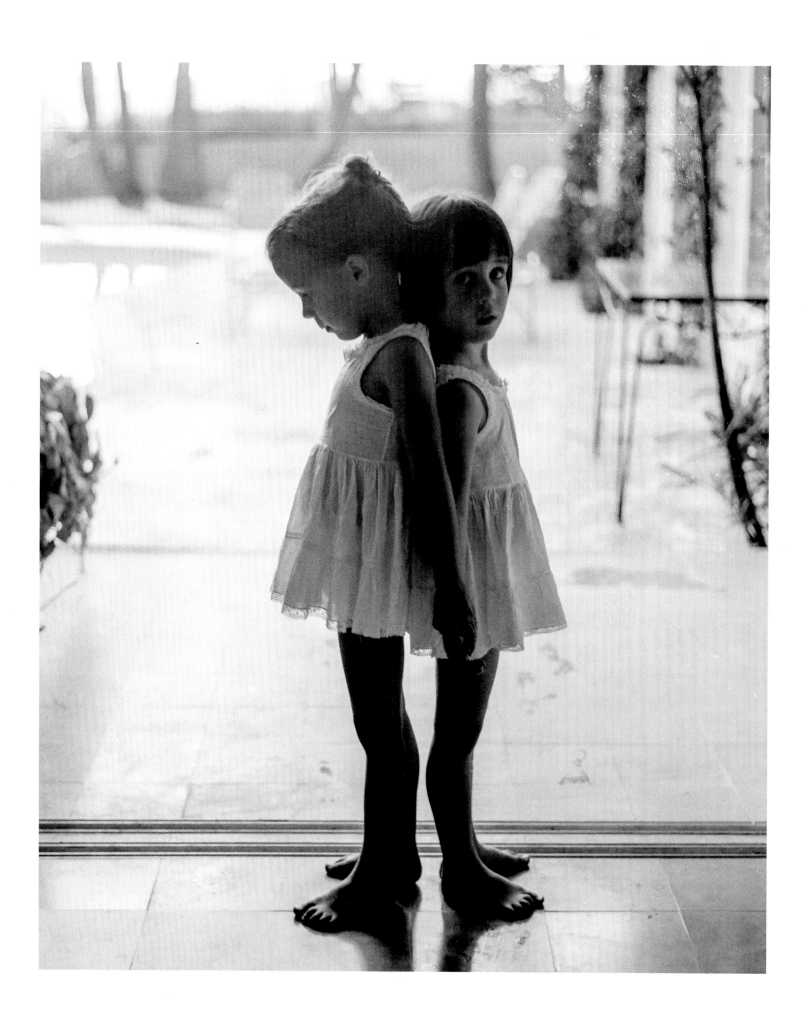

Minnie and Liza Pulitzer, Palm Beach, Florida, 1960. *Facing:* Minnie and Liza Pulitzer, Palm Beach, Florida, 1975.

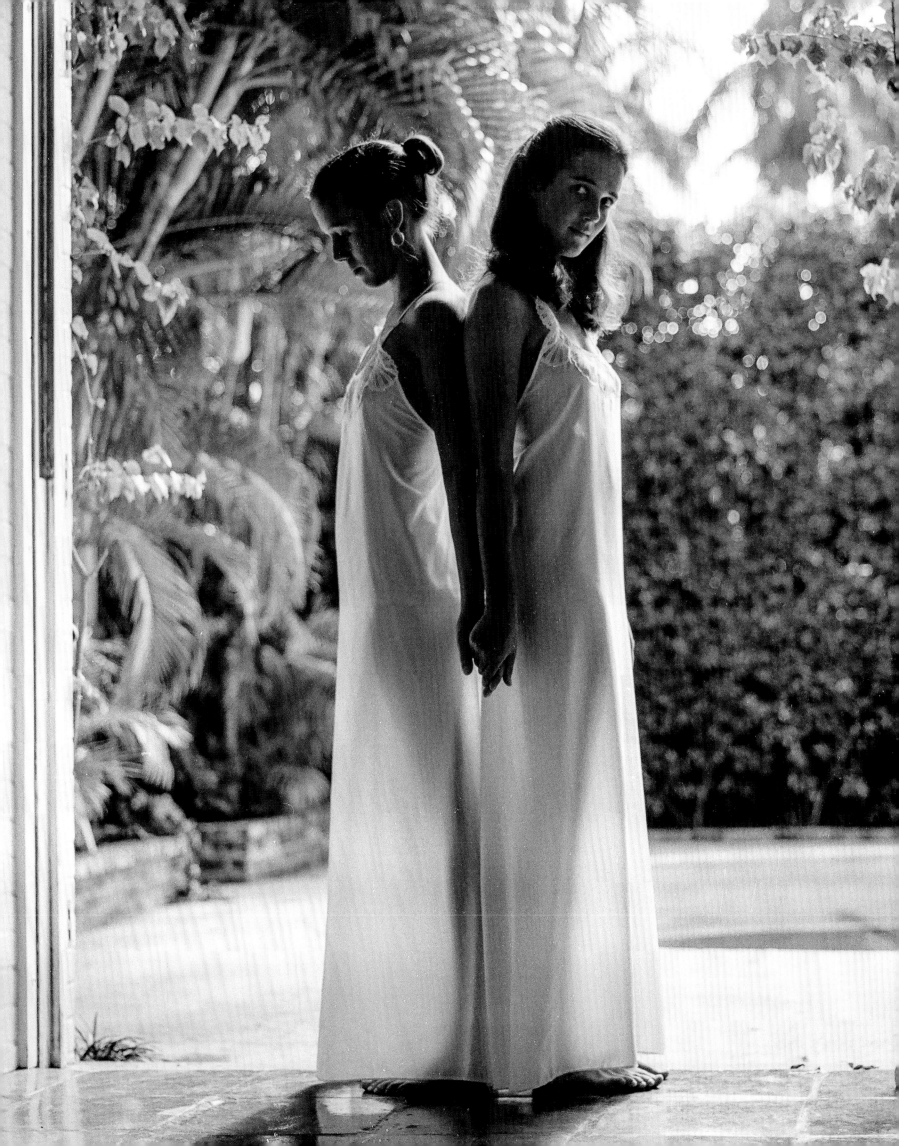

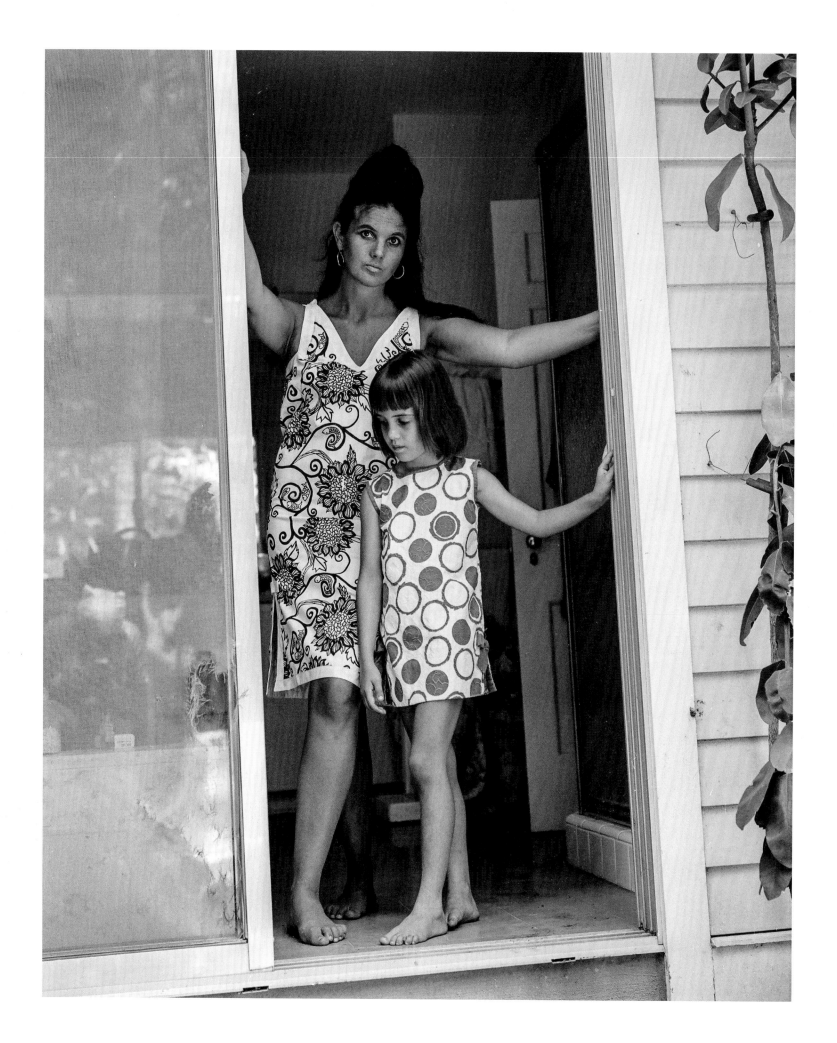

Lilly Pulitzer and daughter Liza, Palm Beach,
Florida, 1961.

Lilly Pulitzer, Palm Beach, Florida, 1961.

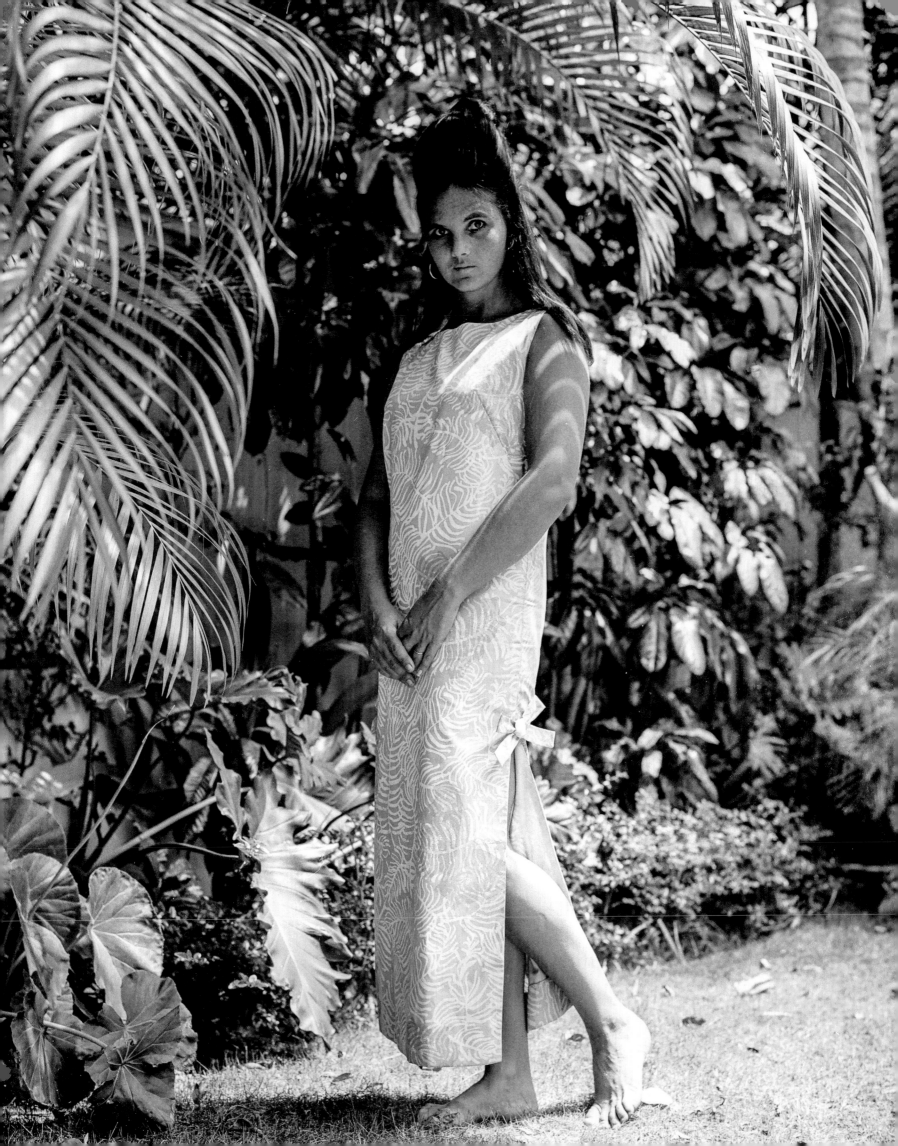

Lilly was mom's very first client in Palm Beach, which was the start of a long, endearing friendship between the two of them. Lilly was Mom's best friend and ally!

Kate Kuhner

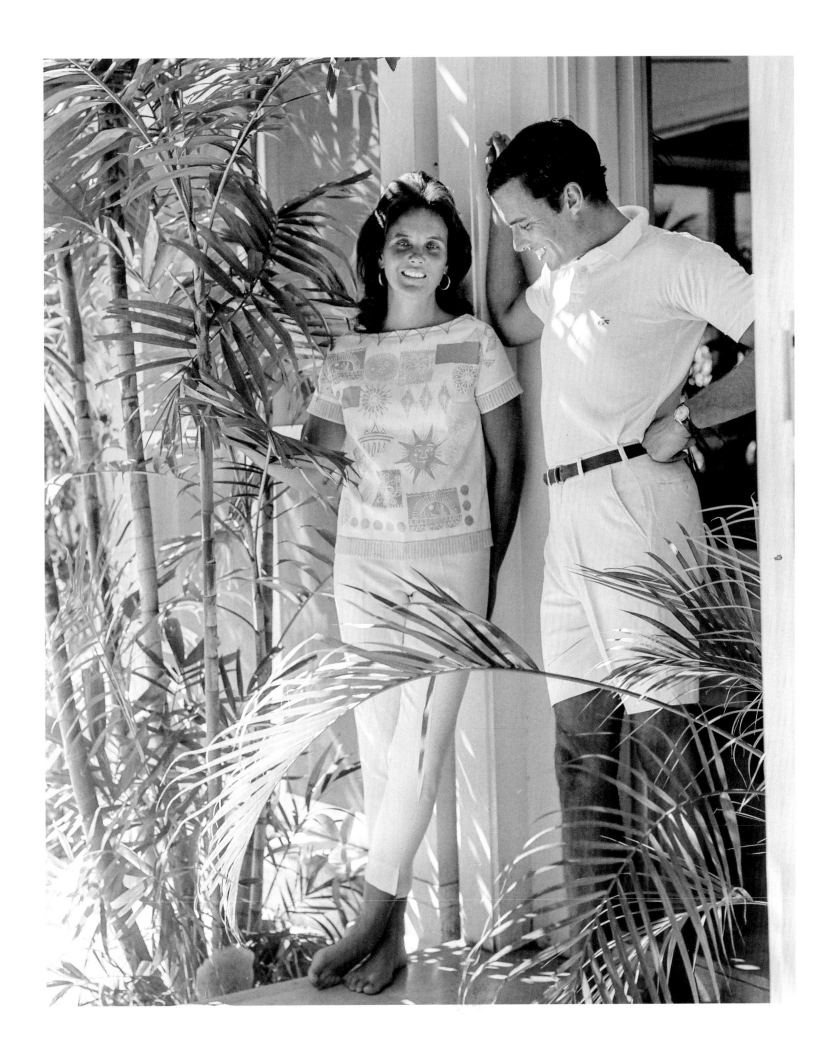

Lilly and Peter Pulitzer, Palm Beach, Florida, early 1960s.

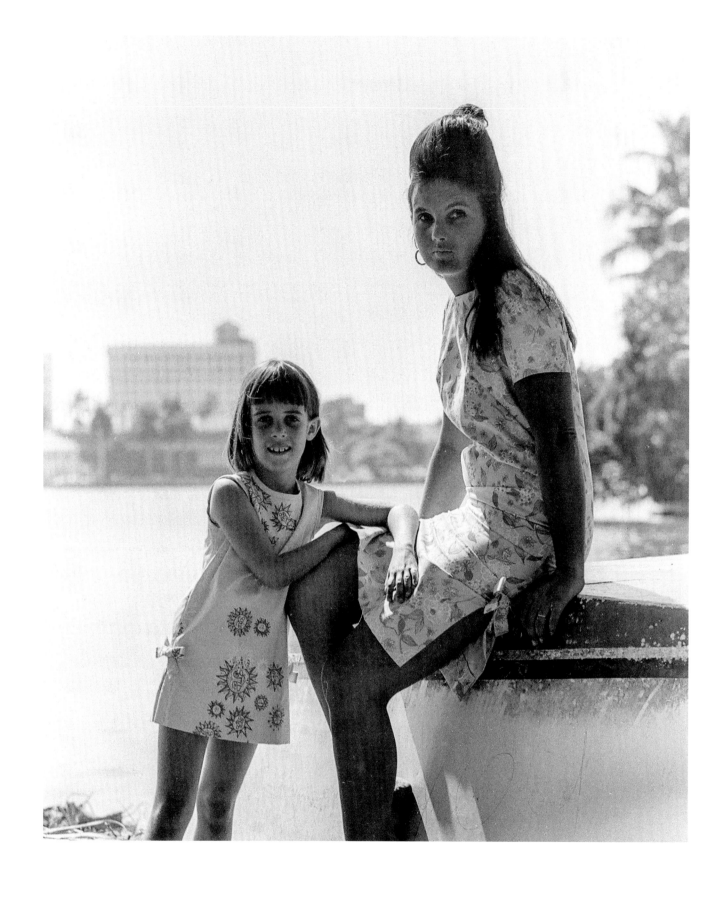

Lilly Pulitzer and daughter Liza, Palm Beach,
Florida, 1963.

Lilly Pulitzer, her sister Flossie Doubleday and all
of their children, Palm Beach, Florida, 1963.

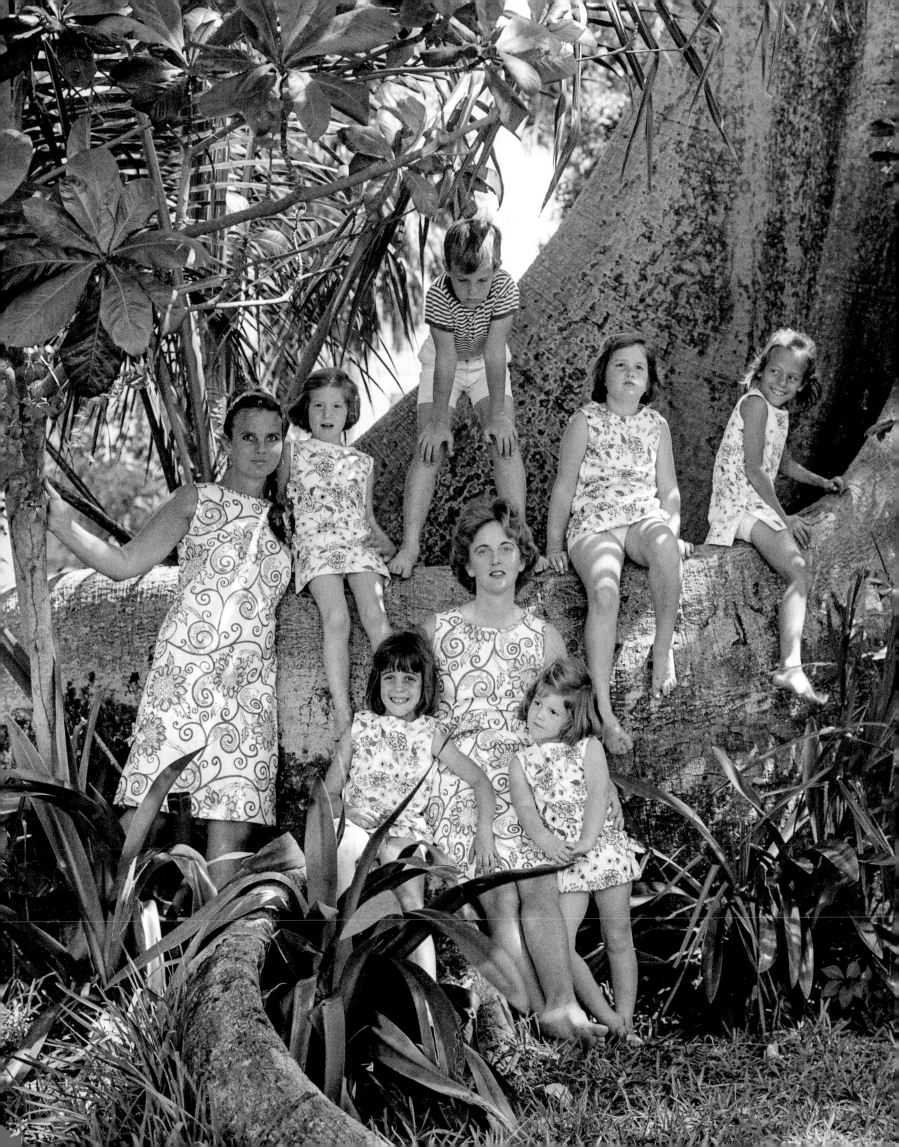

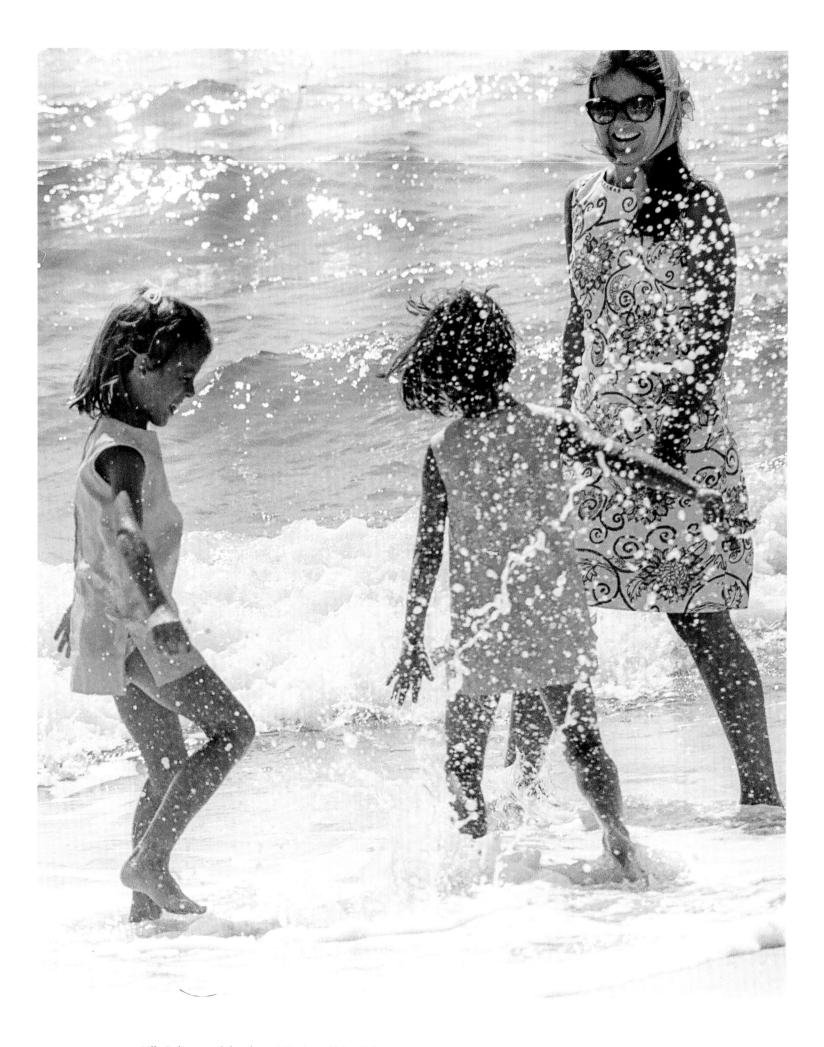

Lilly Pulitzer and daughters Minnie and Liza, Palm
Beach, Florida, 1963.

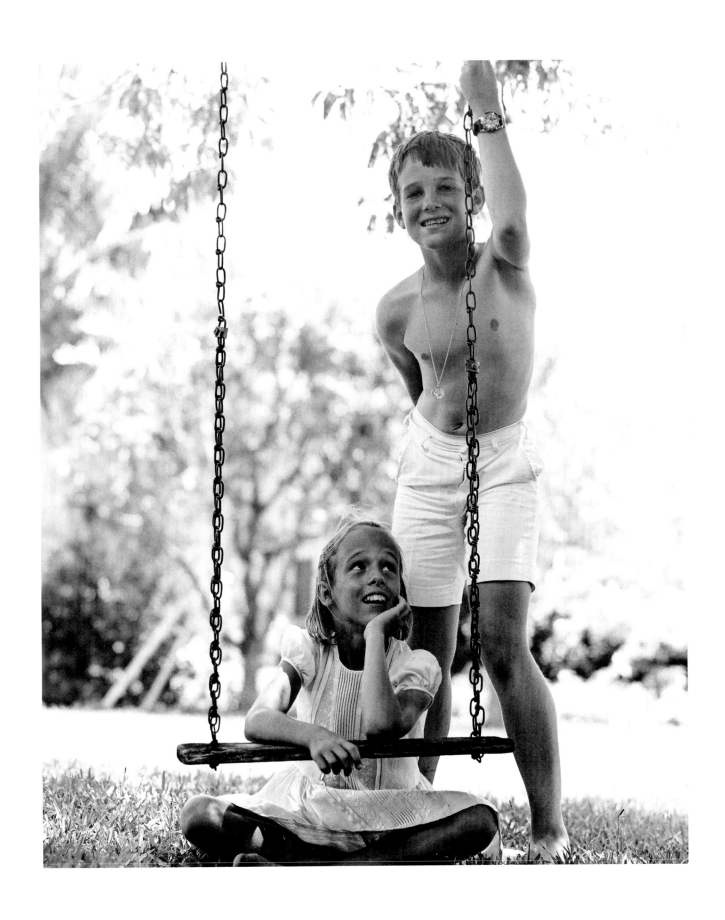

Minnie and Peter Pulitzer Jr., Palm Beach, Florida,
late 1960s.

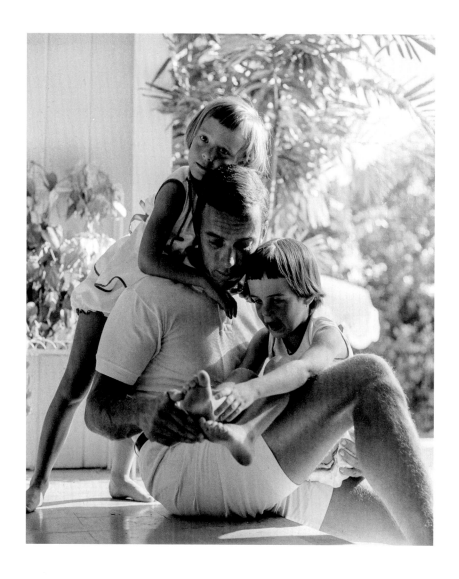

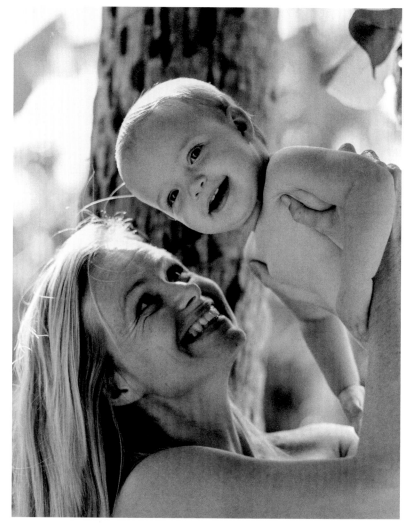

Peter Pulitzer with daughters Minnie and Liza, Palm Beach, Florida, 1961.

Hillary Pulitzer with Jessie, her daughter with Peter, Palm Beach, Florida, 1987.

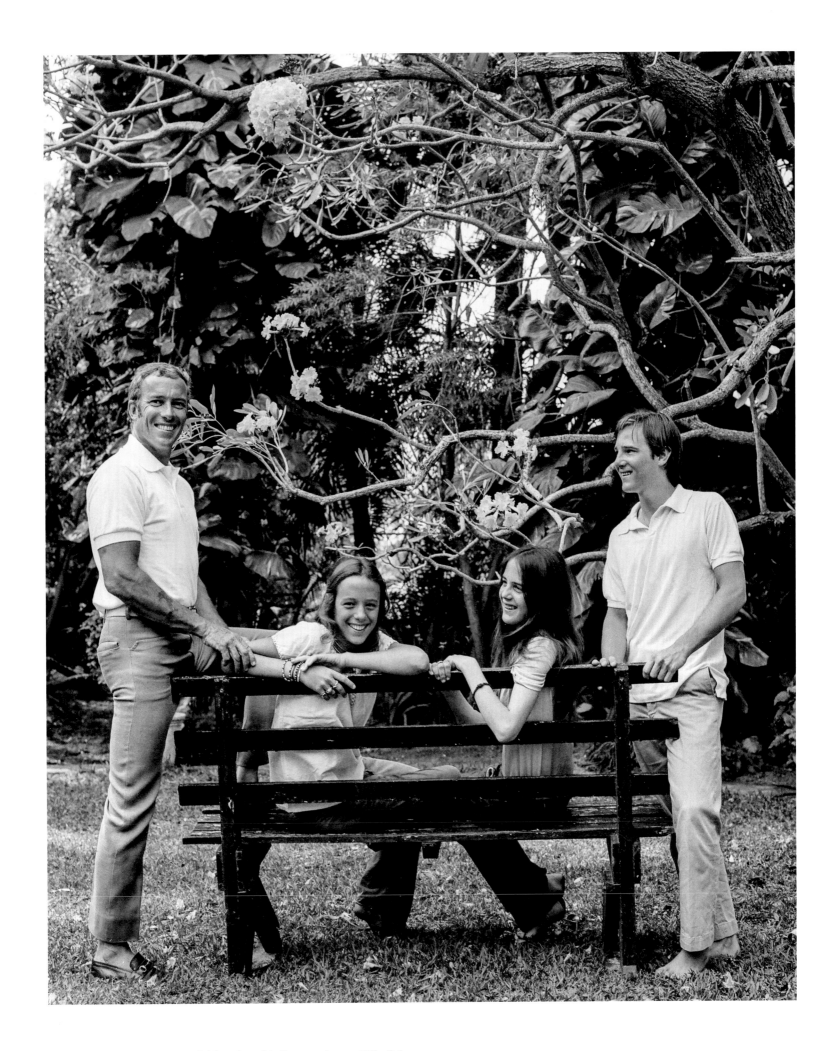

Peter Pulitzer and his children from his first marriage to Lilly, Palm
Beach, Florida, 1971.

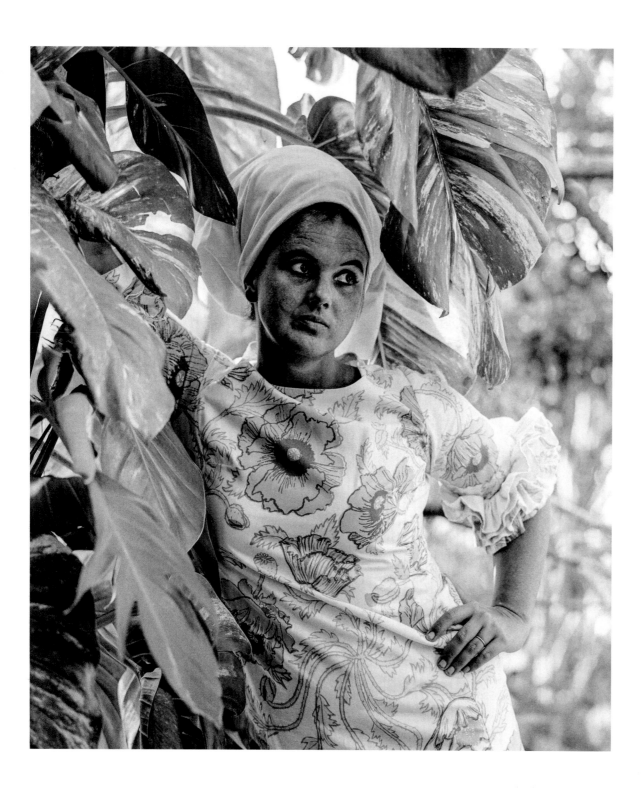

224 Above: Lilly Pulitzer, Palm Beach, Florida, 1966.

Lilly Pulitzer, Palm Beach, Florida, 1966.

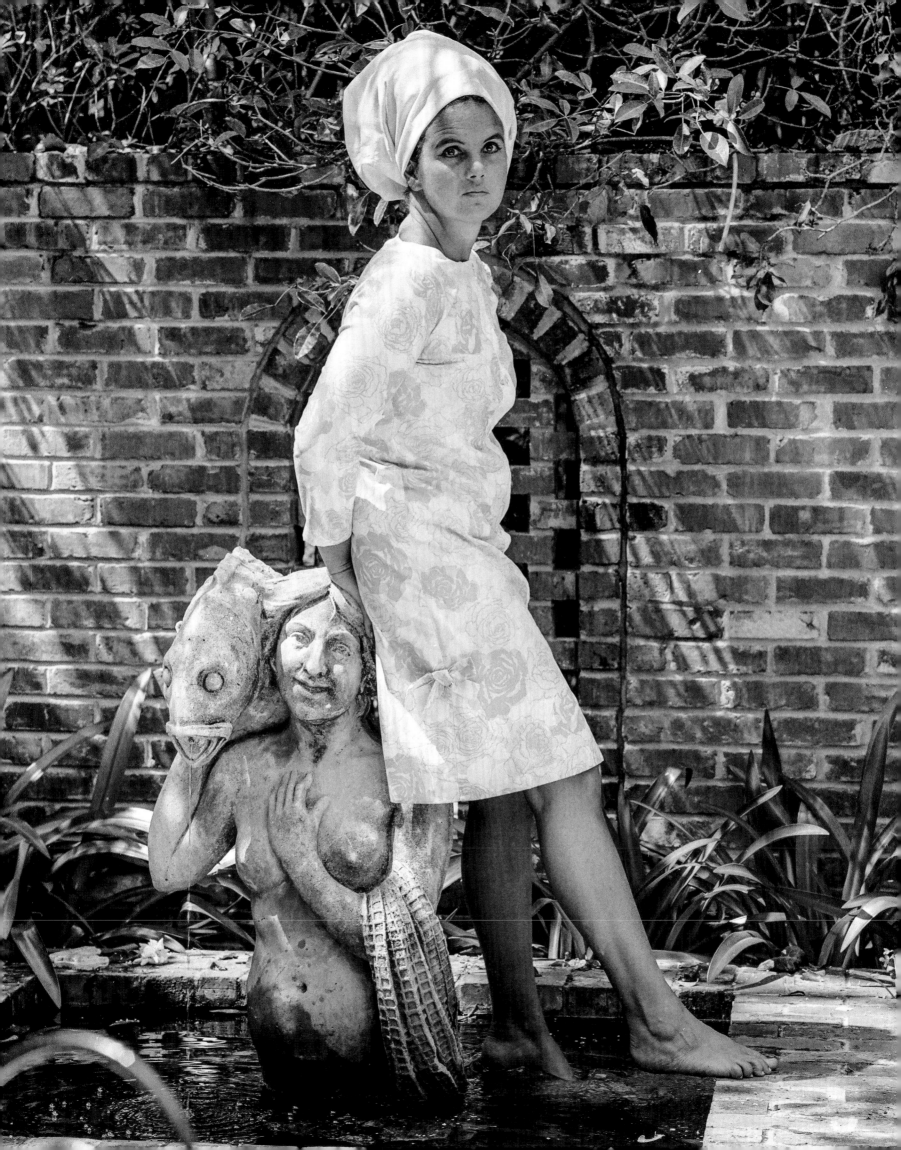

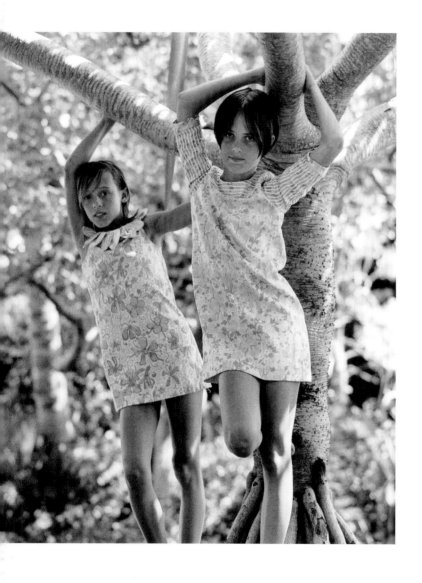

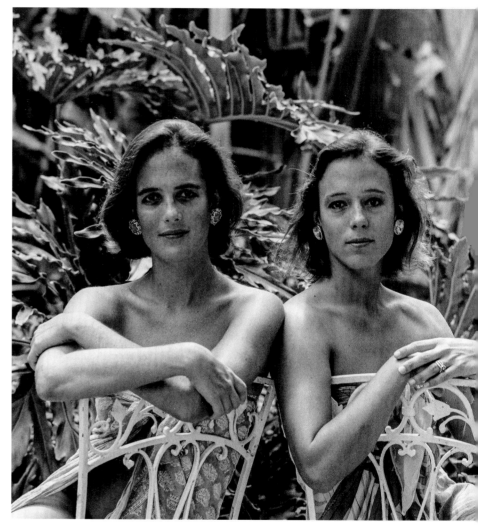

Minnie and Liza Pulitzer, Palm Beach, Florida, late 1960s.

Liza and Minnie Pulitzer, Palm Beach, Florida, 1985.

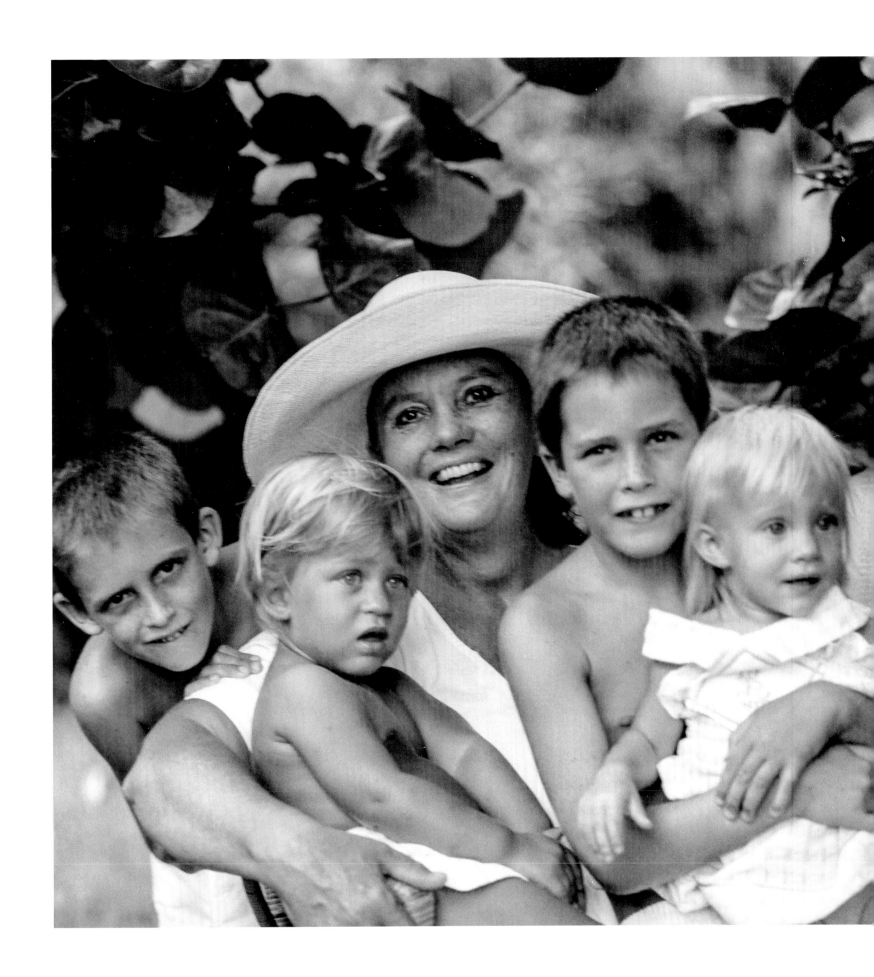

Lilly Pulitzer with her grandchildren, Christopher
Leidy, Rodman Leas, Bobby Leidy and Lilly Leas,
Palm Beach, Florida, 1988.

227

REID FAMILY

The name Ogden Reid defines public service, as US Ambassador to Israel and a six-term congressman representing New York. The publisher of the family-owned *New York Herald Tribune,* Reid married Mary Louise Stewart in 1949. Together they raised a family of six in a spectacular Renaissance Revival mansion in Purchase, New York. It was later donated to Manhattanville College, at which time it was renamed Reid Hall.

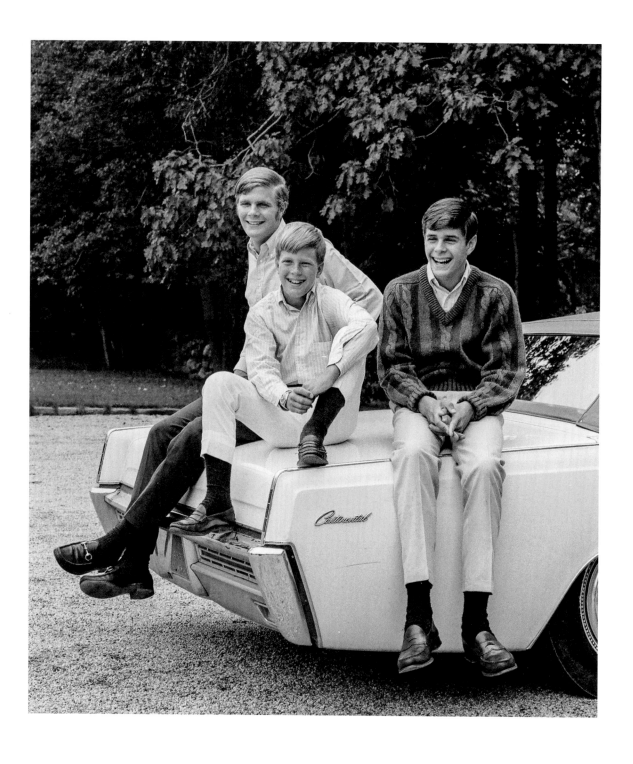

Stuart, William and Michael Reid, Purchase, New York, 1969.

Facing: Mr. and Mrs. Ogden Reid with children Elizabeth, Stuart, David, William, Ogden M. and Michael, Purchase, New York, 1969.

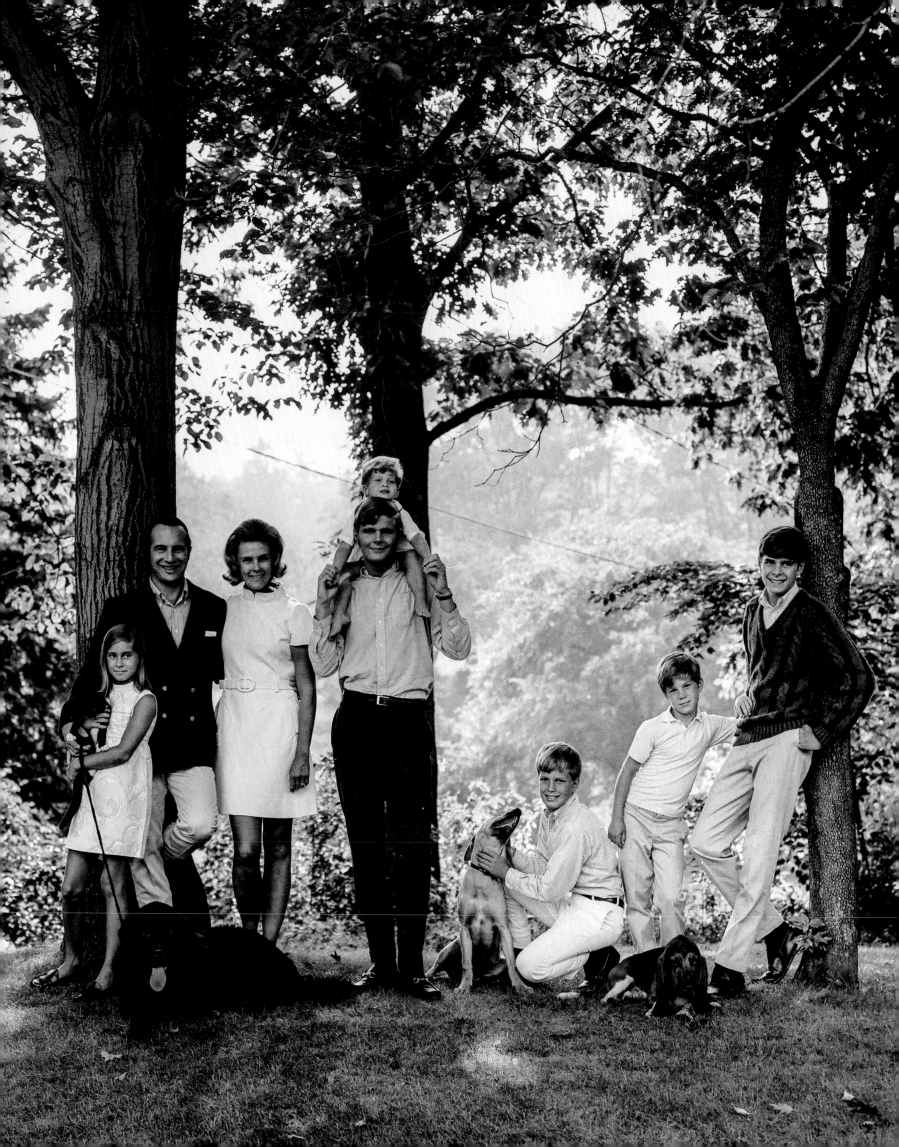

RHINELANDER FAMILY

Descendants of Philip Jacob Rhinelander, a Huguenot who fled from France in the late seventeenth century, have left an extraordinary mark on both New York and Newport high society through a vast family fortune built from real estate holdings.

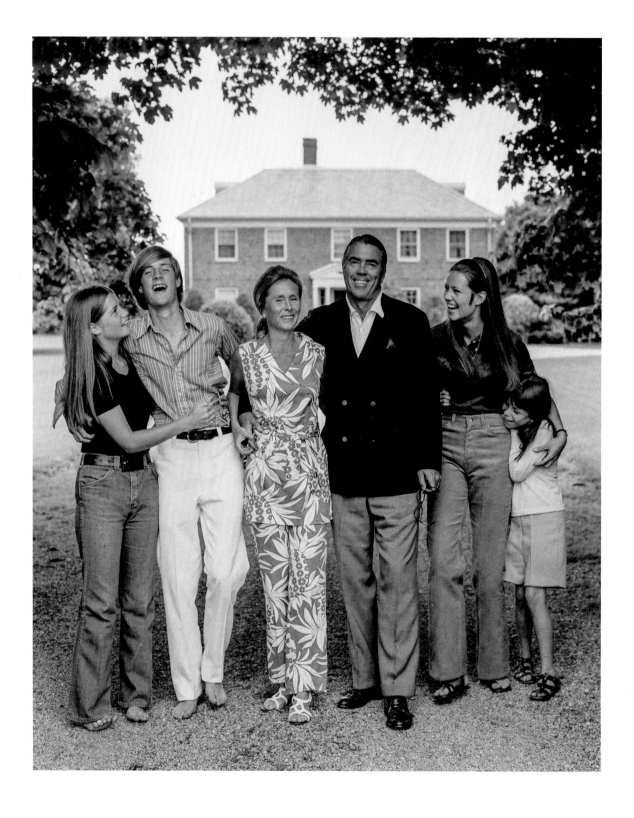

Tanya and Oakley Rhinelander with their blended family, Newport, Rhode Island, 1970.

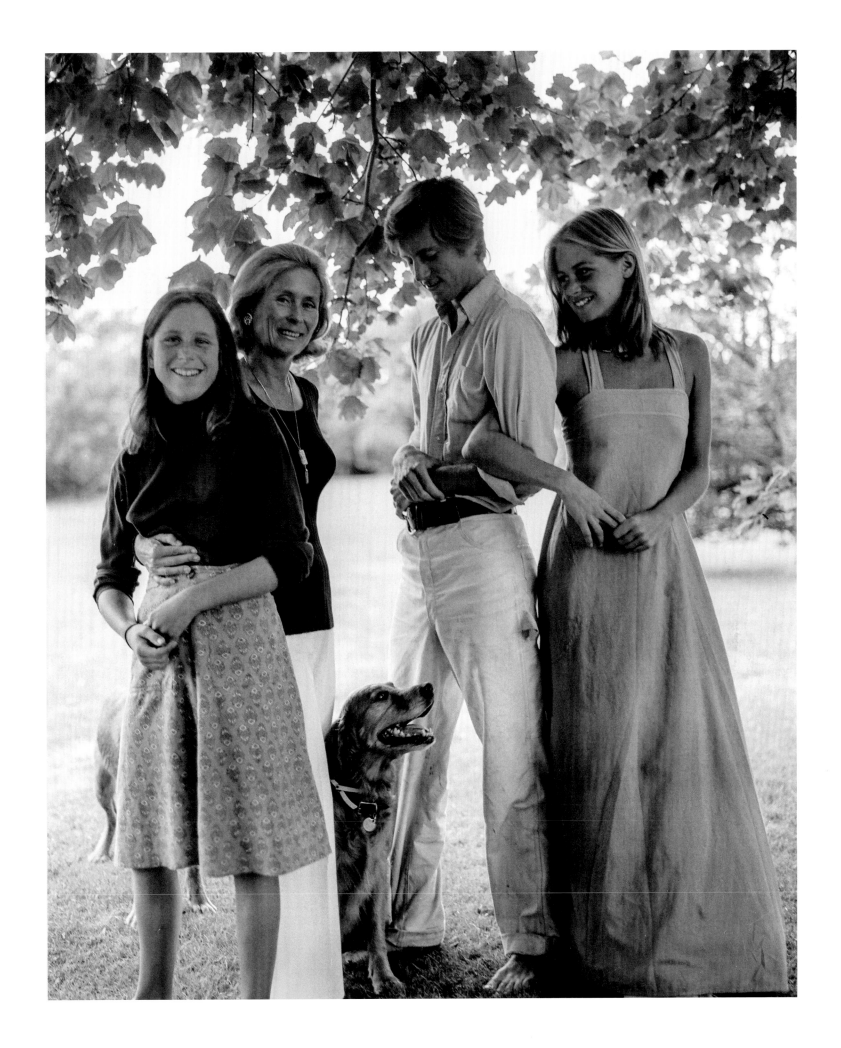

Tanya Rhinelander with her three children,
Newport, Rhode Island, 1975.

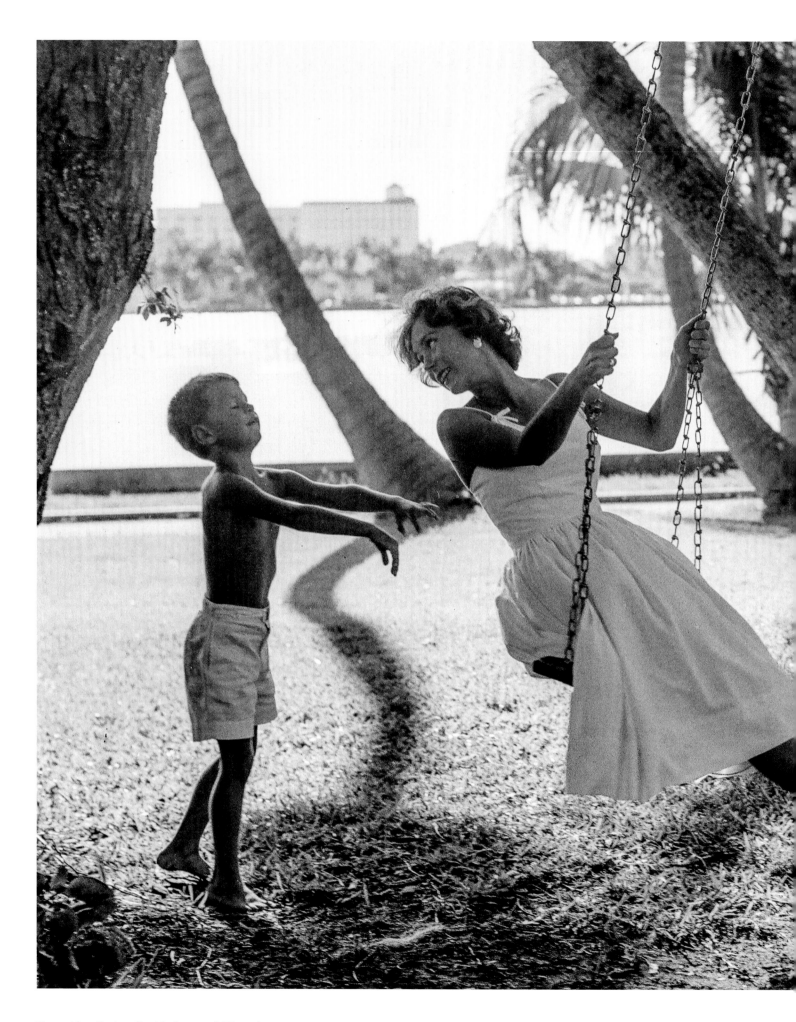

Tanya (then Brainard) with the two children she
had with Snelling Robinson Brainard, Palm Beach,
Florida, 1959.

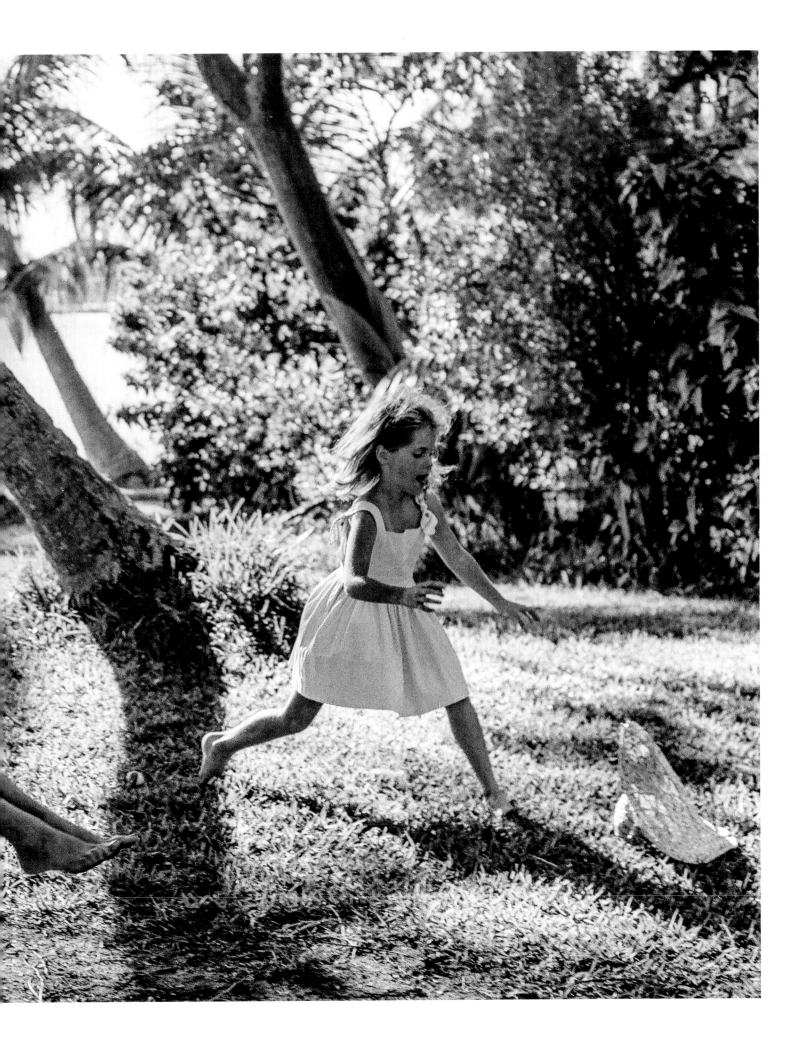

ROBINSON FAMILY

When Mr. and Mrs. Alexis Obolensky of Palm Beach announced the engagement of her daughter, Ann Gennett (now Ann Summers) in the *New York Times* to Caldwell Colt "Blitz" Robinson in 1964, it was the definition of a Social Register story. The bride-to-be made her debut at the storied Everglades Club, and the future groom, a graduate of the prestigious St. George's School in Newport and Johns Hopkins University, was cut from the same cloth. His maternal grandmother, Josephine, had been married to Ernest DuPont, then to S. Hillen MacSherry, at her Sands Point, New York estate, "Goldenglow," before marrying Francis Robinson, Blitz's father.

Ann Robinson (now Summers) with her daughters,
Alexis, Nicole and Missy, Easton, Maryland, 1974.

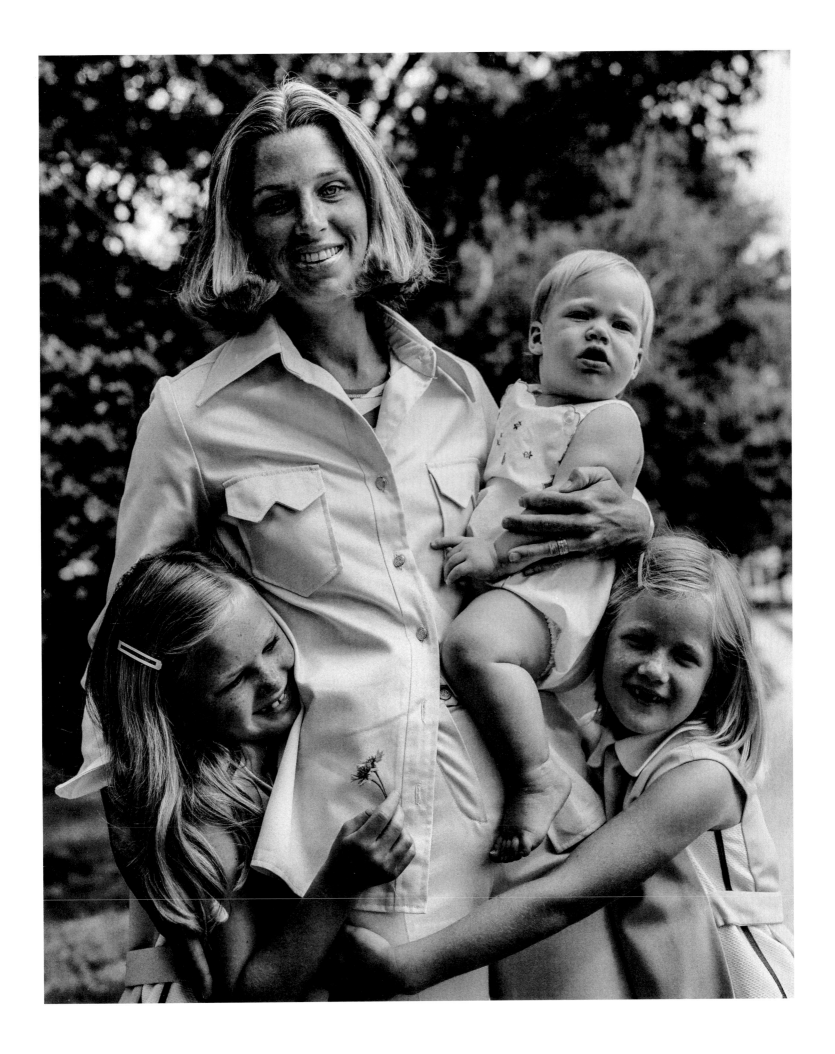

ROSENTHAL FAMILY

There was probably no more attractive or beloved couple in Palm Beach than Leighton and Honey Rosenthal. Snowbirds from Cleveland (with a fortune made in the work apparel business), they purchased an iconic oceanfront home, "Villa Artemis," from the estate of Amy Phipps Guest in the late 1950s. Their daughters, Cynthia Boardman and Jane Horvitz, along with their families, continue to call the glorious house "home." Regardless, the spectacular Grecian-style pool and oceanfront pergola will forever define Palm Beach style.

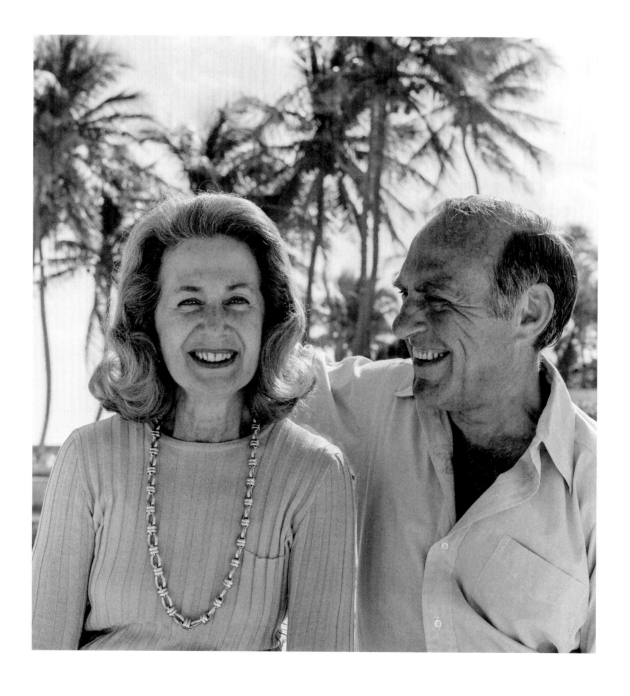

Honey and Leighton Rosenthal, Palm Beach, Florida, 1975.

Facing: Honey and Leighton Rosenthal with daughters Jane and Cynthia, Palm Beach, Florida, 1975.

The one of my dad looking at my mother is actually the best, happiest and favorite picture I have of them.

Jane Rosenthal Horvitz

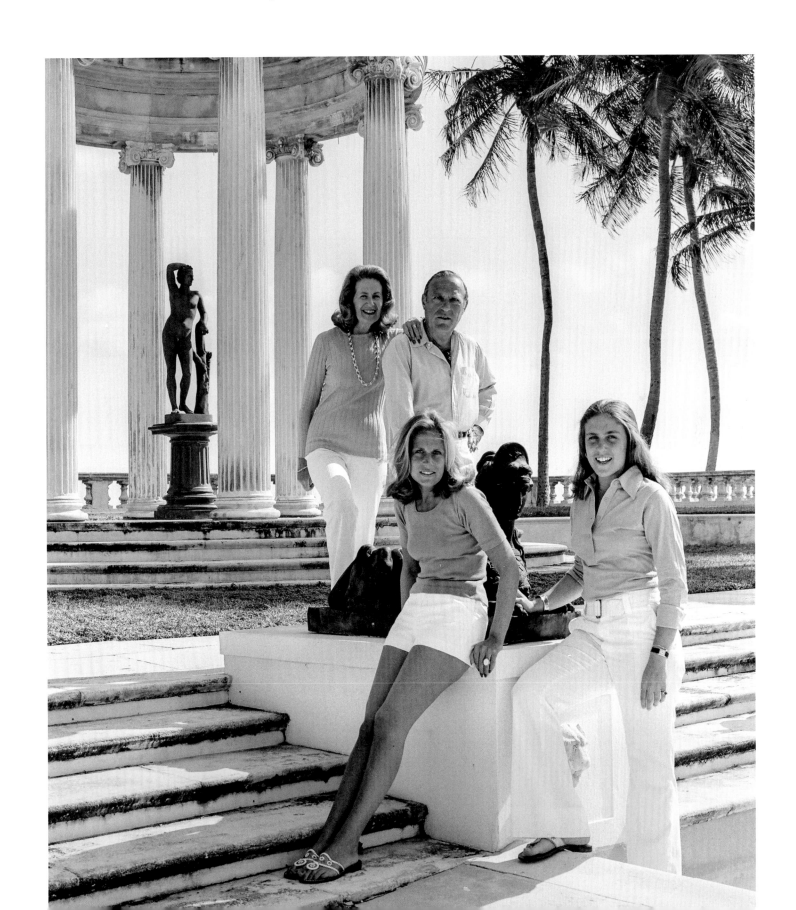

SAUD FAMILY

Princess Dalal bint Saud Al Saud first came to Palm Beach as a child in 1962, accompanying her father, King Saud, who rented a mansion in which to recuperate from surgery in Boston. During that time, the Saudi monarch was paid a visit by then President John F. Kennedy, an encounter that was heavily documented by the media. Other members of the family continued to maintain ties to Palm Beach, with significant commercial real estate holdings.

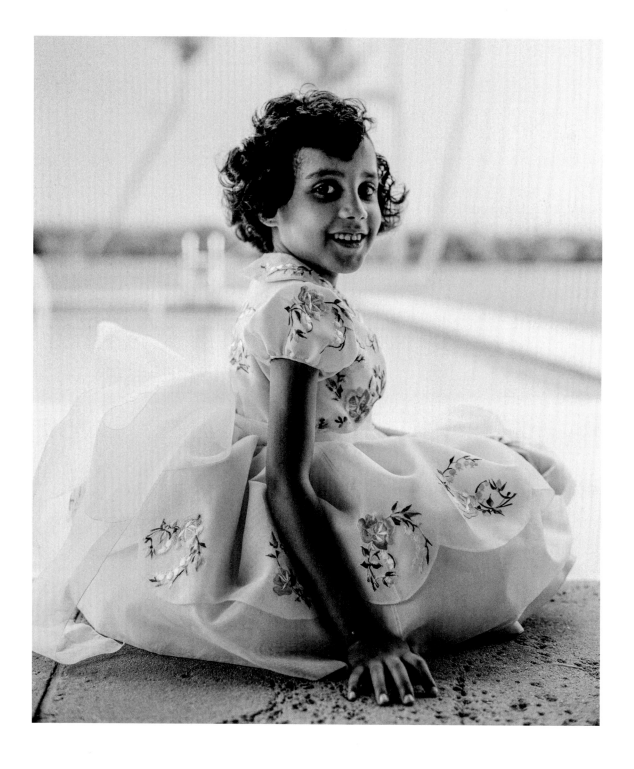

Princess Saud, Palm Beach, Florida, 1962.

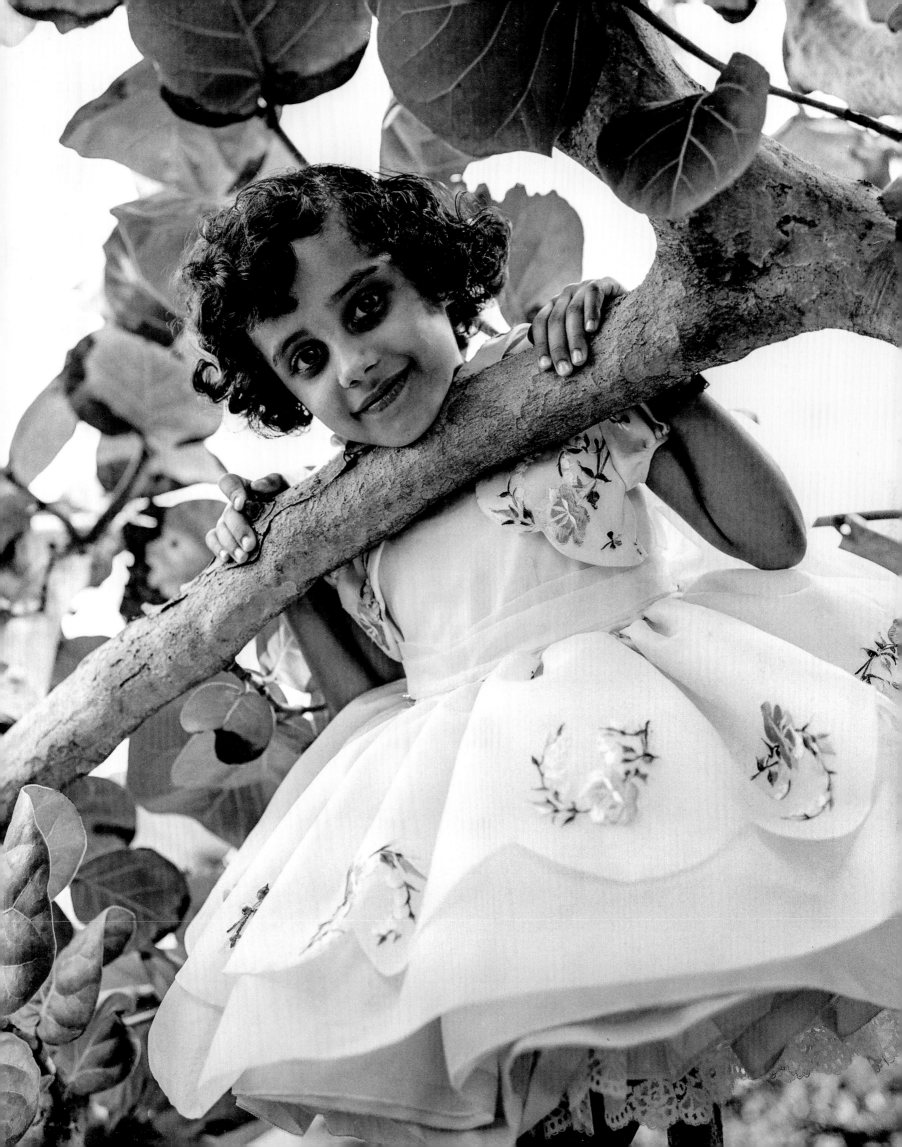

SHERRILL FAMILY

Virgil and Betty Sherrill were both Louisianans who lived a superbly stylish life in New York and Southampton. Their Carrere & Hastings–designed estate, "Mayfair," was famous for its explosion of daffodils every spring. While Virgil was a successful banker, Betty, too, famously soared professionally as the president and owner of McMillen, Inc., one of America's most revered interior design firms.

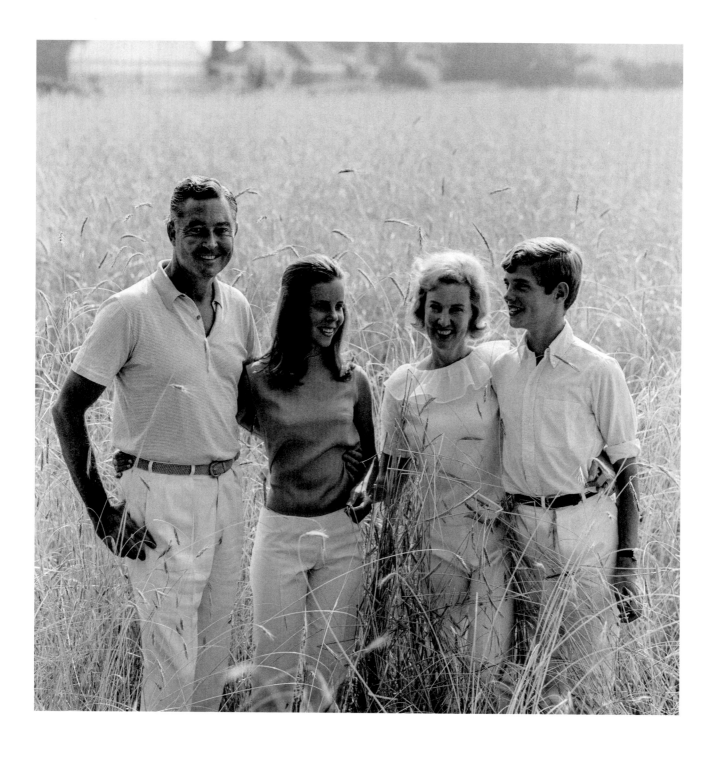

Virgil and Betty Sherrill with children Ann and Stephen, Southampton, New York, 1966.

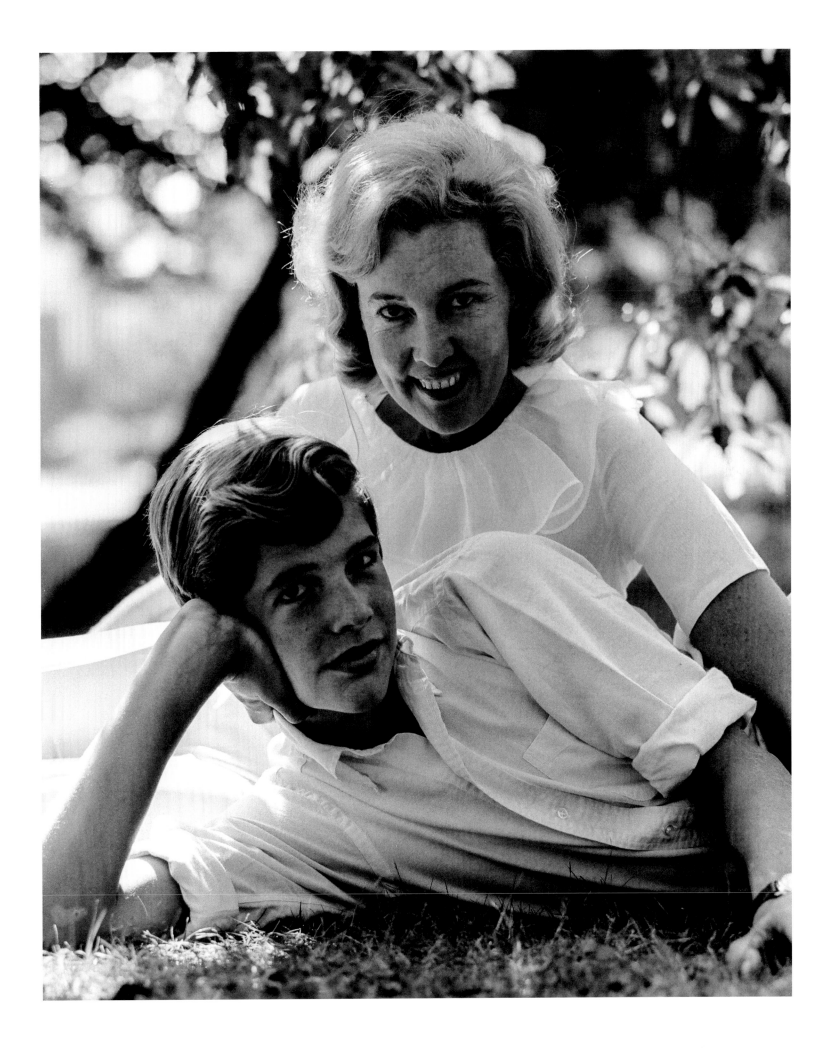

Betty Sherrill and her son, Stephen, Southampton,
New York, 1966.

SHRIVER FAMILY

After being discharged from the navy, Yale Law School grad Robert Sargent Shriver worked as an assistant editor at *Newsweek* magazine in New York. Known as Sargent or "Sarge," he met Eunice Kennedy at a party, and after a seven-year courtship, married her in 1953; he ultimately worked for his brother-in-law's presidential campaign. During the JFK presidency, Shriver founded and served as the first director of the Peace Corps, a role that he continued for many years after the assassination, while Eunice founded the Special Olympics. Sargent served as US Ambassador to France from 1968 to 1970 and after an unsuccessful bid for the Democratic presidential nomination returned to private life. Sargent and Eunice's celebrated and accomplished children, most notably Maria Shriver, continue the family legacy of public service and philanthropy.

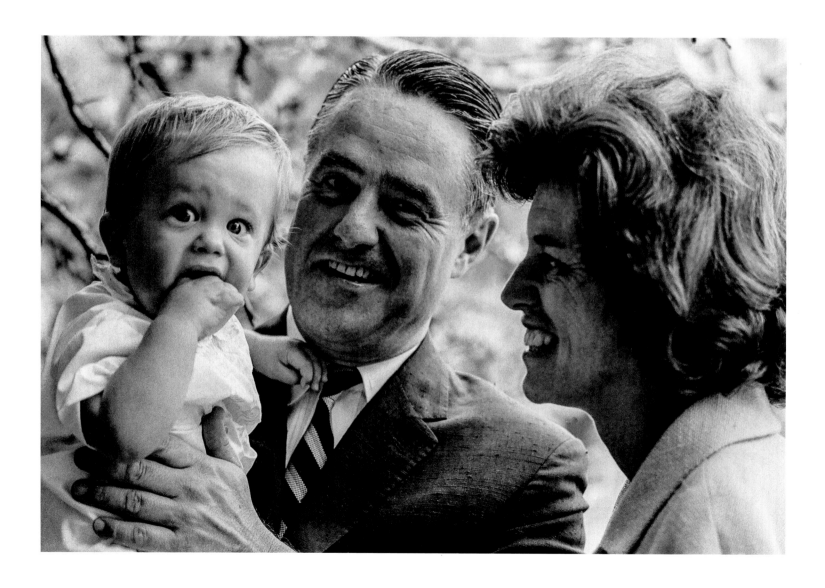

Sargent and Eunice Kennedy Shriver with son Mark, Rockville, Maryland, 1964.

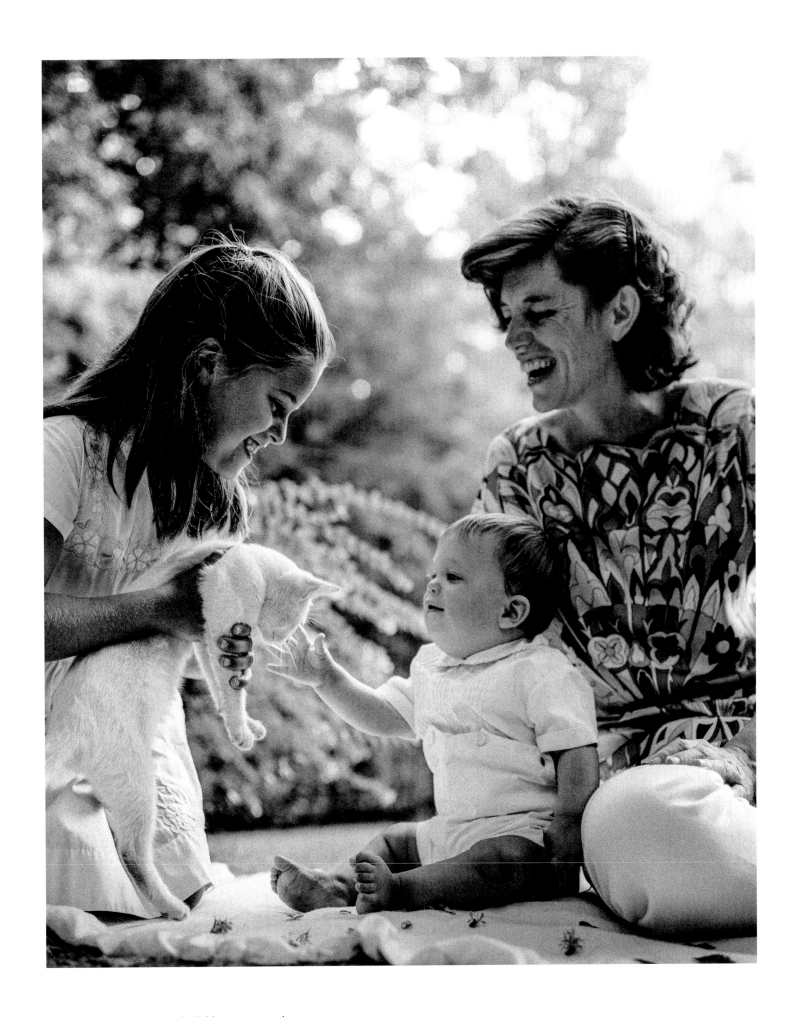

Eunice Kennedy Shriver with children Maria and
Mark, Rockville, Maryland, 1964.

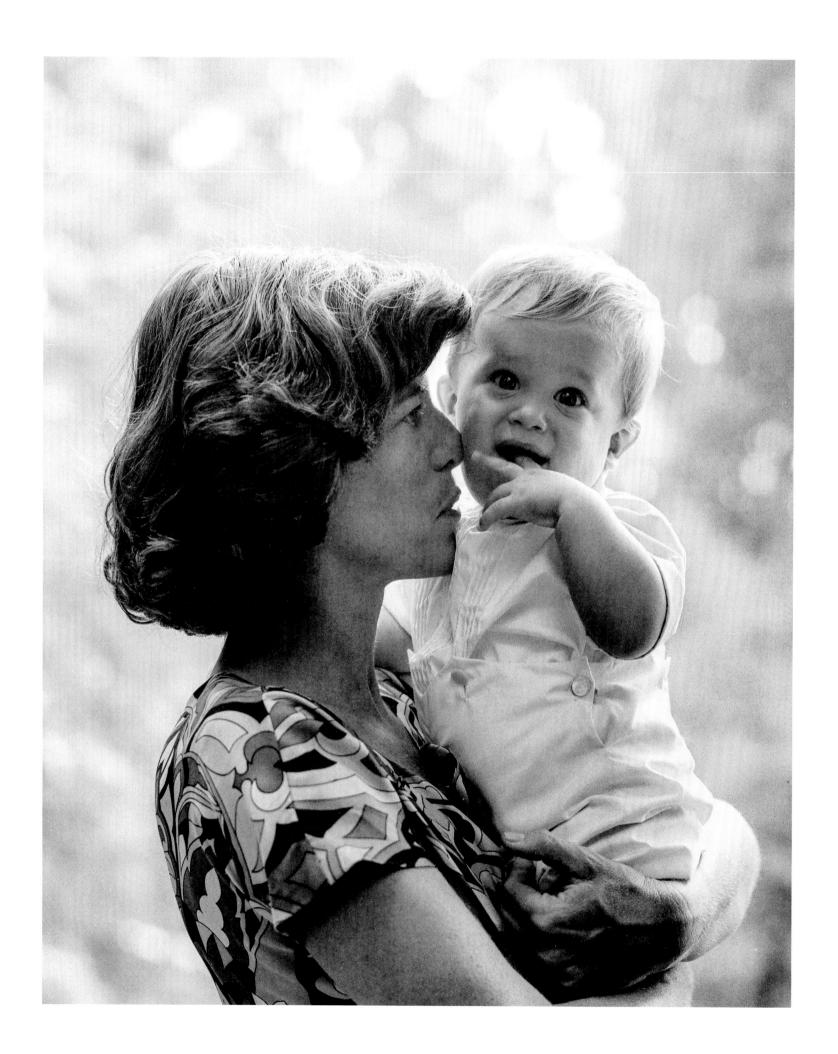

Eunice Kennedy Shriver and son Mark, Rockville,
Maryland, 1964.

Bobby Shriver, Rockville, Maryland, 1964.

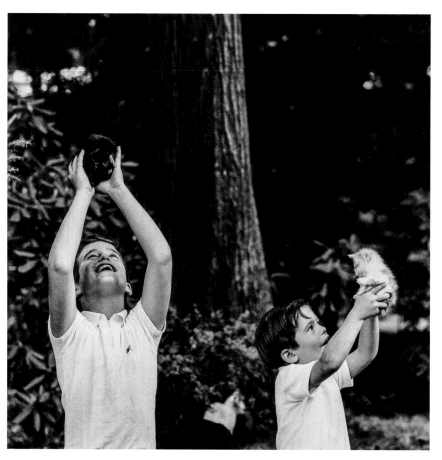

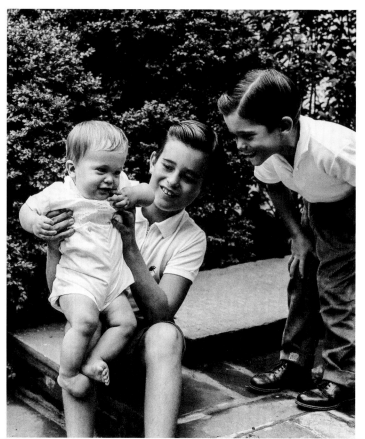

The Shriver children, Rockville, Maryland, 1964.

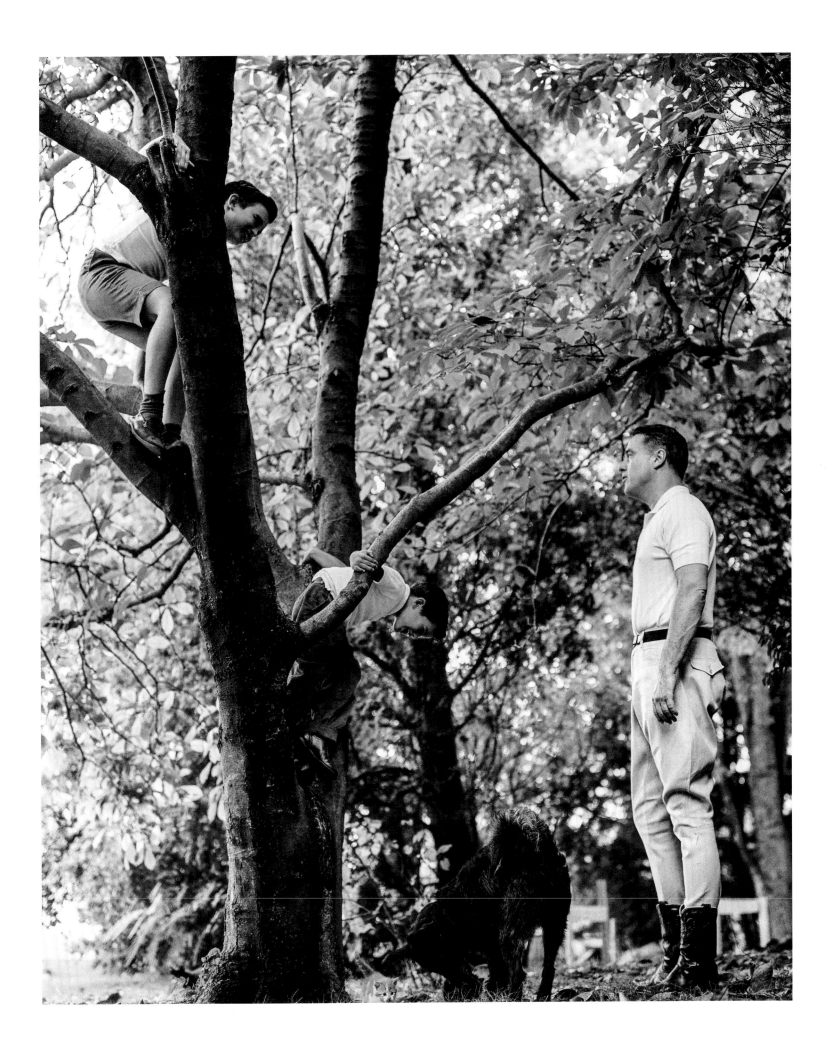

Sargent Shriver with sons Bobby and Timothy,
Rockville, Maryland, 1964.

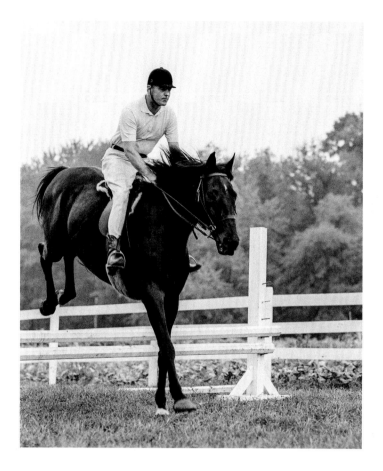

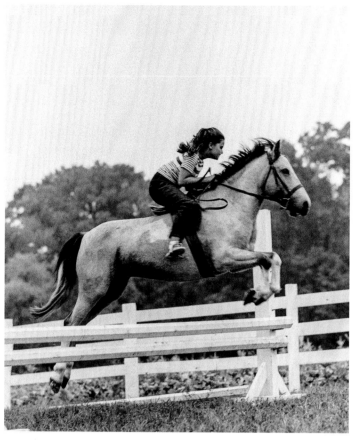

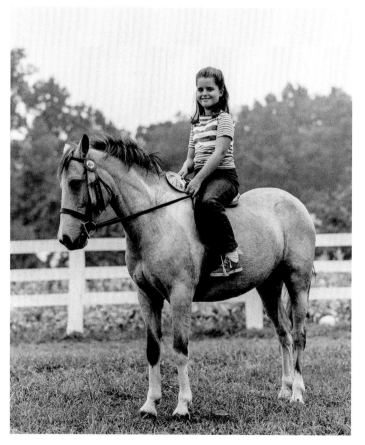

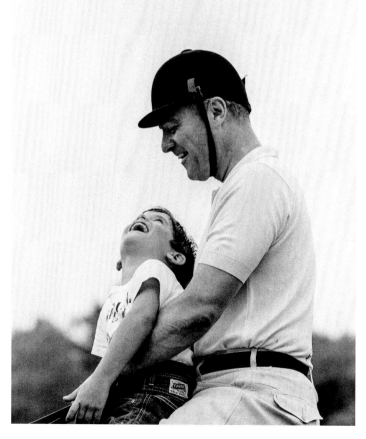

The Shriver family on horseback, Rockville,
Maryland, 1964.

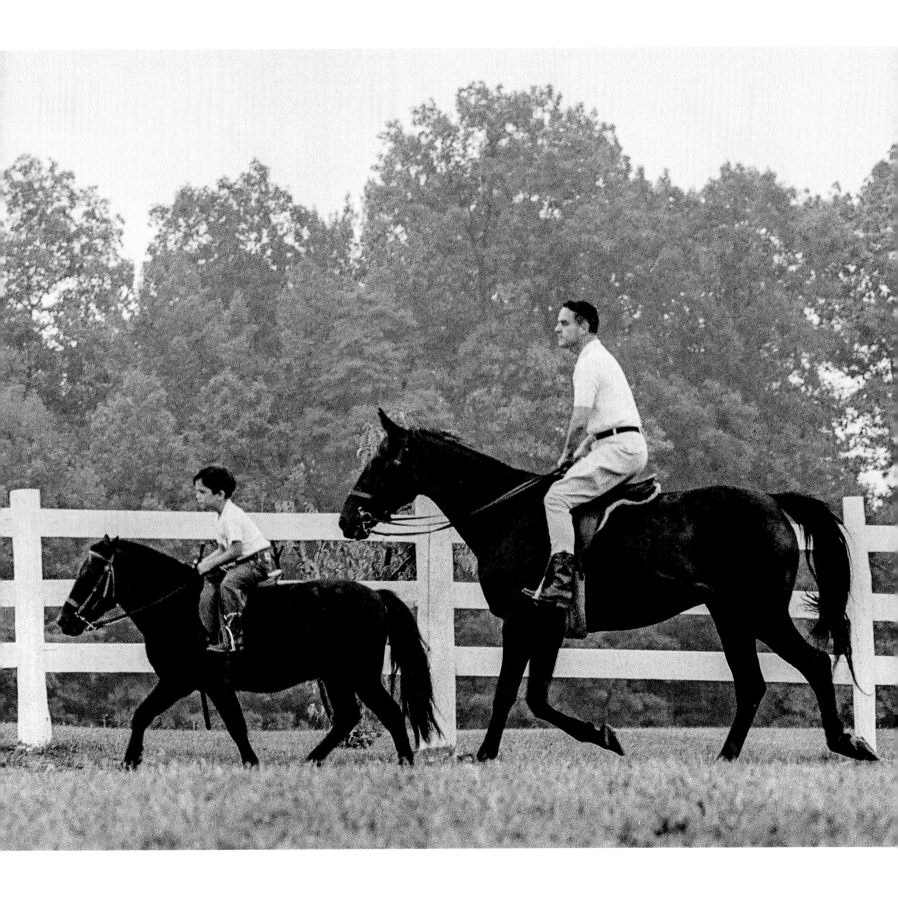

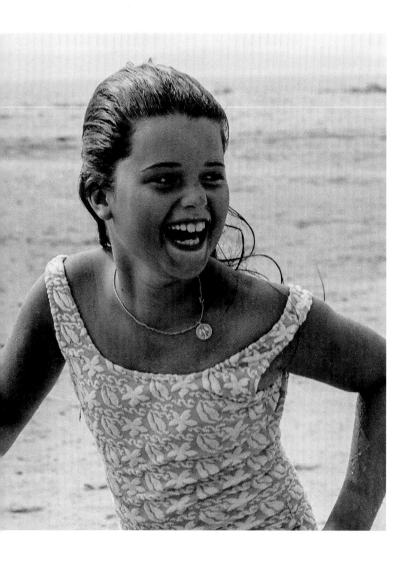

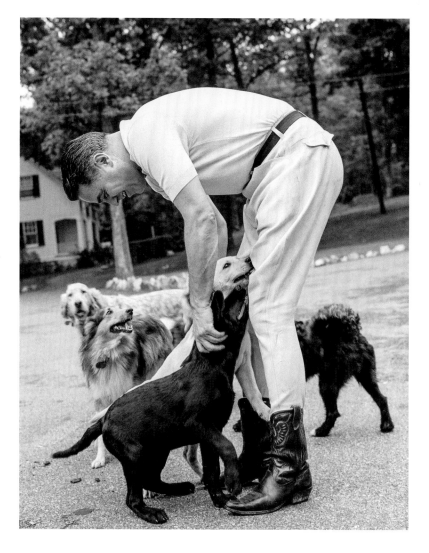

Maria Shriver, Hyannisport, Maryland, 1964. Sargent Shriver, Rockville, Maryland, 1964.

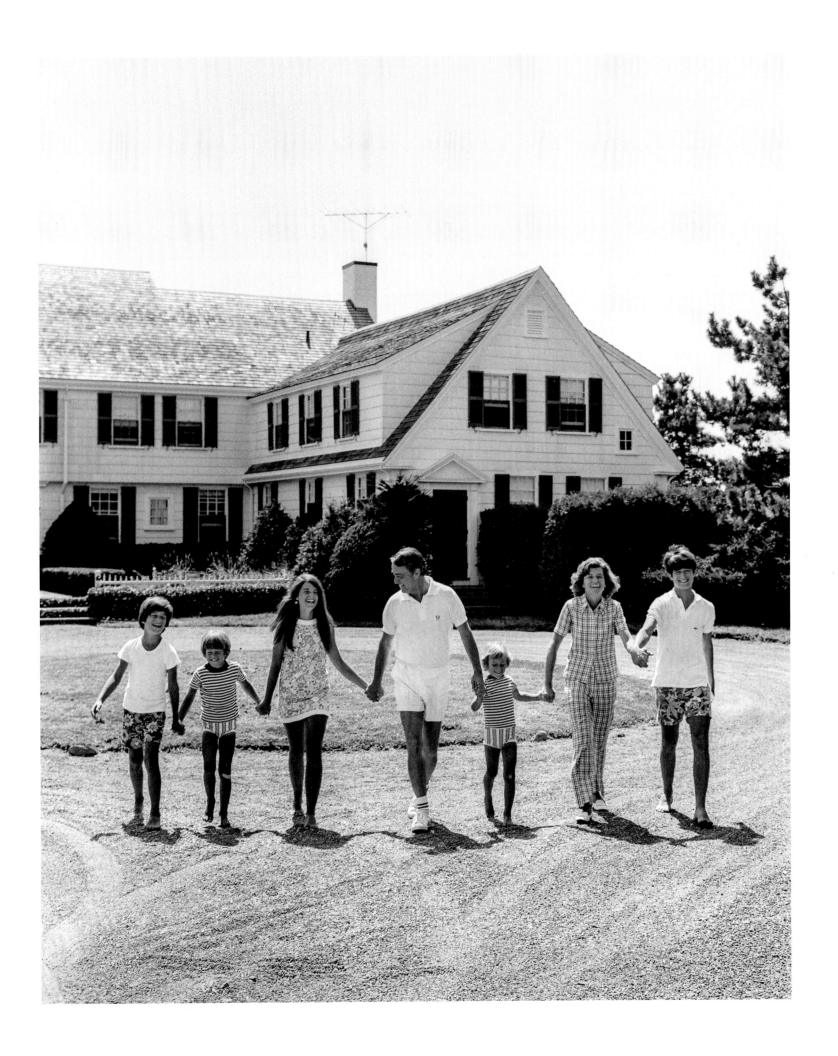

The Sargent Shriver family, Rockville, Maryland, 1977.

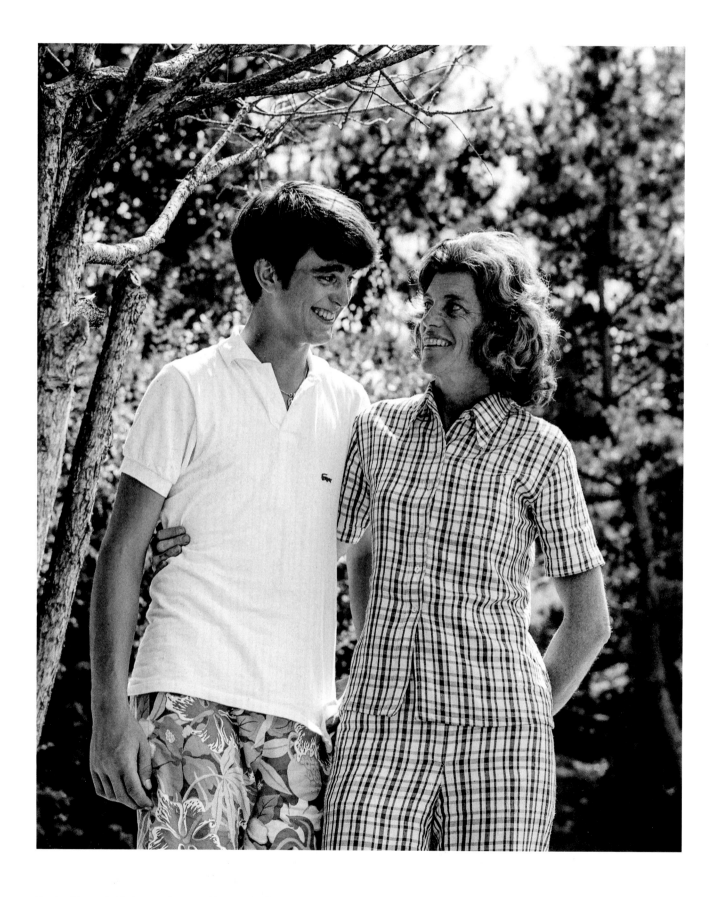

Eunice Kennedy Shriver and son Bobby, Rockville,
Maryland, 1977.

Facing: The Sargent Shriver family, Rockville,
Maryland, 1977.

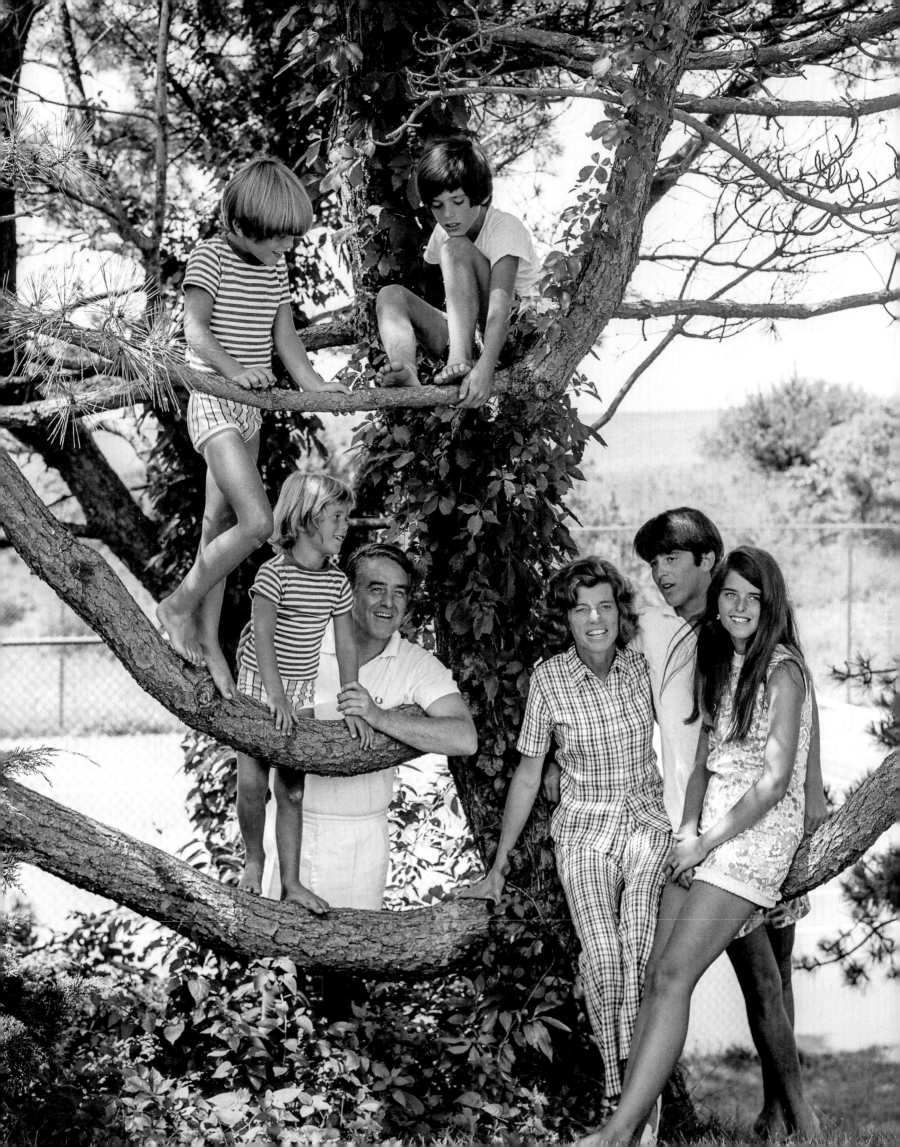

SLOCUM FAMILY

Without the Slocum family, there would be no high society of Newport. From their imposing stone manor on Bellevue Avenue, inherited from an aunt in the 1960s, John and Eileen Slocum entertained often and lavishly, often with political interests, as Eileen was a Republican party stalwart both in Rhode Island and nationally. Their twenty-five-room mansion, called Harold Brown Villa, went on the market in summer 2018, having remained in the family from the time it was built, in 1895.

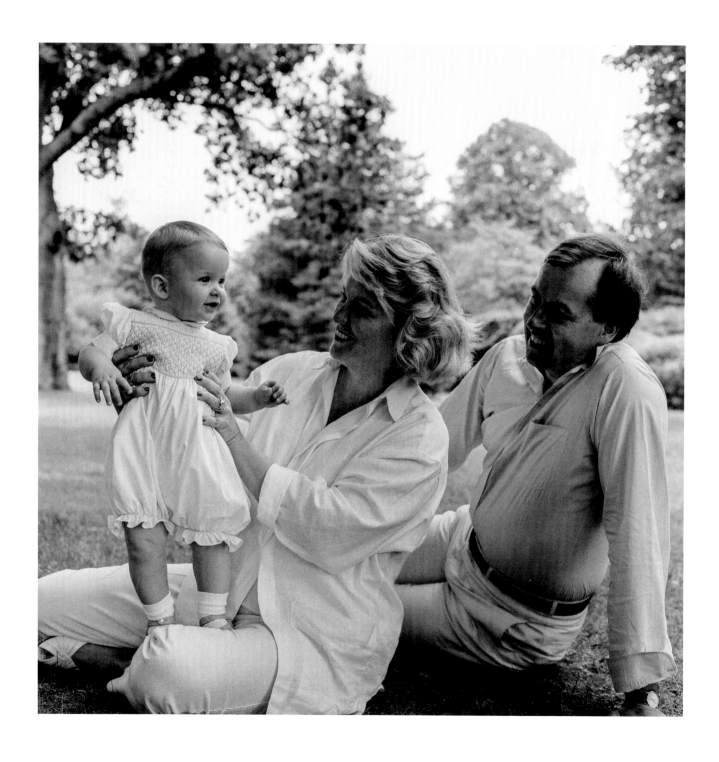

John Slocum Jr., his wife, Diana, and their son
Lawrence, Newport, Rhode Island, 1986.

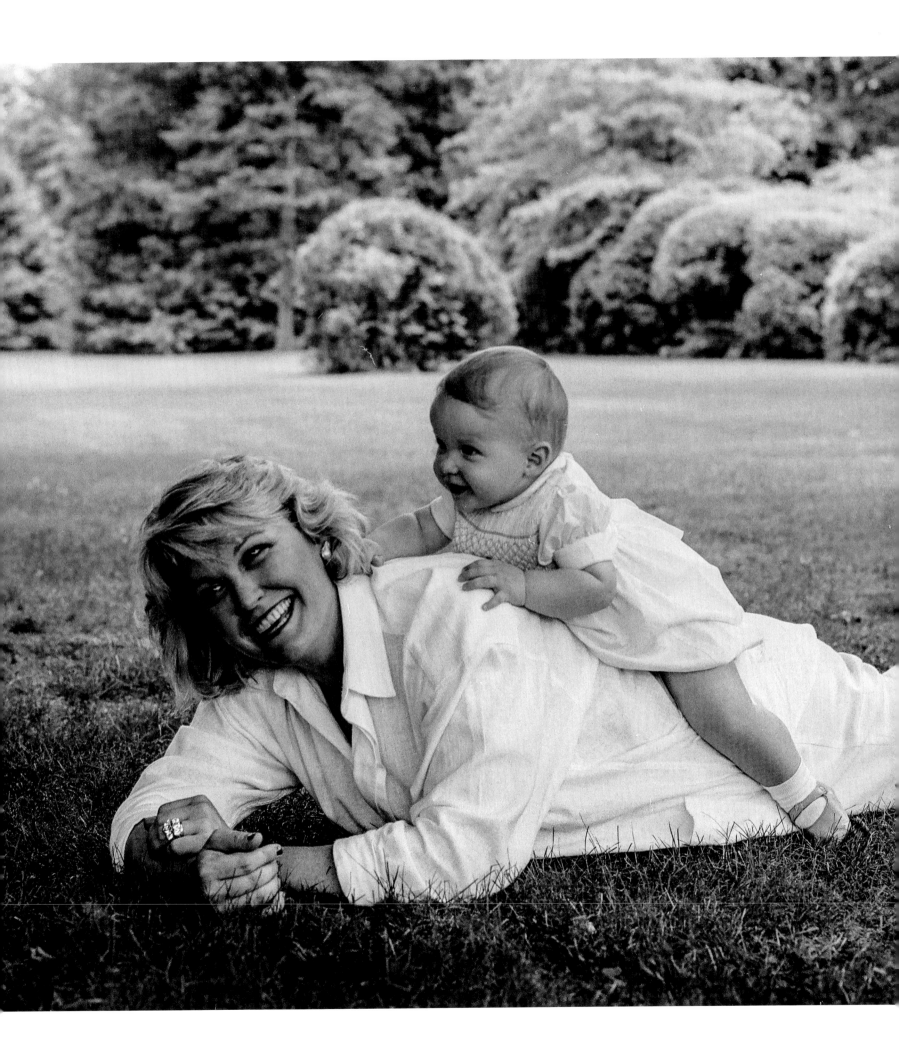

Diana Slocum and son Lawrence, Newport,
Rhode Island, 1986.

EARL SMITH FAMILY

Earl E. T. Smith was a diplomat, US ambassador to Cuba and much-beloved mayor of Palm Beach, a role also famously occupied by his second wife, Lesly. Her daughter from a previous marriage, Danielle, now follows in her mother's (and step-father's) footsteps as a deeply dedicated member of the Palm Beach town council.

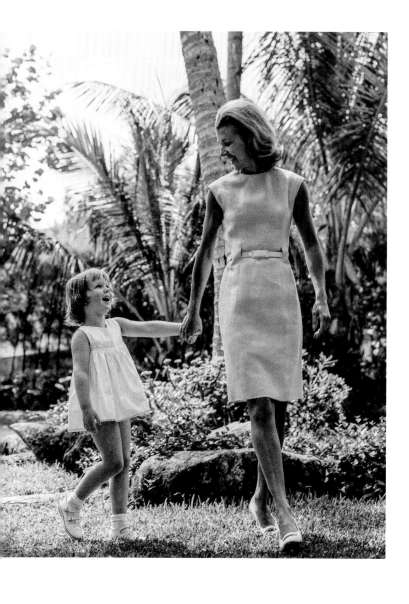

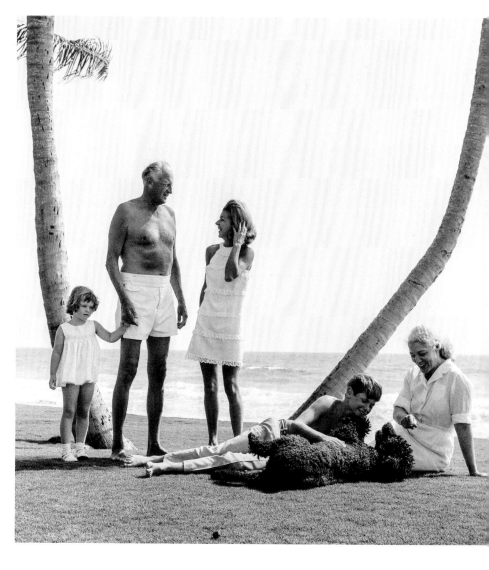

Lesly Smith and her daughter, Danielle Hickox, Palm Beach, Florida, 1968.

Earl and Lesly Smith with her daughter, Danielle, and his son, Earl Jr., and nanny, Palm Beach, Florida, 1968.

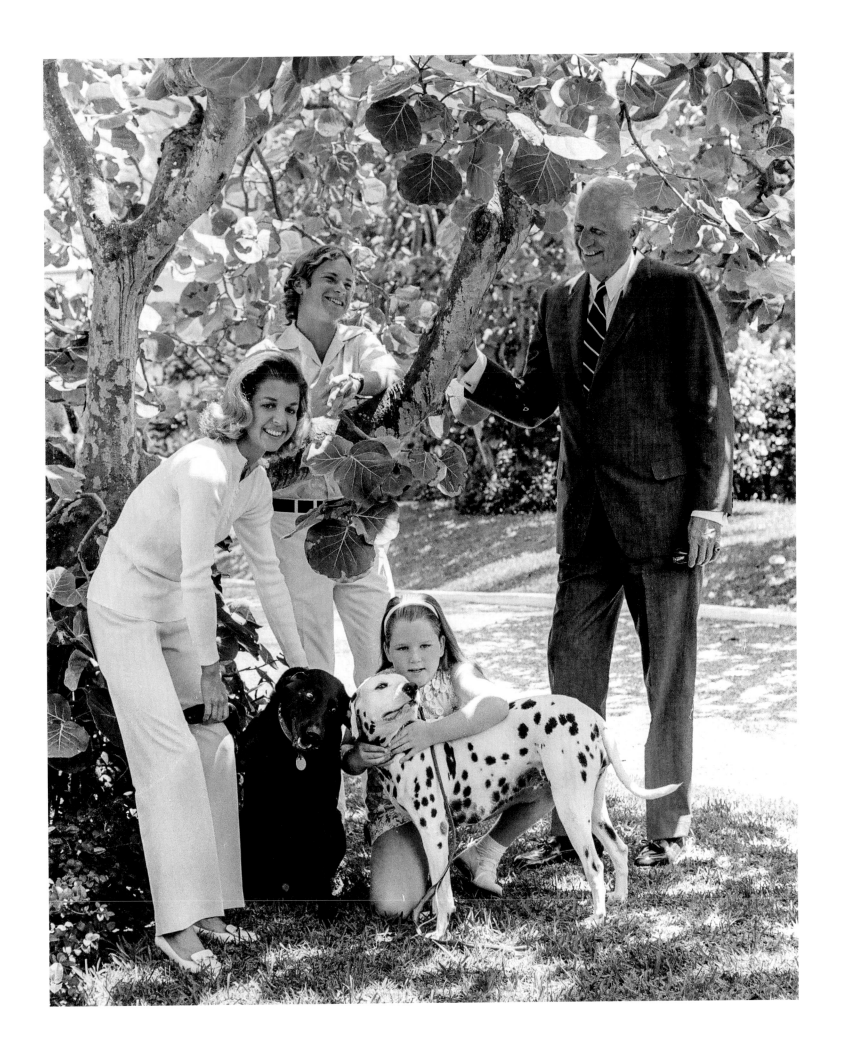

The Earl E. T. Smith family, Palm Beach, Florida, 1972.

PAGE SMITH FAMILY

As a Pan Am pilot for thirty years, the late Page Wright Smith established many of the international flying routes still in use today. His wife, Jane, maintains that global stature as a seemingly ageless leader of high society in Newport and Palm Beach.

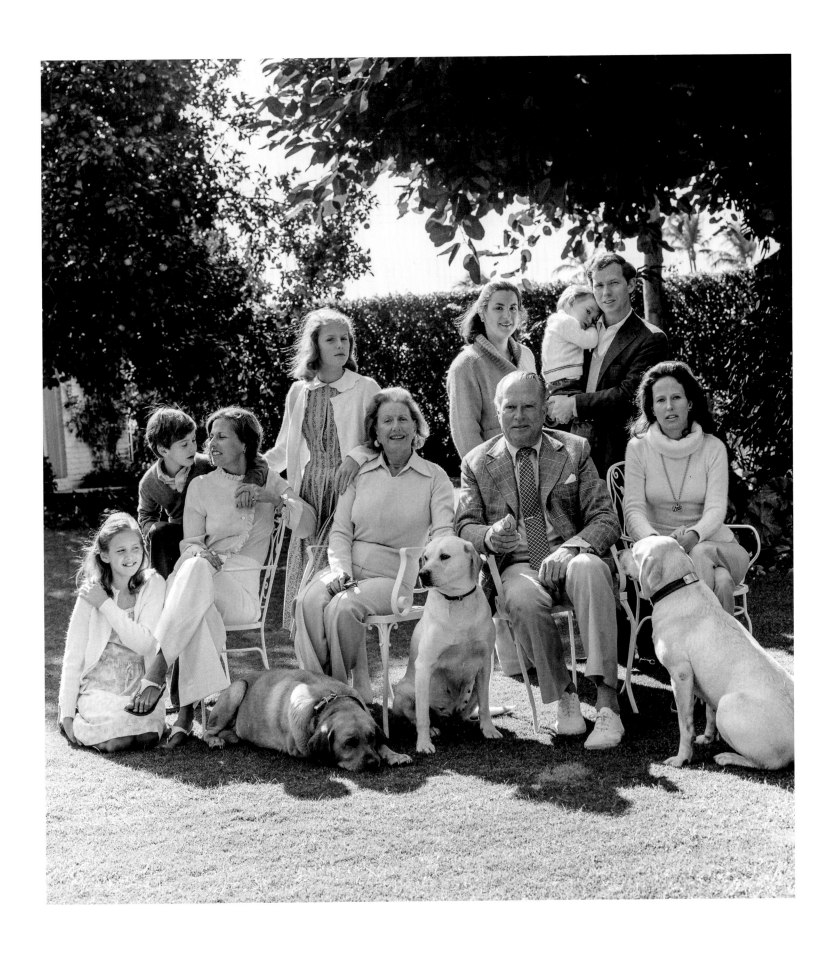

Jane and Page Smith and family, Palm Beach,
Florida, 1980.

STEPHEN SMITH FAMILY

Initially working for his family's New York tugboat and barge business, Stephen Smith's life dramatically changed with his 1956 marriage to one of the famous Kennedy sisters, Jean Ann. He not only took an active role in the many political campaigns that were part and parcel to the Kennedy brand, but he also managed $300 million in Kennedy family investments while overseeing the trusts that benefited all of the children and grandchildren of Joe and Rose Kennedy. For her part, Jean served as the US ambassador to Ireland from 1993 to 1998. They had four children, all of whom follow in the Kennedy mold of accomplishment and service.

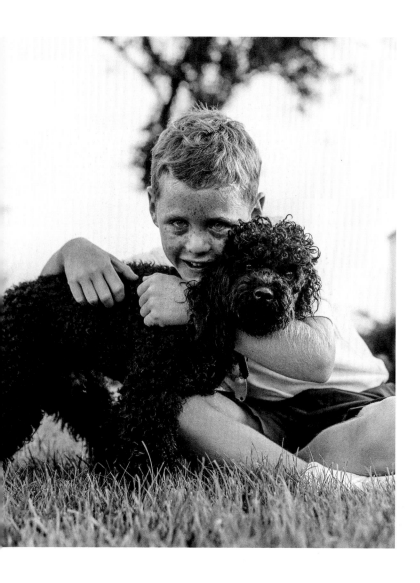

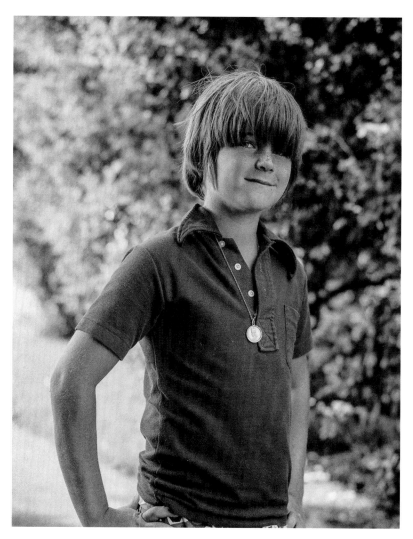

Stephen Smith Jr., Rockville, Maryland, 1965.

William Kennedy Smith, Rockville, Maryland, late 1960s.

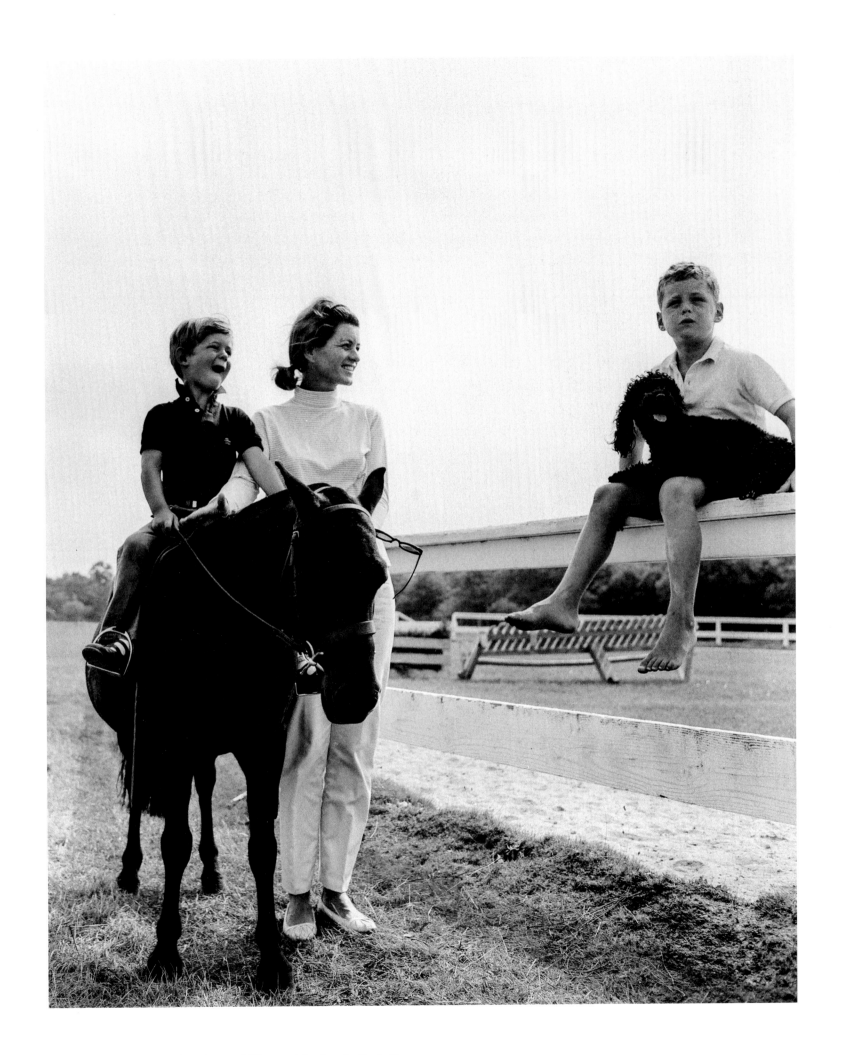

Jean Kennedy Smith with sons William and Stephen Jr., Rockville,
Maryland, 1965.

VAN RENSSELAER FAMILY

Charles Van Rensselaer III was a descendant of one of the founding families of New York. In the seventeenth century, the Van Rensselaers owned a million acres of land. Charles settled in Palm Beach with longtime partner, Tom Cunneen. While not the only gay couple to move seamlessly among Palm Beach's social set, elegantly handsome "Charlie and Tom," as they were known, were both loved and respected by all.

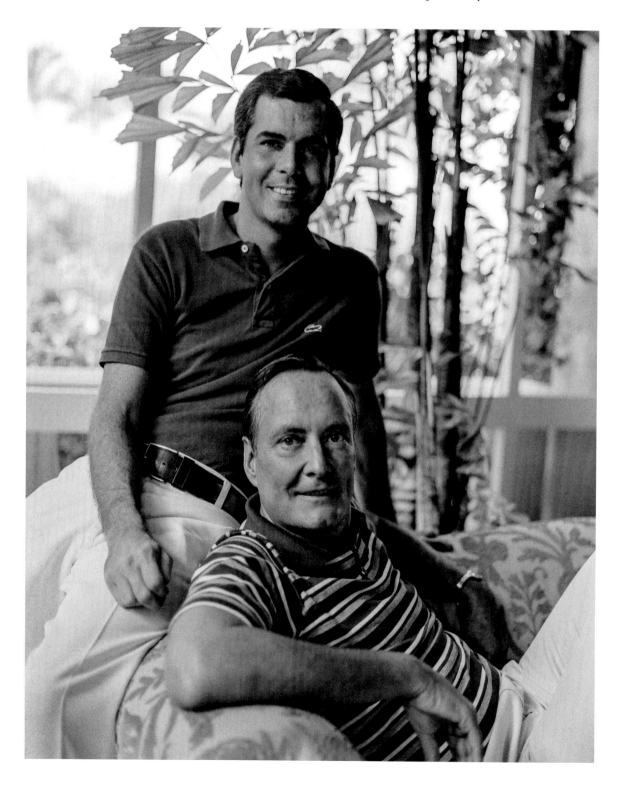

Tom Cunneen and Charles Van Rensselaer,
Palm Beach, Florida, 1977.

VON AUERSPERG FAMILY

In 1956, twenty-four-year-old oil and gas heiress Martha "Sunny" Sharp Crawford married Prince Alfred von Auersperg, a twenty-year old tennis pro from a distinguished but impoverished Austrian family. They had two children, Ala and Alexander and then divorced in 1965. In 1966, Sunny married Claus von Bülow, a former aide to oilman J. P. Getty. They had one daughter, Cosima, and lived lavishly in New York and Newport. Their lives evolved into tabloid fodder due to a series of events that both rocked and captivated high society. The story was chronicled in a book and later made into a film.

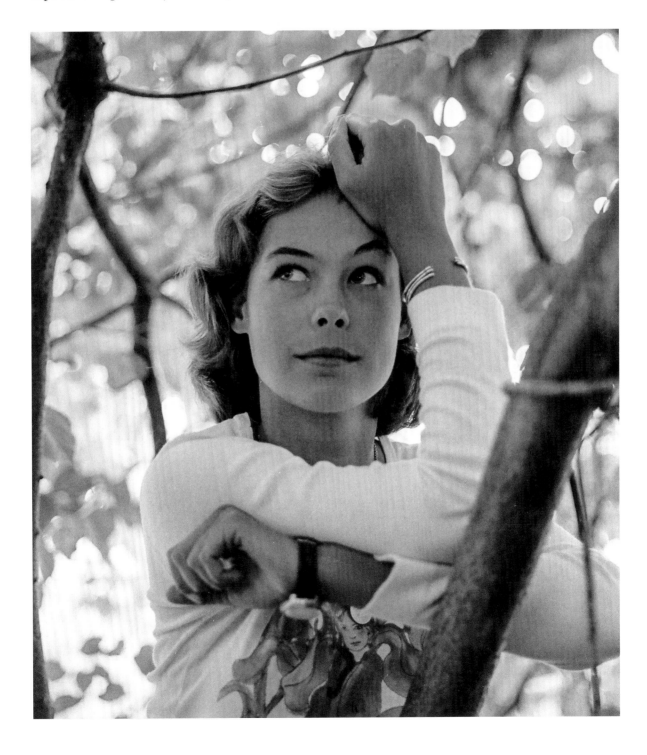

Ala von Auersperg, Newport, Rhode Island, 1975.

WAKEMAN FAMILY

Nancy "Trink" Wiman Wakeman was already an heiress to the John Deere tractor fortune when she married Winthrop Gardiner Jr., the fourteenth proprietor of Gardiner's Island, New York, in 1975. She established a $1 million endowment at Duke University in neuroscience in memory of her second husband, William Thompson Wakeman Jr. "Trink" Gardiner died in 1996.

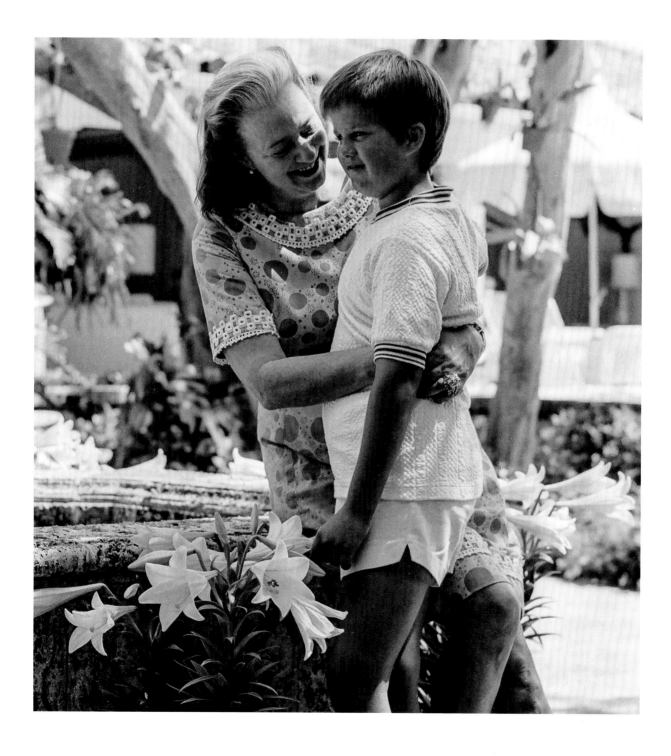

"Trink" Wakeman with her son, Rufus,
Palm Beach, Florida, 1970.

Melynda and Rufus Wakeman, Palm Beach, Florida, 1992.

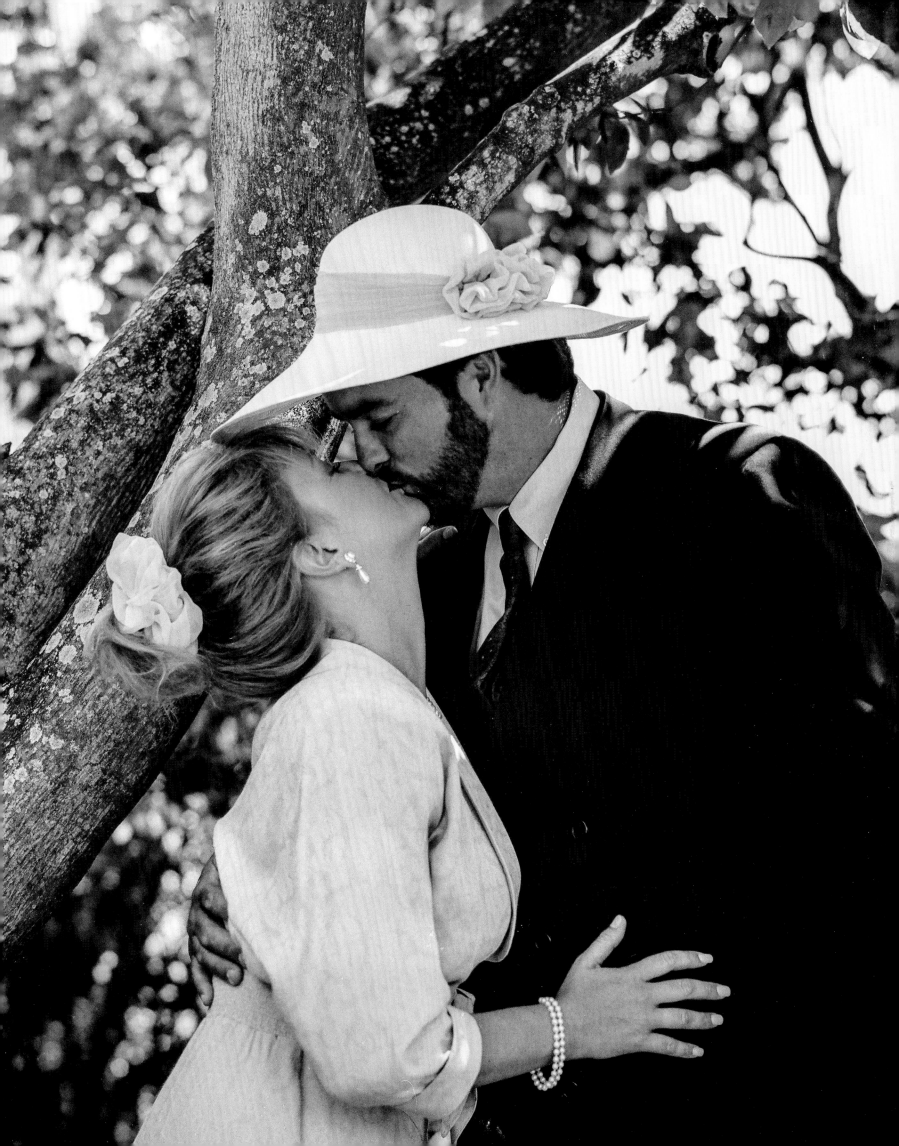

WALLACE FAMILY

Award-winning sports writer Bill Wallace was a fixture at the *New York Times*. He was the first reporter to cover the New York Giants on a regular basis for the paper, along with significant reporting on car racing, skiing, and the legendary America's Cup sailing race. He and his family lived in Southport, Connecticut.

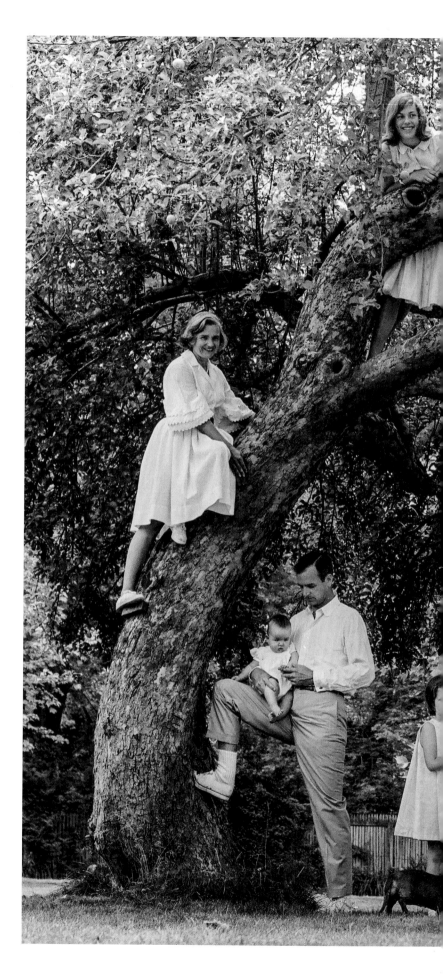

The William Wallace family, Southport, Connecticut, 1961.

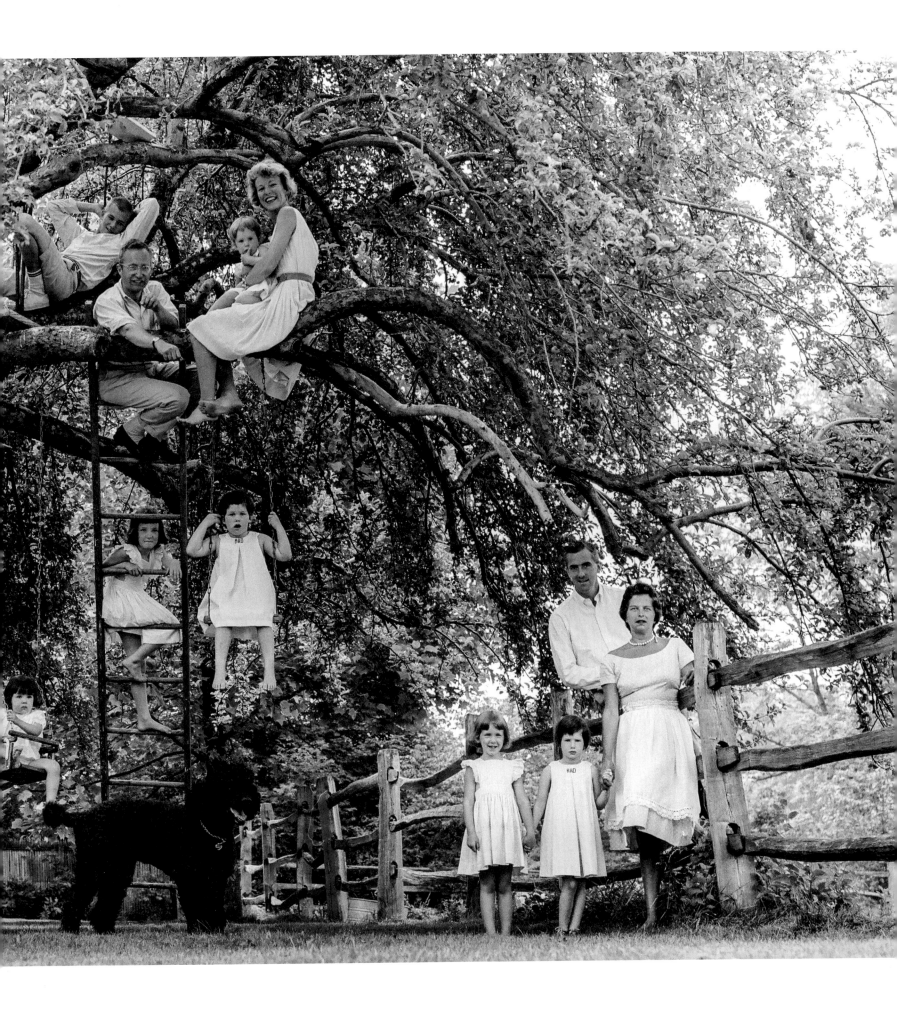

WINDSOR FAMILY

The controversial romance between Edward, the oldest son of England's King George V and Queen Mary, and American divorcée Wallis Simpson and its resulting abdication and marriage, was one of the turning points of the twentieth century. The Duke and Duchess of Windsor, as the couple were titled, drifted through a codependent life in exile. Left with little purpose and a fixed income, they focused on matters of taste, style and, most notably, pugs. Credited as the instigators of café society, they visited New York and Palm Beach often.

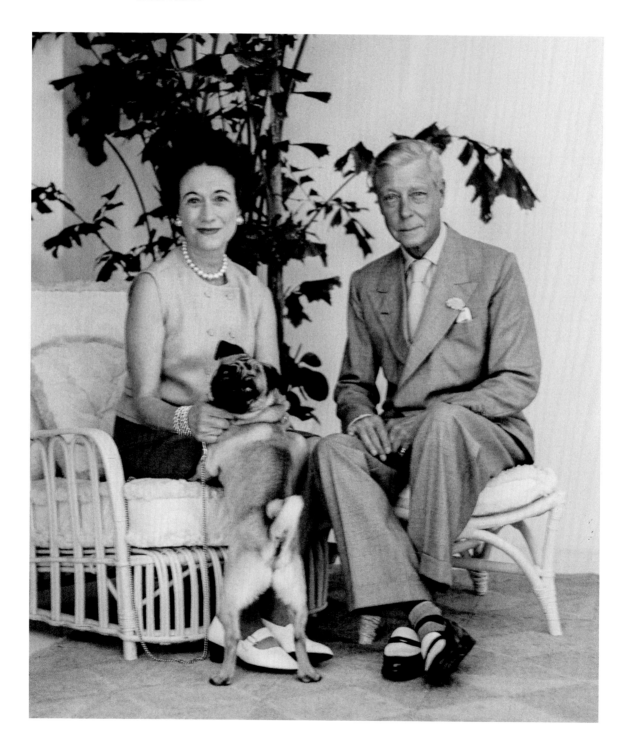

The Duke and Duchess of Windsor, Palm Beach, Florida, 1964.

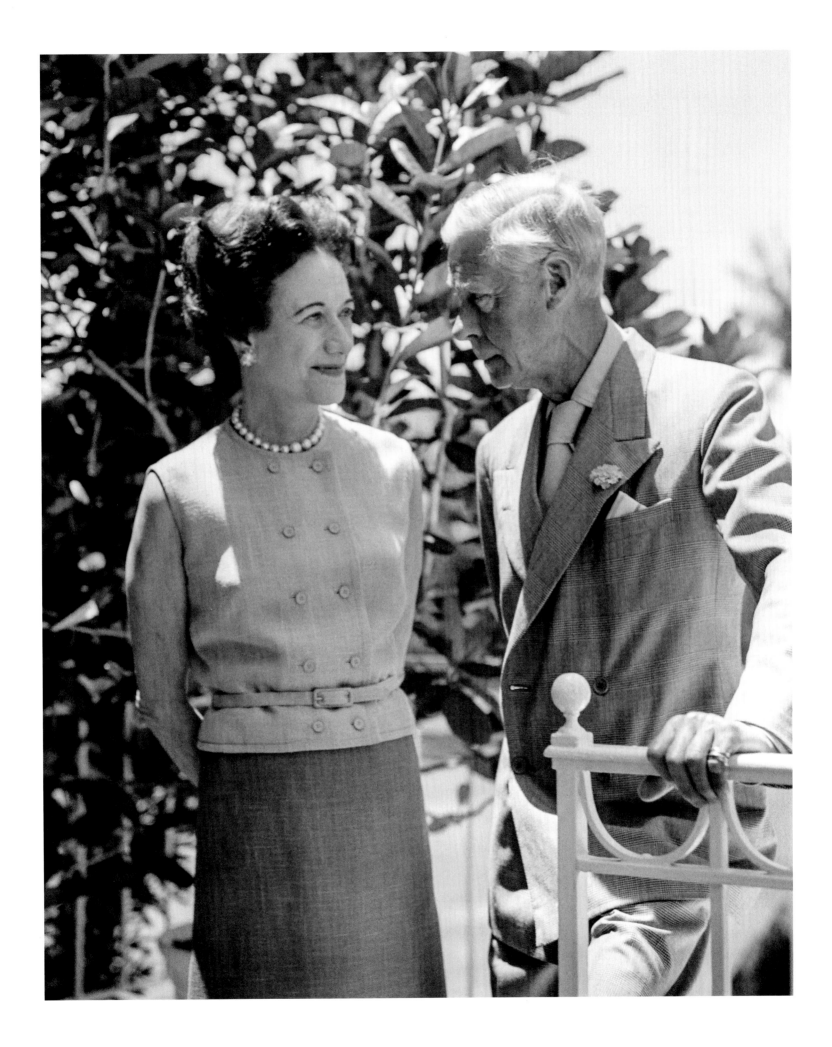

YOUNG FAMILY

After retiring as president of the iconic Chicago-based advertising agency Leo Burnett Company (creator of the Marlboro Man, Tony the Tiger and the Jolly Green Giant), Gen. William T. Young Jr. and his wife, Franci, an accomplished porcelain artist, moved their family to Palm Beach, where they became established members of the community.

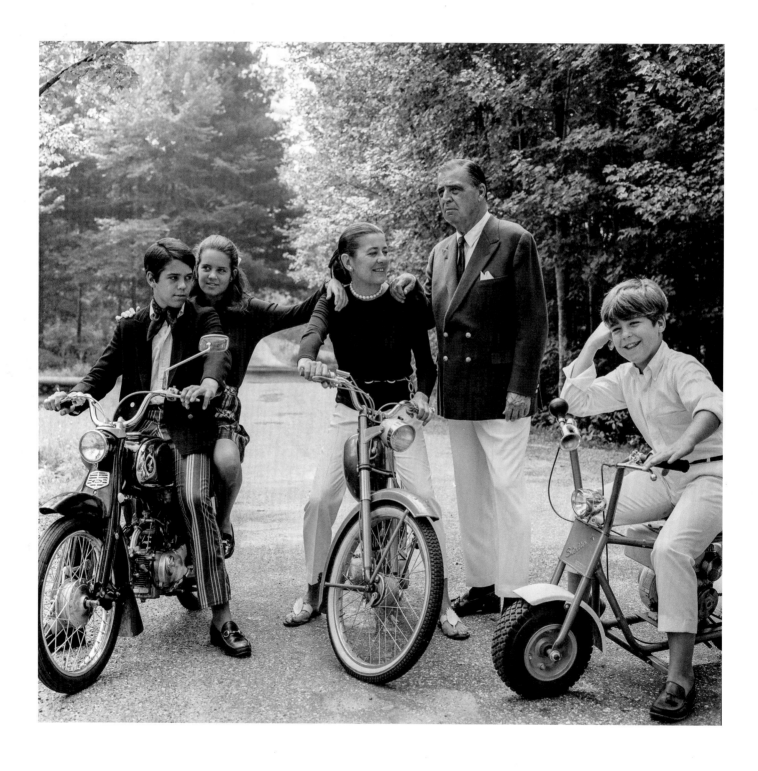

General and Mrs. William T. Young Jr. and children Tandy, Collier and Sheridan, Palm Beach, Florida, 1969.

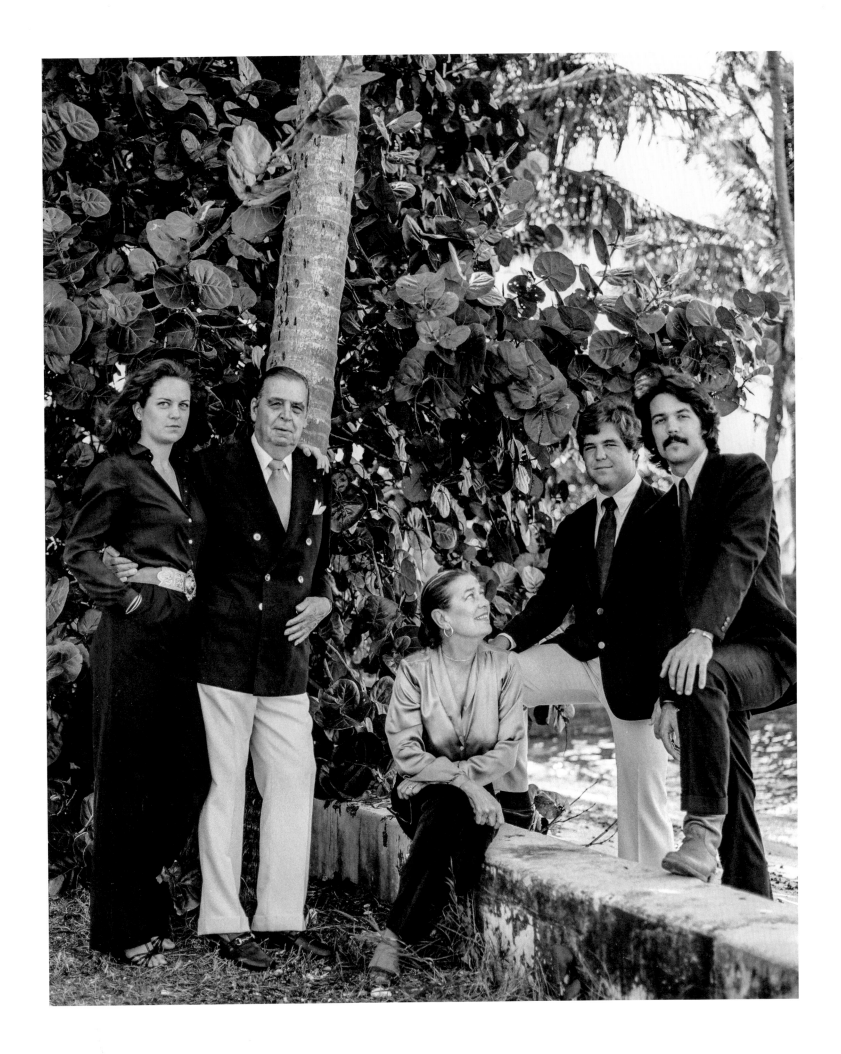

The William T. Young Jr. family, Palm Beach,
Florida, 1978.

First Edition
23 22 21 20 19 3 2 1

Text © 2019 Steven Stolman and Kate Kuhner
Photographs © 2019 Kate Kuhner

Published by
Gibbs Smith
P.O. Box 667
Layton, Utah 84041

1.800.835.4993 orders
www.gibbs-smith.com

Designed by Jeff Wincapaw

Printed and bound in China

Gibbs Smith books are printed on either
recycled, 100% post-consumer waste,
FSC-certified papers or on paper produced
from sustainable PEFC-certified forest/
controlled wood source. Learn more at
www.pefc.org.

Library of Congress Control Number:
2018951227

ISBN 978-1-4236-5178-9